"Making money is art and working is art and good business is the best art."

Andy Warhol

First published 2008

Red Rock Press

Claremont Road

Howth

Dublin 13

Ireland

redrockpress@eircom.net www.redrockpress.ie

Cover photographs

The Irish Times

Photocall

Sportsfile

Printing

GraficasCems, Spain

Printing liaison

Hugh Stancliffe

Proofreading

Elizabeth Mayes

Technical advisor

Michael Cregg

This edition published 2008 © John Burns

The moral right of the author has been asserted. A catalogue record for this book is available from the British Library.

Image reproduction

While every effort has been made to trace the owners of copyright material reproduced herein, the publisher would like to apologise for any omissions and will be pleased to incorporate missing acknowledgements in any future editions.

Visual editing

Every effort has been made to publish paintings in full to maintain the integrity of the artist's work. In order to maximise the dramatic impact of certain paintings we have opted to run some images off the edge of the printed page. Where this occurs some image detail is lost. In addition, where images run across the spine of the book, some image detail is lost in the gathering at the spine. It was the view of the publisher that the facility to display paintings at a larger size compensated for the slight loss of image detail.

SOLD

THE INSIDE STORY OF HOW IRELAND GOT BITTEN BY THE ART BUG

BY JOHN BURNS

RED ROCK PRESS

ISBN 978-0-9548653-7-5

IRELAND GOT BITTEN BY THE ART BUG

NOTE ON SOURCES

SUBSTANTIVE ORIGINAL INTERVIEWS FOR THIS BOOK WERE CONDUCTED WITH MARK ADAMS, BRUCE Arnold, Robert Ballagh, Gillian Bowler, Jonathan Benington, Julian Charlton, Sean Collins, Brian Coyle, Gary Coyle, Colin Davidson, Alan Hobart, the Knight of Glin, Eddie Kennedy, Mary T Keown, David Ker, Gillian Lawler, Antoinette Murphy, Kenneth McConkey, Suzanne Macdougald, Francis Matthews, Mark Nulty, Garrett O'Connor, Mark O'Neill, John O'Sullivan, Larry Powell, Lochlann Quinn, Frances Ruane, Oliver Sears, John Shinnors, Michael Smurfit, Donald Teskey, John de Vere White, Bernard Williams and Ian Whyte.

In addition I used material from interviews conducted in the course of my work for *The Sunday Times* with David Britton, Niall Dolan, James Gorry, Ib Jorgensen, Donal McNeela, James O'Halloran, and Kevin Sharkey.

Shorter interviews to check facts or get a reaction were conducted with, among others, Alan Barnes, Pierre le Brocquy, Hugh Charlton, Frances Christie, John Daly, Allan Darwell, Padraic Hassett, David Mason, Damien Matthews, John Minihan, Colm O Briain, John P Quinlan and John Noel Smith. A small number of people conducted interviews that were entirely off-the-record, and while the material may have been anonymously quoted or referred to, their names cannot be divulged.

I have footnoted sources throughout the main text, but it seems only fair to give further acknowledgement to the publications and websites I have called upon most. They include *Artprice, Antiques & Period Properties, Antiques Trade Gazette, Apollo, Arts Journal, Arts Daily, Circa, Daily Telegraph, Irish Arts Review* (an invaluable source, especially the Under the Hammer column), *The Irish Times* (especially the Fine Art column), *Irish Independent, Sunday Business Post, Sunday Independent, The Sunday Times, The Art Newspaper*. The catalogues and websites of all the major Irish and British auctioneers were used continuously, in particular www.whytes.ie.

I have also consulted a wide range of books on this subject, the most helpful of which were: Bruce Arnold's *Jack Yeats* (Yale, 1998); Matthew Hart's *The Irish Game – a true story of crime and art;* (Walker and Company, New York, 2004); Roderic Knowles, {editor} *Contemporary Irish Art,* (Wolfhound Press, Dublin, 1982); Clare McAndrew's *The Art Economy* (The Liffey Press, Dublin, 2007), Vera Ryan's *Movers and Shapers, Irish Art since 1960* (The Collins Press, Cork 2003); and *Movers & Shapers 2, Irish Visual Art 1940-2006* (The Collins Press, Cork 2006); Don Thompson's *The $12 million Stuffed Shark* (Aurum, London 2008); Robert Wraight's *The Art Game Again!* (Readers Union, London 1975).

For the biographical inserts on artists, I relied heavily on the following sources: *The Art Collection at the Merrion Hotel* (catalogue with biographical detail from Frances Ruane); *Irish Painting* by Brian P Kennedy (Town House, Dublin; 1993); *A Dictionary of Irish Artists* by Walter Strickland (reprinted Irish Academic Press, 1989); *Great Irish Artists* by S B Kennedy (Gill and Macmillan, Dublin 1997); *The Art of a Nation; Three Centuries of Irish Painting* (Pyms Gallery catalogue, 2002); *The Hunter Gatherer: The collection of George and Maura McClelland at the Irish Museum of Modern Art* (Christie's, London 2005); *The Painters of Ireland* by Anne Crookshank and the Knight of Glin (Barrie & Jenkins, London 1978); *A Free*

Spirit – Irish Art 1860-1960 by Kenneth McConkey (London, 1990); *Irish Renascence* (exhibition catalogue; Pyms Gallery, 1986); *A time and a place – two centuries of Irish Social Life* (exhibition catalogue, National Gallery of Ireland, 2006); *Treasures from the North – Irish paintings from the Ulster Museum* (exhibition catalogue, National Gallery of Ireland, 2007). Also thanks to Ciaran MacGonigal who generously shared his research on Irish artists.

ACKNOWLEDGMENTS

MY SINCERE THANKS TO EVERYONE WHO AGREED TO BE INTERVIEWED, FOR THEIR TIME AND PATIENCE. I am extremely grateful to Alan Hobart for giving me access to the entire run of Pyms Gallery's excellent series of catalogues and books going back to the early 1980s. A very sincere thanks also to Damien Matthews who generously shared a huge number of tomes from his (obviously) extensive library of art books. Thanks to both him and John O'Sullivan for taking the time to read several chapters in advance and give me their expert opinion, constructive suggestions and advice.

Thanks to my employers, *The Sunday Times*, for giving me some space and to my colleagues for their support and advice, especially Frank Fitzgibbon, John Mooney and Denis Walsh. Thanks to Fergal Phillips, Eileen Martin, Jason O'Neill and Mark Paul for their help.

A great number of people gave me practical help, whether it was a contact number, a book, a reference, an introduction, a clarification, a correct spelling or just some encouragement. So thanks to Fergus Ahern, David Britton, Alan Byrne, Sarah Carey, Carissa Casey, Liam Clarke, Stuart Cole, Eamon Delaney, Aidan Gaffney, Dave Hannigan, Mike Hogan, Ciaran MacGonigal, Michael McLaughlin, Jim Milton, Tara Murphy, Jane Norton, Kevin O'Connor, Kevin Rafter, Alan Ruddock, Christine Ryall, Eithne Shortall, Mark Sinclair and Ian Whyte.

I would like to thank the pictures' editor of *The Irish Times*, Peter Thursfield, members of *The Irish Times* photographic library, in particular Esther Murnane, for their assistance. In addition I would like to thank Camille Lynch of the National Gallery of Ireland, Michelle Ashmore of the Ulster Museum, Alex Davis of IVARO, Laura Ward-Ure of DACS, and the estates of various artists for their help and courtesy in sourcing and securing the necessary clearance for use of those images. In this regard the help of Adam's, de Vere White & Smyth, Whyte's, Ross's and the Taylor Galleries is very gratefully acknowledged.

Both the publisher and I wish to extend our sincere thanks to Simon McCormick for his aesthetic judgement. While I'm at it, thanks to everyone who gave me a break in journalism – Diarmuid Healy, David Rice, Ken Finlay, Ite Ni Chionnaith, Clare Duignan, Eoghan Harris and Liam Clarke.

Writing a book is not a solo effort; it's a family enterprise. So most of all I would like to thank my family for putting up with this nonsense for almost two years. Sarah, Lucy and Johnny: the computer is free again. My deepest thanks go to Jacinta, my wife. Without her support, love, encouragement and help, I would have given up a long time ago. This book is dedicated to her, with my love.

JOHN BURNS, OCTOBER 2008

PROLOGUE

JOHN SHINNORS LOOKED OUT OF THE WINDOW OF HIS STUDIO AT THE DULLNESS OF A
Limerick day. It was a year in what he calls "the horrible 80s"; it might have been
1986. In the artist's hands were the keys of his studio, a spacious first-floor room
in an old house on O'Connell Street, Limerick's main thoroughfare. Behind him
on the wooden floor were canvases in Shinnors' trademark black and white, some
with an intermediate grey or the slightest touch of rust. Friesian cows, magpies,
scarecrows – all in gestation, waiting to be brought alive by the artist's brush.

CONTINUED ON NEXT PAGE

John Shinnors in his Limerick studio, 2008 : "I said to myself 'I'll post these keys back to the landlady because I can't keep this place up anymore'. I didn't even have my car at the time – I was off the road. I couldn't afford the petrol and insurance."

Though he had worked here for six years, and it was only a few doors away from where he was born, Shinnors felt no emotional attachment to this room. And now he was giving it up. "I said to myself 'I'll post these keys back to the landlady because I can't keep this place up anymore'. I didn't even have my car at the time – I was off the road. I couldn't afford the petrol and insurance."

He'd have to get a job, in a factory or an office. The 36-year-old father had mouths to feed. In his time he'd been a busker, a waiter, a postman. He'd keep painting, "in the evenings when I came home." But not full time, not any more.

He'd given it a go as a professional artist after he won a prize a few years earlier. "I was 32 then. I said to myself 'I'll get a proper studio'. So I cleared out the old back room that I was painting in, gave up the drinking in the afternoon across the way, and came here." But it hadn't worked. "There wasn't any interest in Irish contemporary art."

Ireland was at one of the lowest ebbs in its economic and social history, wracked by unemployment, poisoned by political corruption, drained by emigration. Shinnors' paintings needed time – your eye took several minutes to make out the shapes in the abstraction. But few people in Ireland in 1986 had the time or the inclination, and whatever money they had wasn't going to be wasted on art.

Something happened to make Shinnors change his mind that day. He never did post the keys back to the landlady. He doesn't remember now what it was . Maybe the phone rang – a commission. Someone like John O'Sullivan, a collector from Dublin who bought the odd piece.

An executive in IONA Technologies in Dublin, O'Sullivan remembers another day, in the early 1990s, when he and his brother were in Limerick and Shinnors brought them back to his house – "a modest bungalow with a bit of an extension on it," as he recalls. Shinnors showed them a beautiful diptych, and O'Sullivan's brother, bewitched, bought it for £800. Years later Shinnors, a fiercely proud man, confided that the purchase had put the Christmas dinner on his table that year. "He had three or four kids at the time," O'Sullivan said, "and his work just wasn't selling."

Jump forward to mid-November 2004. The scene is the Taylor Galleries on Kildare Street in Dublin, the pro-cathedral of Irish art, agents to the crème de la crème – Louis le Brocquy, Tony O'Malley, Patrick Scott, Camille Souter. This premier gallery is preparing for its latest exhibition of John Shinnors' work.

It'll be called Twenty Two Paintings – that's how many there are. But those who arrive on the first night – 19 November – will find 22 red dots. Every one of them will have been sold.

Six days before the exhibition opens, the pictures arrive from Limerick, freshly framed, bubble wrapped. Phone calls go out to the select few on a Saturday afternoon – "the truck is on its way." The Taylors' top Shinnors clients get first dibs on the fresh work. O'Sullivan has paid his dues to the high priests – he is summoned to the temple and assembles with the rest, everyone eyeing each other warily.

There's Stewart Kenny, the bookmaker turned Buddhist.[1] Over here is Ib Jorgensen, the fashion designer turned dealer. All around are women of means and ladies who lunch.

Eventually John Taylor appears, the first bubble-wrapped painting under his arm. The truck has arrived. The crowd gathers around as he unwraps it, and one of the women shouts: "I'll take it!" Taylor tears the wrappings from each work, and as soon as he does, someone stakes a claim. The divvy-out is working, somehow, until Jorgensen and a well-heeled lady want the same piece. An "I was here before you" row ensues.[2] The Taylors, who hate a fuss, let them sort it out themselves.

"If you didn't speak up quickly, you left empty-handed," O'Sullivan said. "The meek did not inherit. There was no real method, and no way of seeing all the work before you made a choice. But within minutes the entire Shinnors show was sold – before it had even been hung on the walls of the gallery."

John Shinnors was enjoying a reversal of fortune. Some deity had flipped a coin, and this time it had come up heads. He was "hot". The "right people" had started buying his work. "He'd started getting into important collections," O'Sullivan said. "At one point John de Vere White[3] approached me – he was helping to furnish Johnny Ronan's[4] house on Burlington Road. He wanted a Hughie O'Donoghue, a Tony O'Malley, a Pat Scott, a William Scott, a le Brocquy, and a Shinnors. Now as soon as an artist starts to get into that company, people start taking notice. It gets around – the right people see it."

But it wasn't just the right people who were buying Shinnors' work; some of the wrong people were too. Speculators lurked everywhere. In May 2007 he had a sell-out show in London. Within three months one of the works sold there, *Gull Goes East*, was in Morgan O'Driscoll's auction house in Cork where it sold for €35,000 – twice what the buyer paid in London. That's how "hot" Shinnors had become – buy one, double your money in months. A better return than any stock, share or property. Shinnors' art was now a commodity, to be bought and sold, traded and "flipped", worth its wealth in platinum or gold.

How had this happened? Had Shinnors become a great painter overnight? Actually, no. Indeed, some of the work of which he is proudest, such as the Resurrection series, was painted in the late 1970s. It was Ireland that had changed.

On its knees in the late 80s, it was now striding the international stage like a Colossus. It was rich, modern, self-confident and at peace. Its people were prosperous, assured and acquisitive.

They bought cars, properties and Prada handbags; planes, second homes and private education. And when they'd bought their fill of patio heaters, decking, plasma-screen TVs, remote-control gates and Japanese koi fish for the pond in the garden; when the drive wouldn't hold any more SUVs and a fourth foreign holiday in one year seemed a hassle, they bought art. And

1 At the age of 50, Kenny retired as chief executive of Paddy Power's, the bookmaking firm that he founded, a very wealthy man.
2 Jorgensen says he doesn't remember any "particular chaos that night. I just remember I was allocated one picture, which I bought, and which is in my collection. If you want to buy a Shinnors I have one – €30,000."
3 A charismatic auctioneer known in the business as "Buzzer".
4 The mega-rich property developer, a principal in Treasury Holdings.

many of them didn't buy well.

On 31 May 2006, the eve of the best summer in a decade, Adam's auction room on St Stephen's Green in Dublin was packed out the door and down the stairs. Lot 152 was a Norah McGuinness called *The Little Harvest, Mayo*. The auctioneers claimed afterwards that this was a "spectacular" picture which "jumped off the wall", and insisted that "these guys knew their pictures."[5]

But Adam's don't keep the really good stuff until lot 152 of a 204-item sale, sandwiched between a €6,000 George Gillespie and an €800 John Kingerlee.

The Derry artist's record was €34,000 – the estimate for this was €25,000-35,000. The seller was a little old lady who had cried when her paintings were taken away to be sold.[6]

She was about to cry tears of joy, because the bidding raced past the reserve, the top estimate, €100,000, and then €150,000. Still two bidders slugged it out – an accountant in the room, a businessman on the telephone. The accountant only backed down when the bidding reached €210,000. The businessman buyer had to add a 15% premium to his winning bid.

By any standards, €241,500 was a

COURTESY WHYTE'S © JOHN SHINNORS

Left: Trapeze by John Shinnors, which sold for €28,000 at Whyte's September auction, 2006.

5 Comments by James O'Halloran, both in an interview with me and in The Sunday Times, 18 February 2007.
6 Adam's had a copy of The Little Harvest made and it still hangs over her mantelpiece. The vendor, who'd only wanted €25,000, wrote to thank the firm afterwards. "I was a sad old cow," she said. "Now I'm a rich bitch."

spectacularly foolish price to pay – at least five times more than should have been paid. As one appalled dealer remarked afterwards: "There's a Norah McGuinness three times its size hanging in Patrick Guilbaud's restaurant.[7] So that must be worth a million."

But of course it isn't, and McGuinness's average price has only risen about 20% since that May 2006 spike.[8] If the buyer's grandchildren sell *The Little Harvest, Mayo* in their dotage one hundred years hence, they still won't get €241,500.

By 2006, a mania seemed to have taken hold of some buyers once they set foot in auction rooms. Irish people love sport, they don't like to be beaten and they are liable to show off – art auctions pander to each of these tendencies in turn. In order to prove that they had both money and taste, the Celtic Tiger's nouveau riche outbid everyone else in the room.

Offered the same pictures for less money when nobody was looking, they weren't interested. When a Francis Bacon watercolour sold at Sotheby's for £250,000, John de Vere White rang up the agent of one of the underbidders. "I told him I had a much better example here in my office – same year, same everything. He said his client had had a rush of blood to the head. No. He didn't even look at it. Isn't that hard to believe?"

Paintings had become trophies, to be won in public, carried off triumphantly, and then hung over the mantelpiece like a moose's head or a tiger's pelt. "People are just buying for the sake of being able to say 'I have a Yeats and it cost me half a million' or 'I have a le Brocquy which cost me a million', and I have two Mercs out in the drive and electric gates," said Brian Coyle, chairman of Adam's.

Coyle told RTE in 2005 that Ireland's new rich were so keen to show off their money, they'd hang their trophy paintings on their electric gates if they could. The remark didn't go down well with his colleagues in Adam's, and with other auctioneers.

"Yes, I got in trouble, partly in here," he admits. "They said 'we'll lose all our clients'. 'We will not', I said." How right he was. Adam's had its best ever year in 2006.

Buyers were going around with lists of "hot" artists, ticking them off. A painter whose style was instantly recognisable, who had a distinctive brand, was more likely to sell. Even if his work was considered by critics to be mediocre, like Markey Robinson's.

"There is a percentage of new buyers out there who have plenty of money, husbands working very hard, and if they waste 20 or 30 grand on a Mark O'Neill or whoever you want to mention, it doesn't matter in the scale of things," says de Vere White. "They're having dinner parties and they believe their guests will be delighted to see a Markey Robinson. So they only want to buy Irish pictures, because they want people to be able to recognise the work on their walls, to be able to say 'do you like my Mark O'Neill, or my Donald Teskey? We were lucky enough to get that in Adam's.' They don't want a picture on their wall that they paid €80,000

7 Part of the Merrion Hotel collection owned by Lochlann and Brenda Quinn.
8 Understandably, McGuinness's family sold some of her work the following March in Adam's, and made prices in the €35,000 to €52,000 range.
9 Important Irish Art Sale, 5 December 2006.
10 The Art Newspaper, 1 April 2001. And it doesn't appear to be an April Fool's.

for and that no-one will recognise."

Over the last decade, Irish art has experienced an unprecedented boom. Such is the surge in prices that even experienced Irish auctioneers are sometimes befuddled, not knowing where to set their estimates. Outsiders haven't a chance. In the summer of 2006 the BBC's *Antiques Roadshow* was asked to value a previously unknown painting of Achill Island by Paul Henry. Mark Poltimore, one of the experts, was bowled over – this was "one of the most exciting pictures" he had ever seen on a roadshow. He'd go so far as to value it at £40,000 sterling, €60,000. But what did he know? Poltimore mustn't have heard about the Irish art boom. When the picture was sold by Adam's a few months later[9] it fetched €220,000.

From being almost unsaleable in the 1970s, Irish pictures had become the hottest property on the international art market by the late 90s. *The Art Newspaper* measured the growth rate in different categories of picture between 1985 and 2000. It found that the Old Masters – the likes of Goya, Vermeer, Michelangelo and Leonardo da Vinci – had compound growth of 4.8% in those 15 years. Impressionists – Degas, Renoir, Sisley – had 6.4%, not including Monet. Throw in Monet, the most famous Impressionist of them all, and the category enjoyed 10.1% growth.[10] But not even that could top the growth in the value of Irish painting in that time – it led the field with 11.7%.

The peak, according to *The Art Newspaper*, had come in 2000. In June of that year *Badger and Young Underland* by John Shinnors was sold by de Vere's for IR£36,000 – smashing the artist's record by a distance and putting him firmly and forever on the Irish art map. Shinnors had arrived. This is the story of why he got there. And because he didn't travel alone, because we all went with him, it's the story of the cultural journey of a nation too.

1

WHAT GOES UP....

"You use a glass mirror to see your face; you use works of art to see your soul."
George Bernard Shaw

THE WAY BRIAN COYLE OF ADAM'S TELLS IT, THE STORY OF THE IRISH ART
market begins on 6 December 1973 with the sale of *A Palace*. "It was
very big, 24 inches by 36, and we thought we were going to get about
£2,000-3,000, but we got £15,000, an unheard of price for a work by
an Irish artist," the chairman of the country's biggest auctioneering
firm said. "Things literally started taking off from there."

For those who like their starting points to be symbolic, the sale of
A Palace won't disappoint. First, it was painted by Jack B Yeats, the
country's best-known and most sought-after artist who leads the
market to this day. Second, it was an illustration of the power of
provenance in Irish art sales. An expressionist work of an entertainer
performing in The Café Royal in London,[1] *A Palace* had hung for years
in the dining room of Louis Jammet's restaurant on Dublin's Nassau
Street. Some of the bidders would have been nostalgic customers. But
it was a rich collector who won – Nesbit Waddington from Drogheda.
Money always beat sentiment at auctions.

1 According to Bruce Arnold's biography of Yeats.

PADDY WHELAN/THE IRISH TIMES

Bryan Coyle of Adam's auctioneers at the rostrum during the sale of Harvest Moon by Jack Yeats in 1989. The painting was bought by Michael Smurfit for £280,000. See pages 32 and 33 and chapter 2.

"...e did have a Yeats for sale occasionally, or a Paul Henry, ...t no Irish art sales. In fact it's debatable how much interest there was in at the time."
Brian Coyle.

The hammer price was almost double Yeats's record. The previous year, *By Streedagh Strand* made £9,500; bought by Sir Anthony O'Reilly for his new office in the Heinz headquarters in Pittsburgh[2] to which he had just moved, having been appointed a senior vice-president. It seemed that, at last, people were willing to pay big prices for Irish paintings – the sort of money they'd pay for Dutch or Italian art, furniture, silver or antiques. Coyle, who had been working at Adam's for 20 years, persuaded his boss that these prices represented a business opportunity for the auctioneering firm.

"I suggested to Jim Adam, my senior, that we have an Irish art sale and his attitude at the time was 'there's no money in Irish art'. In those days silver and furniture fetched very big prices. We sold Dutch and English pictures. We did the contents of Irish houses, but they didn't always include Irish pictures. There had been an Anglo-Irish background to collecting so [aristocrats] tended to buy Dutch and Italian. We did have a Yeats for sale occasionally, or a Paul Henry, but no Irish art sales. In fact it's debatable how much interest there was in Irish art at the time."

Almost none, but that was beginning to change. Rosc, the first big exhibition of contemporary international art to be held in Ireland, had been an enormous popular success. Some 50,000 people thronged to the RDS between October 1967 and February 1968 to see works by Pablo Picasso, Francis Bacon and Joan Miro. The second Rosc exhibition, in 1971, featured Mark Rothko, Rene Magritte and Max Ernst. There were no Irish artists in these shows – the organisers reckoned no Irish artist was good enough – but it helped raise public consciousness of modern art.

And by now the state was levelling the playing pitch for Irish artists, to the point where they could start to compete. Charles Haughey, as finance minister in 1969, had decreed that all income earned from art would be tax-free. A restructured Arts Council got its first full-time salaried director in 1975, and started to buy artworks as a way of supporting painters and sculptors. Trinity College Dublin set up an art history degree course in 1966, and UCD followed suit.

There were other green shoots to suggest that Irish art's long winter was over. The duopoly of the Dawson and Hendriks galleries in Dublin was being challenged. These two had divided up the Irish art world between them for decades. Now there were new names over the doors – Tom Caldwell, the Oriel on Nassau Street, Cynthia O'Connor, the Brown Thomas gallery. That meant more outlets for artists, many of whom had been relying on group shows and

2 He told Forbes magazine, 8 April 1996.
3 Better known as the Irish Independent's leading political writer, he opened the Neptune Gallery in 1963, and in that same year began writing about fine arts for The Irish Times.
4 Smith's assistant set up the Taylor Galleries in succession to the Dawson.
5 AIB, it is generally agreed, now has the finest corporate collection of Irish art. Rather than just buy work for their new headquarters, they took a sustained, long-term approach. "In any one year you are not going to get many brilliant works of art," Ruane says. "I thought what AIB should do was, rather than have an art collection that smacked of 1979, 1980 or 1981, take a slower approach, a museum approach, to be in it for the long term. And that's what they did, and that's why I'm still doing it." It now has over 2,000 works distributed through its branches nationwide.
6 Owner of Fota House.

the Royal Hibernian Academy's annual exhibition to sell their work.

While David Hendriks along with Leo Smith in the Dawson had controlled the art market for serious collectors, it would be wrong to suggest they made a fortune doing so. "Leo Smith struggled to make a living," explains Bruce Arnold, who was a dealer, collector and writer on fine arts from the 1960s onwards.[3] "He was a bachelor and he looked after his sister, Ms Smith, and he paid John Taylor a relatively small salary and looked after John in an avuncular way.[4] John wasn't earning the sort of money that he would have got in London working for Sotheby's. Hendriks was also a bachelor, had a tiny staff, did elegant shows seven or eight times a year, some Irish and some foreign. Between them they commanded the loyalty of 20-30 artists, and did the best they could for them."

Meanwhile a few big Irish companies had started their own art collections. P J Carroll, the cigarette makers in Dundalk, was the first – commissioning paintings and sculptures directly from artists for its factory. They were followed by Bank of Ireland in 1970 and eventually by Allied Irish Banks, which hired Frances Ruane, an American art curator who had moved to Ireland in 1973, to assemble its collection. "It was a very small, cliquey kind of market with only a few galleries," Ruane recalls of the late 1970s. "You could very easily know everything that was happening. Art was way down the pecking order in terms of what people could afford. Adam's was the only real player in the art auction business and they didn't deal with contemporary work. AIB asked me what I thought they should do. Irish art really needed support and I thought it would be logical for them to collect it."[5]

But the market was slow to take off. Wealthy Irish buyers often allowed themselves to be out-muscled on big pieces by British rivals. Sean Collins, a dealer who opened a gallery in 1970 on Dublin's Clare Street, remembers having to almost bully customers to buy something. "Apart from Richard Wood in Cork,[6] there was no market outside Dublin for Irish paintings at all," he said. "When you'd show a nice picture to Sotheby's or Christie's they'd say 'lovely painting, pity it's Irish'. That's the way it was.

"The first picture I really remember cracking was about 1971 in Sotheby's, a William Ashford called *The Emigrants*, of a family leaving Dalkey on a side-cart. Sotheby's, even though they told me they'd no market for Irish pictures, put it in anyway, and it made £22,000. Tony O'Reilly was bidding on it against Richard Green, a big dealer in London, who bought it, I don't know who for. The impetus did start around that time."

Adam's Irish art auctions in the 1970s were quite different affairs from what they are today. First off, they were held in the afternoon. The firm didn't have to worry about accommodating nine-to-five workers – they wouldn't be turning up. The bidders were either dealers, for whom going to auctions was their job, or landed gentry. The sales were not set up with casual purchasers in mind. "The catalogues were very minimal things, small in size," said Coyle. "Jim Adam would simply have 'a painting by Paul Henry showing the west of Ireland'. And we never printed estimates in the catalogue. The staff and I would meet clients and tell

them 'oh it's going to go for £800-1,000' or whatever.

"The big difference between auctions now and when I started is the phone bidding. It was very exciting in the 1970s. Auctions were packed with people, 200 or more. The feeling was palpable – the money was there coming at you; much less money than now but a lot of money then. People were there bidding themselves; very few phone bids were made. Maybe it's because some people had more time to spare in those days."

A high proportion of these private buyers were Protestants, who still dominated the professions, especially law. Many of the sellers were also Protestant – including second – or third-generation inheritors of Big Houses or large estates. In an economic climate of high interest rates and oil prices, not to mention crippling overheads on old houses, some of these landowners were living in genteel poverty and needed to raise money. So supply of paintings was plentiful. Meanwhile some exceptionally talented Irish artists were coming to the end of their careers, and their lives – the likes of Frank McKelvey, Maurice MacGonigal, Nano Reid, Dan O'Neill, Norah McGuinness, Mary Swanzy and William Leech. Nothing boosts a good artist's prices so much as his death. Work assembled by these painters' dealers and collectors throughout their lives now began to filter onto the secondary market. Gradually, Irish art prices began to rise.

FRANK MILLER/THE IRISH TIMES

The buzz from Adam's soon attracted the attention of the neighbours. In 1976, both Sotheby's and Christie's appointed their first permanent representatives in Ireland. Their choice of two titled peers – Lord Henry Mountcharles and Desmond FitzGerald, Knight of Glin – was a dead giveaway as to who was selling art in Ireland at the time. Mountcharles and FitzGerald were hired for their social connections as much as their knowledge of art, their task being to persuade other members of the Anglo-Irish aristocracy to consign their estates to the two big international auction houses. "They knew where the good stuff was," said auctioneer Garrett O'Connor. "They were welcome into all the Big Houses. They got phone calls because of their reputations." In the event, Mountcharles only lasted in his four-day-a-week role for one year before handing over to his cousin, Nicholas Nicholson, who continued to work from Slane Castle until Sotheby's opened an Irish office.[7]

Between 1978 and 1981 the Grand Hall at Slane hosted five Sotheby auctions. While they were dominated by glass and silver, these sales also featured top-class Irish art. The first,

7 The Irish Times 23 October 1976 and October 1977.
8 Very little of this was "lying" at Slane – it was in bonded warehouses elsewhere. There was a little on the premises for tasting.
9 25 April 1981.

starting on 20 November 1978, took in £245,674 with a highlight being William Orpen's *Reflection Self Portrait* which made £9,000, breaking the artist's previous record of £6,825. The weak punt proved a mixed blessing for Sotheby's: while it encouraged British art dealers to make the trip to Co. Meath, it meant vendors didn't always get the prices they wanted. Sotheby's second Slane sale, on 25-26 June 1979, featured eight top Yeatses, and ended at midnight on the second day having taken in £328,065. This included £60,000 in wine sales, which hadn't featured the first year.[8]

The sales were social events in themselves. Mountcharles and Sotheby's invited clients to a wine evening beforehand to view the works, and there was catering on the premises during the auctions to accommodate the buyers and the gawkers. "The sale in Slane has proved in the past not just a place for the millionaire but a fairly satisfactory auction for the collector who can only buy modestly," purred *The Irish Times* in advance of the 1980 sale. And D'Olier Street was even more enthusiastic a year later:[9] "This marvellous setting with the prospect of reintroducing Irish antiques back into the country and the feeling of a day out yet time unwasted makes this a very popular event. Even if the bidding goes sour the graceful Boyne acts as a salve. There are but 500 lots…"

The Slane sales were most certainly not "reintroducing Irish antiques back into the country", however. Some 80% of the lots originated in Ireland, and the majority of buyers were foreigners who took their purchases out of the country afterwards. But media coverage of the two international auction houses tended to be fawning; we were almost grateful that they took the trouble to visit us and sell our art. "Sotheby's experts to give free advice," ran a headline in *The Irish Times* in 1978, which said that the firm would be sending "a team of experts" to give "free advice to the public on their antiques". This, readers were assured, was a "valuable" service. As if Sotheby's was in Ireland for anything other than the money.

As soon as they stopped making it, they left. The second day of its 1981 Slane sale, featuring 140 drawings, paintings and watercolours, raised £99,865, far more than the

PAT LANGAN/THE IRISH TIMES

Far page: Desmond FitzGerald, Knight of Glin (right) with Nick Robinson, husband of former President of Ireland, Mary Robinson, at the funeral of architect Sam Stephenson in 2006. Above: Lord Henry Mountcharles at Slane Castle in 1998. Mountcharles and FitzGerald were hired for their social connections as much as their knowledge of art.

previous day's totals for glass, silver and furniture.[10] The highest price was £10,000 for Yeats's *Daughter of the Circus*. But it was noticeable that the total take for the two days was down – to £239,000. Sotheby's had a second sale at Slane later that year, a general one with modest items of wider appeal, and that was its last.

The problem was the sinking Irish pound. After breaking with sterling in 1979, the punt was adrift on international currency markets and after a heady period where it maintained parity with sterling and even moved ahead, it lost ground. The Irish pound's weakness attracted scavengers: antique dealers from Britain and Northern Ireland were soon scouring the country looking for silver, gold, furniture and paintings which they could buy at a 25% discount due to the strength of the sterling in their pockets. Newspapers in Waterford and Limerick carried ads announcing that certain British dealers would be holding court in local hotels. The weak punt cut two ways, though. Those with artefacts of real value didn't want to sell them in Ireland any more; they wanted sterling.

"The idea of having the sales in Ireland was that English people wanted to buy Irish art and they came to Slane," explains a former Sotheby's employee.[11] "But when sterling became more valuable, Irish people wanted to sell their stuff in Britain, so that ruined the Slane sales and that was the reason they stopped. There had been parity between the punt and sterling for a while, but once sterling went up that was that. It was a shame – they were great sales. Mary McAleese reporting for RTE was there for one.[12] There was a lot of stuff from the Big Houses, the relics of auld decency. People who had to sell."

Sotheby's had two large house sales in the 1980s, but everything else Irish consigned to the auction house was shipped to Britain for auction. The former employee says his work eventually consisted of packing paintings in boxes and getting them ready for export. "It was so busy. The amount of time I spent at Customs in Dublin Port, or at the border. We were packing up stuff and sending it out."

Every picture that left the country needed a licence from the National Gallery of Ireland, but that was a formality. The odd item was delayed, but the Gallery had no money to buy any of these major works itself. If they stopped these exports, sellers would probably smuggle their paintings out of the country and over to London anyway. "Yes, some pieces were spirited over to Britain," confirmed the Sotheby's source. "I don't think the Gallery ever stopped pictures, but you could be held up for a while. Their budget was very low, and there was no way they could pay for these things, but if they could, they would make an offer."

This was one-way traffic; nothing was coming back. Irish buyers at London auctions were

10 £28,000, £31,000 and £50,000 respectively.
11 Who requested anonymity.
12 The Irish president was an RTE journalist in a past life.
13 This caused a deal of controversy, mainly because the house had earlier been offered to the state. At least the National Library purchased the house's important collection of papers.
14 The practice continued until a delegation led by the fiery Tom Ryan marched into Christie's in London and demanded that they stop selling Irish pictures under a British label. The auction house readily complied – the late 1980s wasn't a propitious time for a London-based business to get drawn into an Anglo-Irish spat.
15 A memorable description from The Times in 1988.

effectively paying 25% more because of the currency difference. Then 23% VAT was slapped on top of the buyer's premium, and that was before you arranged shipping of paintings back to Ireland. Few bothered. The net effect was that throughout the late 1970s and well into the 1980s the country was systematically stripped of its art. Some of what left will never come back.

Christie's was also a player in that process. Its first Irish art auction was in Dublin's Hibernian hotel, and then it embarked on a series of Great House sales, including three in a seven-month burst during 1976. These were Malahide Castle, followed by Newtown Park House in Blackrock, and then Clonbrock in Co. Galway.[13] At Newtown Park a Walter Osborne made £17,000 – "a world record price for Osborne or indeed for any Irish picture that we sold", according to Bernard Williams, the firm's ebullient Scottish and Irish director. "It was a record that lasted for about 20 years. It was an enormous price then."

The Christie's house sales were also major events, and attracted international art dealers. "It was such a big thing that, certainly at Newtown Park, every newspaper had two or three pictures on their front page and then two or three pages of pictures inside," Williams said. "It was such huge news at the time. Christie's of London, as we were referred to here, had come to Ireland."

In value, these were far bigger sales than Slane. The auction at Adare in June 1982 grossed £945,000, while the following year a sale at Luttrellstown in Clonsilla made almost £3m. As with Slane, a high proportion of the lots left the country, with dealers coming from as far afield as Los Angeles and the Middle East. In truth, few enough important Irish paintings were sold – the Irish ascendancy's taste had been more Dutch Restoration than west of Ireland scenery. But Christie's was getting plenty of good Irish pictures elsewhere, and selling them in their "British" auctions in London.[14]

All of this put their Irish representative Desmond FitzGerald, the Knight of Glin, in an exquisitely awkward position. As president of the Irish Georgian Society, "the sturdy, plum-spoken gentleman"[15] was campaigning to preserve Ireland's country house heritage. As Christie's representative, he was acting as funeral director as the Big Houses' collections were dismantled and dispersed. Naturally he is all too aware of that contradiction himself, having being publicly accused at the time of being an arch-hypocrite.

"As Christie's representative, I had to deal with all the inquiries about anything that was going to be sold," he said. "I had to travel around the country, in many cases looking at rubbish and junk. I had an office at my house in Waterloo Road in Dublin but there weren't many callers there. People used to call to me here [at his castle in Glin, Co. Limerick]. Mountcharles and I were really chasing around the same avenues. It was very competitive – it always has been.

"Some of the country house owners were broke – although not Malahide or Adare, they just found it impossible to keep up the effort of maintaining their estates. A couple of the sales

FRANK McKELVEY

BORN: 1895, BELFAST

DIED: 1974

PAINTING STYLE: ACADEMIC

HGHEST PRICE: £84,000 (SOTHEBY'S, 2003)

FANS SAY: HE PRODUCED MORE BEAUTIFUL AND DECORATIVE LANDSCAPES THAN ANY OTHER IRISH PAINTER

CRITICS SAY: MOST OF HIS OUTPUT WAS CHOCO-LATE BOXY. VIEWERS DERIVE 95% OF THE PLEASURE TO BE HAD FROM A MCKELVEY IN THE FIRST FIVE MINUTES.

IF YOU COULD OWN ONE: CHILDREN ON THE BANKS OF THE LAGAN

BEST EXAMPLE ON PUBLIC DISPLAY: EVENING, BALLYCASTLE, CIRCA 1924 (ULSTER MUSEUM)

€56,000
2006

The son of a painter and decorator, Frank McKelvey attended Belfast College of Art while working as a poster designer on the side. He won the Brett prize for figure drawing at the age of 16, and the Fitzpatrick award for figure drawing two years later. His study of an old woman, The Grandmother, won £10 at the Taylor prize competition in 1918.

One of his earliest commissions was to make watercolour copies of 200 old Belfast views and portraits for a patron, Thomas McGowan. The collection is now in the Ulster Museum.

Until about 1924, he concentrated on painting landscapes in Antrim and Down, and sold works for as much as £25. In that year the Irish Times said "one feels the sunlight in every one" of McKelvey's paintings.

He began to visit Donegal and in the 1930s travelled regularly to the west of Ireland. From 1918 until the year before his death, McKelvey never missed an exhibition at the RHA, showing at least three works per year.

He held a one-man show in 1936 at which three of his landscapes were bought by Dutch residents in Ireland as a wedding gift for Queen Juliana. He also painted portraits, mostly of eminent Northern

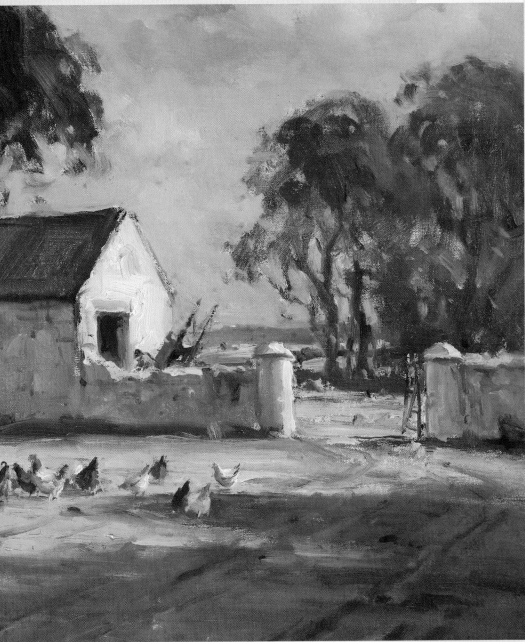

Ireland personalities, but many of an indifferent standard. From the 1950s onwards, he made regular trips to France where he produced good quality work.

A prolific painter, McKelvey's produced his best work in beautifully structured seascapes, coastal views and landscapes of Donegal, Connemara and Antrim. He painted rather too many farmyard scenes – using the 60 hens he owned as subjects – and in the end his scenic motifs became predictable. He can be accused of allowing the market to dictate his later output.

did break my heart. The one I would regret most was Adare Manor, where my grandmother came from. But I mean, you can't save everything. We had to try to do the best for these people. Otherwise they wouldn't have got the money they deserved. My colleagues and I had a lot of sympathy and expertise, and [the sales] were also catalogued properly. The sale of art in Ireland up to the time that we came in was rudimentary.

"So a few tears were shed, but we had our laughs as well. The house sales were great social events. I remember we had oysters in Castle Hacket,[16] and Dolores Keane sang [this sale was in July 1986]. It was a fantastic time, an enormous social event. The sales were hugely popular." In its *International Magazine* for 1984, Christie's boasted that not only did its Irish house sales attract tremendous national and international support, they were "the greatest fun".

One intriguing visitor to the Christie's house sales was Jim Williams, an art dealer from Savannah, Georgia, who is the subject of the novel *Midnight in the Garden of Good and Evil*. At one auction Williams bought nine small pastel portraits by Henrietta Deering, a 17th-century Irish-born artist who emigrated to America.[17]

Desmond FitzGerald concedes that the main buyers were English dealers, but argues that Irish people simply didn't have the money in those years to hold onto their treasures. Container loads of Irish furniture were shipped to the United States, he says, because it looked like American furniture, which is far more valuable. But it wasn't wanted in Ireland anyway, so nobody shouted stop. "What use would it have been to shout stop?" FitzGerald says. "Who else was to buy it? There were very few Irish buyers. There were lots of Irish buyers for silver, because it was stamped and dated. Pictures, people didn't really know anything about. And furniture? There was little interest."

An art scholar of distinction himself, FitzGerald lobbied for important items to be bought by Irish private collectors or museums. He tried to persuade the National Museum to buy important items of furniture, usually with little success, and did slightly better with the National Gallery, on one occasion convincing it to buy a collection of drawings by Maria Spilsbury Taylor by private treaty. "I was always beleaguering the national institutions," he said. "I would make a great deal of effort with the important items to keep them in the country or get them into a museum. I wasn't always successful but I made the effort."

This defoliation of the nation's art treasures mostly took place below the radar of public attention, but one exception was the sale of 23 important pictures from Castletown House in Co. Kildare by Christie's in the summer of 1983. The property of Desmond Guinness, who had to sell some items due to his divorce settlement, the collection included four Thomas Roberts' views of Carton House, each estimated at £80-130,000 sterling. Also under the

16 Six miles from Tuam, Co. Galway.
17 These pastels were later re-sold by Sothebys and are back on this side of the Atlantic.
18 An Irish artist who died in 1771.
19 A legendary horse trainer, who collected art in the 1970s and 80s.
20 The four Roberts are back, in a private Irish collection.
21 The impact of this half-page ad was surely diluted by the full page Sotheby's one facing it.
22 IAR, Spring 1987.

hammer was a series of pastels by Robert Healy,[18] studies made at Castletown of people hunting, walking, skating and shooting, including a long frieze of a hunt. FitzGerald admits that their export was "tragic", and reveals that he tried manfully to keep them in Ireland.

"I went to see Vincent O'Brien[19] in a box at the Phoenix Park racecourse and said to him 'look, these are the most marvellous pictures of horses that have been painted in Ireland; why don't you buy them?' He had no interest. He wasn't hostile – he just didn't react really. So they were sold. One went to Yale in New Haven and all the others, the groups on horses and skating and walking, were bought by an Arab prince and are in a collection in England. I regret that very much. It's sad that none of them ever came back."[20]

There's still a Healy Room in Castletown, but in place of the original paintings hangs a series of photographic reproductions. It is a nagging reminder of what Ireland lost in those years. Certainly the country can plead poverty, but in the end it just didn't care enough. And there was undoubtedly some nefarious carry-on too. The late 1980s was the most corrupt epoch in Irish life, with politicians being bribed and businessmen salting away money in offshore bank accounts. It would be amazing if that crookedness didn't seep into the art world, hardly a model of openness and transparency.

Brian Coyle reckons that some art owners sent their valuables to London for auction in order to avoid paying tax. "There's no doubt about it. I don't know why the Revenue doesn't catch onto this," he said, implying that the practice continues. "They avoid paying 20% capital gains tax by selling in England. Overall it had an adverse effect on the supply of quality pictures [to Adam's]. Because the prices we were getting were as good or better."

In the mid-1980s Adam's took to placing ads in the trade press almost pleading with vendors not to export their paintings. "You don't need to go to London to obtain top prices for your heirlooms," said an ad in the *Irish Arts Review* in the spring of 1985.[21] "Our sales attract international attention…our catalogues circulate throughout Europe and North America and we also have a very large percentage of Irish buyers to compete and purchase here."

Two years later the *Review* noted that the "outflow" of art to London was particularly suspicious given that higher prices were being realised at home. "The Dublin salesrooms often report better prices for similar items," it said.[22] "By selling in London anonymously an owner [can] salt away the proceeds in some offshore tax haven account." A perceptive comment, given that this was written ten years before the existence of the Ansbacher accounts was known.

Ted Nealon, the arts minister in Garret FitzGerald's government, acknowledged that there was a problem and that the law regulating export of artefacts was useless. He revealed that 500 export licences had been granted in 1984, but given that there were no penalties under the 1945 Documents and Pictures Act, those 500 exporters needn't have bothered. In 1985, Nealon set up a committee to devise ways of stopping the haemorrhage, and a year later it

GERARD DILLON

BORN: 1916

DIED: 1971

PAINTING STYLE: NAÏVE

HIGHEST PRICE: £192,000 (CHRISTIE'S, 2007)

FANS SAY: IRELAND'S LOWRY

CRITICS SAY: "HIS FIGURES OFTEN CRUDE, HIS COLOURS ILL-CONCEIVED, HIS PAINT APPLIED, AS ONE WOULD EXPECT FROM A NAÏVE AND PRIMITIVE TECHNICIAN, CRUDELY." BRUCE ARNOLD

IF YOU COULD OWN ONE: SELF PORTRAIT IN ROUNDSTONE

BEST EXAMPLE ON PUBLIC DISPLAY: YELLOW BUNGALOW (ULSTER MUSEUM)

The son of a postman and the youngest of eight children, Dillon was born on Lower Clonard Street just off the Falls Road in West Belfast. At the age of 14 he was sent to serve his time as a house-painter and during his life would work as a labourer, boilerman and night porter in both Belfast and London, where he moved in 1934. While he attended some art classes, he was effectively a self-taught painter with the main influence on his work being the French artist Marc Chagall.

The key episode in his life was a cycling holiday to Connemara in 1939, with a friend and aspiring artist Ernie Atkin, and the city slicker was mesmerised by both the rugged landscape and the simple life of its inhabitants – including fishermen and farmers.

"These people are a race apart, very friendly and polite, they never intrude," he said later. "They carry this politeness to a degree unbelievable to me." In homage to Connemara's whitewashed cottages he painted his family's Belfast house in

similar style. Unlike other artists inspired by the West of Ireland, he concentrated on its people and their customs more than its landscape, in particular exploring their isolation.

His first solo exhibition was in a gallery on St Stephen's Green in 1942 opened by Mainie Jellett, a friend and fellow artist who was one of the first to recognise Dillon's talent. She encouraged him to

experiment with collage and textiles as well as paint. Although he exhibited at the RHA the following year, Dillon was forced by financial circumstances to return to London to work on demolition gangs.

In 1951 he was given a loan of a house on the island of Inishlacken, a mile off Roundstone, Co Galway and he spent a year there with George Campbell, another friend and fellow artist, returning regularly to the mainland by rowing boat. He also explored other nearby islands such as Omey, north west of Clifden, where he completed a memorable series of paintings capturing its annual race day. Art dealer Victor Waddington paid Dillon £1.10 a week to return to the West of Ireland in the

CONTINUED ON NEXT PAGE

recommended a series of tax incentives to encourage the retention and repatriation of works.

There was even a certain amount of chicanery involved in the movement of what few pictures were returning to Ireland from London. "In the 1980s it was difficult for Irish people to bring stuff back from Christie's sales, because you had to declare them [to Customs] and pay an import duty," said Williams. "Some of the galleries, well, let's just say some paintings managed to find their way across the border. But there were some honourable galleries, like the Cynthia O'Connor, who would fulfil all the importation requirements."

GIVEN THAT IRELAND COULDN'T HOLD ONTO REPRESENTATIONAL AND HISTORIC ART, ABSTRACT AND contemporary paintings didn't stand a chance. There was little respect for abstraction, and almost no market. This was partly because of the general disdain in which art in general was held. In 1982,[23] Professor John A Murphy noted that Irish people tended to regard the visual arts as "part of an imposed colonial culture...as an alien heritage". Painting had long been a Protestant affair, while Catholics engaged in creative writing (notepads being cheaper than canvases). The result was that art was regarded as an elitist pastime, something the upper classes did to entertain themselves.

Irish people became "involuntary philistines", Murphy argued. They reacted with "an instinctive feeling of bafflement and resentment at their exclusion from this privileged world". Vandalism was one expression of this alienation, and still is to this day.[24] Sneering at work that couldn't readily be understood was another. Confronted by an abstract painting in the 1980s, the average Irish person's glib response was to remark that their four-year-old daughter could do better.

One incident seared on the consciousness of the art community is a *Late Late Show* in 1980,

CONTINUED FROM PREVIOUS PAGE

mid-1950s, along with Nano Reid, to complete further works.

In the 1960s he began to explore his own identity in his art, sometimes portraying himself as a masked pierrot, a symbol of his grief and sadness. The sense of his own mortality heightened when three of his brothers died in the early 1960s and he himself was diagnosed with the same heart condition. He died at the age of 55 and was buried, at his own request, in an unmarked grave in Belfast's Milltown cemetery.

Dillon, who was known to give away works

in his own lifetime, has enjoyed an extraordinary renaissance in the past three years with several works fetching six-figure sums in Dublin and London. "Gerard would probably turn in his grave at these prices," said Martin Dillon, the author of many bestselling books about the Troubles including The Shankill Butchers and The Dirty War, who is a grand-nephew.

"To think that all those years when he was making his own ties, weaving, and using sand in his back yard to make sand paintings in order to make sure none of this was wasted, he could have had some of this [money]."

in which Gay Byrne held up a black and white newspaper reproduction of a minimalist work by Agnes Martin[25] which had been purchased by the Hugh Lane Gallery from a Rosc exhibition. "Can you imagine paying public money for this black canvas?" Uncle Gaybo demanded?[26]

Antoinette Murphy, who now runs the Peppercanister Gallery in Dublin, said Agnes Martin's work was treated like a joke. "That wouldn't happen now," she believes. "People would take it more seriously or at least consider it. People now have the confidence to look at something and express their own opinion on it. That's a major step forward, and I think it's exciting. We have taught our young people something useful if they do that. Even adults wouldn't in the past. Don't forget there was a small pool of buyers and even of people going to look at art. Now it's opened up. People are more receptive to it."

There was little enthusiasm for abstract art in the auction rooms. Coyle said this was because it had "little or no following", so Adam's didn't bother to offer the work of contemporary artists in its sales. Sir Basil Goulding, one of the leading collectors of the 1950s-70s, asked Coyle for advice about selling part of his large collection of modern art. He was told to offer it privately because most of it had no chance at auction. So Goulding hired the Hendriks Gallery, and most of his collection was sold overseas. "All the international works were offered to London dealers and went out of the country for low prices," the collector Patrick J Murphy has said.[27] "Things now worth millions going for £2,000, £3,000 each. It was the outstanding private collection in Ireland, but it was too early. People weren't tuned in."

But one person was: John de Vere White realised that Adam's conservatism had left a gap in the market. Frances Ruane says: "Adam's didn't deal in contemporary work; they dealt mainly with older art, 18-19th century, maybe the beginning of the 20th century, but there was no secondary market for more recent work. The person who first saw that there could be an auction market for contemporary art was John de Vere White. He felt there was a second-hand or resale market for contemporary things that Adam's had ignored, and successfully developed that. Later Ian Whyte jumped in, and Adam's responded by beefing up its contemporary side quite a bit, but it was really de Vere who identified that niche."

Buzzer, as he is known in the business, started out as a real estate agent, but there was art in his blood. His father, Terence de Vere White, was a man of letters, a literary editor of *The Irish Times* and a voracious art collector. He was a pallbearer at Jack Yeats's funeral, being one of only two Catholics in the Anglican church for the service.[28] Buzzer was friendly with John Taylor, the dealer, who in 1985 asked him to conduct an auction in the new Swan

23 Quoted in Rodney Knowles book Contemporary Irish Art, published in 1982.
24 Note, as one random example, the ill-treatment meted out to the Cow Parade in 2003. While these bovines had survived unscathed on the mean streets of Chicago, New York and London, within days of going on parade in Dublin one had its head sawn off and another its wings clipped.
25 A Canadian-American artist who died in 2004. She considered herself an abstract expressionist.
26 The story is retailed by Dorothy Walker in her interview with Vera Ryan in Movers & Shapers 1 (2003).
27 Also interviewed by Vera Ryan.
28 According to Bruce Arnold's biography of Yeats.

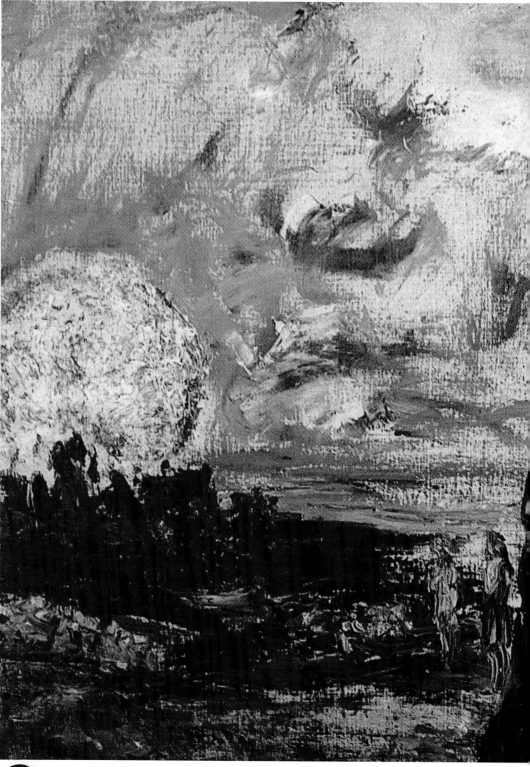

£280,000
1989

Harvest Moon, Jack B Yeats

Shopping Centre in Rathmines on behalf of a friend who was opening an art shop.

"So we went up there on a Sunday and I got up on a ladder and we sold paintings in a disused unit that hadn't been opened yet," Buzzer recalled. "Whoever turned up got very good value. That was the start of it, and we then got involved with John Taylor, who had a lot of stock, and we started doing auctions down in his premises in Dawson Street. He saw this auction method as a way of getting rid of surplus pictures. We did sales that grossed £30,000 and £40,000, and it was a part-time thing for us. And then we moved to the RDS and it got a bit bigger, people started to bring us in pictures.

"So it grew and grew. We were still estate agents and I was very involved in the residential end of the market. We acted for builders, selling property. Art was just an aside. But the market got bigger. In 1987/88 a good sale for us was about £50,000, whereas for Adam's it was £150,000-£200,000, but we were delighted."

Taylor eventually backed out of the auction business, and concentrated on the primary market, and de Vere White teamed up with Barry Smyth, another real-estate auctioneer. But he kept a focus on contemporary artists, the likes of Louis le Brocquy and Michael Farrell, and fought against the popular perception that no profit would be made on these paintings until the artists died.

AS THE GLOOMY 1980S WOUND TO A CLOSE, THE PACE OF IRISH ART AUCTIONS QUICKENED. IT WAS helped by a stream of high-quality works coming onto the market. The auction house was no longer just a place where you dumped unwanted pictures. "I would think that the quality of what's in the auction houses over the last 10 years wouldn't be remotely as good as it was in the 1980s," comments Lochlann Quinn. "The 80s was probably the first release of a generation, so a lot of very fine paintings came up. Solicitors and doctors were among those selling them."

For years the Cubist works of Mainie Jellett had largely been ignored, but when a particularly good collection came up at Adam's in 1986 the results were "startling",[29] with one getting an unheard of £4,800. At the same sale there were good prices for Nano Reid, and two exceptional Yeatses – *O'Connell Bridge* and *Going to Wolfe Tone's Grave* – fetched £28,000 and £25,000 respectively. In the autumn of 1986 a sale in the ballroom wing at Mount Juliet by Sotheby's raised £590,000. The surge continued into 1987, with a record £13,000 being achieved for a typical Frank McKelvey, a scene of a woman and child feeding chickens outside a thatched cottage, which had been estimated at £3,000-£5,000.

By 1988, the market was moving fast. Records for Irish artists were being broken on both sides of the Irish Sea, and no sooner were they broken than they were smashed again. Yeats' *The New Road* was sold by Adam's for £56,000, but that November *The Path of Diarmuid and Grainne* was sold at Sotheby's for £93,500 sterling – yet another record. They were really going mad for McKelvey – despite the sameness of a lot of his oeuvre and its unchallenging

chocolate-box style.[30] In March 1989, Adam's sold one of the Northern artist's works for £32,500, and then Christie's sold three for about £20,000 apiece. Adam's was back in June to create a new record – £46,000 "for swans", as Homan Potterton[31] wrote in the *Financial Times*, "while more chickens went for £35,300 in October." Paul Henry's prices experienced a similar surge, with a record of £63,800 being set for one of his Connemara landscapes.

Bruce Arnold says this boom was an "integrated development", more genuine than the one that followed it a decade later in the mid-1990s. "It was a true, intelligent, slow, conservative development of a collectors' market, involving galleries, dealers, books and writing about art, and an active critical set-up. For example I did my life of William Orpen in 1981. Effectively that book said 'you have all been ignoring the greatest Irish painter of the 20th century. Here he is. Go and buy his works'."

And they did.

This phenomenon was not unique to Ireland: the international art market was booming too. In 1989 Sotheby's had the most successful year in its history. A huge surge in wealth in America and Britain, helped by a rolling back of the punitive tax rates of the 1970s, was one reason why art prices were taking off in the two main centres – New York and London. "Greed is good," was the decade's catchphrase, and conspicuous consumption was most definitely in. "Art began its transformation from luxury to fungible asset, from bagatelle to investment," said *The Art Newspaper*.[32] "Banks started to lend money on art and form 'art advisory' departments. Auction houses began providing 'guarantees', 'advances' and 'financial services' to buyers and sellers. Art had been monetised."

It became known as "the Japanese bubble". The price of land in Japan had soared, and after the New York stock market collapse of 1987, Japanese investors were looking for somewhere, anywhere, to stash their money. So they piled into the Impressionists. In March 1987, for example, a Japanese insurance millionaire paid almost $40m for a van Gogh *Sunflowers* at Christie's in London. Ryoei Saito, a Japanese paper tycoon, paid $82.5m for van Gogh's *Portrait of Dr Gachet*, and just a week later paid $78.1m for a Renoir.

The rising tide lifted boats in every part of the market, and in Dublin they bobbed higher than most. "Around 1988/89, there was a sale in a remote part of England and it had a couple of Letitia Hamiltons in it, and one sold for £20,000 after having an estimate of something like £1-2,000," recalls de Vere White. "That was the catalyst. Suddenly in a sale in Adam's, estimates were blown out the window. Stuff that was in from two to three thousand started to sell for six. Overnight prices just soared. People had the view that Irish art had been undervalued, and suddenly it was over-valued. The huge jump in prices meant that people who had been sitting on pictures for years said 'well now's the time to sell'. So a huge belt of paintings

29 Said The Irish Times.
30 Of course there is often a sudden upward movement in artists' prices soon after they die, partly due to the machinations of dealers. It can take a decade or more for the prices to find the correct level.
31 Who had retired as director of the National Gallery of Ireland in 1988.
32 No. 182, July-August 2007.

came onto the market. You'd go up to Adam's and there'd be 10 McKelveys in a sale, eight Paul Henrys, 14 Mildred Anne Butlers, nine Letitia Hamiltons. People couldn't believe that a picture that they thought was worth a thousand was now getting 10."

Auctions had become more democratic places: private buyers were now prepared to take on the dealers in hand-to hand combat and to trust their judgment enough to out-bid them. "Education had improved, there was more publicity and media coverage," Coyle said. "People got over the intimidation of auctions. A lot of people had been afraid they didn't understand the value of paintings and felt safer going to a dealer and giving him 25-40%.

"We still didn't have to put much detail in catalogues, because we were fighting the sellers off. I was pushing them out the door here – telling them 'I don't want any more Yeats in this auction'. Alright so I'm exaggerating, but it was a bit like that." The first trickle of Irish paintings even began to return from America, as owners there were alerted to the fact that the quaint west of Ireland landscapes hanging on their walls were worth a fortune back on the auld sod.

In its end-of-term report for 1989, Adam's calculated that 28 new record prices had been set for works by Irish artists. Some of those records held for well over a decade, and were only broken in 2006 when the market went crazy again. The apogee was probably Adam's May sale in 1989, which took in IR£700,000 for 200 lots. One of the works sold was *Indoors Outdoors* by Louis le Brocquy, which went for £60,000, an unbelievable price for a living artist. "There seems no pattern, no reason, no justification for the frenzy with which buyers compete for works by almost anybody," a clearly appalled Niall Fallon wrote in *The Irish Times*. Some recent prices had even made international dealers blanch, he said. Letitia Hamilton, Mildred Anne Butler and Frank McKelvey making £30,000 or more "are in their own way as ludicrous as the artificial millions for Picassos and van Gogh."

Galleries were also enjoying a boom, albeit it on a more modest scale. The Hendriks Gallery had closed suddenly in 1988, never having recovered from the sudden death of David Hendriks five years earlier. But by then the Kerlin had already established itself as a contemporary art gallery, and it took on some of Hendriks' artists, including Barrie Cooke and Basil Blackshaw. "Dublin's commercial galleries went through some hard times in the 1980s," the *Irish Arts Review* noted. "But 1989-90 brought a welcome clutch of sell-outs, such as Michael Mulcahy and Elizabeth Magill." Only four years earlier, with unemployment at almost 18% of the labour force, a report entitled Crisis in the Arts had said that the recession had so severely curtailed private patronage of the arts "that now most visual artists can expect little financial return through sales and commissions".[33]

By the end of 1989, Brian Coyle was warning his customers that they were paying too much for some works by Irish artists. He was right to be uneasy; the warning lights were already flashing. Some prices had started to level off, even drop. The Adam's sale of Christmas 1989 raised £1.3m, with 20 works failing to reach their reserves. It was clear that the market

needed to consolidate.

But there was no time. The following year it went into a slump the likes of which had not been seen for a generation and which has not been seen since. Once again the Irish market took its cue from the international one. In the early 1990s the Japanese investors, who had bought without regard to value or price, disappeared. Even though they had concentrated their purchasing power on a small segment of Impressionist and modern paintings, the whole market collapsed once the Japanese left. Everyone's backside was hanging out the window, including banks which were left with collections of van Goghs and Renoirs as collateral against loans. At Sotheby's Impressionist sale in early 1991, only 60% of lots sold. "It was not a question of how low the price was pitched," said Ivor Braka, a London dealer.[34] "For many works there were no buyers at any price."

Sotheby's found itself with a couple of dozen Jack Yeats's, and panicked. A former tax lawyer based in the Channel Islands had tried to corner the market for Yeats's oils, not realising how many of them there were – no-one did until Hilary Pyle produced a catalogue raisonné, the official listing of the artist's work, in 1992.

"That book revealed that there were 1,200 oils and cornering the market was never going to be a starter," explained a London auction house source. "This chap had bid on Yeatses all through 1989 and 1990, and he was opposed at auction by various people, so he single-handedly drove the prices up. He eventually came a cropper – ran out of money I think in late 1990, and had to get an enormous loan from Sotheby's. He pledged something like 20 Yeatses [as collateral] against his money.

"Sotheby's sold all the pictures, en bloc, in about 1992/93 at the depth of the market just to recoup their money, sold them all in a single package to Tony O'Reilly who then brokered quite a few of them back onto the market. They were crazy to sell them, because the paintings were let go for absolutely zip and there were one or two tremendous items."

Other international auction houses laid off staff, and closed branches. Sotheby's share price plunged. Dealers who had hyped up some contemporary artists as trendy and "hot" were hiding under their beds when clients came back to offload their over-priced purchases. The worst hit in Ireland was Christie's, who had returned in 1988 to cash in on the boom in prices, holding two sales a year, in Dublin and Belfast. "In 1990 we had a big sale in the Conrad hotel and a big sale in Belfast," said Bernard Williams. "And by the end of 1990 the whole thing had gone. We sold £2m sterling of Irish art in Ireland in 1990, and in 1991 we sold £186,000. There was a complete collapse."

In less than 20 years, the Irish art market had seen it all. It had gone from nothing to boom, and from boom to bust. All it needed now was a breather, a break to find its second wind.

33 Quoted in Robert Ballagh by Ciaran Carty (Magill, 1986).
34 Quoted in The $12m stuffed shark, by Don Thompson (Aurum, 2008).

2

THE BIG GAME HUNTERS

"The best art is the most expensive, because the market is so smart."
Tobias Meyer, head of contemporary art, Sotheby's

A TELEPHONE RANG IN SOTHEBY'S AUCTION ROOM IN LONDON DURING ONE of its Irish Sales in the late 1990s. Hard to believe now, but that was quite an unusual event. While there were plenty of telephones in the room, they were being used to ring out, as dealers consulted with clients when various lots came up. This telephone was being used to ring in.

The trill came as music to the ears of Henry Wyndham, the chairman of Sotheby's in Europe, who was in the rostrum at that very moment trying to sell a Lavery. He had been looking desperately in the direction of Padraic Hassett, an estate agent from Wicklow, who was sitting impassively at a table that Sotheby's had specially provided. "Padraic was sitting there utterly uninterested," recalls Mark Adams, who worked with Sotheby's at the time. "Then the phone rang on his table and he picked it up, nodded at Henry, and bought the picture just as it was being knocked down. It was amazing. For me it added to the lustre of his client. He must have had some sort of psychic hot line." Michael Smurfit had saved the day for

ALAN BETSON/THE IRISH TIMES

"Like everyone else of my **generation**, when you got married you had no money and then you had children and you had even less money."
Lochlann Quinn.

Sotheby's yet again.

"When our Irish Sales started in 1995 we were worried if Hassett wasn't there," Adams admitted. "He and Michael Smurfit had this amazing system. Padraic would sit on one side of the room, he would get a table to himself with a telephone on it. Michael would ring Padraic at about the time that the lot might be coming up."

So important was Hassett at art auctions in the late 1980s, throughout the 1990s and into the early 00s, that they almost wouldn't start without him. Christie's also provided him with a telephone so he could take instructions from Smurfit. "The fellows in Christie's and Sotheby's would be in a terrible state waiting for Padraic to come up the stairs with his brief-case," said John de Vere White. "And if he didn't appear, there were wobbles. But year after year Mr Hassett appeared at their Irish Sales and sat with the telephone and stuck his hand in the air, and would spend £1m or £1.5m or £2m, and was a major player. I never saw Smurfit, it was always Hassett, and I never quite knew how Smurfit viewed anything. I think he must have bought lots of paintings that he never viewed, buying them on the basis of catalogues and photographs."

Dr Michael Smurfit was one of a group of businessmen who became rich in the 1970s and multi-millionaires in the 1980s. These self-made men – including Tony O'Reilly, Barney Eastwood, Tony Ryan, Martin Naughton, Lochlann Quinn, JP McManus and John Magnier – were the first generation since Irish independence in 1922 to get extremely rich under their own steam. Their wealth was neither inherited nor based on the value of land or property. They made fortunes from beans, bookmaking, planes, radiators, newspapers and horses.

While this group of multi-millionaires was often lumped together for the purpose of making some social observation or other, they were very different people, and generalisations about them were best avoided. Some flaunted their wealth, acquiring all of the millionaire trappings including country seats; but others didn't. Several became tax exiles; a few chose to remain resident in Ireland. Some made vanity purchases, such as loss-making newspapers, golf resorts or stakes in football clubs, and struck poses on the international stage. Others were inconspicuous to the point of anonymity, in both their personas and investments.

But they did have one thing in common, this first generation of Irish multi-millionaire businessmen: they all bought Irish art. Large amounts of it, and for high prices. Their reasons for doing so were quite different. Sir Anthony O'Reilly, for example, appears to have been projecting an image of himself as a man of culture. Some of John Magnier's purchases, on the other hand, seem to have been investments or to avail of tax schemes. Lochlann Quinn appears to want to re-shape the artistic taste of the Irish nation, and to change the nature of the National Gallery of Ireland. But these are impressions we form by judging what they bought, and where, and even from whom, and most especially what they did with their artworks afterwards. What we can definitely say, however, is that they bought within a narrow range – their collections are dominated by Irish artists of the late 19th and early 20th

century. They fetishised Yeats, adored Orpen and Lavery, and were persuaded to admire le Brocquy and Paul Henry.

"I think on the whole they were quite nervous buyers," said Bruce Arnold. "They did buy Yeats – who was secure. Later on they began to buy Orpen, Lavery, Osborne, but on the whole they were quite timid and didn't have great judgment. Some of them were shrewd – Tony Ryan had a wonderful eye. He bought early and bought well, and formed a collection that outclassed Smurfit, and I would guess that Smurfit paid more. Naughton is a shrewd collector – he has bought well – and Magnier has begun to buy extravagantly well.

"It's hard to characterise the millionaire collectors. There wasn't much public spirit about them. They were the first generation to be wealthy and they wanted to demonstrate their wealth and the power of buying in what they collected, as well as where they lived and what wine they drank."

Because this bunch of super-rich buyers concentrated on a tight range of artists, they had a huge impact on the Irish market. From the mid-1980s on, the steepling prices of Yeats, Orpen and Lavery reflected the intense level of competition among these millionaires to get their hands on the prized pieces. "They were buccaneer sort of collectors," said auctioneer Ian Whyte. "They were willing to walk into a room and seriously damage each other. They were trying to out-do each other at various things. You'd know who their agents were, and they wouldn't mind people knowing that So'n'So bought X. There was a bit of bravura and show about it."

Easily the best known of those agents was Hassett. In September 1989 he and his client completed the stand-out sale of the 1980s, a purchase so jaw-dropping that it made the front pages of every newspaper next day: they paid IR£280,000 for Yeats's *Harvest Moon* at an Adam's sale. Legend has it that when the phone rang that evening in Adam's, Smurfit was calling in his instructions from a golf course in Marbella. Hassett now admits that's not true, although he sometimes told the story in jest. Afterwards all sorts of people approached the estate agent, not knowing who he represented, wanting to know "would we sell it, and make a profit from it?". But Smurfit wasn't interested in turning a quick buck. "Michael just wouldn't sell it," his agent says.

Of all the big-game hunters[1] of the Irish art world, Smurfit attracts the most scepticism. Some in the trade claim he doesn't have a good eye, buys pictures sight unseen, and treats art as a commodity. *The Irish Times* once accused him of collecting only as "an ego thing".[2] Similar charges have been levelled over his purchase of the K Club in Co. Kildare. So how does he react? "Absolute nonsense," he snorts. And do such criticisms hurt? "I don't let rubbish comments affect me," he says. "If I did I'd be a worried man all my life."

To speak of these millionaire collectors in the singular is wrong; in almost every case their

1 As Frances Ruane has described them.
2 Irish Times, 10 May 2003.

wives played pivotal roles in their art buying. Brenda Quinn, Susan Magnier and Carmel Naughton, in particular, were equal partners with their husbands in the amassing of collections. Michael Smurfit had not one but two wives – and he credits both.

"About 40 years ago my wife Norma thought we needed some decoration for the house, rather than the same plain walls, and she persuaded me to buy my first Yeats for £500. Which wasn't easy to do at the time because I didn't have £500. So that's how it started, in the late 1960s," he said.

"She was the one who sparked my interest in Yeats and I started to study his different periods and he became my favourite artist. No other artists interested me at the start – it took a bit of time – most of them were outside my financial ability anyway. But any time I had a spare bit of money, we used to go and buy something and slowly but surely built up our collection. Initially I just bought in Ireland. I didn't go overseas until about 15 years later. By the late 1970s, when I started to make some serious money myself, I started spending some serious money on art.

"I wasn't thinking in terms of the price of it, more the beauty of it. I wasn't buying to sell. So you're looking at a place on the wall and thinking: 'oh that could do with an Orpen, or that could do with a Leech, or a Yeats, that area'. My home was quite small at the time so we didn't have that much space to put art on the wall."

When Jefferson Smurfit opened a new office in Clonskeagh, it was decided to put the best of Irish art on the walls and in the grounds. The company's board agreed to make the necessary investment. In fact the ownership of the "Smurfit collection" was split three ways – 50% was Michael Smurfit's, 25% was the company's, and a Smurfit foundation owned a further 25%.

While Michael's taste remained for 19th-and early 20th-century art, Norma bought a lot of contemporary pieces for the new wing of the company headquarters – works by Donald Teskey, Felim Egan, Sean McSweeney and Barrie Cooke.

"My favourites would be Orpen, by far. I think he's a wonderful portrait artist and I have a nice collection of his. I thought Orpens were under-valued at the time and that has turned out to be the case. *Mrs St George* is a painting I adore, magnificent, certainly the best Orpen that I've seen," he said. "I like Maurice MacGonigal, and Leech. I have about 10 Laverys. But I know nothing about contemporary art. My home tends to be old-fashioned, high ceilings, country house-type furniture – it doesn't suit to put a modern, multi-coloured square-looking thing on the wall. It would clash with the surroundings. And I've never wanted to own a Renoir or a Picasso or things of that nature. That would not be my focus."

Through his second wife, Brigitta, he became a fan of Swedish art and in particular Carl Larsson, Anders Zorn and Bruno Liljefors. He now has a Swedish room in his house, with just Swedish paintings, and has an adviser in Sweden who sources and buys pictures for him.

And what were his buying patterns? Smurfit insists that he always did his homework on

paintings, studying the catalogue and the provenance, speaking to experts. He did go to pre-openings, maybe one in four or even one in two. He took advice from time to time, but mostly relied on his own judgment. Clearly he had had a bad experience with dealers, and preferred to buy on the open market – even though that meant his purchases were made in public and usually more expensive.

"I tended to buy more from auction than I have from galleries. I find that the value in auctions is the value," he said. "When you go to galleries...Well, I knew on one particular occasion a painting was 100,000 for one person, 150,000 to another and 200,000 for another, sterling, all in the space of about three months. So I think for some of the dealers it's a question of what they think the market, or the person they are selling to, can afford rather than what the intrinsic value of the painting is. Whereas if you buy at auction at least you know what the intrinsic value is. It's a fair value."

But isn't there a tendency to lose one's head at an auction, to get caught up in the excitement and spend more than one had planned? "I've never had that problem," he said. "For example, at the last auctions at which I bought five paintings, between Christie's and Sotheby's,[3] I think I bid on maybe five more that I didn't get. I put a value on a painting and that's it. Otherwise it becomes crazy."

Smurfit's concentration on the auction scene is unique among his peers. Many observers would argue that using the same agent, Hassett, at most sales meant he didn't get good value. There are "bitch bidders" – people who will take on a celebrity rich man in the auction room out of resentment, just to make him pay more. Although Mark Adams says: "I don't know that anyone set out to bid against Smurfit. That would be a dangerous game."

Another dealer says that actually Smurfit bought a lot at the reserve price, because he was buying pictures that didn't interest others. "His taste was always a bit different. He was really his own man. I don't know if anyone really advised him. He knew what he liked and was brave enough to buy it and not worry what people thought."

Bernard Williams of Christie's confirms this: "You wouldn't know what [Smurfit and Hassett] went for, because they have their own taste. You couldn't necessarily take in a very important picture in the hope that it would finish up in that collection. He was slightly maverick in his taste, like everything the man does. He had some really good pictures and some other things that perhaps we wouldn't have equated with him, but maybe they fitted into one of his houses or whatever.

"I have one major buyer in Scotland who won't buy anything privately. He has been offered some wonderful private pictures but just feels that the only way he knows he's paid a fair price is by buying it at auction. Equally [Smurfit] is brave enough to go after something no-one else is bidding on. Some buyers wait for others to start bidding. They don't have their own conviction. There's one major collector in the north of Ireland who will not bid on

3 The Irish Sales of May, 2007.

something unless someone else is bidding against him. That's sad. They can't make up their own mind that this is a wonderful picture."

In any case Hassett insists that he was a moving target, not a sitting duck. "Only about half the time I'd be in the auction room and consulting him on the phone," he says. "A lot of the time I was given a [spending] limit, and it was only when I wasn't that I'd have him on the phone. I knew the buyers and I'd be spoofing to them, trying to find out how much they were going to give. And I didn't always bid in person – sometimes I used different names on the phone."

Smurfit accepts that he and the other millionaire collectors had an influence on pricing, through competing against each other. But while some Irish paintings may be over-valued, they are not the only commodity for which people pay too much. "If someone told me ten years ago that €200,000 plus costs would be paid for a horse that hadn't raced, I'd say you must be crazy. It's not just art that has gone up – it's everything around it. In relative terms you might say that Irish art has under-performed the property market."

He has been generous with his collection, sending pieces on loan to museums as far away as Australia. "I think that's part and parcel of the duty you have as a collector. They pay the cost of shipping; I'm just happy to loan it. Once I gave something to a gallery for three months and the show was such a success that they kept it for a year." That generosity includes the occasional gift, such as his donation of Yeats's *The Bar* to Princess Caroline in Monaco in 1990 during an exhibition.[4]

That same year he made an impulsive gift of Yeats's *The Forge* to Charles Haughey, at the same time as he was donating *The Flag* by Lavery to the state. That act of kindness landed him in the Moriarty Tribunal, where the crooked former taoiseach's personal finances were being raked over. Smurfit had warned Haughey not to sell the picture quickly – it was worth over IR£50,000 – because that would make it look like a cash gift. He expressed the hope that it would in fact become a Haughey heirloom. "The gift did raise eyebrows in certain places," he concedes. "It's very unfortunate when people read things into situations that aren't there."

A large slice of Smurfit's collection, as we shall see, was sold off in 2003 and 2004. But he is now back in the auction rooms, still buying Yeats and spending high six-figure sums on paintings like *Evelyn, Lady Farquhar* by Lavery.[5] "Until the day I leave the planet I will continue to add to the collection," he said. He is thinking of a cull, however, taking out some that he hasn't taken to, or that just won't fit. "There's nothing worse than being in a room and there's a painting that you don't particularly like staring down at you all the time and you're saying 'I know that damn thing doesn't work there'. I don't want to store my paintings like some people have to do because of a lack of space. If I can't hang them on the walls I don't want to have them."

Smurfit has bequeathed his collection to his children, with the proviso that they can't sell. His youngest daughter will get first pick, and then it will go up the line, and he hopes they

will use this opportunity to start their own collections. His two children with Brigitta will get the Swedish pictures, and the other four will get the Irish. "Whether I give some to the state or not is something I'm still debating with my family because there are some pieces that I think would sit better in a state rather than a private collection, particularly one that is going to be broken up into six pieces," he said. "That's something we will give some thought to."

While Smurfit tends to avoid dealers, most of the other big-name rich-man collectors have no such misgivings. John de Vere White explains the importance of dealers in world art, and how they serve serious collectors. "There's a huge role for the very knowledgeable, well-connected dealer who can source world-quality pictures privately," he said. "Because there are people who don't want to go onto the public market with those pictures. You can't put a £10m picture on the market and have it fail. So the high-powered dealer has often been an outlet for this type of picture, and he can place them because he has the clients."

Alan Hobart is such a dealer. The founder of the Pyms Gallery in London in 1975, he is one of Britain's most powerful art dealers – a man who has spent seven-figure sums in Christie's and Sotheby's, and whose client list is a fillet of *Who's Who*. Such is his power in the market-place that Hobart has acquired the affectionate nickname Mr Muscles.

The son of an Irish mother, and married to a Monaghan woman, Hobart's art antennae were receptive to signals from Ireland long before his rivals. In the late 1970s he realised that the weak Irish market provided a great opportunity. "Lavery was then considered Scottish and Walter Osborne was considered English," he recalls. "There really wasn't an Irish market here in the UK. We realised that there were great Irish painters that hadn't been recognised and therefore it was a market we could begin to specialise in."

Alan and Mary Hobart didn't have to look far for stock. During the War of Independence from 1919-1921 and in the years and decades after it, thousands of Protestants fled Ireland and re-settled in the south of England. They brought their art with them, and as that generation died out, their pictures surfaced in small auction houses all along the south coast. The Hobarts took out advertisements in publications such as *Country Life* to signal their interest. They were mining a rich seam, because Irish art had been utterly neglected in England. "The dealers here, from the 1930s to the 60s, just hadn't bothered to take an interest," Hobart said.

The initial idea was to bring Irish art to the attention of London buyers – to persuade English doctors, lawyers and stockbrokers as well as belted earls to invest in Yeats or Roderic O'Conor. With the IRA's terrorist campaign at full throttle, it took a brave dealer to mount the sort of exhibitions that Hobart did, with titles like Irish Renascence and Celtic Splendour. "It wasn't easy in the 1980s putting up posters in the window saying things like Irish Revival," he said. "We were lucky that we never got a brick through the window. But we had plenty of attention on us in many ways."

4 For Hilary Pyle's rather unkind comments about same, see her interview in Movers & Shapers 2.
5 Sold at Sotheby's Irish Sale in 2007 for £748,000.

"Whether I give some to the state or not is something I'm still **debating** with my family because there are some pieces that I think would sit better in a state rather than a private collection."
Michael Smurfit.

Clockwise from above: Michael Smurfit keeping serious golfing company in the form of Tiger Woods. Norma Smurfit with daughter Sharon. Michael Smurfit has bequeathed his collection to his children, with the proviso that they can't sell.
Anne Yeats, niece of Jack B Yeats, Carmel Naughton, former chairman of the National Gallery of Ireland and Brian Coyle of Adam's auctioneers.
Art dealer Theo Waddington with his wife Vivenne and U2 manager Paul McGuinness.
Property developer Sean Mulryan of Ballymore Properties.
Alan and Mary Hobart of Pyms Gallery, London.
Gallery owner Marie Donnelly, former chairman of the Irish Museum of Modern Art.
Centre opposite page: Martin Naughton of Glen Dimplex with Raymond Keaveney, director of the National Gallery of Ireland.

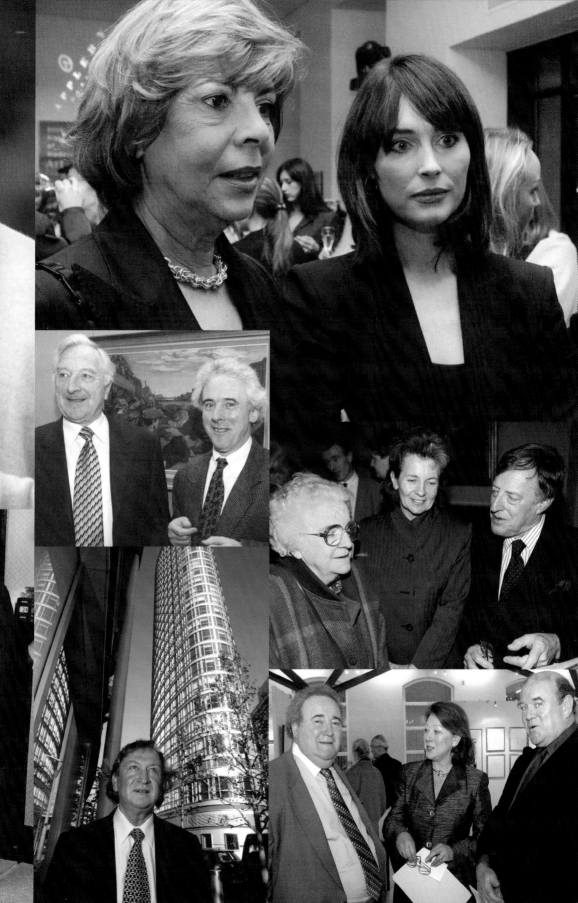

Hobart's Irish exhibitions were supported by academic catalogues of a high standard and usually featured superb examples of works by the premier league of Irish artists. The Irish Renascence exhibition in 1986, for example, had Osborne's *Children in Church*; Lavery's *On the Bridge at Grez*;[6] Leech's *The Gate*; *Dancing at a Northern Crossroads* by Charles Lamb; one of Yeats's finest works – *O'Connell Bridge*; Kernoff's *Bank Holiday, Killiney*; and *Hommage to Fra Angelico* by Mainie Jellett.

Pyms didn't just source its stock in England; Hobart bought extensively from Irish galleries and auction houses throughout the 1970s and 80s. At times he paid far more than private collectors, even though that would mean waiting years to make his margin. Among the stand-out prices was the £176,000 sterling[7] for John Luke's *The Bridge*, paid at Christie's in Belfast in October 1988,[8] a record price at the time. At Christie's Irish Sale in 1999, he paid £496,500 for Frank O'Meara's *Reverie*, which had been estimated at just £50-70,000,[9] and said he would have bought it at any price.

Hobart bought *Reverie* for his biggest client: Graham Kirkham, a north of England businessman[10] who made a vast fortune from selling sofas. The adopted son of a miner, Kirkham left school at 17 and got a job in a furniture store. When his company, DFS, was floated in 1993, Kirkham celebrated by buying a £3.5m Gainsborough painting called *Peasants Going to the Market* – a joke about his origins. He now has a vast collection, including many Turners and Constables, and while Irish art represents only a small fraction, Kirkham is said to have Orpens and Laverys that are "unsurpassed by any collection, public or private".[11]

One trick Hobart used was to hang Irish paintings alongside similar works by much better known European artists. "What Alan used to do, which I thought was very clever," said John de Vere White, "was buy a good, say, William Leech for £10,000 and put it in an exhibition for £20k hanging beside a Pierre Bonnard or a French Impressionist of the same period which would be £120k. And people would come in and say 'William Leech?' 'Oh yeah, same period, probably knew each other, had coffees together'. 'And it's only £20,000?' And the person would buy it."

Hobart's gamble was that rich Irish people would eventually be inspired to buy great Irish paintings. There was only so much of this stock that his English clients would buy – and the likes of Sean Keating and Paul Henry were never likely to win many British admirers. In the 1980s, many of the Irish paintings the Hobarts put into their exhibitions didn't sell, and were brought back to London and put into their private collection to wait for better days. Hobart bought Yeats's *Going to Wolfe Tone's Grave* at Adam's in 1986 for £25,000 and it remained in his gallery until 2004, too abstract and sophisticated for most tastes. But he persevered. He had seen other countries' art markets take off once their economies did, and noticed how patriotic they became about their paintings, and reckoned some day Ireland would be like this too.

"It happened in America, and Australia. English and Scottish people also became very

nationalistic and wanted to buy their own paintings. We always thought it would happen one day in Ireland. It seemed to me that once Ireland joined the EU and dropped sterling, you could see it making headway. There was a new belief, and one could see that the market would move eventually, and we always had faith in it."

That faith was rewarded. A key moment was the day in 1983 or 84 when Lochlann Quinn, then finance director of a small privately owned company called Glen Dimplex, first called into Pyms Gallery. The businessman who would soon put together one of the most important private collections in Ireland was just starting out. "Like everyone else of my generation, when you got married you had no money and then you had children and you had even less money," he recalled. "You'd be dropping into the major galleries – not obsessively because you go to college and you start your career and you're busy at 1,001 other things. So although I was interested, it wasn't the primary focus of my life. One of the first things that affects you is when you get a house, you get a wall, and you think 'what will I put on it?' It focuses in on you at that stage for the first time.

"I suppose I started buying big time at the beginning of the 1980s because my economic circumstances, based on a business outside of Ireland, were quite good. I don't think prices were dear then, but it was the start of the trajectory of price increases. And yes, Alan Hobart in Pyms was a significant influence."

Quinn was spending a lot of time in London on business, and started to pop into Pyms nearly every week. He remembers the time Hobart was preparing an exhibition of paintings by Mary Swanzy, which he had bought from the artist's studio. "I saw all these Swanzys on the floor, which were tremendous, full of colour, and I said 'oh wow'. I had just got involved with Patrick Guilbaud at that time,[12] which was in a very contemporary building behind the Bank of Ireland headquarters [on Dublin's Baggot Street]. And I thought to myself 'God, these would look fantastic on the walls'. So I bought eight off him, unframed and on the floor, and we put them in Guilbaud's where they got a great reaction. And now there wouldn't be a restaurant in Dublin of any consequence that doesn't have paintings on the wall, and yet that was the first, in 1985. In 20 years we've moved to a point where no self-respecting restaurant would be without them."

Quinn's business partner, Martin Naughton, soon followed him into Pyms and John Magnier and Vincent O'Brien are also known to have been clients in the 1980s. So, too, was

6 Which made Lavery the first Irish painter whose work made £1m when it was sold by Christie's in 1998.

7 All prices fetched in the UK by Christie's and Sotheby's are quoted in sterling, and given that the exchange rate with the punt and the euro varied widely over the period in question, I haven't converted many of the sterling amounts. Note also that Sotheby's and Christie's include the buyer's premium in their quoted sales prices. Irish auction houses don't. It is, perhaps, fairer to include the premium as it represents the real price the buyer has had to pay.

8 Hobart bought it again – this time well within its estimate - for £441,500 at Christie's Irish Sale a decade later.

9 The Art Newspaper; and Hobart confirms this.

10 Who is now Lord Kirkham, because he was ennobled by the Conservative Party to whom he loaned £4m in 1995.

11 According to William Laffan, an art historian and curator, writing in Apollo magazine in September 2004.

12 Created in 1981, Guilbaud's has been Dublin's most decorated restaurant ever since. It is now based in a Georgian townhouse within the Merrion Hotel.

SIR JOHN LAVERY

BORN: 1856, BELFAST

DIED: 1941

PAINTING STYLE: NATURALIST

HIGHEST PRICE: £1.3M (CHRISTIE'S, 1998)

FANS SAY: A LYRICAL PAINTER OF INTERNATIONAL IMPORTANCE

CRITICS SAY: THE QUALITY OF HIS WORK DECLINED MARKEDLY ONCE HE CONCENTRATED ON PORTRAITS

IF YOU COULD OWN ONE: THE BRIDGE AT GREZ

BEST EXAMPLE ON PUBLIC DISPLAY: MRS LAVERY SKETCHING, 1910 (DUBLIN CITY GALLERY, THE HUGH LANE)

Lavery was the son of an unsuccessful publican who died at sea when he was three. His mother passed away a few months afterwards and Lavery was brought up by relatives near Moira, Co Down. At the age of 10 he was sent to Ayrshire to be educated, but eventually ran away to Glasgow and worked as a photographer's assistant, while attending art classes by night. He went to the Academie Julian in Paris, and spent time at the artists' colony in Grez-sur-Loing, a pretty village south of Fontainebleau. He was heavily influenced by the work of Frank O'Meara and other painters there working in "plein air" style. He returned to Glasgow in 1884, and

£1.3m
1998

became leader of the "Glasgow Boys", a group dedicated to the idea of painting outdoors. Four years later he was chosen to paint Queen Victoria during her visit to the International Exhibition. He decided to leave behind his experiments with Impressionism and become a society portraitist.

In 1896, Lavery moved to London and set up a studio. Widowed after one year of marriage, he then married Hazel Trudeau, whose husband had also died a short time after they were wed. Of Irish-American background, Hazel was an amateur painter and a society queen in London. She introduced Lavery to the rich and famous, and the two played a peripheral role in the Anglo-Irish negotia-

tions of 1921, lending their house to the Irish delegation. Hazel is said to have had an affair with Michael Collins. She is portrayed in several of her husband's greatest works, and appeared dressed as Cathleen ni Houlihan on Irish bank notes from 1927 to 1975. Lavery was appointed official war artist to the Royal Navy during the First World War, and was knighted for his work even though he never visited the front. He painted a convoy of ships in the North Sea from an airship.

He was a chronicler of his time and of its fashion, capturing many of the leading political figures of his era including the British royal CONTINUED ON NEXT PAGE

Fred Krehbiel, a fantastically wealthy American industrialist who'd opened a branch of his Molex factory at Shannon in 1971, married a Kerrywoman, and bought a house in Fenit. *Apollo* magazine reckons Fred and Kay Krehbiel have "what is perhaps the most representative collection of Irish paintings in private hands", in which "the discreet guiding hand of Alan Hobart of Pyms Gallery is apparent".[13] The collection, displayed in a suite of specially built galleries in their home, starts with the mid-17th century. Included is Lamb's *Dancing at a Northern Crossroads*, which featured on the front of a Hobart catalogue in 1986.

Collectors like Quinn and Naughton had a magnet effect – attracting back to Ireland some of the works that had been scattered throughout England, Europe and America over 50 years. In part these collectors were motivated by a streak of patriotism, a sense that these pictures belonged in Ireland and it was their duty to bring them home. Brian Coyle of Adam's believes that Tony Ryan, the millionaire founder of Ryanair, bought Orpen portraits in London precisely in order to reclaim them for his native country. The most famous of these was *The Blue Hat*, a three-quarter length portrait of Vera Brewster, which the Tipperary businessman bought at Christie's in 1986 for £126,500, even though the estimate was £30,000-40,000. Years later Ryan told an artist friend that if there was a fire at his home in Lyons, "the only picture he'd like to take would be *The Blue Hat*".[14]

Ryan once described to Coyle a visit he'd paid to a London furniture dealer where a mirror surrounded by studs had caught his eye. "He was very Irish-proud, Tony," Coyle said. "When he asked the toffee-nosed assistant 'what's that?' he was told 'it's just an Irish mirror, not very important, it's only £35,000'. And Tony said 'I'm taking it – it's coming back to Ireland'."

Professor Kenneth McConkey of the University of Northumbria says that from 1980 onwards there was an organised attempt to retrieve national treasures and to bring back pictures that had been lost or rediscovered, and they turned up in some pretty obscure

CONTINUED FROM PREVIOUS PAGE

family, Churchill, De Valera, Lloyd George, Michael Collins and Terence McSwiney on their death beds and Roger Casement at his trial for treason. His portraits were elongated, and his palette was dominated by dark colours.

People involved in leisure activities was a constant theme – whether they were boating, sketching, playing tennis, messing about on the water or just lazing around on the grass. He and Hazel visited Morocco frequently, and Lavery extensively painted its people and landscapes. He also worked in Spain, Germany, France and Italy.

He donated 35 of his paintings to the Ulster Museum on the occasion of its opening. After Hazel's premature death in 1935 he moved briefly to Hollywood with the idea of painting portraits of the stars, but returned to Ireland at the outbreak of the Second World War to live with his stepdaughter.

He wrote an autobiography, Life of a Painter, and died in Kilkenny in 1941.

hideaways, even private collections in Oslo. "A few rich businessmen began to take an interest in Irish art in the early 1980s and that began to spread. And they had a sense that 'this is our heritage, it's important to us, and we almost have a sort of moral duty to go out and sell our shirts and buy these pictures and bring them back to Ireland'. And that of course gives a huge confidence to contemporary production, which had languished for years in Ireland. If you were an artist in the 1960s, as I was, you really had to get out of the place in order to make a go of it. That has changed."

An example of this trend was at Christie's Irish Sale in London in May 1998, which featured particularly intense competition between the big-name Irish collectors with Magnier and Smurfit visibly active; Hobart buying Orpen's *A Mere Fracture* for £716,500; and another unidentified Irish collector paying more than IR£1m for a Yeats for the first time.[15] Carmel Naughton paid £265,000 for Leech's *Blue Shop, Quimper* and £370,000 for Osborne's *Beneath St Jacques, Antwerp*. These were both record prices, and as the *Daily Telegraph* observed, represented huge leaps from the £42,000 paid for Leech in 1991 and the £88,000 for Osborne in 1990. But there was something else significant about the two original sales – they had taken place in Belfast and Dublin. Now the pictures were returning home, and given that they were going into the Naughtons' collection, there they would be staying.

"Over the last 25 years an awful lot of work has been repatriated to Ireland," Quinn agrees. "The first reaction when something comes up for sale overseas now is that the Irish market hears about it. I got a beautiful Lavery years ago from a dealer in Philadephia, who had got it from a client whose father had bought it from the gallery in 1930. So they don't bring them back here for sale, but they let us know that they are for sale. We got a Walter Osborne last year up in Stockholm.

"A lot of Jack Yeats was sold in North America and Canada because Victor Waddington had customers out there. Prominent Irish Americans in the 1930s and 1940s did buy. Francis Murnaghan, a judge in Baltimore who died about five years ago, built up a great collection of Irish paintings."

Of course Quinn wasn't just buying for Ireland, he was buying for himself. He feels lucky that when he started buying in the early 1980s, he was prepared to pay more than most of his rivals, so he tended to get the paintings he wanted. He now has a collection of about 150 pieces, but there's still a dozen or so that he let go and that in retrospect he knows that he shouldn't have, because they were great paintings.

"Once or twice I was willing to pay an awful lot more for a painting and ended up getting it for less," he admits. And has he ever lost the head in an auction room and paid too much?

13 Laffan, see earlier reference, who acted as their curator.
14 Confidential source. Ryan passed away in October 2007.
15 A full report on this sale was carried by The Daily Telegraph on 1 June 1998. The Telegraph's coverage of the Irish Sales was particularly astute in this period, and its correspondents not only recognised Irish art collectors when they arrived to bid in person, they were usually able to work out what London art dealers they were using. But Carmel Naughton and other leading Irish collectors were never seen at Irish Sales again after being "outed" by the Telegraph. Christie's were furious over the coverage.

"I have no more space on the walls. I have nowhere to put them. They're behind sideboards, they're draped in sheets in sheds, they're wrapped in plastic foam, and I'm still buying."
Gillian Bowler

DAVID SLEATOR/DARA MAC DONAILL/THE IRISH TIMES

"Ah no, because if you're not going to re-sell them I don't know what going too far means. If you're not going to re-sell them it doesn't really make an awful lot of difference." He admits that collecting becomes "a bit of a disease". And the more properties you own, the more wall space you have, and the more pictures you buy. But some Irish collectors don't even let a lack of wall space get in the way of their obsession.

GILLIAN BOWLER ARRIVED IN IRELAND IN 1973, the same year that Adam's sold *A Palace*. Born in the Isle of Wight to an Irish mother and a British father, she had moved to London at the age of 16 and worked with Greek Island Holidays. Four years later they sent her to Dublin to open an office. She soon set up her own travel company, Budget, from a basement in Baggot Street. In what may be the first successful use of product placement in Ireland, she took to wearing sunglasses on the top of her head like a headband, even when indoors, a teasing reminder of summer holidays in a country that goes without sun. In 1987, when her company was sold to Granada for almost IR£5m, Gillian Bowler became a very wealthy woman.

She was interested in art from an early age, having been taken to London's galleries from about five and spending her pocket money on postcards of Modigliani's paint-

Above: Gillian Bowler. Left: Tony Ryan photographed outside the Tony Ryan Academy for Entrepreneurship, Dublin, 2005. Ryan died in 2007. "He had a wonderful eye. He bought early and bought well, and formed a collection that outclassed Smurfit, and I would guess that Smurfit paid more." Bruce Arnold

ings. Her grandfather was a society portrait painter, but there's art on both sides of the family, and she reckons she inherited the gene. As with Michael Smurfit and Lochlann Quinn, her collection had modest beginnings. Her husband Harry would wonder how much her latest purchase had cost, as he watched their house gradually fill up, and she would rub out the decimal point on the prices – making a £3,000 picture look like a £300 one.

"I'd remove the decimal points of the price of paintings that I really shouldn't have bought because I didn't have the money to buy them," she said. "But I would not have spent money on clothes. A pair of Louis Vuitton shoes or a Hermes handbag would not have any appeal to me, but a really beautiful painting…"

The collection, much of it bought from the Hendriks and Taylor Galleries, spilled out of her Dublin home and into her larger-sized country retreat, and then onto the walls of Budget Travel. She bought a lot of contemporary Irish artists – Basil Blackshaw, Tony O'Malley, Louis le Brocquy – and went through a phase of the older ones, which she bought at auction. "So I have a Yeats and an Osborne, and things like that. It wouldn't be where my interest lies, and they're now stuck in an old-fashioned dining room. While there are a fair few famous names in that section, it doesn't excite me in the way that more modern stuff does, like Patrick Collins, Barrie Cooke, John Shinnors, Rowan Gillespie. I suppose I felt you don't have a complete collection of Irish art unless you've a Yeats and a Walter Osborne. In hindsight I would be happy to shove all of them in an auction tomorrow and buy more new stuff."

"I found it so addictive," she admits. "I have no more space on the walls. I have nowhere to put them. They're behind sideboards, they're draped in sheets in sheds, they're wrapped in plastic foam, and I'm still buying. But I've really slowed it down and would rarely buy now. There's just the odd occasion where I'd see something that I really wanted. I've never sold anything. Ideally I should go through them…"

She isn't sure why she is so passionate about art – maybe it was having been exposed to it from an early age, and developing her own eye. She didn't buy for investment, although sometimes she pretended otherwise to Harry, and she never saw the boom coming. "My husband used to say 'what is the point?', and that's why I moved the decimal points, and I would say 'Ah, it could be a good investment. It'll probably go up in value'. And I didn't really believe that they would. Well, I got them valued the other day[16] – I won't tell you what they're worth – but I hadn't had them valued for 10 years and I was just staggered. Because I never bought them as an investment."

Not for Bowler a pretty landscape, a vase of flowers, or women feeding chickens in a farmyard. She once bought a large painting by Barrie Cooke for £3,000, of a woman in the nude lying on a sofa and clutching what looks like a gin bottle. She thinks it's his best painting. "Someone said to me 'you couldn't hang it anywhere'. Well, it's got pride of place in my sitting room. I just didn't see it like that."

16 This interview was done in autumn 2007.

Instead of buying art that suited her house, she made her house fit with her art. "I actually had to raise the height of my sitting room wall at one stage in order to accommodate this vast monster of a thing. But you have to feel passionately about it, and want to have to do that. It isn't a question of saying 'this picture is in a price bracket that I can afford, and it's not offensive, and it tones in with our furnishings' or 'we can say that is by X who is very well thought of and is up-and-coming'. This is not a social one-upmanship along with the four-wheel drive." She says she never buys from an investment perspective, and cautions others against doing so. "It's a cliché but if you buy what you like and get years of pleasure out of it, it's a real plus that it goes up in value. Buying because it's a fashionable name at the moment is lottery-like."

Bowler, the founding chairman of the Irish Museum of Modern Art in 1989, doesn't agree that Irish people have been conservative in their tastes. Whatever its shortcomings, the importance of that museum was brought home to her in an unpleasant exchange with Peter Mandelson, the British minister. Finding herself sitting beside him at a north/south dinner, Mandelson wondered where Bowler was from and what she did. "I said I lived in the republic and did various things, businesses, and I'm the chairman of the museum of modern art. He said: 'Oh God, I didn't think the Irish knew anything about art'. For somebody who was meant to be a career diplomat it was such a put-down. And I said: 'So you haven't heard of any of our Irish artists or writers? You mustn't be too widely read.'

"For him to say 'I didn't think the Irish knew anything about culture or any of the finer things in life' was amazing. It's fair to say we will never catch up with the great Italian museums, but at least we do have a museum."

She continues to be interested in young and emerging artists, and is happy that 12-hour working days don't leave much spare time to frequent galleries because she has no place to put more paintings. She reckons 95% of everything she bought was through galleries, because the auction house scene seems more contrived. And what of Michael Smurfit's preference for doing it the other way round? "Smurfit is looking at this from a totally different angle than I am," she said. "If you did a painting and no-one had ever heard of you and I really liked it, I would buy it. The price is there; the gallery lists it. Michael Smurfit is buying with a view to art as an investment and to grace his many palaces around the world, so he has got to be the biggest collector of Yeats and all that. That doesn't do anything for me. That's telling me that he is treating art as a business. It makes absolute sense in that case to buy through auctions. I couldn't be more of a polar opposite to him. I like the painting and the painter, and if it bombs and nobody ever hears of you again, that doesn't bother me in the least. It's your work I like."

The criticism is often made nowadays that Irish art buyers have lost the run of themselves, have become slaves to auction-house hype and are being lured into paying silly money for so-so pictures. But Bowler points out that the same could have been said of her in the 1970s or early 80s "when I didn't have a bean. You could say I was being lured into

BARRIE COOKE

BORN: 1931, CHESHIRE

PAINTING STYLE: ABSTRACT EXPRESSIONIST

HIGHEST PRICE: €28,000 (ADAM'S, 2008)

FANS SAY: BRAVE, ELEMENTAL, UNDER-APPRECIATED

CRITICS SAY: PAINTINGS OF SEWAGE FUNGUS? YUK!

IF YOU COULD OWN ONE: BLUE FIGURE, 1985

BEST EXAMPLE ON PUBLIC DISPLAY: THE LOUGH DERG PIKE, 1980 (CRAWFORD GALLERY, CORK)

ALAN BETSON/THE IRISH TIMES

Above: Barrie Cooke photographed in his Sligo studio.

Born in Cheshire to an English father and an American mother, he spent his teenage years in Bermuda and Jamaica before moving to America. He first studied marine biology at Harvard University, but quickly switched to art history. He held a solo exhibition in New York in 1950, and settled in Ireland in 1954, staging his first show in Dublin the following year.

He has been based in Clare, Kilkenny and most recently near Lough Arrow in Co Sligo, on which he fishes and keeps a boat

Cooke's work deals mainly with nature and specifically with water. In 1988 he painted a diptych entitled Death of a Lake, which told the story of an Irish lake destroyed through eutrophication.

Cooke has also been inspired by New Zealand, Borneo and Lapland, and by esoteric organisms, such as microscopic algae and sewage fungus.

He recently said: "Sewage fungus and blue-green algae – these things are rather beautiful even though the consequences are dire."

Cooke has also painted nudes and landscapes, and did a series of animal carcass paintings in the 1960s, inspired by his work in a slaughter house.

He has also produced sculptures, including a series of perspex boxes containing real and artificial bones.

From the beginning, Ireland enthusiastically

embraced Cooke, sending him as its representative to the Paris Biennale as early as 1963. He is a founder member of Aosdána, and has collaborated with poets such as Ted Hughes and Seamus Heaney. He is represented by the Kerlin gallery. His work is in the Irish Museum of Modern Art and the Ulster Museum, as well as several institutions in Holland, most notably the Stedelijk.

galleries, sucked in, and ending up with two paintings, not just one. The reality is that it has turned out, somewhat surprisingly, to be a really good investment. I don't think there's anything that has gone down in value. Most of it has gone up in huge multiples.

"Why do you buy a painting? Two reasons. Either you're a mega-million collector and it's serious investment art and you are going for the classics or, and I think this is the most enjoyable space to be in, you are learning about art and buying all the books and finding it an endless source of fascination and that's when you should start buying for your own home and not just ticking the boxes against the right name."

But ticking the boxes is exactly what many of the big-name collectors in Ireland seem to do. Flick down through the *Sunday Times* Rich List and you will find the names of all the top collectors, because most wealthy people in Ireland now collect art. Of the top ten on that list in 2005, for example, seven of them were serious art collectors – Hilary Weston, Tony O'Reilly, Dermot Desmond, Tony Ryan, John Magnier, Martin Naughton and U2 (Paul McGuinness has an extensive collection;[17] the band has collectively bought art including, in 1989, a Basquiat that sold in 2008 for £5m; and Bono not only collects but supports artists such as Rasher and his friend Guggi, whose paintings adorn the dining room of the Clarence Hotel).

Were you to walk into some of these people's mansions and view their collections, you could hardly tell one from the other – because there is a set millionaire-Irishman collection, a join-the-dots assembly of Yeats, Osborne, Orpen, Lavery, Le Brocquy, not forgetting a few pictures of horses. While rich Irish collectors of the 18th and 19th centuries showed their sophistication by shunning native paintings and buying Italian and Dutch, the elite today do it the other way round, as if hanging a picture of a peasant by Yeats or a Connemara sky by Paul Henry in their sitting rooms is required to prove that they're still Irish.

"A lot of them have tried to put together an overall Irish collection across the board," agrees dealer Sean Collins. "That might sound easy but it's not, because you can search for a long time for one decent Dan O'Neill, or whatever it might be, and there could be 50 guys bidding against you. All the builders are into their pictures, the likes of the Baileys and Sean Mulryan. Mick Bailey[18] likes his cattle pictures, and animal paintings. He's a farmer at heart. A picture of a big bull would suit him."

Of the big-name collectors in Ireland, only Joe and Marie Donnelly appear to have enthusiastically embraced cutting-edge international art. Joe, a former bookmaker, and his wife, who had a brief and controversial spell as chairman of IMMA, commissioned Claudio Silvestrin, an Italian architect, to build them a gallery on Vico Road in Dalkey.[19] The exhibits there include drawings by Picasso, Matisse and Georg Baselitz, a bronze sculpture by Willem de Kooning, a stuffed headless doll by Sarah Lucas, a pair of fur-covered stilettos by Dorothy Cross,[20] and a portrait of Marie Donnelly by Francesco Clemente, an Italian. In their overseas properties, in Paris and New York, the Donnellys have furniture by Carlo Mollino and Charlotte Perriand, as well as Chinese antiquities and a Charles II mirror.[21]

But Lochlann Quinn says it is wrong to be cynical about Irish millionaires' traditional tastes. After all, the educational system left most of us visually illiterate. Art is taught properly in only a handful of schools. We've had to educate ourselves.

"A lot of people are coming to art in their late 20s, early 30s, not having been exposed to it in school," Quinn said. "They see art in other people's houses, in the odd restaurant, they see publicity in papers. I'm sure there has been a bit of trophy hunting. People saying 'ok, we've got our money, now I want a Yeats or a Lavery'. But I don't know that there's much wrong with that. If they end up liking the paintings then it's a fantastic buy for them. And as their eye gets trained and tuned in, they'll starting buying others. So if their first painting was a trophy, well, great if it triggers an interest in art which ends up giving them satisfaction for the rest of their lives.

"A lot of people say 'trophy hunting' in a sneering sense, but I wouldn't. The odd person buys a painting and has no interest and it's just there as a decoration, but I'd say they're very few."

A coterie of millionaire businessmen kick-started a boom in Irish art prices in the mid-1980s. By spending five-figure, then six-figure and finally seven-figure sums on Irish paintings, they made a splash, created headlines and emboldened the generation of buyers that came after them. In the absence of influential art critics and curators in Ireland, and because there was no powerful cabal of dealers as there was in London, these collectors' purchases helped mould the taste of a nation. If Yeats was the artist of choice of Tony O'Reilly, Michael Smurfit and John Magnier, well then he was a must-have for anybody who aspired to a decent Irish art collection.

The taste these millionaires dictated in the late 1980s and early 1990s was overwhelmingly conservative – pretty, safe pictures that would almost certainly hold their value. While some ended up on the walls of tax exiles' retreats in Geneva, Monaco and Barbados, a good proportion came back to Ireland, recovered from the international pawnshops to which an impoverished nation had consigned them.

17 He once registered a judgment against John Heather which led to the art dealer being declared bankrupt in May 2005. The judgment, registered on 2 October 2002, was for €93,078.76.
18 Property developer, racehorse owner, head of the Ward Hunt Union, and habitué of the planning tribunal, he and his brother Tom founded Bovale in 1983.
19 To which the public have a right of access, as per the terms of the planning permission. The Donnellys retain the right to refuse admission – and this writer was turned away as soon as management realised he was a journalist.
20 According to councillors from Dun Laoghaire/Rathdown who were given a guided tour.
21 Laffan op cit.

3

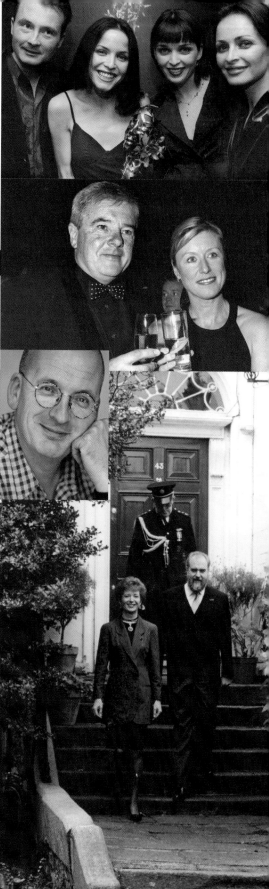

TIGER, TIGER BURNING BRIGHT...

"Nothing so undermines your financial judgment so much as the sight of your neighbour getting rich."
JP Morgan

ASK ART AUCTIONEERS TO RECALL THE FIRST half of the 1990s and they shudder. After the surge of 1989 the market entered a prolonged period of repose during which prices for all but the top Irish artists stagnated or went backwards.

The prognosis was bad from the very first sale of 1990 at Taylor de Vere's, where prices were down across the board. Bidding on Osborne's *The Bathers*, which had been given a top estimate of IR£80,000, stalled at IR£44,000 and wouldn't budge.[1] Middle-ranking artists whose prices had spiked in the late 80s were friendless.

Typical was Letitia Hamilton, whose

1 The Irish Times report.

"Overnight a conservative **theocracy** seemed to have taken a giant step towards liberalism... Meanwhile Irish musicians, artists, writers and sports stars were on a **winning streak** the likes of which the country has not seen before or since."

Far page: Neil Jordan who received an Oscar in 1993 for his screenplay of The Crying Game. The Corrs who along with Enya, Sinead O'Connor and The Cranberries were achieving enormous international success during the 1990s. John McColgan and Moya Doherty, producers of Riverdance. Booker Prize winner Roddy Doyle and Mary and Nick Robinson on the day they left their Ranelagh home for Áras an Uachtaráin.

This page: Bono and the Edge in full flight during U2's Slane concert in 2001. Bono is a keen collector and is supportive of his friend Guggi's work as well as emerging young talent Rasher.

works were making up to £30,000 a year earlier. A glut of them came on the market in 1990 and, when they could be sold, the prices were disappointing.

Irish pictures also performed poorly in London auction houses, with only Yeats's prices holding up, and Roderic O'Conor and Paul Henry just about holding on. Orpen was one of those who suffered.

Apart from the general recession on the world art market, there were special factors hurting Irish auction rooms even more. Firstly, sellers had got used to crazy prices and were insisting that auctioneers put high reserves on their pictures. Some speculators were looking to make a quick profit; they were in for an expensive disappointment.

As Robert O'Byrne wrote some years later:[2] "[In] the late 1980s...the Irish art market witnessed a surge of interest but in the recession that followed, many works lost a great deal of their worth. Particularly vulnerable were middle-ranking and prolific artists such as James Humbert Craig, Frank McKelvey and Maurice MacGonigal. Returned too quickly to the auction rooms, they often failed to find new buyers."

John de Vere White recalls: "We'd sold Dan O'Neills and McKelveys and Mildred Ann Butlers in 1989-90 for £20,000-£24,000 and then up to the mid-90s – everyone forgets this – those pictures were only £5-6,000. The thing collapsed completely. You had people coming in here with pictures that they had never taken out of the bubble wrapping, that they had bought as speculations, people with Paul Henrys that they had never unpacked. Now that's gospel. And you'd look at a picture and say to a guy 'that's worth £7,000' and he'd reply 'that's unfortunate because I bought it as an investment and paid £15,000 three years ago'. But he needed the seven.

"The only people buying pictures were dealers and things were very difficult. The market has made a huge recovery since then, but McKelvey, Hamilton, Craig – what I would call traditional painters – have never really recovered in relation to that first boom of the 80s."

One reason is that by the time the market did bounce back, tastes had matured and buyers were more inclined to buy a complex work by le Brocquy or William Scott than a safe scene of children feeding chickens.

Christie's pared back their Irish sales to two in 1991 and one in 1992. Once the market cooled, sellers became reluctant to part with their pictures and then the recession worsened because the quality of work on offer was so indifferent.

The speculators were gone, and so were the naive first-time buyers who fell in love at first sight with chocolate-box landscapes. The buyers who were left knew their stuff.

They realised, for example, that only a small proportion of Yeats's output was truly great and for a while his price structure began to make sense again. Logic and common sense were back in, romance and impulse buying were out.

Taylor de Vere's did well in December 1992, selling over 80% of 130 lots and grossing £200,000, but both they and Adam's had poor sales again at the start of 1993.

OUTSIDE OF THE SALESROOMS, SOCIAL, POLITICAL AND CULTURAL CHANGES WERE AFOOT THAT HAD nothing to do with art but which would soon put a spring back in the auctioneers' gavels. Between 1990 and 1995 a sequence of events and triumphs lifted the spirit of the nation and projected a positive international image of the country for the first time in decades. The end result was that by the mid-1990s it was fashionable to be Irish, and Dublin in particular was regarded as a "cool" place and Europe's main repository of "the craic."

The single most important event was the IRA ceasefire of August 1994. While this was broken for just over a year in 1996-97, it essentially marked the end of a terrorism campaign that had blighted the island for 25 years. The world stopped associating "Ireland" with bombings and shootings. Hundreds of thousands of people, especially Americans, who hadn't fully grasped that the Troubles were mainly in the north, overcame their fear of coming here. Several Hollywood films, including *Braveheart* and the opening sequence of *Saving Private Ryan*, were shot in Ireland even though they were set in other European countries. Anglo-Irish relations especially improved. Ordinary British people, whose lives and property had increasingly become IRA targets, looked across the Irish Sea with a good deal more affection once the bombings stopped. Some British firms realised that peace would be good for business, including a number of Fleet Street newspapers which launched Irish editions at that time.

There was plenty of "good news" for them to report, starting with the Republic of Ireland's first-ever qualification for the World Cup, in 1990. A team managed by Jack Charlton got to the quarter-finals, and returned to an ecstatic welcome from over 500,000 people. While there was an unprecedented feelgood factor at home, Irish fans proved wonderful ambassadors for the country abroad, their good cheer and exemplary behaviour being internationally praised. The experience was repeated more or less in 1994, although the team exited one round earlier and the welcome-home party was a few degrees less enthusiastic.

The other event in 1990 that sent a wave of "good news" stories about Ireland around the world was the election of Mary Robinson as the country's first woman president. Overnight a conservative theocracy seemed to have taken a giant step towards liberalism. The legali-sation of homosexuality, contraception and divorce in the following years confirmed Ireland's coming-of-age as a modern European state.

Meanwhile Irish musicians, artists, writers and sports stars were on a winning streak the likes of which the country has not seen before or since. Roddy Doyle won the Booker Prize in 1993, and Seamus Heaney was awarded the Nobel Prize for Literature two years later. There were two Irish Oscars for *My Left Foot* in 1989,[3] and another for Neil Jordan in 1993 for his screenplay of *The Crying Game*. These sandwiched an Oscar nomination for Richard Harris in *The Field*. In 1992, Brian Friel's *Dancing at Lughnasa* won a Tony Award for Best Play, after a

2 The Irish Times, 12 December 1998.
3 Brenda Fricker for best supporting actress, and Daniel Day Lewis, an honorary Irishman, won best actor for his portrayal of Christy Brown.

successful run on Broadway. That same year Michael Carruth gave the country its first gold medal at the Olympic Games in 36 years, winning the welterweight boxing division.

Irish singers other than U2 had a succession of hit singles and bestselling albums, most notably Sinead O'Connor's *Nothing Compares to You*, Enya's *Watermark* album which featured *Orinoco Flow*, The Cranberries' *Linger* and The Corrs' *Forgiven not Forgotten*. There were victories in the Eurovision Song Contest in 1992, 1993, 1994 and 1996, with the result that Ireland hosted the competition in each of the following years. In 1994, the contest was famously overshadowed by its interval act and *Riverdance* was subsequently developed by Moya Doherty and John McColgan into a full-scale show which is still touring the world. It was difficult to believe that traditional Irish dancing, a grim and joyless affair in which nothing moved above the knee, had been transformed into such exuberant and glamorous enjoyment. Implausibly, *Riverdance* made Ireland look sexy. Meanwhile a television comedy about Irish priests starring Dermot Morgan had Britain in stitches.

Those giddy years, and this series of achievements, created what is now called "the *Riverdance* effect." It helped tee up the decade of unprecedented prosperity that followed, but more importantly it changed the image of Ireland as a backward, culturally stunted and violent place to being a centre of coolness and hip. We moved from a cultural cringe to a cultural swagger. Being Irish was no longer an embarrassment – it was positively desirable, and it was notable how many famous people began to stress their Irishness. All of that positivity seeped into the art market, and by the end of the 1990s artists who had long been considered Scottish or English, the likes of Sir John Lavery, William Scott and William Crozier, were being reclassified as Irish in order to boost their prices. As Bernard Williams explains: "Even if you've got an 1888 Glasgow-Exhibition Lavery, the Irish will pay more for it than the Scots. So why not?"

Kinsale in west Cork was a particularly good vantage point from which to view these changes. Oliver Sears was an art dealer there in the 1990s. "In the beginning my operation in Kinsale relied wholly on a passing trade," he recalled. "And it was a knowledgeable, cosmopolitan passing trade. But Ireland in the mid-1990s was an incredibly fashionable place to visit on the back of the first ceasefires. There was a whole trickle-down. You may laugh, but the *Riverdance* effect was way broader than you'd imagine. People who didn't even know where Ireland was managed a connection with this phenomenon. Kinsale was booming then. Afterwards it kind of went over the hill and changed completely. I brought my business upmarket and I discovered that art lovers appear in all walks of life. The boom in art appealed to the greed of people across the board, wherever they came from."

The *Riverdance* effect was particularly noticeable in London. "Irishness became so fashionable," said Alan Hobart. "Long gone now are the days when not a week would go by without some derogatory remark [in the press] about the Irish, and the hand-outs they were getting from the EU." Hobart would eventually be invited to the audience for Bertie Ahern's speech in the House of Commons in 2007 – the crowning of Irishness in London. "It was a

Hilary Weston, Galen Weston and Alannah Weston pho-
tographed in Brown Thomas, Dublin, part of the Weston empire.
Galen drove bidding sky-high for Orpen's Portrait of Gardenia St
George with Riding Crop, which had been estimated at
£400,000-£600,000 at Sotheby's 2001 Irish Sale in London.
The painting was eventually knocked down to Guy Morrison,
acting for an anonymous American collector, for £1.8m.

great occasion and a wonderful moment for Ireland," he said. "It's like everything – you need patience."

Donald Teskey, a Limerick artist at the start of his career, was invited by a London gallery to do an exhibition in 1994. "It was when the peace process was starting to kick in, and Londoners were a bit more open to the idea of Irish artists, and towards buying Irish art," he said. "It was almost like they now had permission to say 'I actually like that'."

Sotheby's and Christie's weren't slow to pick up on the possibilities. Sotheby's, who had been putting Irish paintings into a "British and Irish" sale, was persuaded by Mark Adams[4] that it was missing an opportunity. "Christie's were holding sales in London, Dublin and Belfast and really cleaning up that market," Adams recalled.

"I was always on at Sotheby's – probably because my mother's Irish and I partly grew up in Mullingar – and lobbying to take over the Irish side, to establish it on a more autonomous basis. No-one really listened until Henry Wyndham joined as chairman in 1994. I got a lot of Irish pictures in for one sale and we took them across for exhibitions in Dublin and Belfast in 1994, which led indirectly to the Irish Sale in 1995. To an extent it was dumb luck. We could see something was happening, but we had no idea, nobody at Sotheby's had, that it was going to be this successful."

Christie's created an Irish Sale in 1996, and is still rather miffed that Sotheby's gets all the credit for the idea of selling Irish paintings in London. "[After the dip in the early 1990s] we started back up again in 1994, with a sale in Newman House, and in 1995 it was even bigger," said Bernard Williams. "It was a bit unfair – that year Sotheby's hadn't set out to have an Irish Sale; they had got this collection of pictures from Switzerland that were Irish, and they said 'let's have it'.

"But it's funny, by moving from Dublin to London, we went from having a £750,000 sale to a £2m sale. Because not only were international collectors aroused by the fact that Irish art was out there, so were our own colleagues. When Christie's had a sale in Dublin or Belfast that was run by the Glasgow office, we weren't reaching the San Francisco office. By moving it to our international centre, it awoke the whole of Christie's. Suddenly we would find a very good John Luke in Australia, Yeatses would turn up in the States. It was really a case of educating one's colleagues as well as the market."

Irish auction houses didn't particularly mind this British incursion onto their turf. "They brought more people into the market," Stuart Cole of Adam's said.[5] "More importantly they also brought more international sellers – that's where they really shone."

Both auction houses scoured America, Canada and Australia for Irish art to sell. "I put in a lot of effort finding pictures in the States," said Adams. "There was a phenomenon in the

4 Born in 1966, Adams has an MA in History of Art and joined Sotheby's in 1989. He left in 2000, to join Agnew's as director of contemporary art, and in 2002 set up his own dealership, Mark Adams Fine Art.
5 Quoted in the Sunday Business Post.
6 Artdaily.org

mid-part of the 20th century of people who had made it good over there coming back to visit their families and they would buy a picture from someone like Victor Waddington as a souvenir. A lot of Paul Henrys went back, and Yeats, traditional Irish stuff. These people were buying almost as a gesture of cultural support. And in the late 1990s we got a lot of this work out of America. Their children, who were American-Irish at that stage rather than Irish-American, were happy to sell those pictures, which meant nothing to them."

Williams says there is very good Irish art in America to this day, especially Laverys from the time of his exhibition in Philadelphia. "I found one in Las Vegas last year. So it's worth sourcing from over there," he said. "We get a few things from continental Europe. Lavery had a big exhibition at the Venice Biennale in 1911, showed 70-odd pictures, so there's a few of them around."

These Laverys were just as likely to be put into Christie's Scottish sale, however. When they found *The Goose Girls* in south-west Scotland, it was auctioned in Edinburgh in October 2004.[6] A Lavery painting of a golf links in North Berwick was unsold in a Scottish sale in 2000 and rejected again by buyers at the Irish Sale in 2001.

Many of the bidders at the Irish Sales were dealers from Dublin, Belfast and Cork, some of whom managed, particularly in the early years, to turn a quick profit by buying paintings, reframing them, adding a 25% margin or more, and selling them onto Irish clients. This practice continues, although collectors' use of the internet nowadays means transactions are more transparent. Over a decade after they were launched, however, up to 80% of the buyers at the Sotheby's and Christie's sales in May are still Irish.

In the 19th century, aristocratic Irish families brought their debutante daughters over for the London Season, a round of social, artistic and charity engagements including dances and dinners. Now a group of well-heeled collectors and a cabal of powerful dealers make the annual pilgrimage each May to London for an Irish Season, around which a lively round of social events has sprung. "Some collectors go over and make one purchase just to be part of the scene," says one participant. "There's a lot of boozy lunches. It's like an art Cheltenham." The theme is taken up by several Bond Street galleries who put Irish paintings in their windows for the week.

In creating these sales, Sotheby's and Christie's were hoping that international buyers would emerge to take on the big Irish names, and that these cosmopolitan collectors would extend the Irish range well beyond a small handful of artists. "At that stage Tony O'Reilly was still in the market, just. He was about to get out and become more international," said Adams. "The Magniers were still buying hard. Barney Eastwood [a boxing promoter and bookmaker] was buying a lot, but a bit more cannily than the southerners. But it was very much that first generation of seriously rich guys who everyone was following and everyone was talking about. The pace was set by them. They were conservative – it was the art you would expect them to buy. You could easily buy Louis le Brocquy at that stage – I can remember in 1993 being

LETITIA MARION HAMILTON

BORN: 1878, DUNBOYNE CO. MEATH

DIED: 1964

PAINTING STYLE: LANDSCAPES, USING THICK IMPASTO

HIGHEST PRICE AT AUCTION: £33,600 (SOTHEBY'S, 2004)

FANS SAY: A TALENTED OBSERVER AND SYMPATHETIC PORTRAYER OF THE IRISH LANDSCAPE

CRITICS SAY: A PREDILECTION FOR THE MOST SUGARY TONES AND A SUPER-ABUNDANCE OF WHITE INEVITABLY SUGGEST THE CONFECTIONER'S

IF YOU COULD OWN ONE: SLIEVE DONARD, CO DOWN, C. 1935

BEST EXAMPLE ON PUBLIC DISPLAY: SNOW IN CO. DOWN (DUBLIN CITY GALLERY, THE HUGH LANE)

€19,000
2008

The Hamiltons, a Protestant family, were landed gentry of military disposition who lived at Hamwood House near Dunboyne, Co Meath. Letitia was a cousin of Rose Barton, a talented watercolourist. She and older sister Eva were educated at Alexandra College, and then studied under William Orpen at the Metropolitan School of Art in Dublin. Letitia then travelled to Belgium for further study under Frank Brangwyn and to the Slade School of Fine Art in London. On her return to Ireland she founded, with Paul Henry, the Dublin Painters Group in 1920. Two years later she exhibited at the prestigious Irish exhibition in Paris.

Having received the best art education available at the start of the 20th century, Letitia Hamilton then had the means to travel extensively throughout Europe. She visited the continent every year and kept a studio in Venice. Like Eva, and several other prominent Irish women artists of the time, she never married. Letitia created many European landscapes, including scenes of Venice, but her best paintings were of rural Ireland. Her later work was notable for use of

thick impasto and the palette knife. While her bright colours, especially pink and white, led some critics to dismiss Hamilton as a lightweight, among her supporters was Victor Waddington, the leading Dublin art dealer, who exhibited her work alongside Jack Yeats, Dan O'Neill and Gerard Dillon.

From 1947, she lived in modest circumstances at Woodville in Lucan, Co Dublin, which features in several of her later paintings.

She and her sisters kept paying guests in order to help make ends meet. She signed her paintings LMH.

really pleased if I could see a Louis "head"[7] for £4,000-£5,000. Even Louis was too far ahead of the game for them.

"So I was chasing the idea of the Irish-American collector. There were 40m Irish Americans, and with the exception of one or two – like Brian Burns and Fred Krehbiel – there were no significant Irish-American collectors of 20th century work. They were not buying on the scale that we always dreamed of, not on the gold-rush scale. We had hoped that here would be the guys who would challenge Magnier."

So before the Irish Sale, Sotheby's would exhibit the paintings in New York and Boston as well as in Ireland, but their dream was never realised. "The Irish Americans I met were more sentimental about the idea of Ireland than informed about it," said Adams. "They had an emotional rather than an intellectual interest. And up against the likes of Lochlann Quinn, that sort of wishy-washy feeling for Ireland was never going to..." Translate into hard cash.

Christie's says it did manage to extend the palate for Irish art, but not by much. It also found that the billionaire Irish-American collector prepared to pay silly money for Irish pictures was a myth. "There's about three of them," said Williams. "When we take things to New York to show, we could view for one day because the amount of Irish Americans who buy Irish art is very, very few and usually they have got an agent in London anyway. So there isn't this huge wealth of American money.

"A lot of the Irish Americans are pretty ill-educated people. They'll come back and buy a tea towel, not a Paul Henry. So there isn't this huge bank of buyers there that we can rely on for our Irish Sale, and we've tried. Once we even thought about holding an Irish sale in New York. But it isn't going to happen. Brian Burns did buy well, but doesn't any more. He's a great self-publicist."

Burns, a San Francisco lawyer and chairman of BF Enterprises, is the grandson of immigrants from Kerry. Over two decades he has amassed a typical Irish millionaire collection of 150 or more paintings, including lots of Yeats and Osborne, a few Orpens and Laverys, a Paul Henry, a Mary Swanzy, some portraits of horses. For a while Burns was the Irish-American collector from central casting: "I used to think I had to find somebody digging peat with a slane to prove that [the picture] was Irish," he told *Forbes* magazine. "My narrow view caused me to overlook some fabulous paintings by Irish artists of European scenes." His collection is spread among three houses in Palm Beach, Lake Tahoe and San Francisco, and a selection has toured America and visited Dublin.

By the time the Irish Sales got going, Burns' buying was done. Not so Peter Lynch of Fidelity Mutual, at one time America's largest and most successful stock fund. Lynch's best-known buying principle was "invest in what you know", and he put it to good use in purchasing Yeats's *A Farewell to Mayo* for a record £804,500 at Sotheby's in 1996.[8] The provenance alone would have added a zero to the price: the painting had been bought in 1942 by Laurence Olivier for his wife, Vivien Leigh.[9] This was the most striking success from Sotheby's policy of bringing

the highlights of its Irish Sale on tour to New York and Boston. "*A Farewell to Mayo* was bought by a guy in Boston whom none of us had ever heard of – but who saw it in Boston," said Mark Adams. "So we did get the occasional buyer out of it."

Another ex-patriate buyer was Galen Weston, a Canadian businessman who is ranked 59th richest in the world,[10] and is married to a former Dublin model, Hilary Frayne. He was involved in one of the most exciting battles ever seen at an Irish Sale – in Sotheby's in 2001 – for Orpen's *Portrait of Gardenia St George with Riding Crop*. It had been estimated at £400,000-£600,000, but the bidding soon went over £1m. Unusually for a mega-rich collector, Weston was in the room and bidding himself, with Hilary by his side. He had flown in especially from Toronto that morning. He was up against an anonymous American private collector, on whose behalf Guy Morrison, John Magnier's dealer of choice, was bidding on the telephone.

"Weston pulled out at £1,050,000, before changing his mind and re-entering the contest," reported *The Daily Telegraph*.[11] "Yet, with a rueful smile, he finally conceded defeat at £1.8m leaving the American with a bill of £1,983,500 once Sotheby's had added its commission." It remains a record for any Irish painting. Sotheby's were laughing all the way to the bank, having earned more than £180,000 for what amounted to a few minutes' work.[12]

In its first year, Sotheby's Irish Sale raised £3,606, 868,[13] and 85% of the lots were sold. Six paintings made over £100,000 with the best price fetched by Yeats's *My Dark Rosaleen*, which had been estimated at £100,000-£150,000 but made £496,500. "Irish art has taken its place in the world market," a delighted Mark Adams said afterwards. The 1996 sale was even stronger, grossing £4.2m for 417 lots. A Lavery fetched £166,500, Yeats's *Leaving the Raft* went for £661,500 (twenty times what it had fetched exactly 10 years earlier) and a new record was set for Mary Swanzy – £69,700 sterling – more than three times the IR£22,000 it had been. It was at this sale that Peter Lynch bought *A Farewell to Mayo*.

In 1997, Sotheby's total nudged up to £4.7m, with 100 fewer lots. Its 1998 sale featured Yeats's *Singing 'Oh Had I the wings of a Swallow'*, which an auction house ad boasted afterwards went for IR£1,007,500. You can see why, for once, they converted the sale price into punts. Christie's totals in its first two years were more modest – about £1.5m each – showing that Sotheby's had the benefit of first-mover advantage. But the world's biggest auction house caught up in 1998 with a bumper sale, grossing £4.3m including £870,500 for Yeats's *The*

7 Le Brocquy's Heads, of which more anon, were a series of portraits of the likes of William Butler Yeats and James Joyce. They are often lazily called "iconic". Most critics feel that le Brocquy should have stopped the series much earlier, with Bono of U2 certainly being a head too far.
8 Daily Telegraph 1 June 1998 credits him as the purchaser.
9 The Irish Times, 28 December 1996.
10 by Forbes.
11 28 May 2001.
12 At that time, Sotheby's charged 15% on the first $50,000 and 10% thereafter.
13 As with all Sotheby figures, this includes the buyer's premium, then 15% on lots sold for $50,000 or less. On lots of higher value, 15% was charged on the first $50,000 and then 10%. After February 2000, the premium was increased to 20% of the hammer price on the first $15,000, 15% on the next $85,000 up to $100,000, and 10% above $100,000. This was simplified in 2003 to 19.5% on prices up to $100,000 and 10% above, and in 2003 the percentages were increased to 20% and 12% respectively. In 2007 the rates were jacked up again, and there was a further increase on 1 June 2008, with buyers paying 25% on the first $50,000 followed by 20% of the value up to $1m and 12% thereafter.

Proud Galloper, the second highest price the artist had obtained to that point.

All of this acted like an electric shock on the prone and comatose body of the Irish art market, which by 1996 was sitting up and looking in rude good health again. The market worldwide was also recovering. The International Art 100 Index shot up 8% in the first nine months of 1996, with French Impressionists up 18% and Old Masters 29%. Keeping stride was 20th-century Irish painting, up 26%, a far healthier performance than markets in any other European country.[14] Records were tumbling again – Paul Henry up to £166,500 from the IR£68,000 which had been set in 1990, for example. Gerard Dillon went from IR23,000 in 1995 to £89,500 at Sotheby's three years later. Leech septupled in price, Lavery quintupled, Dan O'Neill more than trebled, Orpen more than doubled.[15]

It wasn't just paintings either. Irish silver at Sotheby's and Christie's was also being knocked down for record prices. "If you took away the Irish connection, prices might be a tenth of what they reach," Peter Waldron, senior director of the silver department at Sotheby's, commented at the time.[16]

Irish auctioneers were also setting records, but not on the London scale. Prices fetched in Dublin for the likes of Paul Henry were invariably surpassed within a year by the Big Two. A good auction in Ireland at the time grossed IR£1m. At its summer sale in 1997, for example, Adam's in conjunction with Bonham's of London managed IR£750,000. Buyers were still sticking with established, dead artists rather than taking a punt on contemporary ones. The most popular artist at Adam's in 1998, for example, was Mildred Anne Butler (a painter from Kilkenny who died in 1941) with 21 works sold. She was followed by McKelvey, MacGonigal and Edwin Hayes (a Dublin-born watercolourist who died in 1904). Frank Egginton, a British painter who died in 1990 and who specialised in traditional Irish landscapes, was the closest that buyers got to something modern.[17]

Another feature of the Dublin sales was the dearth of top quality Yeats, Osborne, Leech, Lavery, Orpen and O'Conor, which were all being sold privately or in London. In the absence of these luminaries, the money percolated down to a second tier of painters – the likes of William Conor, Percy French, Harry Kernoff and Dan O'Neill – whose prices began to take off. Many of the top works from the first half of the 20th century had already found permanent homes, either in museums or in the collections of multi-millionaires, forcing wealthy buyers to lower their sights. But what was noticeable by the end of the 1990s was the huge increase in the number of such wealthy buyers entering the market, buyers for whom high price tags were no deterrent. By now the Celtic Tiger was roaring, and they were riding on its back.

WHILE THOUSANDS OF BUSINESSMEN AND PROPERTY DEVELOPERS MADE VAST FORTUNES IN THE economic boom of 1994-2006, the effect on most ordinary people was a surge in their standard of living. They could now indulge in the finer things in life, and whenever the consumer boom looked like flagging, banks and credit card companies were only too pleased

to hand out virtually unlimited credit and 120% mortgages to get it back up to speed. The sharpness of the recession that people had endured in the 1980s and early 1990s added bite to the bonanza of consumer spending. Was it any wonder that we behaved like a bunch of starving tenants who had finally been invited up to the Big House for a feast?

The engine of the boom was employment. In 1983, about 1.2m people in Ireland had jobs and 16% of the labour force hadn't. By 2004, there over 1.8m people at work and unemployment was below 5%.[18] While some of the new workers were foreigners, a high percentage was women: female employment almost doubled in a decade. And most of these were "good jobs". The sector of the workforce that expanded the most was "professionals", followed by what are described as "associate professional and technical" staff. With skill shortages in many areas, the average employee earned a lot more. "Compensation per employee and earnings before deductions increased in Ireland by almost 36% between 1999 and 2004, a substantially faster rate of growth than in most other countries," the National Competitiveness Council reported in 2005.[19] By the end of it, Irish pay rates had caught up with the rest of Europe's, and workers were been paid on a par with their counterparts in Britain, Germany and France.

As with the art boom, the surge in property prices was merely an Irish take on a world-wide phenomenon. It's just that the figures were more startling and coming from a very low base. House prices in Ireland had fallen in real terms throughout the 1980s. Over the period of the boom, new-house prices increased four-fold and second-hand houses almost five-fold.

The year it really went crazy was 1998, when prices went up 31%. The flagship sale of the boom was in that year – Sorrento House in Dalkey, an elegant end-of-terrace four-storey house on two acres of headland with 180-degree views of Killiney Bay was bought for IR£5.9m by Terry Coleman, a mobile-phone millionaire.

It was the highest price ever paid at auction for a house in Dublin, and was paid even though the property was in need of extensive refurbishment.[20]

The laws of supply and demand tell us that Irish house prices must have soared because there was a shortage. True, and all the more surprising given the sheer number of houses that were built in Ireland over the 12 years of the boom. Once again we were coming from a low base: fewer than 20,000 houses had been built in 1988, for example. In 2006, at the height of the housing boom (as it would prove to be with the art boom) some 88,000 new dwellings were built. "This is an extraordinary output performance for any country outside of wartime reconstruction conditions," marvelled commentators Tony Fahey and David Duffy.[21] "It is

14 The Art Newspaper, 1/10/1996.
15 Compiled with the help of Irish Arts Review 1999.
16 The Times, 8 July 2000.
17 The Irish Times, 3 April 1999.
18 CSO, Labour Force Survey.
19 Quoted in "Employment and the Quality of Work", by Philip J O'Connell and Helen Russell, an essay in Best of Times? The social impact of the Celtic Tiger (IPA, 2007).
20 The Irish Times, 28 September 2006.
21 Taken from "The Housing Boom" an essay in Best of Times? op. cit.

around four times the output per head of population of most countries today...."

Not only were there lots more houses and apartments, there were far bigger ones. Only about 42,000 houses in the country had seven rooms or more in 1971, but by 2006 that number was over 200,000. This was very good news for anyone selling art. Paintings hang on walls, and the more walls there are, the more paintings will be sold. Consider the 88,000 new dwellings built in 2006. Imagine that they have, on average, five rooms each, and therefore 20 walls. That's 1.76m more walls in Ireland. To continue this back-of-the-envelope calculation, let us imagine that only one in every 25 of these households buys paintings, and assume that they buy two each. That means in 2006 alone, a market for an additional 7,040 paintings and artworks was created. Was it any wonder that auction houses and galleries were springing up around Ireland quicker than mushrooms on a wet day?

As well as the 300% increase in the number of houses in Ireland, thousands of foreign properties were purchased. The exact number of houses that Irish people have bought overseas is unknown, for tax reasons. One educated guess is 60,000 foreign properties worth €5.5 billion.[22] Reaching for the back of the envelope again, if we were to assume that one in ten of these more affluent owners decided to hang Irish landscapes on the walls of their Spanish, French or Floridian properties in order to remind themselves of home, and each bought two pieces, we have a market for another 12,000 paintings.

Of course art wasn't top of the shopping list when Irish people became rich. Cars were. By 2006, there was a car for every two people over the age of 15 in the state, a total of 2.3m vehicles, three-quarters of them private.[23] Big, flash cars were especially popular. A wealth report from National Irish Bank published at the beginning of 2008 reckoned "there are more Mercedes cars per head in Ireland than in their native Germany." The use of calendar years in the registration number was undoubtedly a contributory factor – there is no easier way of telling your neighbours, friends and work colleagues that you are on the economic pig's back than by purchasing an 08 or 09 car in the first six weeks of the year. Such a social statement reaches a far wider audience than a Yeats or a le Brocquy over the mantelpiece.

Next on the shopping list was holidays, and the growth in foreign travel over the period of the Celtic Tiger was quite extraordinary. With over 300 flights a day from eight Irish airports providing 45,000 seats to 140 different cities, not just one but two family holidays a year became the norm for some. In 2006, there were 6m visits overseas by Irish people – well above an average of one each.

Saving became passé, to the point where Charlie McCreevy as finance minister had to offer hefty bribes to Irish people in 2001 and 2002 to encourage them to start putting something aside. Irish banks and credit card companies stoked the consumer boom, trebling their lending to private households from €39 billion in 2000 to €134 billion in 2006.[24] With money so easily available, it was hardly surprising that much of it was spent foolishly. Gambling became almost the national pastime – with an estimated €3.6 billion wagered in 2006. Robin

Williams, an American actor, famously noted that "cocaine is God's way of saying that you're making too much money." Irish people were clearly making far too much – moving into the top five of the European league for cocaine use, according to an EU report published late in 2007.[25]

Some spending was criminal; some of it was criminally insane. Hermes, one of the most desirable labels in the world, opened an outlet in Brown Thomas on Dublin's Wicklow Street in 2005 and soon there was a waiting list for its Kelly bag, made famous by Princess Grace, even though it cost up to €10,000 if you wanted the version with ostrich feathers. The cheapest product in the Hermes store was a frilly scarf that could only be worn around the wrist or tied to a bag – the price was €89.[26]

While the ladies were buying Louis Vuitton and Chanel watches, the lads were buying Aston Martins and private aircraft. Property developers – and many of the nouveau riche had links to the land – can always justify buying private planes on the basis that they need to get an aerial view of their assets. In reality, most don't want the hassle of finding parking for their Porsches at the Galway Races. Officially, there were 140 helicopters in Ireland at the end of 2006, with 40 of these registered for the first time that year.[27] But the real figure was much higher, because many construction tycoons registered their aircraft in Britain. Five pilot training courses were needed to keep up with the demand.

One of these aircraft was put to artistic use in April 2007. Tennant's auctioneers in North Yorkshire were selling the contents of three estates, and among the lots was a Sean Keating painting entitled *Ulysses of Connemara*, which was estimated at £30,000-£50,000 sterling. This depicted a group of people in the west of Ireland watching an emigrant ship sailing away to America. Perhaps it was the sentimentality of this 1952 image, the visual reminder of how their forebears had been driven out of the country by poverty, that fired up some Irish businessmen.

The Tennant's auction centre in Leyburn "was buzzing with anticipation and excitement throughout the two-day sale", its website reported afterwards. "It attracted bidders from far and wide, including a group of buyers from Ireland, some of whom arrived by helicopter." Between them they bid up the Keating to a preposterous £400,000 sterling. "It sold to a determined Irish gentleman who stood in the central aisle throughout the gripping bidding process," Tennant's reported. "He will be taking the picture back to its homeland."

The work of Sean Keating (1889-1977), a Limerick artist, was exactly what you would expect newly enriched construction or property tycoons to get soppy about. A traditional

22 Research by Datamonitor and OP Knowledge.
23 CSO transport figures for 2006.
24 Quoted in The Irish Times, 20 November 2007.
25 The European Monitoring Centre for Drugs and Drug Addiction. Its report found that 2% of the population had used cocaine in the last year, the fifth highest rate in Europe.
26 Sunday Business Post, 17 April 2005.
27 Figures from the Irish Aviation Authority.

Portrait of the artist

WALTER FREDERICK OSBORNE

BORN: 1859, DUBLIN

DIED: 1903

PAINTING STYLE: IMPRESSIONIST

RECORD PRICE AT AUCTION: €825,330

FANS SAY: NO IRISH ARTIST HAS EVER PORTRAYED CHILDREN SO WELL OR WITH SUCH AFFECTION

CRITICS SAY: TOO CONSERVATIVE TO BE REGARDED AS A TRUE IMPRESSIONIST

IF YOU COULD OWN ONE: THE INTRUDER, 1883

BEST WORK ON PUBLIC DISPLAY: APPLE GATHERING, QUIMPERLE, 1883 (NATIONAL GALLERY OF IRELAND, RIGHT)

The second son of William Osborne, an animal painter, Walter was educated in Rathmines before studying at the Metropolitan School of Art. He travelled to Antwerp after winning a scholarship, studying under another animal painter, Charles Verlat, and then to Brittany, which was even then popular with artists who liked to work outdoors.

He painted many classic Breton scenes including farmyards, markets and orchards. He then spent several years in England, painting its people and countryside, working outdoors, living from hand to mouth, and travelling to the Suffolk coast and counties like Oxfordshire and Hampshire.

Some of his best work was done in England, and as a result he has built up a large following there. He spent the winter months in Dublin, exhibiting paintings each year at the RHA. In the 1890s he settled permanently in Dublin and soon afterwards painted an important series of paintings set around St Patrick's Cathedral.

He opened a studio at 7 St Stephen's Green, and among his students at the time was William Leech. He continued to paint "en plein air" around the capital, and using a noticeably lighter palette, but found it difficult to sell such works so he switched, as so many painters of his generation did, to more lucrative portraits. He received commissions mostly from members of the Irish establishment – lawyers, clergy, bankers, society ladies posing with their children.

As with Lavery and Orpen, his portraits were the weakest part of his oeuvre although he won a bronze medal at the Exposition Universelle in 1900 for his portrait of Mrs Noel Guinness and her daughter.

Osborne turned down a knighthood in 1900 and died, unmarried, at the age of just 43 of pneumonia, his final work Tea in the Garden remaining unfinished.

It is a beautiful combination of naturalism and impressionism, and a nagging reminder of what Irish art lost when Osborne was cut off in his prime. By a bitter irony, it was probably the fact that he had spent so long outdoors painting that eventually cost him his life. "His passing deprived Ireland of a great painter just as he was beginning to explore a freer style that seemed to give fuller expression to his talent," critic Cristin Leach has written.

At an RHA retrospective held shortly after Osborne's death, Sir Hugh Lane bought three works by the artist, including Tea in the Garden. They cost the collector just £60, and formed the basis of the Dublin Municipal Gallery's impressive collection of the painter's work.

Osborne, who helped bring up his niece after her mother (his sister) died in childbirth in Canada, was superb at depicting children in a warm and sympathetic way. Most of his greatest work feature babies or children, such as The Tempting Bait (1882), in which a young boy teases a dog with a juicy morsel from his plate.

painter and an ardent nationalist, Keating glamorised Irish rebels in the War of Independence in such works as *The Men of the South*,[28] which shows a group of IRA men about to ambush a lorry. He also sentimentalised the people of the Aran Islands in a series of cloying and clichéd images. After Irish independence, his reward was a series of official commissions, the most important of which was to record the ESB's development of the hydro-electric scheme on the Shannon between 1926 and 1929. Keating, effectively a propagandist for the Irish Free State, depicted the work as an heroic, almost mythological, project.

Keating's previous record was about a third of the price paid at Tennant's – the €190,000 achieved by Adam's for *Men of Aran* in 2005. Within a few months *Ulysses of Connemara* was in the window of the Apollo Gallery on Dublin's Dawson Street, with an asking price of €1.6m, although that was "negotiable."[29] Its new owner, a gentleman from the racing fraternity, may have thought he could turn a fast buck by flipping the Keating. But the days when you could double the price of a painting simply by transporting it across the Irish Sea are over, thanks to the internet, and many Dublin dealers are out of pocket or out of business as a result.

Property and art are natural bedfellows, and developers have always been credited with having "a good eye" for a picture. As well as owning Maybachs, Beechcraft and racehorses, the leading developers of the boom, the likes of Johnny Ronan, Sean Mulryan and Derek Quinlan, amassed valuable art collections too. In the late 1990s and early 00s, developers and builders elbowed their way into the auction rooms, barging past the professionals – doctors, accountants and lawyers – who found their buying power declining in relative terms.

"At the top end of the scale you're definitely looking at the property business – builders and speculators, property moguls," said auctioneer Ian Whyte. "Builders seem to have a great visual sense. They know what they like and they are not easily influenced. At the top end they are not quite as adventurous [in terms of price] as their predecessors. Maybe they are starting to be; the Sean Keating auction in Yorkshire being an example. It's a little quieter than that in Dublin, but there is competition, sometimes on smaller pictures – the €20-30,000s. Sometimes they are bid up to €50,000-70,000. Two guys really want it and they don't care what they pay for it. We call it a spike, where a particular artist goes for much more than usual. The Norah McGuinness painting sold at Adam's that was supposed to get 30/40 thousand and went for 210 is an example. I don't think she's reached anything near that since."

It wasn't only property developers who became rich during the economic boom, of course. Bank of Ireland has estimated that there are now 30,000 euro millionaires, up from a few hundred in the 1980s.[30] Throughout the late 90s and in the 00s the Irish upper middle class expanded enormously. These people were far better educated than their grandparents and

28 In the collection of the Crawford Gallery in Cork.
29 According to Hugh Charlton.
30 Mentioned in "Lucre of the Irish", an article by John Murray Brown in Prospect magazine, January 2008.
31 Born in 1921 in Rathdrum, Co Wicklow, King was a successful businessman who took up painting in his mid-30s and had his first solo exhibition at the age of 38. He was a founder organiser of Rosc, whose influence is credited with pushing his work towards abstraction. King was the subject of a retrospective in the Hugh Lane Gallery in 1981 and died five years later.

parents, for whom the Inter Cert and then the Leaving Cert had been career launching-pads. An arts degree in UCD became the new educational entry level. Between 2002 and 2006 alone, the number of third-level graduates grew by almost 200,000, to 830,000.

Higher levels of education created not just an interest in art, but in more contemporary and cutting-edge works. "We have an educated population now who travel and see things, and who have the confidence to trust their own eyes," said Antoinette Murphy of the Pepper-canister Gallery. "And houses and apartments have changed too. There are more apartments than ever, and their lay-out demands a different type of artwork. The interiors tend to be very plain – in the past you might have had the walls decorated with flowery wallpaper."

In the past the trophies displayed in houses were furniture and silver – grand pianos, sideboards of trinkets, enormous gilded mirrors over the mantelpiece. No longer. "The demand now for furniture is very small," said Brian Coyle of Adam's. "People have gone off the idea of buying old furniture. There's a taste for minimalism, which in turn has probably brought in a taste for abstract art. Artists like Cecil King[31] fit in more with modern apartments than they would with a Victorian house in Clyde Road, say. It's cheaper to buy older furniture than modern, but modern fits in better with the current taste, which is more Scandinavian in character."

Once they had bought the apartment, the car and the house in Spain, the newly wealthy cubs of the Celtic Tiger piled into the art market. But this was quite a different world from what they were used to. Here, things were done and sold differently. It wasn't like going to Brown Thomas or to an overseas property exhibition in the RDS. Some of the leading art galleries in Dublin were snooty and looked down their noses at new money. The main auction houses – de Vere's, Adam's and Mealy's of Castlecomer – did business in an old-fashioned way. Their clients wore Crombie coats and reeked of Protestant or professional money. The business of selling paintings was opaque and mysterious, a nod and wink world inhabited by cunning dealers who looked like they'd steal the milk out of your tea. Auction catalogues still gave minimal information. In short, these art auctions seemed to be for and about other people, not the dotcom generation, even though it badly wanted to buy.

You didn't need an MBA from Harvard to know that this represented a glorious business opportunity; to realise that the staid world of Irish art auctioneers was ripe for plunder. Up to the late 1990s, Sotheby's and Christie's had "had it their own way," admits Bernard Williams. "The only competition we really had was Adam's, who wouldn't leave St Stephen's Green to find a picture. That's why we'd won so many house sales; Adam's wouldn't have on-the-premises sales because it was too much like hard work. They sat there because it just automatically came into them."

At the start of the new century the Irish auctioneering establishment got a rude awakening. There was a demand, a need, for art to be sold in Dublin in retail style.

The hour had come – so had the man.

4

HAMMER AND TONGS

"It is only an auctioneer who can equally and impartially admire all schools of art."
Oscar Wilde

TALL, BESPECTACLED, URBANE – IAN WHYTE is every inch the salesman. He speaks in a quiet, reassuring voice; he smiles easily; and he is courteous and patient, always willing to take time out to share the news and gossip of the Irish art world. Along with the politeness and the charm comes the occasional flash of steel, a hint of toughness.

This is almost reassuring, because you do need a visual clue to confirm that it was this soft-spoken businessman who, from a standing start in the year 2000, became the biggest selling art auctioneer in Ireland within four years; that here is someone who

€180,000
2006

Above: Ian Whyte of Whyte's Auctioneers: Right: Cubist Landscape with Red Pagoda and Bridge, by Mary Swanzy, circa 1926-28, sold by Whyte's for €180,000 in 2006.

IMAGE COURTESY OF WHYTE'S © ESTATE OF MARY SWANZY

was trading in stamps, coins, postcards and telephone cards at the end of the 1990s and then out-sold Adam's, with its century-long tradition and all its well-heeled clients and its premier position on St Stephen's Green, beat the oldest and best-resourced auction house on its home turf – paintings – in both 2004 and 2005.

So how did that happen? Consider, first, what John de Vere White replies when you ask him how he sources paintings for his auctions. "I don't know what other people do, but we do absolutely nothing," Buzzer says in that characteristic booming voice of his.

"We try to look after our clients well. It's a word-of-mouth business. We've been here 25 years and that means something – you get the odd picture back to sell that you sold 15 years ago. I know that some of our competitors are far more aggressive in hunting down business than we are. We do not knock on people's doors and say 'have you anything to sell?' or 'this is a very good time to sell'. We simply don't do it. There is a huge element of luck in it, and we sit here."

To demonstrate how much luck is involved, he tells you about getting a phone call from a woman in Madrid in the spring of 2007. Someone had given her de Vere White's name, someone the auctioneer barely knows, and she had three paintings by Louis le Brocquy that her husband had bought directly from the artist and she wanted to sell.

"She thought about Sotheby's and Christie's and this good friend of hers, that I vaguely know, sent her to us." So Buzzer despatched his assistant, Rory Guthrie, to Madrid next day and the woman handed him the three le Brocquys. Guthrie binned the rotten frames at the airport, and flew back. The paintings were late entries in de Vere's sale that summer, and sold for a total of €250,000, representing a commission of almost €40,000 for the firm. "That's a prime example of the luck involved in this business," Buzzer marvels.

Shortly after Christmas of 2006, he got another phone call – this time from London. The caller had a friend who'd met Buzzer in Kenya. He was thinking of selling an Orpen, he'd like de Vere's to have it. Turned out to be a portrait of Vera Hone from the *Angler Series*, titled *The Blue Hat*. De Vere's had the centrepiece for its summer sale in 2007, and ended up inviting in the RTE cameras to film the bidding go to €500,000. Moral of the story: "If someone leaves in a picture for you to sell and everything goes well and then a relative is selling, they send them to you." De Vere White concludes: "There's a lot of luck in it."

Now this model works well for a businessman with the sort of contacts book that Buzzer has, someone who counts millionaires like Lochlann Quinn among his golfing buddies. While Buzzer is at base, filling up his auctions on phone calls and word-of-mouth, Ian Whyte and his staff are scouring Northern Ireland, Britain, Europe and even America for pictures.

They've visited France, Belgium, Italy, Germany and Switzerland. Buzzer can sit waiting for the apples to fall into his lap, but Ian Whyte must go into the orchard and shake the trees. And when shaking doesn't produce tasty enough fruit, he climbs up and snaps the apples from their stems.

WHYTE'S SINCE 1783, THE LETTERHEAD SAYS. HIS FAMILY WERE GLASS AND CHINA MERCHANTS WHO operated from various city centre addresses including Marlborough Street and South Great George's Street.[1] Demand for china and glass had tapered off by the time Ian Whyte entered the family business in the early 1970s, and he had to change the firm's direction towards "small collectables", stamps and coins, but also football programmes, medals, bank notes, old books and film posters. He became a licensed auctioneer in 1975 and began to hold public auctions at the firm's premises in Marlborough Street. A lot of it was nickel and dime stuff, quite literally. Sometimes two staff were needed to answer the phones, because the public was ringing in all day every day wondering about the value of this coin or that stamp. The vast majority of their stuff was worthless. Whyte's lost count of the amount of 1916 Proclamations they were offered that were not the real thing.[2]

Customers would come in with "stamp collections" to be valued. The first thing Ian Whyte would ask them was: "How much have you spent on it?"[3] And they'd look at him blankly. What did he mean, 'spent on it'? They hadn't spent anything on it. They'd torn the stamps off letters for years and put them in an album – weren't they worth something? "Well, you know, you're hardly going to find anything of use in there," Whyte would tell them. "A collection of stamps you got for nothing…they're unlikely ever to be worth anything."

Even with items of genuine worth, you were talking small beer. Football programmes from the 1930s were "the cream", but that meant they were worth about IR£400 in the 1990s. A programme from Ireland v Germany in 1936 which had a Nazi swastika on it was sold by Whyte's for about IR£300. Those from the 1940s and 50s made between £10 and £20. The programme from the match on Bloody Sunday in 1920 – perhaps the most historic game ever played at Croke Park – was worth about £1,000. Tickets to that game were worth less. All-Ireland medals – "the ultimate collectable of GAA memorabilia"[4] – fetched between £500 and £1,500. And the surprising thing was the more recent the medal, the more valuable it tended to be. All-Ireland medals that were a century old were worth about £700. Programmes from GAA games in the 1940s made about £100. No-one was going to become a millionaire trading in this stuff.

For a year or two in the 1990s it looked like telephone cards might become lucrative. A trial telephone card had been issued for an Irish Management Institute conference in Killarney in 1989, and two of them were sold in the late 1990s for £1,000. Another one got £1,300. But this boom proved to be ephemeral – the popularity of telephone cards was about as enduring as Rubik's Cube. Soon collectors weren't even making their money back on cards – they ended up having to sell them off for about half the face value.

1 Some autobiographical information is taken from "Under the hammer – collecting at auction in Ireland" by Whyte's colleague, Jane Eckett, in Circa art magazine, 108, Summer 2004.
2 Mentioned in a Sunday Tribune profile, 11 May 2003.
3 Interview with The Irish Times, 11 February 2000.
4 Ian Whyte in The Irish Times, 5 February 1999.

Not that the business didn't have its good days. One collection of stamps realised about £100,000 when it was auctioned by Whyte's in February 2000 – even though that was "millions of stamps in 320 albums collected over a lifetime."[5] An auction of Irish tokens once made about £35,000 – the biggest collection every sold. A sale of cigarette cards in 1996 made £150,000 – a world record at the time. Then there was the rare archive newsreel footage of the aftermath of the 1916 Rising, the War of Independence and Bloody Sunday, which sold for £95,000 at Whyte's in June 2000. Even that was a slightly disappointing price, because "overseas bidders [had been] discouraged by talk of the film being given to the state."[6]

By the end of the 1990s, the supply of "small collectables" was drying up. It was becoming difficult to get enough worthwhile lots to fill sales. After he had finished in that market, and

when the property boom was in full swing, Whyte ruefully remarked that his premises on Marlborough Street was making more in rent than the sales he'd held there ever did.

Ian Whyte was already a collector of art when the boom took off in the late 1990s, and he'd sold the odd picture at his auctions too. By 2000, he could see there was a gap in the art market a mile wide. The dotcom generation was deterred by the apparent inaccessibility of auction houses and was ready for a supermarket-style approach. "We felt the art market was one we could apply our discipline to," Whyte said. "We were used to doing very specialised type catalogues with a lot of detail, and to doing a lot of research. We felt that some of the

5 The Irish Times, 11 February 2000.
6 Whyte quoted in The Irish Times, 12 June 2000.
7 The lottery tried to thwart the syndicate by disconnecting Lotto machines they were using, even though the group was acting perfectly legally. This left them £140,000 and 250,000 combinations short of certainty. Their efforts were masterminded by Stefan Klincewicz, a Polish businessman. The National Lottery soon put three extra balls in the drum, ensuring that no syndicate could ever try to buy up all the possible combinations again.

art sales here weren't as highly organised as, say, the art sales in England. So we came in, and we entered the market at the right time. It was booming."

Someone who helped persuade him to make the leap was Garrett O'Connor, who was working in AIB as a banker, having a few years earlier been part of the Scruffy Murphy's syndicate which almost bought up every combination in the Irish National Lottery on the May bank holiday in 1992. The 28-man group made a modest profit. They'd had to share the £1.7m jackpot with two other winning tickets but recouped their £830,000 investment and a bit more by covering 90% of the possible four-number sequences, which were worth £100 each as a special bank holiday bonus.[7]

"All along I had this passion, since I was a young boy, to buy, sell, collect and restore art,"

Far page from left: David Britton of Adam's. Mark Adams, formerly of Sotheby's, now a London based art dealer. John de Vere White – "Buzzer" – a legend in the Irish art world. Above: James O'Halloran of Adam's drives on the bidding for Louis le Brocquy's Sick Tinker Child which sold for €820,000 in December 2006.

FAR PAGE: COURTESY ADAM'S/JOHN DE VERE WHITE. THIS PAGE BRYAN O'BRIEN/THE IRISH TIMES

O'Connor said. "In 1999, when the market was strong, I approached Ian. I could see there was room for an art auctioneer to come in with the skills I felt Ian had – good marketing, PR, catalogues. Ian Whyte is a wonderful marketeer. Eventually he said yes. I still worked [at the day job] and tried to source stuff, but he was working full time at it. He talked to consultants, took advice, and we went for it: we had our first sale in 2000."

Whyte's tactic was to go in at the bottom of the market – offering pictures for £200 or less,

the sort other auction houses would turn up their noses at. This would be about affordability rather than quality. Ordinary people could walk into a Whyte's sale without paying for a catalogue, not be intimidated once they got inside, and spend far less than £1,000 or up to £40,000 as they chose. In pursuing this art-for-all approach, Whyte was consciously creating a new generation of collectors. He knew that once the dotcommers were lured into auctions and experienced the buzz, once they'd bought a painting or two, they'd be sucked in, they'd catch the bug. "Give them the scent and they'll be hooked," was his philosophy.[8] "Think hounds after the fox. I'm giving them the scent."

You could almost say he was bribing the buyers: viewers at his fourth auction, an "affordable art" sale at the Gresham Hotel in December 2000, were plied with mince pies and wine. Art is being liberated, one viewer marvelled: "It's not for the elite."[9] Nor were the prices: some of the paintings sold for as little as €30. Once, these buyers would have put a framed poster on their walls – a Manhattan skyline or Che Guevara. Their parents had the Pope and the Sacred Heart. They could afford original art.

Soon Whyte had to move premises to where his customers were based: on Dublin's southside. Part of the reason for moving out of Marlborough Street was that the traffic in the area had become intolerable due to the renovation of O'Connell Street. Southsiders were taking 40 minutes to cross the Liffey – "the northside was effectively cut off," as Whyte complained at the time. But he admits, too, that art collectors felt uneasy about bringing valuable paintings into the badlands at the back of O'Connell Street. "People didn't want to bring stuff to the northside," he said. "Marlborough Street was a bit downmarket for them so we said we'd better open over here [in Molesworth Street]." He was moving into the heart of Dublin's art world, a mini-Bond Street with 20 or more galleries all within 10 minutes' walk. De Vere's was just around the corner, and Adam's was at the back. Now the country's three main auction houses were within spitting distance of each other. And spit at each other they did.

"From our point of view it's a bit unfortunate that his name is Whyte and he's opened an office around the corner," harrumphs John de Vere White. "I don't mind competition but I don't like confusion. And he has caused us difficulty because of the confusion." Whyte counters that since Buzzer's firm is known as de Vere's, the confusion isn't that bad. "I know we lost two important pictures to him in the last few years over the confusion and we may have, unknowingly, gained one or two. We do occasionally get telephone calls for him which we redirect – any cheques are of course cashed immediately," he quips.

In his first year, Whyte gave his competitors absolutely nothing to worry about. His debut sale, on 8 March 2000 in the Shelbourne Hotel, was a modest affair. Of the 178 lots, just over 81% sold – a respectable proportion. Some €400,000 was raised, representing an average of about €2,750 per painting. The top lot was Sean Keating's *The Turf Men of Aran*, which made

8 Quoted in The Irish Times, 16 December 2000.
9 Ibid.
10 O'Connor soon left to work for Mullen's Laurel Park in Bray, and then branched out on his own.

€52,000 – but this was more than the double the next highest price. Whyte's second auction, in June 2000, was a bit of a disaster, however. Of the first 11 lots of the "Irish and International Sale", only one sold – and that for €2,200. Of the first 70 lots, 55 were unsold. But that was the low point: his sale in October that year was much stronger, and by 2001 his two main rivals knew they were in a game.

"His timing couldn't have been better," said de Vere White. "He did his apprenticeship – he had some sales that were very average – and then he promoted himself well, put on a very good show, and then the market took off in his favour."

As well as switching offices in 2001, Whyte's changed auction venues, moving permanently into the RDS, which was solidly on the southside as well as having ample parking for the SUVs and the people-carriers. They provided staff to hold the hands of nervous first-timers. "I was very active on the floor," said Garrett O'Connor. "I was good with people – that was my forte. They would ask me questions, they wanted advice. 'Would this be a good investment?' You'd talk to them about what they wanted – was it for the house? Did they want a good decorative picture?

"Adam's and de Vere's were wondering would it last. It did a take a year to get going at Whyte's – the first year was up and down. The second year the name started to get known, and people started bringing them pictures – better stuff."[10]

Whyte's had aimed to be a feeder auction house for the big two, selling starter paintings to collectors who would go on to buy more valuable pieces at Adam's and de Vere's, a picture-for-everybody-in-the-audience approach. So lightly did his competitors take the challenge that they sometimes sent vendors round to Whyte's with lower-value paintings that they couldn't be bothered to sell.

But very soon Whyte's began to get marquee prices for its top lots – such as the €130,000 for le Brocquy's *Reconstructed Head* in April 2004, or the €96,000 for Robert Ballagh's *My Studio, 1969* a couple of months earlier, a picture that was let slip by de Vere's. When Mike Hogan, the owner of *In Dublin* magazine, had to divest himself of the painting, he first offered it to Buzzer, whose daughter had worked in his publishing business. When de Vere heard its dimensions, he dismissed it as uncommercially large. So Hogan phoned up Whyte's wondering if *they'd* be interested in his Ballagh. Staff were around within minutes, electric screwdrivers in hand to loosen it from the wall, lest the publisher change his mind. *My Studio, 1969* appeared on the cover of a Whyte's catalogue and, no doubt compounding Buzzer's annoyance, his best friend Lochlann Quinn was the purchaser.

"We came in to do a niche thing, to cater more for the middle collector; people spending up to 20-40 grand. That was our market," said Whyte. "We started to get more expensive stuff, and the volume of our sales was quite high. So by accident more than design we noticed in 2004 that we'd outsold Adam's, and we did it again the following year. They beat us in 2006 but we'd still say we're number one because they share some of their auctions with Bonham's

My Studio, 1969, by Robert Ballagh, which Ian Whyte pinched from under the nose of John de Vere White when Mike Hogan put it up for sale. Lochlann Quinn was the purchaser – at €96,000.

of London."

Whyte's policy of shaking the trees in search of the apples, and raiding the next-door orchards of Northern Ireland and Britain, paid off. The promise of securing a Celtic Tiger-style price in Dublin winkled out many family heirlooms in Belfast and around England. An example the firm used to persuade owners to consign was the le Brocquy tapestry they'd sourced in Seattle and sold for €106,000 in 2001 and which had originally been bought from the Dawson Gallery in 1972 for £1,000.

"We got quite a lot in Northern Ireland," Whyte admits. "We had good contacts up there and also in Britain. We were able to get paintings that had been out of the country for years, including the le Brocquy we sold recently for €680,000 which [came from Cheshire and] had been out of Ireland for over 50 years."[11]

He did great, arcing sweeps of England, often returning from trips to the UK with 40 or 50 paintings stashed in the back of his car. "Ian will be travelling via Liverpool to Cheshire, Yorkshire and then on to the A1 to London, thence back to Liverpool via the M4, M5, M6 and M56 and can arrange to meet clients en route," one of the firm's recent ads said. On one trip in early 2008 he picked up one Yeats-related picture at 7am in Liverpool and another that evening in London. There were four trips per year at the start, but now he's cut them back to two. "We've pillaged the place," he admits.

The "valuation days" he held in Belfast were especially worthwhile – since the city was home to many of Ireland's leading artists and works they had sold throughout their careers were still with primary buyers. Good examples of Gerard Dillon, Markey Robinson, Frank McKelvey, John Luke, William Conor, Colin Middleton, Brian Ballard, Basil Blackshaw and Dan O'Neill all crossed the border in Whyte's car, confirming the old adage that Belfast produces the art and Dublin sells it.

Whyte's used a network of tipsters and runners in Ireland and other countries, people who had been scanning the market for stamps and coins and whose antennae had been retuned to the Irish art frequency. But the competition of so many auction houses looking for quality Irish paintings meant there were no easy pickings. A Whyte runner once tipped him off about an auction in a village in Oxfordshire which hadn't been advertised, and which had several Irish pictures. When the runner went to the auction with her instructions, she found herself up against at least 10 phone bidders from Ireland.

Whyte's did have one extra weapon in this competition for consignments – a great website. It featured a searchable archive that put information which was once the jealous preserve of dealers at the fingertips of the dotcom generation. The hundreds of paintings that Whyte's sold were all in this online database with full catalogue notes, provenance, estimate,

11 A Family II (or A Family and their Cat), sold at Whyte's in April 2007. It was bought at Christie's in London in 1985 by Alan Hobart and featured in Pyms' Celtic Splendour exhibition that year. Hobart sold it on for a modest profit shortly afterwards and would have been nonplussed to see Whyte's achieve a price that was almost 10 times higher. Homer nods.
12 Interview with Vera Ryan in Movers and Shapers II, page 199.

the price they'd made previously at Whyte's, or an acknowledgement if they hadn't sold.

This stripped a layer of mystification from auctions and made private buyers the information equal of dealers, who were rapidly becoming redundant as the art market went retail. In the late 1990s the *Irish Arts Review* started publishing auction results, and eventually produced an *Annual Price Guide to Irish Art*, a list of every Irish picture sold from about €2,000 upwards at auctions in Dublin, Belfast and London. The decision to do this was taken by Homan Potterton, a former director of the National Gallery of Ireland, who was the magazine's editor from 1995 to 2002.

"The dealers were understandably annoyed," he said afterwards.[12] "When I worked out that it was feasible to do an art price index, I decided it would be interesting. The prices were published in *Art Index* anyway. Dealers have a shop to run and a stock to maintain, anyone would know they'd have to have a mark-up, but they didn't really like the extent of their mark-up being made so readily available. Several of them withdrew their advertising and were quite bad-tempered about it."

There were down-sides to Whyte's putting so much information on their website. In its September 2007 sale, for example, lot 89 was Frank McKelvey's *Breezy Day, Marble Hill Strand*, with an estimate of €20,000-30,000. Someone thinking of bidding could find out from Whyte's searchable archive that it had been offered the previous April with an estimate of €35,000-40,000, and hadn't sold. Crucial information for the buyer who eventually bought *Breezy Day* at its lower estimate – €20,000. Or consider *Currachs, Connemara* by Maurice MacGonigal. This painting was first offered for sale in Whyte's in September 2003 with an estimate of €6,000-8,000. There were no takers.

It was re-entered the following September, with an estimate of €4,000-6,000; still no takers. In early 2005 – same result. Exactly one year later the vendor tried again, this time with an estimate of €3,000-5,000. No joy. In the old days, the fact that the painting had been "burnt" four times would have been known only to the auctioneer, seller and maybe a couple of astute dealers. Now it is common currency.

Whyte's policy of putting full provenance into its catalogues and on its website also showed up the amount of dealers' stock included in some sales. Once you tell people that a picture sold in the last few years at Sotheby's or Christie's, you might as well be saying: "This lot was bought by an Irish dealer who stuck a new frame on it, and now he's trying to make a profit of 50% or more by selling it onto you."

This level of transparency also made it obvious if a painting was being "flipped". For example, the provenance of Norah McGuinness's *On a Full Tide*, lot 66 in Whyte's February sale in 2008, said it had sold at Whyte's in September 2005. A check on www.whytes.com shows it made €6,700 first time out. Thirty months later, the estimate was €8,000-10,000. So the seller was hoping to turn a profit of about €2,000. Nothing doing; the work went unsold.

"The other thing, and I'm not saying this against any of our competitors," says de Vere

DANIEL O'NEILL

BORN: 1920, BELFAST

DIED: 1974

PAINTING STYLE: ROMANTIC

AUCTION RECORD: £274,716

(SOTHEBY'S, MAY 2008)

FANS SAY: HIS SENSUOUS HANDLING OF PAINT MAKES HIS WORK WONDERFULLY MYSTERIOUS AND ACHINGLY SAD

CRITICS SAY: HE ONLY BECAME POPULAR WHEN ALL THE GOOD JACK YEATSES WERE GONE.

IF YOU COULD OWN ONE: LITZI

BEST EXAMPLE ON PUBLIC DISPLAY: THE BLUE SKIRT (ULSTER MUSEUM)

€50,000
2007

The son of an electrician, O'Neill himself was apprenticed to an electrician and found employment in Belfast shipyard. Working night shifts, he painted by day and did life-drawing classes in Belfast College of Art. He also studied in the studio of Sidney Smith. After the 1941 Blitz, he salvaged wood for carving. That same year he held his first exhibition at the Mol Gallery in Belfast.

In 1945, Victor Waddington became O'Neill's dealer and encouraged him to give up work as an electrician and become a full-time painter. An exhibition at the Waddington Galleries in Dublin the following year was a virtual sell-out. Waddington is thought to have financed O'Neill's six-month trip to Paris in 1949 where he visited the main galleries and intensively studied works by the likes of Maurice Utrillo, Georges Rouault and the Old Masters. Over the next few years he completed his best work. He moved with his wife and young daughter to a cottage in Conlig, Co Down, which had a small

CONTINUED ON NEXT PAGE

JACK MCMANUS/THE IRISH TIMES

Daniel O'Neill photographed in 1971.

CONTINUED FROM PREVIOUS PAGE

artists' colony and where George Campbell and Gerard Dillon were already living. One neighbour remembers the tall, dashing O'Neill going outside in a thunder storm in order to absorb the full power of nature. "It was really beautiful, with the lightning flashing through the trees," the artist later recalled.

O'Neill followed Waddington to London in 1957, from which time critics says his work became more introspective and gloomy. Twelve years later George McClelland, a Belfast dealer, invited O'Neill to do a one-man show, his first in 18 years. It was a complete sell-out. O'Neill moved back to his native city but died three years later.

His best paintings conjure up a romantic dream world, with dark-skinned figures, surreal suns and intense, oddly coloured skies.

He painted many images of women, giving them sad expressions but huge, soulful eyes. "At times this borders on the obsessive through the sheer repetition of the subject matter," one critic observed. "Despite this, each female portrait is unique." O'Neill's motto was that in painting, "strength lies in simplicity".

Revived during the boom, his prices have steepled since the €185,000 sale of The Red Bow in Adam's in 2005. This is part of a general revival of the Belfast school of the 1950s, with Dillon, Campbell and Colin Middleton all achieving popularity. Although it is becoming fashionable to mock the limited range of O'Neill's work, his followers are enthusiastic. Sotheby's broke the auction record for the artist's work at its Irish Sale in May 2008.

White, about to score a point against his main competitor, "but the difference too would be when you've been in business a long time and you've established relations with clients, you have a very small percentage of pictures in your sale that don't come from private houses. I have loads of dealers now that I could ring up and say 'I'm trying to fill an auction, would you give me 10 pictures?' And they are happy to give you the pictures if you agree to their reserves. But ideally what you are striving for are pictures that are totally market fresh and are for sale because people have gone to heaven or they're trying to help their children, rather than a dealer's stock."

Of course Whyte's wouldn't maintain this website if it wasn't paying its way, and it does this by attracting vendors. "The internet is great for helping sellers get in touch with us," confirms Ian Whyte. "I'll give you a typical situation: an estate in America is being dispersed and people inherit a Paul Henry painting. Henry means nothing to them. So they Google him and see who has sold Paul Henrys, and generally the Irish auction houses have sold more. Sometimes they pick us because we have a good website. We do get quite a bit through the internet. Before that, people wouldn't really have known where to go. They might have sold the Paul Henry in the local auction house." So as well as France, Belgium, Italy, Germany and Switzerland, Whyte's have had consignments from Iceland, Sweden, Denmark, Hungary, Spain and Portugal.

The internet site is supplemented by an expensive marketing campaign, of a type that leaves competitors in the shade. A flurry of ads appears in newspapers and magazines in Ireland and England, both national and provincial, before each Whyte's sale. Flattery is a key technique: sellers are told that "discerning investors" and "connoisseur collectors" await their pictures in Whyte's auction house. British collectors are encouraged to "sell Irish art where it sells best" i.e. in Dublin. "Despite all the hype of overseas sales," one Whyte's ad said, "Dublin is still the best place to sell Irish art, and Whyte's have a discerning clientele which will pay generous prices for Irish works of the highest quality."

Some of the ads are quite cheesy; one claims that Whyte's four sales a year are "carefully scheduled and planned to achieve the best results for our sellers and to provide the best quality at appropriate times of the year for our buyers." Many of them get right under the skin of competitors. "The difference between him and us," snorts Bernard Williams of Christie's, "is that he has to spend €350,000 a year advertising whereas we have the name behind us." Spoken like a man who has seen a choice picture or two swiped from under his nose on home turf.

A front-page advertisement in *The Irish Times* in early 2006 boasting that Whyte's "last year sold almost €9m worth of Irish art at auction, nearly €1m more than any other firm in Ireland" really drove some people in Adam's round the twist. Sources at the firm gleefully pointed out that a Paul Henry which had sold for €120,000 was incorrectly labelled *Spring In A Riviera Garden* (which is actually a Lavery painting) when it should have been *A Village in*

Connemara. "Look at this arriviste," was the implication. "He knows nothing about art." While that was making rather a meal out of a misattribution, it was also missing the point: only a handful of people in Ireland would have spotted the mistake. Most of them were probably Adam's clients already.

Whyte's rivals did try to counter his marketing onslaught in more positive ways, such as offering news items to journalists about their own auctions and generally improving their marketing. "There is intense competition out there so you're all the time trying to come up with an angle," admits de Vere White. "In our summer sale of 2007 we produced a little booklet of postcards of our ten top pictures and sent them to all our clients. And we produced a little hardback cover for our top 100 clients and hand-delivered them to houses. Was that all a bit over the top? Well, in my view it wasn't too far over the top because we did have the pictures."

He remains sceptical about how much impact glossy catalogues have on buyers. "You can do big write-ups about pictures, but who does this satisfy?" Buzzer wonders. "It certainly satisfies the vendor that you've written six paragraphs about his picture. But I don't think it has a grain of an effect on the market. In one recent Adam's sale the cover picture on the catalogue didn't sell. Sometimes I feel a big write-up can put people off, they'll say 'oh for God's sake I have no chance of getting this'. I firmly believe that if we produced a photostat catalogue in black and white, we'd get just as good prices. But the vendors wouldn't be happy and they'd go to our rivals."

Whyte's catalogues are still the best in the Irish market, largely the work of Jane Eckett,

€1,400
2007
When the contents of Patrick Leonard's studio, which included *Blanchardstown Hospital Outpatients* (opposite), were consigned to Adam's in April 2006, Whyte's nipped in first, selling 84 Leonard pictures from George McClelland's collection in February. Adam's was furious, thinking its sale had been scuppered, but such was the buoyancy of the Irish art market in early 2006 that both auctions ultimately did well.

an art history graduate of the University of Queensland in Australia. It is significant that when Adam's finally awoke from its slumber and reacted to the threat posed by Whyte's, a first step was to beef up its catalogues.

It hired consultants such as Nick Nicholson[13] and Ciaran MacGonigal to write learned essays on the top lots. Another significant step was hiring David Britton, a chartered accountant who was running the Frederick Gallery, as director of business development. Britton's tasks were to take on Whyte's marketing machine and help reinstate Adam's as the biggest seller of art in Ireland. That had been achieved by 2006.

Adam's reluctantly admits that it fell asleep at the wheel. "What could we do? We couldn't monopolise the whole market," pleads Brian Coyle, its chairman. "We didn't take

13 Formerly of Sotheby's.

our eyes off the ball in terms of wanting to get business, I don't think. But perhaps it appeared we did because [business] slipped back after the introduction of John de Vere White. It could be that we did slip back a bit, we were a bit self-satisfied maybe. The problem with the 1990s was that Sotheby's and Christie's started Irish sales, and that was the real competition to us, not John de Vere White." So while Adam's had its guns pointed at London, a domestic competitor crept up behind and mugged them.

"Adam's got up off [their backsides]," said Garrett O'Connor. "They hired David Britton, who is a good art dealer and is passionate about his business. He was brought in effectively as head of marketing and did a huge job. He did a very good turnaround on Adam's."

David Britton married into art: his wife is a daughter of John Reihill, an oil tycoon with a huge collection of paintings at his home, Deepwell, and who once donated three Francis Bacons to the Hugh Lane Gallery. Britton had worked with Adam's in the early 1990s and in 2005, the year after they'd been out-sold by Whyte's, the firm came knocking at his door looking for him to come back.

"I was headhunted," Britton said. "Part of my role was to increase business in the firm." One of his ideas was to put the Adam's showrooms to use in the months between auctions. He staged loss-making exhibitions of contemporary artists just to get people used to the idea of coming into Adam's. "We are unique among the top auction houses in that we have our auctions in our building – we're carrying the cost of having major showrooms," said Britton. "We had rooms that were unoccupied and nothing happening in them for many months of the year. My job was to think [of things to do in them]. It wasn't necessarily from a financial point of view, it was to get people in the door." The number of sales Adam's held on their premises also increased. They started auctions of contemporary paintings and prints, and of sporting art, a particular success and further proof that Irish people's love of horses includes putting pictures of them on their walls.

From 2005 on, battle was joined between Adam's and Whyte's on a number of fronts, with no quarter given. When the contents of Patrick Leonard's studio[14] were consigned to Adam's in April 2006 on the instructions of his widow Doreen, Whyte's nipped in first, selling 84 Leonard pictures from George McClelland's collection in February. Adam's was furious, thinking its sale had been scuppered, but such was the buoyancy of the Irish art market in early 2006 that both auctions ultimately did well.

Another battleground was the emerging market for historic manuscripts and letters. This should have been Whyte's territory, but Adam's secured a remarkable €700,000 in 2005 for the surrender letter that Padraig Pearse wrote at the end of the 1916 Rising. The following year it held an "Independence Sale", auctioning off letters and documents relating to statesmen such as Eamon de Valera, Michael Collins and Pearse. The highlight of this sale, run in conjunction with Mealy's, was a 1907 document that it billed as the "original words and music" of *Amhran na bhFiann*, the Irish national anthem, in the hand of Peader Kearney, the

composer. Once again Whyte got in first, holding a History Sale three days earlier featuring a Peader Kearney Archive, which included a manuscript verse from the anthem in the composer's handwriting.

So who had the best lot? In the weeks leading up to the sales, Whyte fired a volley of shots across his back wall in the direction of Adam's, disputing the value of their Kearney manuscript and claiming there were copies of it in the National Museum. "I don't know how they can make out it's so unique," he sniffed, "though I'm sure the thing has some merit. It's not the only copy in existence."[15] Adam's insisted that they had the original manuscript and that it was "sour grapes" on the part of Whyte's to suggest otherwise.[16]

Adam's won this skirmish: Whyte's withdrew its Kearney archive at €460,000, some €40,000 below the reserve. Adam's sold its Kearney manuscript for €760,000, although that was below the figure it was aiming at. Adam's had to cope with the additional complication of members of Sinn Fein's youth wing bursting into its auction room and shouting: "Ireland's past is not for sale." In this they were quite wrong: Ireland's past most assuredly is for sale and in the countdown to the 100th anniversary of the Easter Rising we can expect thousands more items of revolutionary memorabilia to be auctioned.

Adam's had another "Independence Sale" in 2007, including letters written by Padraig Pearse from his cell in Kilmainham. Whyte's, meanwhile, fetched €260,000, four times its estimate, for a letter written by Michael Collins to Thomas Ashe. Both houses had competing sales of historical material again in 2008, with prices being ratcheted up a further degree. Speculators are now active in this market, probably because they have noticed that state institutions such as the National Museum and the National Library are enthusiastic bidders for such material. The museum, for example, was the under-bidder on the Collins/Ashe letter. It has a 1916 Room at Collins Barracks to fill, and will eventually open an Easter Rising museum in the GPO.[17]

BY 2006 IT WAS CLEAR THAT RATHER THAN FORCING EVERYONE ELSE TO TAKE A SMALLER SLICE, WHYTE'S had simply made the art pie bigger. Company records show that Whyte & Son Ltd had an operating profit of €681,019 for 2006, up from €222,761 the previous year. It had net current assets worth over €1.2m, compared to little more than €100,000 in 2001. The position at de Vere White & Smyth Ltd was almost as healthy: it had net current assets of over half a million in 2005, twice what it had been two years earlier. Adam's reported a profit of €228,086 in 2006, a huge increase on 2005, and the accounts indicate that senior personnel were being paid sums approaching €150,000 a year.

14 Born in 1918, Rush-based artist Patrick Leonard died in 2005.
15 Quoted in The Sunday Times, 19 March 2006.
16 Ibid.
17 Stuart Cole of Adam's says he offered the Pearse surrender letter to the state for €50,000 only to be rebuffed. "They ended up bidding a couple of hundred thousand at the [subsequent] auction and it ended up making €700,000." Possibly as a reaction to this, the state has over-paid for other items. It paid an extravagant €4m including fees for the Joe Stanley collection in 2007.

WILLIAM ORPEN

BORN: 1878, STILLORGAN

DIED: 1931

PAINTING STYLE: ACADEMIC

AUCTION RECORD: £1.98M (SOTHEBY'S, 2001)

FANS SAY: "HE WAS BRILLIANT AT EVERYTHING... PORTRAITS, LANDSCAPES, NUDES, CONVERSA- TION PIECES. HE IS A PROPER RE-DISCOVERY." WALDEMAR JANUSZCZAK, SUNDAY TIMES.

CRITICS SAY: LITTLE MORE THAN A SECOND-RATE LAVERY – WHICH IS TO SAY, A FOURTH-RATE JOHN SINGER SARGENT.

IF YOU COULD OWN ONE: THE DISAPPOINTING LETTER, 1921

BEST EXAMPLE ON PUBLIC DISPLAY: THE ANGLER, 1912 (TATE GALLERY)

William Newenham Montague Orpen was the youngest of four sons of a well-to-do Protestant solicitor. Something of a child prodigy, he was accepted into Dublin's School of Art at the age of 11 and to The Slade School in London six years later. He commuted between Ireland and Britain until he was almost 40, teaching at the Metropolitan School of Art in Dublin where his pupils included Sean Keating and Leo Whelan. Summers were spent in Howth, where he painted several memorable portraits of his wife, Grace, on the headland overlooking Dublin bay. "He painted at incredible speed without alteration or erasures," said an awe-struck Keating. "And then, if it was not exactly what he wanted, he simply wiped it out and began again – but that was seldom."

Throughout his life, Orpen painted some 600 portraits. His best works were of women and of himself. Among his female subjects were Lottie Stafford, a washerwoman who lived near him in London; Vera Hone, an American who was his neighbour and of whom he made nine studies; and Evelyn St George, another American, who was his patron and mistress for ten years. Mrs St George, six foot tall, and the diminutive Orpen made for an incongruous couple, and were nicknamed Jack and the Beanstalk. After the First World War it was the turn of Yvonne Aubicq, a French girl, to become his model and his mistress.

As the best portrait painter of his day, Orpen earned an enormous income – charging up to 3,000 guineas per commission. He gave a Rolls Royce to a friend, bought another one, and surrendered it for use as a war vehicle in 1914. He was never entirely comfortable in his skin – unhappily married, drinking heavily, depressed and dissatisfied with his own physical stature and appearance.

In 1915 he joined the British army, offering his services as a war artist. "England called her last resources, little Orpen's joined the forces," he wrote to St George. He went to the front in France, painting many portraits of the top brass, but it was the plight of the ordinary soldiers on the Western Front that moved him.

He was invited to capture the peace conference at Versailles and painted To the Unknown British Soldier in France, a coffin flanked by two ghost-like figures from the trenches against the backdrop of the peace conference. It was a political statement about the military commanders who had sent so many hundreds of thousands to their deaths. Before it was accepted at the Imperial War Museum in London, Orpen was made to paint out the soldiers.

He was knighted in 1918, and after the war he settled on the golden treadmill of commissioned portraits. Much of his post-war output is regarded by critics as shallow. Orpen wrote two books of memoirs, drank heavily, and died at the age of 52 of

€500,000
2007

what some suspect was syphilis contracted in France. After his death his reputation in Britain plummeted. Appropriately, it was Irish collectors and curators who helped restore it. The National Gallery of Ireland staged a retrospective in 1978, and it was followed by Bruce Arnold's biography Mirror to an Age.

The boom did the rest.

Imitation being the sincerest form of flattery, the greatest tribute to Ian Whyte's achievement was that several auctioneering firms copied it. Morgan O'Driscoll in Cork and Dolan's in Galway both applied the model successfully. The Whyte's catalogue, with large colour reproductions, detailed notes and occasional essays on particular paintings by experts, became the industry standard. Sometimes, in fact, Adam's strained too much in trying to emulate them, as with the entry in its May 2007 catalogue for John Doherty's *Maxol Lubrication, Dingle*.

Doherty is a photo-realist, so there really isn't much you can say about his painting of a petrol pump against the backdrop of a shuttered building in Dingle, except to pay tribute to the craftsmanship involved by noting that it looks remarkably like a photograph of a petrol pump against the backdrop of a shuttered building in Dingle.

But Adam's wasn't content to leave it at that. "Further investigation causes us to reflect on its wear and tear from the elements and from man's use, and in an ever increasing 'Celtic Tiger' environment, where the property market has surpassed all expectations, we wonder will it be standing in the same spot the next time we pass it," the catalogue entry purred. "And yet, it could represent something entirely different. Could this pump in Dingle be putting emphasis on our dependence on fuel in the present international oil situation, and the current war in Iraq? Or could the pump represent a person? In conversation with the artist recently, he referred to the pumps as having human-like qualities. Is it then a symbol of abandonment? The choice is ours to engage with the subject or not."

Someone who decided to engage with the catalogue entry was Kevin Myers, the acerbic *Irish Independent* columnist. Writing on the morning of Adam's sale he described the catalogue entry as "bilge", and added; "This is poo squeezed out of a constipated alligator's sit-upon. This is the Tate Modern imposing its preposterous art-college wankology upon an Irish auction. I know Brian Coyle, a friend, and an honourable fellow. He could no more write gibberish like that than insert a discontented wasp with toothache under his eyelid." Bad enough, said Myers, that "classical but second-rate painters – Yeats, Henry, Conor – are as ludicrously expensive as they are. But that they might now be further burdened with the preposterous and politicised mumbo jumbo of modern-art speak is simply too much of a cross to bear. Fetch me some paraffin and matches, immediately, someone."

Doherty's petrol pump had been estimated at €40,000-60,000 in Adam's "important Irish art sale". On the evening that Myers' diatribe was published, the pump sold for €84,000 – a new record for Doherty. The irony was that Myers' scathing attack on the catalogue entry had probably just piqued people's interest and driven up the price. Adam's commission, the price of putting that discontented wasp with toothache under Brian Coyle's eyelid, was €12,600.

WHILE THE GENTEEL WORLD OF ART AUCTIONS WAS BEING SHAKEN UP IN DUBLIN, SOTHEBY'S AND Christie's Irish Sales were flourishing in London. Sotheby's grossed £5.7m sterling in 1999, and improved to £5.9m in 2000, a figure almost matched by Christie's. In the millennium year

a third Irish artist, Louis le Brocquy, broke the million-pound barrier – following Lavery and Yeats. Le Brocquy's milestone was far more significant as he was alive to see it. Not surprisingly it was a private buyer that set the record: Michael Smurfit paying £1,158,500 for *Travelling Woman with Newspaper*. This time his agent was on the phone and not in the room, and Alan Hobart was the under-bidder. The price smashed the old le Brocquy record – £133,500 for *Man Writing* – set at Christie's three years earlier.

Travelling Woman was lot 158 in that Sotheby's sale of May 2000, and it was the start of a remarkable run. Six lots later came *Dunquin* by Dan O'Neill, which made £69,500 sterling. This was further confirmation of the former Belfast shipyard worker's growing popularity. Indeed, if one artist can be said to symbolise the art price boom, it is O'Neill, whose best works now invariably fetch six figures. At Sotheby's in 2008, in an otherwise unremarkable Irish Sale, O'Neill made a new record of £216,500 (€274,716) for a *Reclining Figure*.[18]

"The most remarkable phenomenon that I have noticed has been Dan O'Neill," confirms Ian Whyte. "In the last ten years he has gone from €20-30,000 for a particular type of picture to €150,000-200,000. In jumping terms he and Gerard Dillon are the ones I've noticed a lot. The £210,000 one in Sotheby's could have been bought ten years earlier for £20,000." In the early part of the decade, O'Neill's prices were jumping so fast that clever dealers were able to make a profit by flipping his paintings quickly. *Paddlers, County Kerry* sold at Sotheby's in May 2001 for £15,000. It was entered in Whyte's sale that October, where it made €35,000, representing a quick and tasty profit.

O'Neill was lot 164, and nine lots later came Harry Kernoff's painting of *Davy Byrne's Pub* in Dublin. This was bought by the National Gallery of Ireland for £80,500, creating another record. The fourth record in the sequence was lot 197, a McKelvey of a woman and child feeding chickens, which made £78,300. Four records in less than 50 lots, one of which still stands.

In 2001, the total for Sotheby's Irish Sale soared to £7m, although that included the £1.98m Orpen. Christie's had a more modest sale that year, the main disappointment being that *The Whistle of a Jacket* did not set a new Yeats record as they'd hoped. The record was the £1.23m paid for *The Wild Ones* at Sotheby's two years earlier, but this time the bidding stopped at £1,103,750 with the purchaser being David Ker, managing director of Simon Dickinson, bidding on behalf of a "private European collector".[19] The second-highest price at Christie's was £168,750 for Yeats's *Moore's Melodies*, and again the buyer wasn't Irish. There were plenty of records set between the two sales in 2001, including Nathaniel Hone, whose *Boating on the River* made £80,750. In Dublin, 2001 was also a good year for the Irish auction houses. Adam's

18 In a typical piece of marketing wizardry, Sotheby's suggested that O'Neill's reclining woman was inspired by Manet. "It is highly probable that he visited the Musee d'Orsay when he was in Paris in the late 1940s where he could not have failed to see Manet's Olympia," the catalogue entry said. A reproduction of Olympia was helpfully supplied.
19 Ker swears he isn't Irish. Sources in the trade think it's JP McManus, the flamboyant financier and gambler, friend and business associate of John Magnier.

grossed IR£7.2m in sales, its highest figure to date.

Those bumper years of 2000 and 2001 must have lulled the two London houses into taking Irish art buyers for granted. Perhaps they felt that all they had to do was slap up a few Yeatses and Orpens and the nouveau riche Oirish would come running, brandishing their bulging wallets. An example of the cynicism that had crept in was Christie's sale of a William Conor painting in 1997. The oil was titled *Going to Church*. Only one problem: it had sold seven years earlier at Adam's as *On the way to Mass in Connemara*. Being from Belfast, Conor's work was especially popular among Northern Ireland collectors and Christie's admitted changing the title of the painting in order to make it more appealing to Northern Protestants.[20]

"We've changed it into an inter-denominational picture," argued Bernard Williams. "It will appeal to everyone. Our job is to market it to the widest possible audience... Protestant collectors would probably not be interested in the painting with its old name." The rebranding worked – Christie's fetched £16,100 compared to Adam's £3,000. But the sleight of hand, revealed afterwards, wouldn't have impressed Irish buyers, north or south. Meanwhile the London auction houses were including works by the likes of William Scott in both British and Irish sales, depending on their subject matter.

They got an expensive reminder in 2002 that Irish buyers would not be taken for granted, and that deep down many of them resented having to travel to London to pay sterling for Irish paintings. There were plenty of indications before the 2002 season that this would be a cautious year. There had been an economic downturn after the 9/11 terrorist attacks. Huge fines had been imposed on Christie's and Sotheby's in America after they were successfully sued by customers who claimed the two firms were involved in a price-fixing conspiracy. Partly in response, they jacked up their buyer's premium – the extra charge imposed on top of the hammer price – for the second time in two years. Before 1 April 2002, Sotheby's had levied 20% up to £10,000 sterling, and 15% on the next £50,000, and 10% after that. Now they charged 19.5% on the first £70,000, and 10% thereafter. Christie's followed suit within two weeks.[21]

In April 2002, the two London houses exhibited their Irish pictures in Dublin in the usual way – Christie's took over the ballroom of the Shelbourne Hotel for a drinks party, while Sotheby's entertained its clients at their Molesworth Street offices. The paintings, which had been sourced from as far afield as Mexico and Melbourne, also travelled to Belfast and America. Each of the auction houses had a top Orpen; only to be expected after the £1.98m achieved the previous year. Sotheby's had *Interior of Clonsilla with Mrs St George*, a portrait of Orpen's mistress reclining on a chair in her bedroom, staring lasciviously at the artist. Christie's had Orpen's depiction of his wife on the beach at Howth head. They both had big ambitions: Sotheby's estimated its Orpen at £800,000-£1.2m, while Christie's went for £1m-£1.5m. Sotheby's also had a collection of 43 illustrated Orpen letters, which it decided to sell singly, and 27 lots from the collection of Derek Quinlan, a Dublin property dealer, who was

said to be "upgrading his collection".[22] Meanwhile Christie's had a decent Leech – *Aloes near Les Martigues* – which it estimated at £400,000-£600,000. Yeats's *The Avenger*, which featured a young man being forced to sign a document against the backdrop of a firing squad, was estimated at £800,000-£1.2m.

Sotheby's went first, on 16 May 2002. To its horror, the top lot almost went unsold. "There was not a bid in the room until London dealer Guy Morrison, speaking to a client on the telephone,[23] rescued auctioneer Henry Wyndham from his misery and the hammer fell at £800,000 (£886,650 with premium)," *The Art Newspaper* reported. "After that, Christie's portrait had no chance, and went unsold the next day without a single bid." Sotheby's didn't do well with its Orpen letters either – 27 of the 43 didn't sell.

Christie's auction was on the next day, and coincided with the general election in Ireland, although that could hardly be used as an excuse for its three top lots not only failing to sell, but not even attracting a single bid. Christie's did manage to sell 76% of its lots, but a good proportion of these were for less than pre-sale estimates. After the debacle at Sotheby's the previous day – when only 53% of lots sold – Christie's staff had conducted a last-minute ring-around to persuade sellers to reduce their reserves.[24] That helped save their bacon. There was no saving Sotheby's – their gross of £4m was the lowest since the first Irish Sale in 1995 and about half what they'd expected.

So what had gone wrong? In a word, complacency. "Buyers were not seduced by Sotheby's bumper catalogue and over-estimated works," said *The Art Newspaper*. The two disappointing sales had proven that the Irish were no fools, it said. "You can push a market only so far before loyal bidders will sit on their hands and say 'that's enough'. [Sotheby's] need not have bothered with the 26 manned telephone lines; they scarcely rang all afternoon…many of the works were over-estimated and of indifferent quality…what we saw was not a meltdown of the Irish market but a salutary reminder that you can not just bung everything into a vast catalogue with stiff reserves and expect the market to absorb it…the lesson for Sotheby's must surely be that you cannot underestimate buyers' intelligence and assume the market is indiscriminate."

The Spectator reckoned Sotheby's had offered too many second-division pictures at first-division prices. "By some accounts, the absurdly high estimates caused a certain amount of resentment among Irish collectors who do not care to be treated as fools," the magazine said. "No doubt some will say that the Irish art bubble has burst, but the truth is that collectors have just become more discriminating and that Irish art, like virtually every other market, is seeing a growing disparity between the best and the rest." The bubble hadn't burst, of

20 The Guardian, 22 May 1997.
21 There were further increases in January 2003 and September 2007. VAT is levied on top of the premium.
22 The Art Newspaper, 1 June 2002.
23 Almost certainly John Magnier. The Antiques Trade Gazette thought so too
24 Reported in The Spectator, 25 May 2002. A Jack Yeats, On the Way to the Sea, had been estimated at £800,000 and was allowed to sell for £644,650. While reserves were reduced, the estimates printed in the catalogue couldn't be.

course, but the Irish art market was definitely taking a breather. After its growth spurt in the period 1998-2001, it needed to consolidate before making further gains. At the end of May 2002 Adam's, which had also jacked up its buyer's premium, had an indifferent sale, with works by Lavery, O'Conor, Henry and Osborne among the unsolds.

Good examples by the leading artists were becoming rarer. Unimpressed with huge reserves being slapped on these artists' second-rate works, collectors began to look elsewhere. The Belfast school of the mid-20th century – Dan O'Neill, Gerard Dillon, Colin Middleton and George Campbell – experienced a huge surge in popularity. So did a number of living artists: John Shinnors, Basil Blackshaw and Donald Teskey started to get auction prices many times higher than what their galleries were asking. There was still oodles of art money left, and now it percolated down to the next tier.

"The sudden popularity of these contemporary artists shows that the market is fuelled by the level of expenditure people have, and it's nothing to do with the art," John de Vere White says. "The likes of Charlie Tyrrell, Martin Gale, Sean McSweeney, William Crozier and Shinnors didn't suddenly appear on the scene and people said 'my goodness, we have a great crop of painters, let's buy them'. No, people are living in valuable houses now and there's a status to having paintings on the wall and they started to regard buying art as putting away some of their wealth in a constructive way."

It is now thought inevitable that no more than one year after a country's economy or stock market freezes, the effect is felt in its art market. So it was with Ireland: 2003 was the leanest year for almost a decade. The three main auction houses sold €9.7m worth of art, down from €13.9m in 2002 and €14.9m the year before that.[25] There were 500 fewer transactions in 2003, with an average price of €5,931 which was over €500 down, and no headline prices for the auctioneers to boast about in their ads: the top sale in 2003 was a measly €300,000. Sotheby's and Christie's Irish sales in 2003 showed no improvement on the previous year's disappointing out-turn – Sotheby's was up to £4.16m from £4.04m; Christie's was down from £3.5m to £2.8m.

Unlike the last slump, in the early 1990s, nobody was too concerned this time. The Irish art market was quite a different place now, with hundreds more buyers, of a far younger age profile and with a much broader palate. As expected, there was a recovery in 2004, with €13.5m sold by the Big Three in Dublin and the Irish Sales in London improving considerably. By 2005, the market was back to where it had been at the turn of the decade and was about to experience the biggest boom of all – the jaw-dropping craziness of 2006.

By transforming the way they did their business – by becoming more like supermarkets – the auction houses largely created this success themselves. "The auction scene had become like going to the theatre. It was a night out now," said Garrett O'Connor. "People were coming to auctions to enjoy the evening. For our sales in the Radisson Hotel [in south Dublin], they'd come an hour beforehand, have their tea or a drink, a glass of wine, meet their friends, go through the catalogue, then go in and get their seats early. The lights are dimmed, the

auctioneer gets up on the rostrum, and there's good humour. Once things begin to sell, there's a buzz. We did our sales on Mondays, to put on a show for people at the start of the week. We got mixed audiences, male and female, affluent professionals, younger people starting to buy. The market was from 18 years of age up, and it was used as an investment vehicle."

Sometimes all that atmosphere went straight to people's heads, and by the mid 00s auction houses were experiencing "spikes" – hugely inflated, one-off prices that bore no relation to what an artist had achieved before or would again. The Adam's Christmas sale regularly featured this madness, such as *Salmon on a Plate* by Pauline Bewick which was estimated at €3,000-4,000 at their auction in December 2004. It eventually went for €48,000, about five times what Bewick usually makes and a record that could last 20 years or more. As with all such spikes, the price of other Bewicks at the same auction was unaffected.

"I think what happens is that two fellows get sent in by their wives to buy a particular picture for Christmas, and they just don't stop," said Ian Whyte. "You had the peat bucket at Adam's that was estimated at €3,000-4,000 and went for €180,000. Where two people with a lot of money decide 'I want that and I don't care what I pay for it', away you go. A local association also helps. We had a Thomas Walmsley watercolour in a sale in 2004, estimated at €1,500, a little watercolour of Castleisland, which showed a cottage and a bit of land. The price was driven up to €14,000 and I've heard that it was two neighbouring landowners, both of whom thought the cottage was on their property."

By 2005 the professional view was that Irish buyers were spending far too much money on mediocre art. It was all the more sobering hearing this view expressed by the very dealers and auctioneers who were doing so well on the back of customers' foolishness. "I'm not critical of the Irish mentality of only buying their own country's art – that's quite normal," said dealer Oliver Sears. "The thing I would be critical about is the sums of money they spent on very poor works. The carry-on in the art market absolutely mirrored what went on in the property market – people buying cardboard boxes in Ashbourne for 14 times their salary was the same as them spending whopping sums on mediocre artists – ones you'd be embarrassed to show.

"I think Dan O'Neill is an example of an artist who's completely over-rated by the Irish market. He's a good artist, but not one that commands six figures. It's nonsense. I know it's odious to make comparisons but put him up against artists like Pierre Soulage[26] and Dan O'Neill is just like…."

He laughs. "It's nuts, and it's scary. And it's happened because, in the case of O'Neill, his work is accessible, it's easy to read. There is something wholly Irish about it. So people have that kind of money, they're looking for trophies, there's a shortage of good art, and this is what happens."

25 Table 2.5 in The Art Economy by Clare McAndrew, (The Liffey Press, 2007.) Also published in The Investor magazine, March 2006
26 An abstract French painter, born in 1919, who specialises in black .

5

HERE COMES THE MONEY

"He's really a commodities broker who has been let loose on the art world. He claims to love art, but his is the love that the wolf has for the lamb"
Sean Scully, painter, on Charles Saatchi, collector

THE OLD SAYING IS THAT THE THREE DS ARE WHY art gets sold – death, debt and divorce. But to that trio of Ds can be added a fourth – disposal.

After Madison Dearborn, a Chicago-based private-equity firm took over the Jefferson Smurfit group in 2002, it decided to sell off the art that Michael Smurfit, the chairman, had bought for the company over the previous two decades. Introducing a catalogue of the collection one year earlier, Smurfit had said the purpose of buying the art was "to underpin the Irish atmosphere" of the Clonskeagh headquarters and the K Club. As far as the American asset-strippers were concerned, the Smurfit staff could

"Susan Magnier is the one who is really interested," one London dealer says. "He is too, but he's a smart guy and I think he saw an opportunity to put together a good Irish collection at a time when the interest was only just getting going."

Far page: Susan Magnier, wife of John Magnier (above).

make do with feng shui.

"I'd made a conscious decision to build a collection for the company when we opened our new head office, that we were going to have the best Irish artists on the walls," Michael Smurfit said. "And the board agreed at the time. Of course it was a great investment too. But Madison Dearborn took a different view when they took over the company. They didn't really want to have the art; they preferred to have the cash."

The company owned about 25% of the total collection that Michael Smurfit had amassed. A foundation that he established owned another 25%, and the remaining 50% was his personal property. "I still have that 50% – more now, because once I knew that Madison Dearborn was going to sell paintings, particularly some of the Yeatses, I had to go into the market," he said. "I've bought some very nice Yeatses in the last few years."

Of course Smurfit made a lot of money from the takeover deal, but Madison Dearborn got his beloved golf resort, the K Club, and therefore all the paintings on its walls. These were the ones it sold. "There were big black spots where they had been, and the rooms had to be repainted," Smurfit said. He and Gerry Gannon bought the K Club back in 2005, and restored its Yeats Room.

Madison Dearborn couldn't put all the 100 paintings it now owned on the market at the same time, particularly not in the subdued atmosphere of 2002/2003. So it split them into packages – and sent the first group of 10 to Sotheby's for its Irish Sale in May 2003. The American company imposed an important condition on Smurfit: he couldn't buy back any of the paintings himself. He explains: "I wasn't allowed to bid for them because if it was known that I was bidding for anything that I'd previously collected, a lot of people wouldn't have bid against me. I know most of the people that collect art. So it was only right and proper from the company's perspective that I didn't participate in the auctions."

After its disastrous Irish Sale in 2002, Sotheby's set low reserves on the 10 Smurfit paintings the following spring and eight of them found buyers, raising £1.8m sterling. Among the lots sold was Yeats's *A Daughter of the Circus*, which made £285,600, at the lower end of its estimate. *South Pacific*, a Yeats that Smurfit had bought in 1990 for IR£115,000, made £200,000 sterling.[1] The following year, 2004, another 27 paintings were consigned to Sotheby's, and these raised £1.26m, with 10 lots failing to sell. This was a disappointment; the auction house had been hoping to raise £1.6m.

By now no buyers seemed willing to pay seven-figure sums for Yeats and Orpen, and the best results were obtained by Lavery, who had played third fiddle to these two for most of the boom. *Finale*, a Lavery portrait of a young lady at a piano, sold for just a few pounds shy of £600,000, the top of its estimate. This was an especially good price, given that Smurfit had

1 Irish Arts Review Price Guide 2003.
2 It had cost only £75 in 1946, The Art Newspaper observed.
3 The Art Newspaper.
4 Irish Independent, 10 December 2004.

paid £400,000 for it just two years earlier.[2] It contradicted the notion that Smurfit had bought neither wisely nor well.

William Laffan wrote in *Apollo* magazine that the fate of the Smurfit collection was "inevitable, mirroring, on a smaller scale, Japanese corporate buying of Impressionists in the 1980s." The critic added: "The investment potential of art was [not] always paramount in the company's mind when forming the collection. Many of the works offered at Sotheby's resulted in substantial losses for the company, or simply failed to sell."

If this indeed was the trend, there were exceptions to it. An Orpen bought at Phillips in 1994 for £55,000 sold for £120,000. Another Lavery, *Lady in Red*, doubled its top estimate, selling at £364,000.

But overall the Orpens and Yeats's in Smurfit's collection did disappoint when they returned to the market. A self portrait by Orpen depicting himself as an Aran fisherman had been bought in 1996 for £135,000. It was expected to double in price, but failed to attract a single bid. Yeats's *Men of Snow*, a Christmas scene painted in the late 1940s, didn't get its reserve of £180,000.[3]

Lazarus by Louis le Brocquy, which Smurfit had bought for £201,500, the reserve price, at Sotheby's Irish Sale in 2000 sold for £229,600 three years later. After commission payments, this represented about a break-even position.

The residue of the Smurfit collection, some 30 paintings, was given to Adam's for its Christmas sale in 2004, and it also performed somewhat disappointingly, raising just over €300,000.[4] *Dawn*, by Yeats, was estimated at €180,000-200,000 but made only €160,000. Two other good paintings by Yeats, *Nothing is Changed* and *Business*, didn't sell. Two works by Donald Teskey did surprisingly well, however. *Bank Holiday Monday*, which had featured in the Smurfit catalogue, made €42,000, a record for the Limerick artist.

Smurfit insists that the value of what he bought was reflected in the resale prices. "I think Madison Dearborn managed to sell all of them at the prices they wanted," he said. "Of the painters we had, I think we had probably the best examples in private collections. I don't mean that boastfully. It's just that there are a lot of Yeatses around that are not very good, in my opinion, and which have gone for very high money. I've been surprised at some of the prices they've got. Yeats had different periods in his life – he painted normally before he went semi-surrealistic and I have quite a number of those paintings, and they would be like the blue period in Picasso, and worth a great deal more than the average painting."

The biggest wrench for him was the disappearance of Orpen's full-length portrait of *Mrs St George*, which left a 7ft by 4ft blank space inside the main door of the K Club. Smurfit had copies made of some of his favourite Yeats works, and hung them on the walls of the hotel, but *Mrs St George* was irreplaceable. "Yes, I was heartbroken over some of those paintings being sold, and particularly Mrs St George which is a painting I adore," he said. "It's magnificent, certainly the best Orpen I have ever seen."

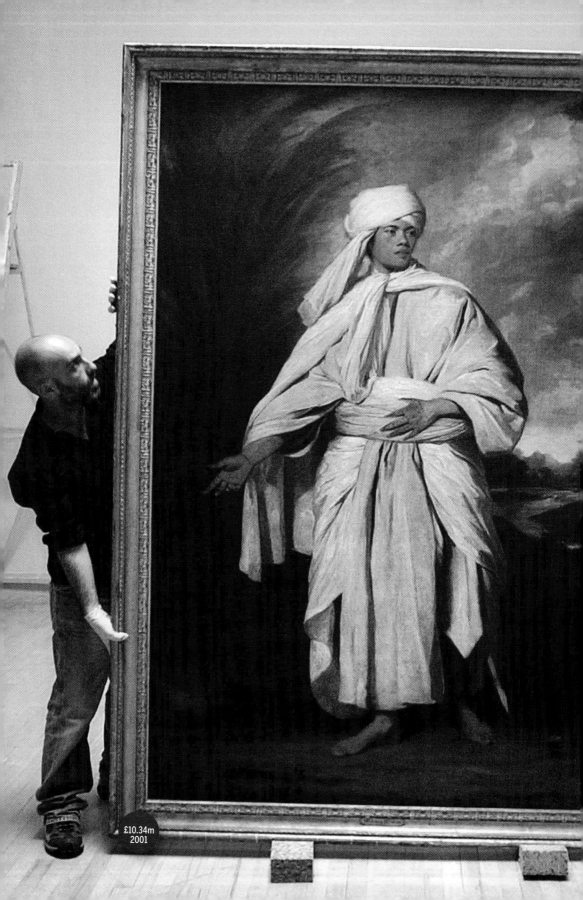

£10.34m
2001

PRESS ASSOCIATION

Mrs St George, which Smurfit had bought at Christie's in 1990 for £200,000 sterling, was undoubtedly the best lot sold by Madison Dearborn. Sotheby's estimated it at £500,000-£700,000 for its Irish Sale in 2003, but bidding was "fast and furious and generated tremendous tension"[5] and didn't stop until it reached £820,000 (or £924,000 including buyer's premium). It was knocked down to dealer Guy Morrison, who conversed with his client via a mobile phone and earpiece throughout, "all the while stalking up and down the aisle, scanning the room to see who was bidding against him."[6]

"Congratulations," Morrison murmured to his client when the hammer came down. John Magnier had secured another trophy.

HE IS IRELAND'S RICHEST ART COLLECTOR AND one of its most secretive. His peers, the likes of Lochlann Quinn, Tony O'Reilly and Michael Smurfit, hang their art in public places, or produce catalogues of their collections, or at least talk about their paintings and their love of art. Magnier does not engage on any level. "John has again said that he would prefer not to give an interview," says a representative, after a second request has been submitted to Coolmore. "He believes that he has a very limited

Portrait of Omai by Joshua Reynolds is moved before hanging at Tate Britain for a summer show in 2005 entitled Joshua Reynolds: The Creation of Celebrity. Then, according to the terms of a temporary export licence, it was loaned to Dublin for six years and is on view in the National Gallery of Ireland.

5 The Irish Times report.
6 Ibid, although the Irish Times reporter either didn't recognise him or didn't understand Morrison's significance.

knowledge of art." But I stress that my interest is in what Magnier has collected not what he knows. Still, no. Guy Morrison won't talk either. Almost everybody else who's had dealings with the multi-millionaire stud owner prefers to speak off the record.

"Susan Magnier is the one who is really interested," one London dealer says. "He is too, but he's a smart guy and I think he saw an opportunity to put together a good Irish collection at a time when the interest was only just getting going." Susan is the second-oldest child of legendary racehorse trainer Vincent O'Brien and his wife Jacqueline, a writer and photographer. Both were buying Irish art from as early as the 1970s. The Magniers followed them into the market in the 1980s, starting in Dublin but quickly outgrowing it and concentrating their buying in London and eventually New York.

"I acted for him for a while; I was in school with him," said John de Vere White. "He's a shrewd buyer with a nose for the best. He's left Irish pictures a long time now, and he's into everything – Munnings, an awful lot of Lowrys, and I'm sure he's bought great French Impressionist paintings."

Suzanne Macdougald of The Solomon Gallery had a few dealings with the Magniers and remembers them as price-conscious buyers. "I sold him a picture many years ago, a Roderic O'Conor painting of Cassis [a small town near Marseilles], and I sold it to him for 20p and I remember the wife, Susan, beating me down to nothing. Then years later the bloody thing came up at an auction."

The Magniers seem to buy art for several reasons. Firstly, they have a lot of wall space – starting with their 2,000-acre stud farm at Coolmore in Co. Tipperary, and including homes in Spain and Switzerland, where he is resident for tax purposes. The Magniers have a mansion in Mayfair, London, and a home in Barbados that is so large it has been dubbed Gatwick and Terminal Two.

Secondly, like many rich men, John Magnier likes a trophy. He is a co-owner of the famous Sandy Lane Hotel in Barbados and a few years ago, along with JP McManus, he bought a 28% share in Manchester United, the world's best known and most glamorous football club. His daughter had a bling-bling wedding in 2002, with 1,000 guests being entertained by Rod Stewart and Ronan Keating in a split-level marquee, while the bride wore a $250,000 wedding gown designed by Ralph Lauren.

In the 1980s and well into the 1990s, Magnier assembled a typical Irish millionaire's collection – lots of Yeats, Orpen, Lavery and O'Conor. For a time he used different dealers to bid for him in auctions, but most of them were rumbled.

In 1998, for example, an eagle-eyed journalist spotted Matthew Green, son of well known dealer Richard, escorting Susan Magnier around a preview of Sotheby's Irish Sale. Green went on to buy a small Yeats, *The Railway Bar*, for £177,500 sterling – three times its estimate.[7] At

7 Report by Colin Gleadell in the Daily Telegraph, 1 June 1998.
8 Art Market on Rebound; The Art Newspaper.

Christie's that same month, Green bought *The Proud Galloper*, another great Yeats, for £870,500 sterling – almost four times its higher estimate.

Notwithstanding their previous relationship, the Greens and Magnier engaged in ferocious competition throughout the May 2002 Christie's auction when a collection of 21 works by Alfred Munnings, Britain's leading equestrian artist, came up for sale. "Even minor works in the collection, which fetched more than £5.8m [in total], sometimes produced frenetic bidding," *The Daily Telegraph* marvelled. "The fiercest rivalry was confined to the front four rows on the left-hand side of the saleroom. [Richard] Green sat at the front with his sons Jonathan and Matthew, while directly behind them in the third and fourth rows were the art agents Titus Kendall and Steve Clarke." *The Telegraph* worked out that Kendall and Clarke never bid against each other, and that both were working for Magnier. At that one sale, the Coolmore boss paid a total of £4.5m for horse pictures, including £1.8m for Munnings' *Evening at the Ford*, and £1.5m for *Coming Through the Gap*.

Two years later the Magniers were included in the top ten most active collectors in the world by *Art News*, an American magazine. The purchase that propelled them onto that list was the $27m spent at Christie's Impressionist and Modern Art sale in New York in November 2003 on a Modigliani, *Nue Couchée Sur le Côté Gauche*, a nude reclining on her left side, undoubtedly one of the finest works produced by the brilliant Italian painter. It had been in the collection of Steve Wynn, a Las Vegas hotel and casino magnate. The price paid by Magnier was not just a new world record for Modigliani – it smashed the old world record (also for a nude painted in 1917) by some $10m[8] – it was Christie's biggest transaction in 2003.

The Magniers have a horse called Modigliani – he ran in Susan's colours. They've named other horses after artists they like – there's been Giacometti and Yeats. Eventually we may see Degas and Renoir – other Magnier favourites. We are unlikely, however, to see a horse named Reynolds.

THE PORTRAIT OF OMAI IS A TROPHY PAINTING. WHEN IT WAS PUT UP FOR SALE IN NOVEMBER 2001, IT was hailed by Sotheby's as "the greatest British painting to come on the market for over 30 years." Omai was a young Tahitian who was brought, willingly, to England in 1774 by Captain James Cook as a scientific experiment. How would a "noble savage" respond to, and be treated by, "civilised" Western society? Within a few days of his arrival, Omai met with King George, and the royal court was so taken with this handsome, elegant and mannerly youth that he became a national celebrity.

Omai seems to have enjoyed his two-year stay in Britain greatly, dining with the Royal Society ten times, visiting the theatre, going on a botanical tour of the countryside, attending the opening of Parliament, shooting, skating, picnicking, playing chess, and being invited to all sorts of events by society hostesses.

The great portrait artist of the day, Sir Joshua Reynolds, was invited to paint the

Polynesian prince. His full-length depiction of Omai featured tattoos on his hands and arms, flowing robes and a head-dress, set against a semi-exotic background, palms and fronds waving behind him.

The painting was first shown at the Royal Academy in London in 1776 to "ecstatic acclaim" but Reynolds kept it in his studio until his death 20 years later.[9] It was bought by a dealer at a studio sale in 1796 for 100 guineas and sold on shortly afterwards to Frederick Howard, who brought it to his family seat, Castle Howard in Yorkshire, where the television adaptation of *Brideshead Revisited* was filmed. There it remained for over 200 years, finally

"That Magnier is the owner of Omai is no longer in any doubt. The minutes of the board meeting of the National Gallery of Ireland (above) for October 2005, released to this author under the Freedom of Information Act, include a report from its acquisitions committee, whose chairman was the writer Anthony Cronin (right). "The Board agreed to the loan of the following eight works from a private collector for a period of approximately six years," the minutes say. And then it lists them: Omai was first, Nue Couchée Sur le Côté Gauche by Modigliani and Evening at the Ford by Munnings. These latter two works, as we have seen, are known to have been bought for Magnier."

re-appearing at an exhibition in 1954. It made a few more exhibition appearances in Britain and New Zealand before Simon Howard, who faced a huge tax bill after his divorce, decided in 2001 that he needed to raise some cash.

Howard first approached the Tate Gallery which offered him £5.5m for *Omai*, all the money it could raise. It wasn't enough, and Sotheby's was called in. Lot 12 of its sale at New Bond Street in London on 29 November 2001 was this 7ft by 5ft portrait, estimated at £6m-£8m sterling, the lower figure being over three times Reynolds' record. It came down to a contest between Guy Morrison and David Graham, an American collector who lives in

9 Daily Telegraph feature, 7 January 2003.
10 Evening Standard, 4 January 2002.

London. Graham was standing at the back of the auction room, bidding through a Sotheby's staff member on the phone. Getting completely carried away with the excitement, he eventually walked up to the woman taking his bids, whispered in her ear, and she dropped the phone.

"Then we were staring each other in the eye as it went higher," Morrison said.[10] The dealer bid £9.4m, and Graham agonised over whether to trump it. His wife appeared to be trying to restrain him; the auctioneer was goading him on. "You like it, don't you," cajoled Henry Wyndham, Sotheby's European chairman. But Graham didn't raise his paddle again, and Morrison's bill, including buyer's premium, was £10,343,500. *Portrait of Omai* had just become the second most expensive British painting of all time, behind *The Lock* by John Constable,

which fetched £10.7m in 1990.

So who was Morrison acting for? Journalists immediately surrounded the dealer and demanded the name of his client. An ashen-faced Morrison confessed that he'd bought it himself. He had been bidding for a client up to £8m, and just decided to carry on. "I went beyond the brief and I now own the painting," he said. "I am happy with that and so is Sotheby's. It is the best English picture that I have seen come on the market in my 25 years in the business." This wasn't a mistake, he insisted, although he didn't immediately have a buyer at that price level.

The painting remained in the office of Sotheby's chief executive over Christmas. Over a month later Morrison still hadn't found a buyer, but said three clients were interested. One of these was outside the UK.

Nothing more was heard for about a year – the painting stayed in storage – and then an application was lodged by *Omai*'s new owner for an export licence. It was made by William Fry solicitors in Dublin. Requesting permission to demolish Big Ben might have been less problematic. The Tate, still disgruntled at having its £5.5m offer refused, lobbied the government to keep the painting in Britain for a few months to allow it time to raise more money. A temporary export bar was put in place by Tessa Blackstone, the arts minister, in December 2002, and a revised value of £12.5m was put on the painting by a reviewing committee.

What ticked off the Tate even more was that Morrison's client would not allow the *Omai* to be exhibited in public while the export bar was in place. "This painting is a national icon and we deplore the new owner's refusal to allow it be put on public view," fumed Sir Nicholas Serota, the museum's director.

It became almost a patriotic war. "The Tate Gallery is gearing itself up to save one of the greatest of all English pictures for the nation," *The Daily Telegraph* reported proudly in January 2003, adding that Morrison's client – the new owner of the *Omai* – is "generally thought to be the Irish bloodstock millionaire, John Magnier."

In contrast to most Anglo-Irish battles, this time an Irishman was the aggressor. After decades of pillaging Irish art treasures, the Brits were about to lose one of their own to the son of a Cork farmer who'd left school at 15. And how ironic that Sotheby's, who directed the one-way traffic of art out of Ireland in the 1970s and 80s, should be Magnier's willing accomplice. But, putting aside the schadenfreude, would the public be better served by *Omai* hanging in Coolmore rather than in a London museum? Stripped of its cultural context and the backstory that gives it meaning, could *Omai* have the same resonance for an Irish audience as an English one?

Morrison wrote to the *Telegraph* a week later. "I can tell you the owners, who incidentally are not John Magnier, reject the criticism levelled at them," he said. Not John Magnier? In the light of subsequent events, we must regard this denial as Jesuitical. If Magnier did not own

Omai on that precise date in January 2003, then his wife Susan did, or a trust controlled by the Magniers did, or Morrison still owned the painting but there was an agreement that it would become Magnier's once an export licence was granted.

Meanwhile "every conceivable effort" was being made by the Tate to "secure this incomparably important British picture for the nation." At the end of March 2003, the museum was about to launch a public appeal for funds. But at the last minute a white knight appeared on the horizon: an anonymous multi-millionaire put up the £12.5m needed to buy *Omai*. "This offer matches some of the great benefactions in the history of philanthropy in the arts," Sir Nicholas Serota of the Tate enthused. He had felt "astonishing excitement and incredible relief" when the donor had called. David Attenborough, who had been lined up to make a public appeal for cash, chimed in: "This is an extraordinarily generous offer. It is not often that I have felt moved to support a public campaign to save a work of art, but the *Portrait of Omai* is exceptional."

But Magnier, or to be more precise Settlements Societé Anonyme, the Swiss company in which ownership was now vested, refused to sell. Magnier turned down the £12.5m even though this was reportedly £1m more than he had paid Morrison. Because he refused the valuation placed on it by the British government, the painting had to stay in Britain, and it remained in storage in a Christie's warehouse. Magnier, it was reported, had a full-size copy made of *Omai* and the *Mail on Sunday* mischievously suggested that the real one might be in Ireland and the copy in London.[11]

The stand-off continued for over a year, with neither side getting any satisfaction from *Omai*. Finally, a deal was worked out between Serota of the Tate and Lochlann Quinn, the chairman of the National Gallery of Ireland.

The painting went on loan to the Tate for a summer show in 2005 entitled *Joshua Reynolds: The Creation of Celebrity*. Then, according to the terms of a temporary export licence, it was loaned to Dublin for six years. In a letter that Lochlann Quinn sent to Serota in December 2004, setting out the terms of the agreement, he said: "At the end of that period the painting will be returned to the UK. The National Gallery of Ireland will give an irrevocable undertaking to return the painting and will obtain from the owner whatever is deemed necessary to give such an undertaking." The export licence issued by British authorities valued *Omai* at £15m, meaning that Magnier had made a further £2.5m profit in the two years while the painting was sitting in a warehouse.

The loan period of six years was not a random figure plucked out of the sky. Under Section 606 of the Taxes Consolidation Act of 1997, anybody who owns a work of art worth more than €32,000 can loan it to an Irish museum for six years, and then sell it and not have to pay 20%

11 Article on 22 February 2004. Presumably for fear of libel, the author was at pains to say that he WASN'T saying Magnier had done this, just hypothesising it. "It occurred to my devious mind how, if I were the owner of Omai – and not too fussy about the rules – it would be possible to switch canvases, frames and packing cases, and arrange for the original Omai to travel to the Irish Republic under the guise of the copy. Fantastic? Certainly. Possible? Very."

LOUIS LE BROCQUY

BORN: 1916, DUBLIN

PAINTING STYLE: FIGURATIVE

**HIGHEST PRICE PAID AT AUCTION: £1,158,000
(SOTHEBY'S, 2000). A FAMILY WAS SOLD BY
PRIVATE TREATY TO THE NATIONAL GALLERY OF
IRELAND FOR £1.7M** STG **(€2.75M) IN 2002.**

**FANS SAY: IRELAND'S MOST IMPORTANT LIVING
PAINTER**

**CRITICS SAY: HIS LAST GOOD WORK WAS IN THE
EARLY 1970s**

**IF YOU COULD OWN ONE: TRAVELLING WOMAN
WITH NEWSPAPER**

**BEST EXAMPLE ON PUBLIC DISPLAY: A FAMILY
(NATIONAL GALLERY OF IRELAND, RIGHT)**

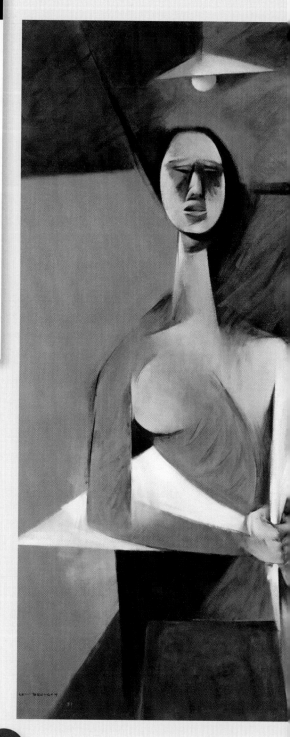

£1.75mStg
2002

His surname, which leads many people to assume he is French, is in fact Wallonian and was inherited from a Belgian grandfather. Louis was educated first in St Gerard's in Bray, before studying chemistry at Kevin Street College and Trinity. He then went to work in the family business – the Greenmount Oil Company, run by Albert le Brocquy and his wife Sybil, a writer. Their eldest child preferred painting to petrochemicals, and Louis learned his craft by studying artworks in galleries around Europe. This would eventually give his painting a much more international style than his Irish contemporaries.

In the late 1930s, le Brocquy became a full-time painter. In December 1938, at the age of just 22, he married Jean Stoney, who was 18. They settled in Menton in southern France, had a daughter Seyre the following June, but returned almost immediately to Ireland when his studio was requisitioned by the military at the outbreak of the Second World War. The marriage broke up in 1941 and they were divorced seven years later. After his paintings were rejected by the RHA in 1942 and 43 for being too modernist, le Brocquy

LOUIS LE BROCQUY (B. 1916) A FAMILY, 1951. OIL ON CANVAS, 147 X 185 CM. NATIONAL GALLERY OF IRELAND PHOTOGRAPH ROY HEWSON. © THE ARTIST. IMAGE COURTESY OF PIERRE LE BROCQUY

set up the Irish Exhibition of Living Art with other like-minded artists such as Mainie Jellett. After the war he left for London, where he got representation with the Gimpel Fils gallery. In 1956 what some regard as his best work, A Family, won an award at **CONTINUED ON NEXT PAGE**

capital gains tax. So *Omai's* likely fate is a return to Britain at the end of 2011 where it will be sold, probably for double or even treble what was originally paid, and Magnier will be able to pocket the profit.

That Magnier *is* the owner of *Omai* is no longer in any doubt. The minutes of the board meeting of the National Gallery of Ireland for October 2005, released to this author under the Freedom of Information Act, include a report from its acquisitions committee, whose chairman was the writer Anthony Cronin. "The Board agreed to the loan of the following eight works from a private collector for a period of approximately six years," the minutes say. And then it lists them: *Omai* was first, then *Nude Reclining* (on the left side) by Modigliani and *Evening at the Ford* by Munnings. These latter two works, as we have seen, are known to have been bought for Magnier.

Of the eight paintings loaned by the "private collector", four are of horses. Among them is *The Red Prince Mare* by Munnings, which broke the world record for the artist when it was sold by Sotheby's in New York in 2004 for €6.4m. There's a work by George Stubbs, regarded by some as the greatest ever painter of horses, and *Shoeing Imaum*, by John Frederick Herring, yet another artist renowned for his equestrian themes. It had sold at Sotheby's in 1998 for almost £1m. Another of the works on the list of eight had been bought by Morrison at Sotheby's three years earlier for £3.2m, just a few months before the *Omai*.[12]

The value of the eight works loaned by Magnier to the National Gallery of Ireland is in the

CONTINUED FROM PREVIOUS PAGE

the Venice Biennale. He re-married, and has two sons with Anne Madden. The family settled in the south of France, making regular excursions back to Ireland but only finally re-settling in Dublin in 2000.

There are several distinct periods in le Brocquy's long and hugely productive artistic career. Among the most important are the Tinker paintings of 1946 to 1950.

The artist spent almost a year researching and sketching travellers in the midlands, and the eventual paintings were done in a cubist style showing the influence of Picasso. Perhaps the most important stage of le Brocquy's career, however, is the Grey Period in the early 1950s, which included the Family series.

He destroyed several works after suffering depression in 1963, but during a visit to the Musee de l'Homme in Paris soon afterwards found inspiration in clay Polynesian heads, which gave rise to his Ancestral Heads series.

When he moved on from those to do a series of famous writers' heads, he came to much wider public attention but few dispassionate critics believe this work is of equal standing to his output from the 1940s and 50s.

Le Brocquy has also produced tapestries, book illustrations and set designs. His best work, such as the Tain tapestries, is regarded as of international significance and he features in public collections around the world, including the Tate in London and New York's Guggenheim.

region of €80m. At the end of six years, they are likely to be worth well over €100m.

Within weeks of Magnier's loan, the Department of Finance changed the terms of Section 606. It extended the period of the loan required from six years to ten. The change to ten years was not applied retrospectively – so Magnier is unaffected. He is the last beneficiary of the old rule.

Meanwhile the *Omai* has caused barely a ripple among the Irish public. "I thought it was very disappointing, the surface finish is poor," said Brian Coyle of Adam's.

Lochlann Quinn defends Section 606 and the Gallery's use of it. "People get to see paintings for six or ten years which they wouldn't do otherwise," the NGI chairman said. "And you're always keeping your fingers crossed that at the end of the day the person who has it there, his economic circumstances might be such that he'll gift it to the Gallery or sell it at half price, or his children might do that. That hasn't happened yet, but this generation has made some money and we might see donations in the future.

"At the end of the day if someone does avoid Capital Gains Tax, it's only 20%. It's not a massive amount, and the paintings are there for a decade. The Gallery has some paintings [under the scheme] at the moment. Some were loaned, I suspect, for tax reasons. Others, because people were afraid to have the painting at home. And we know that with some of them, tax wasn't remotely in the eye of the person who's lent them."

Naturally, Quinn has no problem with the extension of Section 606 from six years to ten. From museums' point of view, it means they get to keep the paintings four years longer.

PETER THURSFIELD/THE IRISH TIMES

Solicitor Noel Smyth who has donated numerous paintings to the State.

AS WELL AS SECTION 606, ART, TAX AND RICH BUSINESSMEN MEET AT ANOTHER SET OF co-ordinates – 1003. This section of the Taxes Consolidation Act allows people to donate important artworks to museums and then write off the value against their tax bill. It has allowed millionaire businessmen to do something we'd all like to do: instruct the state how to spend our taxes. The scheme allows taxpayers to say: "Instead of using my money to pay Ray Burke's pension, or to buy paper clips for the under-secretary to the junior minister in the Department of Enterprise, Trade and Employment, you are to spend it on this fine painting which will

12 When I contacted him in May 2006 for a piece I was doing on all this for The Sunday Times, Morrison said he didn't remember the £3.2m purchase. The painting is The Dutton Family in the Drawing Room of Sherborne Park by John Zoffany, a German born painter who worked for most of his career in England. There were no denials by either the National Gallery of Ireland or Magnier after The Sunday Times identified him as the collector who had loaned them the Omai.

hang in the Irish Museum of Modern Art."

Among the heaviest users of Section 1003 is Noel Smyth, a solicitor best known for representing Ben Dunne at the McCracken Tribunal. He has donated paintings by Yeats, Gerard Dillon, Paul Henry and William Leech to the state. Because most Irish museums have small purchasing budgets, they are thrilled to receive such gifts. In 2005, for example, IMMA got over €200,000 worth of works by Hughie O'Donoghue, some 52 paintings valued at €1m from the PJ Carroll collection, and *Dorothy* by Sean Scully, worth €180,000, from Lochlann Quinn, who'd also donated Scully's *Wall of Light*. In that same year, IMMA spent less than €0.4m of its own money on new work.

The net result is that in 2005, a few wealthy businessmen had arguably more say in what IMMA acquired than the Museum's own curators. Section 1003 has effectively given a few rich people the power to shape public taste in Irish art. Their personal preferences may impact on other people's judgment.[13]

Few have had a bigger influence on public taste than Lochlann Quinn, because few have made as much use of the tax incentives as he has. In 2002 he bought *A Family* by Louis le Brocquy for £1.7m sterling (€2.75m) and donated it to the National Gallery of Ireland under Section 1003. Robert O'Byrne reported in *The Irish Times*[14] that the

13 This holds true even when a museum like IMMA asks wealthy businessmen to buy a particular painting for them and donate it under Section 1003. If the businessman does not like the painting or the artist, for example, he can simply decline.
14 13 April 2002.

BRENDA FITZSIMONS/THE IRISH TIMES

The highlight of Tony O'Reilly's collection is My Beautiful, My Beautiful, an enormous Yeats oil of a man bidding farewell to his horse which some critics believe is the artist's very best work and which was bought directly from Yeats by Sir Basil Goulding in 1955.

"It opened a whole new world to both of us, as Monet and his fellow artists created new horizons of wonderment, excitement and interpretation."
Sir Anthony O'Reilly.

price Quinn had paid "underlines le Brocquy's importance in the pantheon of national art."

It did absolutely nothing of the sort. All it underlined was how important Lochlann Quinn thinks le Brocquy is in the pantheon of national art.

It also underlined the businessman's ability and influence in not only getting the National Gallery of Ireland to accept, for the first time, a painting by a living artist, but also in getting the Revenue Commissioners to agree a valuation of £1.7m sterling – far more than has ever been paid on the public market for a work by the artist.

"I think this is the most important Irish painting of the last 50 years," Quinn said in 2002 after he made the donation. "In terms of its scale, size and content, it would have been a crime for the picture not to have been in this country." While this is an assessment with which many critics and curators agree, by far the most important words in those sentences are "I think." Lochlann Quinn has the clout and the cash to make what he thinks, matter.

Quinn had already played a part in the resuscitation of le Brocquy's reputation in his native country. As Irish art prices took off in the late 90s, so especially did le Brocquy's. In May 1997, Quinn paid £133,500 at Christie's for *Man Writing*, a work from the artist's peak period in the late 1940s and early 50s. It now hangs in a prominent position in the Merrion Hotel.

Similar in style, *A Family* came from the same period. After it was completed, le Brocquy had offered it as a gift to the Hugh Lane Gallery in Dublin, which turned it down, thinking this "modern art" business was a passing phase. It won a prize at the Venice Biennale in 1956, and was bought by the Nestlé Corporation in Milan. Water got into its container while the painting was being shipped to an exhibition in Dublin a decade later. Many in the art world thought *A Family* had been damaged beyond repair, but in fact it was quietly restored by le Brocquy and returned to Milan.

"It was bought out of Nestlé's in the mid-1990s, for not very much, when they had a grand de-acquisition," said Mark Adams, the London dealer who brokered the sale of *A Family* to Quinn. "It was bought by a guy in Milan, whose brother-in-law worked for Nestlé. He bought it partly because he liked it, and partly because he'd heard that Irish work was in demand. And then he just sat on it. I flew over to Milan, saw him, and he wanted an exorbitant price. I think he said £3m, and I told him he was crazy. He dropped it down to £2m and I got the picture over to London and I showed it to Lochlann."

Apparently Quinn wasn't immediately taken with the work when he viewed it at Agnew's in the summer of 2001. It didn't "ring his bell", the term he uses when a painting doesn't appeal to him.

But Adams and Quinn's friend John de Vere White helped persuade the businessman that he should buy the picture for the nation if not for himself. Together they came up with the idea of giving it to the National Gallery of Ireland. If it could be donated under Section 1003, the gesture would effectively cost Quinn nothing. He would simply get to choose that tax

money he was paying anyway would be used on this le Brocquy painting.

The main difficulty was persuading the Revenue Commissioners to accept a valuation in the region of £2m sterling. Three-way negotiations commenced involving Quinn, Mark Adams and tax officials in Dublin Castle. The National Gallery commissioned Adam's auctioneers to do an independent valuation and Stuart Cole, a partner in the firm, assessed it at "in the region of £1.5m." This was a something of a setback to Mark Adams and Quinn, who eventually proposed a valuation of £1.7m to Revenue.

"There are some pictures that are unique and *A Family* is one. I think it's very important," said Mark Adams. "The moment I looked at it I just knew – the hackles literally went up on the back of my neck. I think it's a piece of history. There's nothing quite like it. I think all parties to the deal realised that – Lochlann certainly did. I think Revenue did too. They got various valuations, one of which didn't support ours, and one of which did. They took what I thought was quite a visionary view for tax officials, behaving in a very forward-thinking and creative way. The le Brocquy record at that time was £1.15m for *Travelling Woman*, and *A Family* was a real leap ahead of that, but at least that price [paid by Michael Smurfit] was there to extrapolate from."

There was a last-minute hitch in March 2002 when Revenue discovered that Lochlann Quinn hadn't actually taken ownership of *A Family*. He was asked to provide a receipt for £1.7m sterling and re-apply[15]. Then, in order to square the books, Revenue again wrote to Adam's auctioneers.[16]

"The valuation given by you was 'in the region of £1.5m'," it said. "I understand that it was subsequently agreed to sell the painting for £1.7m. Can you confirm that the figure of £1.7m is within the scope of the valuation given by you in July 2001." Not surprisingly, Adam's didn't want to be a spoilsport so late in the proceedings. "I can confirm that I would consider £1.7m to be within the region of my valuation," Cole wrote back.[17] Revenue finally signed off on the deal.

Shouldn't the National Gallery have been given this £1.7m (or €2.8m) by the government as part of its acquisitions budget, and allowed to choose its own paintings? In theory, yes, but as Quinn points out, this is a pipe dream. "You can't expect a government, with people screaming about conditions in primary schools and so on, to be flashing loads of money on paintings – they really can't," he said. "All great collections worldwide have been donations of one sort or another. Only €6m a year goes into the Section 1003 scheme – it's not a lot of money. All the cultural institutions are competing for it. As long as it is restricted to serious or important pieces – and there is an independent committee overseeing it – I think it's a good idea.

15 Quinn paid for the picture on 21 March and sent a fresh application by courier to Revenue next day.
16 On 20 March 2002. Letter released by Revenue under the Freedom of Information Act.
17 On 25 March 2002. Letter released under FOI.
18 Which was introduced by his brother, Ruairi, as finance minister in the rainbow coalition government of 1994-97. Ruairi Quinn is said to have been a talented painter at one time.

BASIL BLACKSHAW

BORN: 1932, GLENGORMLEY, CO ANTRIM

PAINTING STYLE: SEMI-ABSTRACT

HIGHEST PRICE AT AUCTION: £160,000, TO THE GALLOP, RIGHT (ROSS'S, BELFAST, 2007)

FANS SAY: TECHNICALLY BRILLIANT, HE MAKES DISTINCTIVE AND SUBTLE USE OF COLOUR

CRITICS SAY: HOW CAN AN ARTIST WHO HAS LIVED AND WORKED FOR MOST OF HIS LIFE IN Co DOWN NOT ENGAGE WITH THE TROUBLES?

IF YOU COULD OWN ONE: GRAND NATIONAL (FOINAVON'S YEAR) (1977)

BEST EXAMPLE ON PUBLIC DISPLAY: THE FIELD, 1953 (ULSTER MUSEUM)

Quiet and unassuming, Blackshaw has kept a low public profile throughout his career. The son of an Englishman who kept horses, he was brought up in Boardmills and studied at Belfast College of Art where he won a scholarship to study in Paris in 1951. On his return, he settled again in Co Down, pursuing the three great passions of his life – painting, dog breeding and horse training. Unsurprisingly horses and dogs are regular themes, with much of his artistic inspiration coming from rural life and sport - "a world of fighting cocks, greyhounds, gypsies and 'doggie' men", as one critic described it.

Blackshaw is also accomplished at portraits and nudes. "To me now, portrait painting is a nuisance," he said recently. "I paint portraits for money." His subjects have included writers Brian Friel and Michael Longley, but one of his best was of Douglas Gageby, the former Irish Times editor, which is in the newspaper's offices. He has been accused of cleaving too closely to the demands of the market – producing the sort of horsey pictures

£160,000 2007

that are beloved of some unsophisticated Irish collectors. "Crudely put, he painted to drink at times," said Eamon Mallie, the Belfast journalist who produced a large monograph in 2003. A large number of works perished in a studio fire in 1985, which may have helped push Blackshaw in a more challenging direction.

No fan of exhibitions, he had few notable shows up to the late 1980s. A retrospective organised by the Arts Council of Northern Ireland in 1995 brought him to wider public attention right at the start of the boom. The exhibition travelled to Dublin, Cork and the United States. By happy coincidence, Blackshaw experienced an Indian summer of inspiration, producing large-scale works that moved towards abstraction.

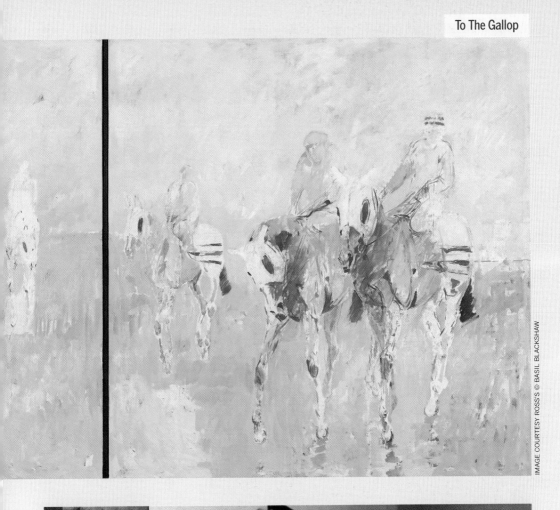

IMAGE COURTESY ROSS'S © BASIL BLACKSHAW

Former President of Ireland Mary Robinson in conversation with Basil Blackshaw at an exhibition of his work at the RHA Gallery, Dublin.

ERIC LUKE/THE IRISH TIMES

"*A Family* was one of the first deals under Section 1003,[18] and it was a bit difficult to get the National Gallery to take it at first because they still had a policy of not taking the work of living artists. But I said 'you're going to have to try'. (I had no connection with the Gallery at the time.) I said 'you'll have to change your policy because this is *the* iconic Irish post-1950 painting'," said Quinn.

Is it? This writer isn't qualified to judge. No-one has contradicted Quinn's assertion, however, certainly not the small cabal of Irish art critics who, with the exception of Bruce Arnold, immediately joined in the enthusiastic applause for the piece.

IN 2005, SIR ANTHONY O'REILLY COMMISSIONED THE SOLOMON GALLERY IN DUBLIN TO COMPILE a comprehensive catalogue of his and wife Chryss's art collection. O'Reilly's catalogue was produced in a small quantity for personal use, being circulated to friends and associates. Leading experts were commissioned to write accompanying articles and catalogue entries – Hilary Pyle on Yeats, S. B. Kennedy on Paul Henry, Bruce Arnold on Orpen, Roy Johnston on Roderic O'Conor.

O'Reilly's collection is known to consist of many examples of the Irish artists he liked, and there are also works by artists from Australia (his first wife, Susan Cameron, was an Australian) collected over many trips there. An equestrian theme runs strongly through the collection.

The highlight is *My Beautiful, My Beautiful*, an enormous Yeats oil of a man bidding farewell to his horse which some critics believe is the artist's very best work and which was bought directly from Yeats by Sir Basil Goulding in 1955. His widow, Lady Valerie, sold it to Tony O'Reilly in the 1980s on a Sotheby's valuation when she needed to raise some money.

The former chief executive of Heinz bought extensively in the Irish market from the late 60s, when he was a young businessman, into the early 1990s. Then, like Magnier, he went international.

He is known to have bought *Diego au chandail*, a sculpture by Alberto Giacometti, which was purchased at Christie's in New York in May 2002 for $3,309,500. But the jewel in the crown, and the purchase that really projected an international image of Tony O'Reilly as a man of culture, is a $24m Monet. Bought in May 2000, it was at that time the largest sum ever spent by an Irishman on a work of art.

In 1892 and 1893, Monet painted 27 views of the façade of Rouen cathedral in north-western France at different times of the day and in different weather conditions. There's one in early morning sun, one in bright sunlight, another on a grey day, one at sunset, yet another on a hazy morning.

It's a hugely important series, representing a key moment in Impressionism. One of them hangs in the Louvre, another in Paris's Musee d'Orsay, and one in the National Gallery of Art in Washington. O'Reilly's purchase was *Le Portail (Soleil)* – a view in mid-day sunlight. After he

bought it, he explained why.

As a 14-year-old in 1950 he travelled with a friend, Frank Turvey, on a cattle boat from Drogheda to Dieppe and they took off on a cycling trip to Paris marvelling at how much damage had been done in the second world war. They stopped en route in Rouen, and were sitting in a café opposite the cathedral drinking glasses of Normandy cider when an old Frenchman explained about the effect the changing light had on the façade and how Monet had painted over 20 versions of it.

"He told us impressionism was about the reality of a building being so, but perception of it being quite different," O'Reilly said in an interview with Pat Kenny on RTE radio in 2000.[19]

Post that interview, O'Reilly elaborated that the more cider the boys drank, the more impressionistic Rouen Cathedral became. "It opened a whole new world to both of us, as Monet and his circle created new horizons of wonderment and excitement as they altered the course of viewing the world through art forever more."

O'Reilly says that his collection was inspired by such life experiences, and put together on the basis of choice rather than fashion or value. "Art is the ultimate democracy," he says. "It's about what delights your eye and your senses."

He credits Peader O'Donnell, the left-wing revolutionary and writer from Donegal, with "igniting in me a life-long interest in art, its interpretations, its secret messages and its different meanings." O'Donnell, he says, "decoded the paintings of Yeats as he explained to me patiently, then a ten-year-old, the meaning of a painting called *The New Road*."

He describes his first purchase as a small oil painting by an artist called Michael O'Gara from Ballaghaderreen, who did an interpretation of Paul Henry's *The Potato Diggers*, a work the businessman admired as a child. "O'Gara was so poor, and yet locally famous, that on the evening of the purchase I had to drive my car on the footpath to shine its lights into his studio shop on the main street," he said. "I paid £10 for it."

"Our collection is made up of a variety of Irish and international artists but it all started on that dark night so long ago in the west of Ireland with a delightful man and a charming little painting. Our collections are assembled without any particular objective other than giving satisfaction and enjoyment to the beholder."

His collection is widely dispersed on both sides of the Atlantic, including of course in Castlemartin, the estate near Kilcullen which O'Reilly bought from Lord Gowrie in 1972. Standing in his stately home looking out at his lands O'Reilly once mused to a *Wall Street Journal* reporter that "there was a day not long ago when people named O'Reilly stood outside a house like this, their noses pressed to the panes."

Now anybody who presses their noses to the Castlemartin windows will see part of the finest art collection currently assembled in Ireland, visual proof and reassurance that this O'Reilly, at least, has made it.

19 Pat Kenny radio show, RTE, 18 May 2000.

Dermot Desmond by the fireplace in the red room of 71 Merrion Square. One of the rare occasions that Desmond has been credited publicly for his patronage was when he sponsored Robert Ballagh's retrospective in the RHA in 2006. The acknowledgement in the catalogue is tiny, hidden among other names, which is how he wanted it.

"He once said to me: 'I don't buy for **investment**. Wouldn't I be mad to? That's my job. Art is my **pleasure**.'"

IRELAND AWAITS ITS CHARLES SAATCHI, A CELEBRITY COLLECTOR WHO MAKES, AND OCCASIONALLY breaks, contemporary artists by buying up whole exhibitions or by spending vast sums on works by unknown painters or even by students, someone whose very ownership validates the artist and the art. The closest may be Dermot Desmond, the billionaire banker, although his patronage of emerging and lesser-known Irish artists is invisible in comparison to Saatchi's flamboyant, attention-seeking purchasing.

One of the rare occasions that Desmond has been credited publicly for his patronage was when he sponsored Robert Ballagh's retrospective in the RHA in 2006. The acknowledgement in the catalogue is tiny, hidden among other names, which is how he wanted it.

"I asked him if he wanted me to acknowledge his help," said Ballagh. "And he said 'Ah, not really'. He doesn't want his name plastered all over the place when he does something like that." As a thank-you, Ballagh painted his portrait, a six-month task, using the backdrop of Dublin's docklands. The artist travelled to Glasgow on Desmond's private jet to watch Celtic play Manchester United in November 2006.

The billionaire's shift towards patronage seems to have come about after an unhappy experience with buying art as an investment. "After that he decided to buy what he liked, so he'll go to an exhibition and buy three or four paintings or if he likes them, he'll buy the lot," said one Dublin dealer. "He has hundreds of paintings. He's a good friend of Pauline Bewick, and a buys a lot of hers. He's a good patron to quite a few artists. He's certainly not buying art for the status."

Desmond, according to trade sources, will go into art fairs and buy an Elizabeth Brophy off the peg.[20] He once bought a painting of a blue kettle by Joby Hickey from an RHA annual exhibition, and is known to have works by Peter Curling, Ireland's most popular equestrian painter, and by bronze sculptor Ian Pollock. A set of 10 works by Ballagh hang in the Sandy Lane Hotel, which Desmond co-owns.

Another source in the art world, who has talked directly with Desmond about his tastes, says: "He told me that when he started collecting first, he was taking advice and felt he ended up with a lot of work that he personally didn't like very much. So he sold that, and just decided to buy what he liked. Now, as far as I can see, he buys according to taste. He once said to me: 'I don't buy for investment. Wouldn't I be mad to? That's my job. Art is my pleasure.' And of course that's the best policy. Anyone who built up really good collections operated absolutely on that basis. Gordon Lambert was one; by the time he left his collection to the state it was worth millions."

There are few enough collectors of Lambert's dedication today. Collecting for personal enthusiasm and without thought to value has been largely replaced by investment buying which is unduly influenced by auction prices. Other art buyers are what David Ker, a London dealer, calls furnishers. "They're decorators. They buy a house, fill it with stuff, and that's it really; they stop," he said. "I can think of only a handful of real collectors, but I can say the

same in England too. Collecting is the absolute dedication that goes into finding what you want. The rest are making a statement, or buying furnishings."

The sixtysomething collectors – the Magniers and O'Reillys – are slowly losing their influence in the Irish market. The images they love, of the western seaboard, of horses, of Irish landscapes and street scenes, do not inspire the next generation of buyers – the fortysomething property developers and lawyers. But the closest that many of these get to international art is the work of Colin Middleton (1910-1983), a Belfast artist who was much less culturally specific than most of his peers. Middleton dabbled in surrealism, expressionism, cubism and even a form of Impressionism, moving between a variety of styles, saying that he could only reflect 20th-century life and respond to its events and influences by experimenting. His influences varied from Giorgio de Chirico, an Italian, to Salvador Dali, the Spanish surrealist; and from Yeats to van Gogh. Middleton's eclecticism and cosmopolitanism is unusual in Irish art, but despite that he is undeniably an "Irish" painter.

"Some of the super-rich come in here, and say 'my wife wants pictures for the house and we haven't a bull's notion, we know nothing about art, but we trust you and this is our budget'," said John de Vere White. "They're saying 'look, we're happy to chuck a million into art'. Some of them don't even want to look at the pictures. I'd make a phone call and they'd say 'fine'. I would buy for them at other auctions, in London, and all over the place. But these super-rich expect you to do the research. And the minute you get them a bad picture you'd be found out instantly. So you take immense trouble to get it right.

"Other people are shrewd, take advice and do research. But there are very few, be they shrewd or stupid, who want to buy non-Irish pictures and that is a pity. At an auction some time ago, we sold a picture by a minor French painter of a market in Concarneau. It was just as good as Aloysius O'Kelly[21] would do. We got €3,500. If it was by O'Kelly, we would have got €25k. So even if I brought foreign paintings here and put them in front of people, they wouldn't buy them."

Irish people developed foreign tastes in the 00s, especially in food, property and fashion. But their appetite for art was only ever sated by the best of domestic dishes.

20 The Australian born artist moved to Ireland in the early 1990s, and quickly built up a following. Her works are generally priced in the €1,500-€3,000 range.
21 Born in Dublin in the early 1850s (precise dates differ), and died in 1926. O'Kelly lived for years in Brittany, lived for a time in Connemara, and eventually emigrated to America. He was neglected in Ireland until quite recently.

6

SMASH AND GRAB

"The art market is a small, incestuous family, inaccessible to the general public, and kept alive by groups of tightly connected insiders. This tiny band, for reasons of status, prestige, knowledge, enlightenment, conquest, posterity, greed, personal pleasure as well as notions of investment or philanthropy, keeps itself thoroughly informed on the buying, selling and managing of what is at best an uncertain prospect."

Quoted in Understanding Art Markets and Management,

Edited by Iain Robertson

IN THE EARLY HOURS OF 12 JANUARY 1990 A GANG OF THIEVES BROKE INTO Dunsany Castle in Co. Meath, the stately home of Lord and Lady Dunsany. Although it was known to have a fine art collection, there was no burglar alarm protecting the 800-year-old Norman castle. The thieves had the relatively simple job of forcing the bars on a ground-floor window. His lordship was in hospital, and Lady Dunsany and her staff were in another wing and heard nothing.

Lady Sheila Dunsany was a noted collector of Irish art, especially of Jack B Yeats and Roderic O'Conor. The thieves helped themselves to five of her works – two Yeatses and three Van Dycks.[1] Three of their frames were found afterwards in a wood near the castle. The value of the haul was estimated at between IR£1m-2m.

Art theft was a favourite modus operandi for Irish criminal gangs at that time. Four years earlier Martin Cahill, the rotund robber known as The General, had pillaged Russborough House in Wicklow,

THE IRISH TIMES

1 Sir Anthony van Dyck was a 17th century portrait painter. Born in Antwerp, he is best known for his portraits of King Charles I of England and his court.

Martin "The General"Cahill photographed outside the Four Courts, Dublin. Cahill was responsible for the theft of a Gainsborough, a Goya, two Rubens and Vermeer's Lady Writing a Letter with Her Maid, from Russborough House in Wicklow, in 1986.

taking a Gainsborough, a Goya, two Rubens and Vermeer's *Lady Writing a Letter with Her Maid*. Two months later – in March 1990 – thieves pulled off the biggest robbery in American history at the Isabella Stewart Gardner museum in Boston. The $200m robbery, which has been linked to the IRA, netted Rembrandts, a Manet, some Degas drawings and Vermeer's *The Concert*. In art-recovery circles, there are still expectations that some of these 13 works will eventually turn up in Ireland.

Art theft doesn't happen in Ireland on that sort of scale any more. As Cahill found to his cost, disposing of well-known paintings is highly problematic. Undercover police are likely to be your only customers. The idea that eccentric millionaires pay criminals to steal works for their basement galleries is the stuff of thriller fiction. Usually, stolen paintings are used as collateral in criminal drug deals. Occasionally, art thieves' motive is to extract a ransom. If a painting has been insured, a ransom payment of 5-10% of its value may be paid by the insurer. Not that they would tell the gardai, but some insurance companies might take a pragmatic decision to pay €100,000 to criminals rather than €1m to the owner.

"I think stolen paintings are very hard to sell. Thieves can't do anything with them," said Lochlann Quinn. "You can nick silver, because one piece is similar to another. Silver, gold and jewellery – they just disappear into the system. But not paintings." The businessman once visited a modest house in Dundrum, south Dublin, where he bought a number of good Yeats and Osborne. Quinn asked the owner why he was selling, and was told that the value of the paintings had become too high. The man's wife was nervous about keeping them in the house. They'd decided to sell rather than be targeted by thieves.

In 1994, the first of the five paintings stolen from Dunsany Castle was recovered. Police in Montreal, Canada, were investigating the theft of a Goya from the Basilica in Quebec City when they came upon *The Head of A Woman* by van Dyck in the possession of two unemployed welfare recipients. Soon afterwards one of the stolen Yeats – *Singing the Dark Rosaleen* – was found behind a sofa when police raided a house in London. It was auctioned in Sotheby's first Irish Sale a year later, fetching £496,500. Then in August 1995, the two remaining van Dycks were found during a police raid on greyhound kennels in Essex. Three men were arrested but there is no record of any of them ever being charged.[2]

And then there was one. The remaining painting was probably the best known – Yeats's *Bachelor's Walk, In Memory*. It may not have been the artist's best work, but it may well be his most famous. From dozens of possible images, it was the one chosen by the National Gallery of Ireland for the cover of its Yeats Centenary Touring Exhibition catalogue in 1971. The painting was inspired by a violent incident at Bachelor's Walk in Dublin city centre in 1914. A group of British soldiers fired on a jeering crowd of bystanders.[3] Three were killed, including an 18-year-old boy. Jack Yeats visited the scene afterwards and noticed that flowers had been

2 'Essex raid yields two Dunsany paintings' The Irish Times, 26 August 1995.
3 Bruce Arnold has written that the incident was an accident and an unfortunate tragedy. The soldiers "panicked and fired, ostensibly above the heads of the crowd, but accidentally killed three bystanders". Irish Independent, 28 January 2007.

thrown on the ground where the fallen had died. His painting depicts a girl wearing a black shawl throwing a flower through a gate on Bachelor's Walk.

In January 2007, the missing Yeats turned up in the most unlikely of places – Sotheby's. At the beginning of the year, the auction house sends out a glossy brochure to promote its forthcoming Irish Sale. When the 2007 version arrived by post in Dublin, several people reached for their telephones to contact the police. *Bachelor's Walk, In Memory* was listed as one of the highlights of the sale – and with an estimate of just £100,000-£150,000. Sotheby's wouldn't say how this hot piece of stolen property had ended up in its auction room. "There is an ongoing police investigation so we cannot comment," the auction house said at the time. Eighteen months later, it wasn't any more enlightening. "There are no more details available. It's still being investigated, looked into. We don't know any more than you do," a spokeswoman said.

Their Dublin rivals were predictably scathing about this bizarre turn of events. "It's the great one of all time," said John de Vere White. "They put an estimate of 100-150 [thousand] on it, and I mean the picture is worth a million. Over a million. And it's one of the most famous Yeatses ever painted, and they didn't know it had been stolen? Very, very odd. How was the vendor of that picture allowing it to go in with an estimate of 100-150 when the picture was worth a million?"

Rank stupidity or something more sinister? "Maybe somebody didn't do their homework properly and will have got the chop," said Suzanne Macdougald. "It made them a laughing stock. On the other hand, these auction houses are not whiter than white. They're not always as honest as they should be."

Stolen paintings come into auction houses quite frequently. Ian Whyte says he gives his catalogues to the gardai, the Police Service of Northern Ireland and to Trace Register in England, an agency employed by insurance companies to track down stolen art. "The RUC did once find two pictures that we had on offer that had been stolen in Co Down two years previously," Whyte said. "We gave them back to the police.

"The most vulnerable paintings are those worth less than €20,000. Some of these art thieves seem to know what they're going for. They'll take the Percy French and leave the big Lavery on the wall. They go for paintings that are not instantly recognisable, and then they'll go to an antiques fair down the country and sell it to a guy at a stall. Only when it comes to auction is it spotted. We tell buyers to photograph their paintings as a precaution."

Robert Ballagh was once contacted by gardai for a valuation of one of his paintings. An Irish diplomat had bought the work at an exhibition in Paris. Afterwards he was transferred to Argentina and put some of his belongings into storage. When the ambassador returned, the Ballagh was gone. Some years later Mike Hogan, the former magazine publisher who was an avid collector of Ballagh's work, rang the artist to discuss a painting he was considering buying at de Vere's. "I remembered it was the stolen picture," said Ballagh. "John de Vere

phoned the gardai. I was never called to court, so I don't know if anyone was ever charged."

But then art crime doesn't take up much time in the Four Courts. That's partly because shysters and conmen usually manage to stay on just the right side of the law. A case in point is a gang known as the Rathkeale Rovers, a band of Travellers from the Limerick town of the same name. They have managed to con both artists and art buyers, but never in such a blatant way that they could be prosecuted. One artist, for example, was persuaded to give the Rovers a painting worth €20,000 on foot of a €1,000 deposit.[4] The Rovers promised faithfully to come back with the rest of the money. Of course they never did – but gardai might have had a difficult time in court providing legal proof that the agreed price was in fact €20,000.

Vermeer's Lady Writing a Letter with Her Maid, stolen from Russborough House by Martin Cahill and which now hangs in the National Gallery of Ireland.

Robert Ballagh had a memorable encounter with the Rovers. One day a knock came at the door of his northside Dublin studio. "Robert Ballagh, is it?" said a man at the door. "Oh my wife loves your work, loves it. I want to buy some." Ballagh explained that he didn't sell from his studio, but the visitor was persistent. "Oh go on, go on. Oh Jaysus, great stuff," he said, spying various works of art scattered around. "Oh f*cking great."

Huge wads of cash began to emerge from his pockets. "How much?" As a way of putting him off, Ballagh asked for £25,000. The man suggested that he would be back with that kind of money later but then his eye alighted on some prints – how much were they? "Well I had no problem unloading a few prints," Ballagh explained. "So I agreed to sell four pieces. And he was going 'I'll bring in the lads to take them out'. It was all very fast. He says 'take that now, count it'. So I counted a pile of notes – there was a thousand in it. He took out six more small bundles; seven grand. Before I could look at it, they're gone. When things calmed down I counted the money, and there's three grand, not seven. And when I look around they have taken about eight pieces, not four. I felt a real f*cking eejit. I contacted a guy I knew from the garda fraud squad. The minute I started to explain he said 'you've had a visit from the Rathkeale Rovers. They've been haunting the art community for the last couple of years'.[5] They wanted me to press charges but I'd accepted the money, and while there was sleight-of-hand stuff going on, I don't think there's a case there. So I said 'what's it all about?' And they said a lot of it is about money laundering."

4 'Con artists target top painters' Irish Examiner, 1 July 2002.
5 The gang is also known to hang around outside auction rooms and approach collectors packing new purchases into their cars.

Other artists have had similar bamboozling experiences with the Rovers – hazy encounters involving wads of cash, fast talking and subtle hints of intimidation. John Shinnors takes no nonsense from them. "Someone was here recently and I had to tell him to 'f*ck off' – that's the only language they understand," he said. "They're a pernicious gang. They wallop my [studio] door down. They come to my house as well. They called to my neighbour's door and asked if I was home. They went straight through her house to her back garden and tried to get into my back. But my dog was there and held them back.

"You don't draw them on yourself. I've heard all the stuff – 'my daughter loves your pictures and she's going to get married'. And I say 'where is she going to hang the picture up – in the caravan, is it?' It's another aspect of the Irish art market. That element comes into it."

Shinnors became a victim of the Rathkeale Rovers in a more indirect way at the beginning of 2008. Lot 107 in Morgan O'Driscoll's spring sale was *The Siege of Limerick*, an enormous 10ft by 7ft work attributed to Shinnors which sold for €20,000. Except the painting was not by Shinnors – a fact which only came to light when the purchaser contacted the artist and asked if he would do some repairs to it. The work, by another Limerick artist, had been owned by Kevin Kiely, a councillor, who'd hung it on the side of his pub, the Treaty Bar, for many years. When he was selling the pub, Kiely was approached by some Travellers from Rathkeale and agreed to sell them the painting for €3,000. The name of the artist, John Hayes, was written on the back of the picture. The new owners proceeded to O'Driscoll's where, the auctioneer says, they produced a receipt for €11,500 which stated that the work was a Shinnors.

The auctioneer now accepts that the receipt was a fraud. Shinnors took out a classified ad in *The Irish Times* to state that the *Treaty of Limerick* was not his work. Kiely says he "regrets dealing with these people from Rathkeale and I'm very sorry I didn't put the painting into storage." The purchaser of the painting was reimbursed.

Caveat emptor – let the buyer beware. In the catalogue for its 2008 Irish Sale, Sotheby's included as lot 129 a pen and ink drawing of a leaping horse by Jack B Yeats, with an estimate of £3,000-5,000. This had already been rejected by Irish auction houses, including Whyte's, as most likely "wrong" i.e. not the work of Yeats. When this was pointed out to them, Sotheby's withdrew it.

There should be, but isn't, a system whereby such "bangers" are taken out of commission. "In an ideal world, any forgery discovered should be destroyed," said Alan Hobart of Pyms. "But they're not, and there are some very clever ones. Unfortunately there are no strict rules or regulations on forgeries."

Garrett O'Connor, the Dublin auctioneer, also believes there should be a way to get "wrong" pictures off the carousel. "They should be destroyed if they are [copies] of important Irish painters, rather than run the risk of them landing on someone's wall," he said. "Or else

an official stamp should be put on it, or the forged signature removed. There should also be an insurance fund that auctioneers can claim from if a painting turns out to be wrong, so they're not just going back to the vendor looking for the money. I'm not saying there is a need for it – it's just you never know when something will slip through." In fact, the big auction houses have professional indemnity insurance. It's buyers that need to be careful, dealing as they are with an unregulated industry.

Forgeries are to the art market what fleas are to a dog, but the extent of this occupational hazard is disputed. A former director of the Museum of Modern Art in New York once estimated that 40% of the top end of the art market is made up of forgeries. Rembrandt is thought by scholars to have painted no more than about 300 works. Yet up to 1,000 "Rembrandts" hang in museums and private collections around the world, many of them the work of apprentices in his studio. Some "Rembrandts" gain and lose authenticity as art scholars re-evaluate the works in the light of new technology and information.

The problems surrounding fakery in the Irish art business are no less intractable. Given the huge amount of money sloshing around, and new collectors' lack of knowledge, there is every incentive for forgers and conmen to try it on. Robert Ballagh recounts meeting two artists in Temple Bar and querying why their work had not been seen in Irish galleries for some time. "The pints were flowing and I said 'how are things going?' 'Oh great. Not with my work, with the other work.' So I asked him what other work he was talking about. 'Oh,' he says, 'I do a lot of Percy French. I've done about 20 this year so far'. And the other fellow says; 'I do Jack Yeats'. He had done about five."

Caveat emptor – the buyer has to beware of fakes not just of historic works but also of contemporary artists. Collectors have to be conscious not just of duds emanating in Ireland, but particularly coming in from England. "Someone might see an English painting that looks like an Irish artist's work, remove the signature and put on a false one," said James Gorry, the Dublin art dealer widely recognised as being the most knowledgeable in Ireland on 18th-and 19th-century art. "So it's a genuine old picture, but not by the artist it says. That sort of thing has gone on for centuries. It's outrageous and horrible, but it does happen. People who collect early pictures are aware of it and have to be careful."

Gorry operates an open-house clinic – allowing collectors and auctioneers to bring old pictures into his Molesworth Street gallery and have them authenticated. He analyses the paint, canvas, stretcher, and frame; compares it with others; checks it under ultra-violet lamps. "A lot of the 18th century painters didn't sign," he points out. "Someone like George Barret – I might only have seen four or five signed out of 400. William Sadler didn't sign. It takes a lot of study, and it's a life-long pursuit. I think the auction houses have improved a lot. Years ago it was very slack."

Ian Whyte, who has sourced a lot of stock from Britain, believes there is a cottage industry based in the north of England specialising in fakery. One scam is to get a watercolour by an

PERCY FRENCH

BORN: 1854, CO ROSCOMMON

DIED: 1920

PAINTING STYLE: WATERCOLOURIST

HIGHEST PRICE AT AUCTION: £58,750

(CHRISTIE'S, 2000)

FANS SAY: ACCOMPLISHED AT CAPTURING THE COLOURS OF IRISH SKIES AND COUNTRYSIDES

CRITICS SAY: IF IT WASN'T FOR THE SONGS, WE MIGHT NEVER HAVE HEARD ABOUT THE PAINTINGS

IF YOU COULD OWN ONE: IN CONNEMARA

BEST EXAMPLE ON PUBLIC DISPLAY: THE QUEEN'S ENTRY INTO DUBLIN (NATIONAL GALLERY OF IRELAND)

B est-known as a songwriter, and most famously for The Mountains of Mourne, William Percy French was also a prolific painter of landscape watercolours. Born near Tulsk in Co Roscommon, the son of a Protestant landlord, he was educated in England and then at Trinity College Dublin. More inclined to play the banjo and write songs than to study, French took years to qualify as an engineer. When he finally graduated at the age of 27, he got a job with the Board of Works in Co Cavan as, in his own words, "an inspector of drains". He was laid off in 1887 and, having lost all his money in a failed investment in a distillery, turned to journalism, starting several journals, including The Irish Punch and The Jarvey, a weekly comic.

When it failed, he concentrated on songwriting and composing, writing plays and comic sketches, and then acting and singing in his own theatrical productions in music halls across Ireland, Britain, America and Canada. His compositions included Are Ye Right There Michael, which lampooned the dire

€40,000
2006

service provided by a railway company in west Clare, Phil the Fluter's Ball and Come Back Paddy Reilly to Ballyjamesduff.

His life had many tragic aspects – his first wife died in childbirth exactly a year after they married, and his infant daughter died a short time later. Jobless and travelling around the country on a bicycle, French would swap his paintings for bed and

Percy French.

breakfast. He painted everywhere he went - including landscapes in America, Switzerland and the West Indies. From the turn of the century he based himself in London, returning each year to Ireland to perform in the main towns and holiday resorts. Sunsets are a regular theme of his water-colours, as is the sun breaking through the clouds. He exhibited regularly at the RHA and in galleries in London. The Oriel Gallery in Dublin has staged many exhibitions of his work, while the Percy French Society in Co Down has a large collection of his watercolours.

He caught pneumonia during a series of performances in Glasgow and died at his cousin's house in Formby, Lancashire in January 1920 at the age of 65.

English artist (of which there are thousands) and attach an easy-to-forge Irish signature – Percy French, Mildred Ann Butler and Helen O'Hara being the favourites – thereby greatly inflating its value. "The amount of fake Irish pictures in England is huge and they tend to turn up regularly at a few particular provincial auction houses and on ebay, where it is difficult to get redress if you buy a banger," Whyte said.

"Especially popular for this kind of activity are those who sign in block capitals or monograms such as Letitia Hamilton, Rose Barton and Colin Middleton. Even contemporaries such as John Kingerlee, Brian Ballard and John Jobson have been 'done'." It is hardly surprising that Kingerlee[6] has been imitated by fakers – given the recent inflation in his prices, and because he signs his paintings with an easy-to-copy monogram of a figure in a boat. Larry Powell, his agent, has queried work in at least two auction houses. "We withdrew an oil painting which had been purchased in England by our client, because on closer examination we agreed it was not Kingerlee's work," Whyte said. "We have turned down several obvious forgeries, mainly from English sources."

Another problem arises with the work of artists who teach. Enterprising students, who have had a helping hand on a particular work from their teacher, sometimes apply the artist's signature and try to sell it. More direct forgery is not as big a problem, but auctioneers do report seeing everything from copies of Paul Henry to forged Sean McSweeneys. Given the doubts surrounding the signature on some of Roderic O'Conor's work, particular care needs to be taken with him.

"There are still floating out there a lot of fake copies of well-known names," said Gillian Bowler. "I've been offered them. I don't really want to go into which artists because then you get sued, because you're upsetting the estate of Artist X. But it's certainly extremely well known in Irish art circles, and they know who they are. They know who the dealers are. There is one particular place where if you went in and said... Well, there is one particular artist and there are more fakes of theirs around than the genuine article. You have to be pretty careful. It may look like the signature, but it's not going to be a bad copy of the signature if they're passing something off as a fake."

Auctioneers have devised a whole glossary of terms to cover themselves. For example, if their catalogue says "with signature", it means "the signature appears to be by a hand other than that of the artist." This is surely a euphemism for "we think this is a fake." In the small print, some auctioneers state that if they use terms like "attributed to", "studio of" or "manner of", they assume "no risk, liability and responsibility for the authenticity of authorship of any lot described by this term and the Limited Warranty shall not be available."[7] So whatever emerges later, you won't be getting a refund. Another auctioneer's convention which is rather

6 An artist who is dealt with fully in Chapter 10.
7 As quoted in the catalogue for Christie's Irish Sale in 2008, page 198.
8 Important Irish Art catalogue, 28 May 2008.
9 For a full treatment of Markey Robinson, see Chapter 8.

unfair is to use a variant of the artist's name if you're not sure that it's his painting. Adam's, for example,[8] use the term Jack Butler Yeats RHA if "in our qualified opinion [it's] a work by the artist." The firm uses the term J B Yeats if "in our opinion [it's] a work not of the period or by the artist."

In the current Irish market, some collectors are particularly suspicious of Markey Robinsons,[9] believing the Belfast artist's works are relatively easy to fake because of the naïve style and the variation in his signature. "Markey Robinson I would have thought was very easy to copy," said Alan Hobart. "I've never bought one in my life. Percy French is possible, but to the trained eye would be easier to spot than Markey." Such claims are robustly denied by those who deal in the artist's work. "We handle more Markey than any other auction house and about 2% of what we have been offered is wrong," said Ian Whyte. "That is less than we see of forgeries of work by James Arthur O'Connor, Edwin Hayes, Percy French or Letitia Hamilton. Uninformed collectors assume that Markeys are easy to fake but in fact most of the fakes are easy to detect by an expert."

Mark Nulty of the Oriel Gallery reckons he can spot a fake Markey even before the bubble wrap comes off. "They are being touched up by some people in the trade, but they don't know their brush strokes and palette," he said. "They are using the wrong colours. Markey did sign paintings automatically, but his real signature was his brush strokes. Having said that, you do need to buy Markeys from a reputable source. Percy French you do have to be careful with also. I have seen a few casualties there as well."

Provenance is a good protection – and it's one reason why proof of good ownership attracts a premium in the auction room. Modern consumer law should also be of use to the buyer. "It used to be caveat emptor, now it's the other way round," argues Ian Whyte. "If you buy a fully attributed Yeats from me and find in five years' time that it's a fake, not only can you ask me for the money back, you can also sue me for the loss. So if you bought it for 50, and a genuine Yeats is now worth 150, you can sue me for 150."

NOT THAT IRISH AUCTION HOUSES OR DEALERS END UP IN COURT VERY OFTEN. JUST AS DOCTORS BURY their mistakes, the art trade will pay to keep theirs secret. It's a confidence business. Anything that damages confidence is to be avoided, at pretty much any cost.

The art market is still run in a gentlemanly, old-world style of nods and winks that only insiders fully understand. An innocent walking into an Irish auction room for the first time hasn't a hope of grasping even the half of what is going on. The first feature that will surprise them is that the pictures on the walls look quite different to the ones in their catalogue. Colour reproductions hide the blemishes and make every painting look lush and rich. "You do have to look at the actual paintings because the picture in the catalogue is over-complimentary, I would admit it myself," said Brian Coyle of Adam's. "They look different – the colour and the texture."

GEORGE BARRET

BORN: EXACT DATE UNKNOWN, MOST LIKELY 1732

DIED: 1784

PAINTING STYLE: ROMANTIC LANDSCAPIST

HIGHEST PRICE AT AUCTION: £512,000

(CHRISTIE'S, 2005)

FANS SAY: ONE OF THE FORERUNNERS OF

ROMANTIC LANDSCAPE PAINTING

CRITICS SAY: DUE TO STRAITENED FINANCIAL

CIRCUMSTANCES, HE PRODUCED AN ENORMOUS

NUMBER OF POTBOILERS

IF YOU COULD OWN ONE: ROOM IN NORBURY PARK

BEST EXAMPLE ON PUBLIC DISPLAY: A VIEW OF

POWERSCOURT WATERFALL, C. 1760

(NATIONAL GALLERY OF IRELAND).

George Barret was born in the Liberties of Dublin, although no-one is sure precisely when. His first dated work is in 1747 and appears to be a student production. He was first apprenticed to a maker of stays for corsets – which were worn by both men and women of the aristocracy in the late 18th century.

He then studied at an art school run by the Dublin Society (later the Royal Dublin Society) . Edmund Burke, the philosopher who was then a student at Trinity, encouraged Barret to paint from nature and introduced him to Viscount Powerscourt. Barret spent several years at the Wicklow estate painting the scenery including the Dargle river and the waterfall, the tallest in Ireland at almost 400ft.

In 1763, Barret headed for London, bringing some of his best paintings with him. There is a suggestion that this was because he wasn't getting enough work in Ireland, although he had also been commissioned to do original landscapes for the library at Russborough House. He had other wealthy patrons too, such as the Taylours of Headfort, but "seems to have been unbusinesslike

and was frequently in financial trouble", according to Anne Crookshank and the Knight of Glin writing in Ireland's Painters. He subsequently painted many landscapes in the Lake District, north Wales, Scotland and the Isle of Wight.

CONTINUED ON NEXT PAGE

Once that has been absorbed, the first-timer will notice how many bids the auctioneer is taking from his book rather than the floor. What he may never realise is that some of these bids are fictitious – the auctioneer is "pulling them from the chandelier", as they say in the business. Why? In order to create the illusion of demand before he reaches the reserve – the price below which he is legally bound not to sell the painting. This number is a secret – known to the auctioneer and the seller of the work, but to no-one else in the room. And why is that? Because otherwise auctioneers would have to open the bidding on every painting at its reserve price and this would greatly reduce the number of bids and eliminate some of the excitement.

So instead, auctioneers pluck imaginary bids from their "book" or from the ceiling or "take them off the wall" until the reserve is reached, pretending that there is interest in a painting when there may be none. Effectively they are bidding for the seller of the painting. "I am entitled within the conditions of sale to bid on behalf of the vendor," explains Brian Coyle. "And you have to get pace into an auction. If I said 'who'll start me at a thousand?', I would get a thousand if it was a Yeats worth four or five. But they'd know they weren't going to get it for a thousand, and they want to get on with it too. The people buying that sort of picture don't want to sit around all day. If it's too slow, you'll go asleep."

The auctioneer will usually give a verbal signal to his audience that the reserve has been reached. "And I'm selling at 10,000," he may say. Another guide as to where the reserve has been set is the published estimate. But auctioneers set their reserves in different ways. In at least one Irish auction house, some reserves are set above the higher estimate – a disingenuous practice similar to an estate agent setting a deliberately low guide price on a house in order to attract more viewers or buyers. In Britain, the reserve is usually set at 80% of the lower estimate, but will never be more than it. So a buyer at Sotheby's or Christie's who sees a published estimate of "£100,000-£120,000" can be confident that the reserve is somewhere between 80 and 100 and that is the minimum he will have to pay.

"The reserve is always meant to be the bottom estimate or 10% below," said John de Vere

CONTINUED FROM PREVIOUS PAGE

He was said to have been bankrupt by the time he was commissioned around 1780 to paint a room at Norbury Park in Surrey, widely considered his masterpiece.

Two years later Burke made him the Chelsea Royal Hospital's official painter.

When Barret died shortly afterwards he left a wife and nine children in penury. The Royal Academy had to grant them a pension. Barret only rarely signed his works, and almost never dated them.

As a result, even experts have difficulty working out precisely what he painted and where. Few of his watercolours survive.

Three of his children became painters with George Barret Junior becoming an accomplished watercolourist.

White. "If I have a picture in a catalogue at €3,000-4,000, anyone bidding knows that they'll have to spend €2,700 or €2,800 minimum, 10% below. So wouldn't it be easier to start the bidding there? Well, there isn't an auction house in the world that does that. And for some reason, and I have thought about this many times, if you're given €1m to spend on a picture and the reserve is €700,000, you would much prefer to start bidding at 450 than open at 700. There's a psychological thing."

What the auction ingénue may not know is that reserves are a key weapon in the battle to get the best pictures. Most auctioneers will set an unreasonable reserve in order to placate a demanding vendor, rather than lose the lot to a rival. But, you may say, then the painting will never sell. And there you'd be wrong: dealers and experienced collectors will sit on their hands if a reserve is too high, but buyers with more money than knowledge, and who have neglected to do their research, will bid anyway.

"I have always said to my clients that the reserve should be a price that we are disappointed with and that a purchaser is thrilled to pay," said John de Vere White. "In other auction houses I find that the reserve is the top retail price because the market is so strong at the moment, and I think that's ridiculous."

As the flow of good-quality paintings to the auction houses dried up throughout the 00s, auctioneers did not just agree to set high reserves – most of them were prepared to reduce or even forgo the vendor's commission. A seller with a top-class Yeats, for example, would have been well advised to ring around the auction houses and bargain for the best deal. He should have been able to negotiate the commission down to nothing. These days auctioneers are only too happy to make their margin by loading all the costs onto the buyers.

"One very big collector I know, with €20m worth of a collection, Sotheby's told him nil commission," said Brian Coyle. "They didn't charge the buyer in London for many years. We always did. As competition for supply increased, they reduced the commission on the vendors – from 10% down to 2% for the really big pictures. And they transferred it to the purchaser. The vendor is supposed to be paying 10% in London now – but I doubt they are charging 10% on [paintings worth] a million. If they are getting 25% off the purchaser, they don't need to."[10]

Also unknown to the first-time visitor to the auction room, the auctioneer may have guaranteed a price to the seller of the painting. This practice is now widely used by Sotheby's and Christie's – once again in order to win consignments – but not yet in Ireland. If supply tightens further but prices remain reasonably strong, guarantees may become a feature of the Irish trade too. For the moment, a favourite trick that vendors use is to give auctioneers a painting they want – such as a top-class le Brocquy – and insist that they accept half a dozen indifferent watercolours as well.

What would further perplex our first-time auction-goer would be to find out that the auctioneer himself owns some of the paintings he is selling. "We don't buy and sell ourselves,

10 The London auctioneers insist that they actually have less flexibility on lower-value paintings than Dublin firms.

we never have," said Brian Coyle. "But I think we are the only pure auctioneers. I think our competitors do. Maybe occasionally if we're stuck on a picture we'll buy it in – but that would be one in a thousand – and sell it again. But that's not the public perception. They think the rest of the auctioneers are like us, and they all do the same."

Two problems arise with an auctioneer selling his own paintings. First, imagine that he is selling two works by Maurice Canning Wilks, both estimated at around €5,000. A buyer interested in Wilks asks the auctioneer which of the two he would recommend. If the auctioneer owns one and not the other, will his advice be dispassionate and objective? Hardly, and that is clearly unfair to the vendor of the other Wilks. The auctioneer is supposed to be working for the vendor, after all.

ERIC LUKE/DARA MAC DONAILL/THE IRISH TIMES

The second problem with this practice is explained by an auctioneer speaking off the record: "Say I had a painting with a reserve of 50,000 and a client trusts me enough to give a commission bid, in advance, of 80,000. Now I know what he is prepared to pay. If my company owns the picture, there would be a horrific temptation to drive him all the way to 80. So it's important that people know what they are dealing with."

Westminster City Council's trade regulations force Christie's, Sotheby's and other auctioneers in their jurisdiction to put a symbol in their catalogues if they have an interest in a lot. Members of the Irish Auctioneers and Valuers' Institute – mostly property auctioneers – should do the same.

"Many of the new auctioneers are actually dealers," James O'Halloran of Adam's wrote in the IAVI's trade magazine in 2006.[11] "They are selling paintings as both agents and principals without letting the prospective buyers know that they have a vested interest in certain items. One well-known Dublin art dealer calculated that a certain Dublin art auctioneer owned as much as 80% of his sale. He [the dealer] should know: the auctioneer was one of his best buyers. It is unfortunate that many of these newer auctioneers are totally unregulated by any

11 The Property Valuer, Winter 2006.
12 "It would be indiscreet of me to mention anybody," he told the Daily Mail in June 2008. "Reputable people in the trade say the practice is rampant." He said everyone knew what was going on "other than the uninitiated".

Main photograph: James Gorry of the Gorry Gallery, widely recognised as being the most knowledgeable in Ireland on 18th-and-19th century art.
Left: Mark Nulty of the Oriel Gallery, reckons he can spot a fake Markey Robinson even before the bubble wrap comes off.

professional body and can operate without any ethical or regulatory guidelines."

O'Halloran repeated this criticism one year later in the same publication: "The practice of auctioneers selling items in which they have an undisclosed financial interest seems to be rampant and IAVI members should be aware that our code of conduct prohibits this practice without clear disclosure of ownership in the sales catalogue."

O'Halloran will not identify the culprits on-the-record.[12] Given the animosity between the firms, might he be talking about Whyte's? "It could not be us as I am a licensed auctioneer since 1976 and could hardly be described as 'new'," said Ian Whyte. "I do not buy works except for my clients or my private collection and the allegation made in his article could not, under any circumstance, be applied to Whyte's. His reference to a dealer supplying 80% of the works for an auction sounds far-fetched." Whyte also points out that he has never seen Adam's disclosing an interest in any lot sold by them "even though there have had to be instances where this has occurred."

Some newer and provincial auction houses sell a high proportion of dealers' stock. In one case, the auctioneer is really just a dealer having a public sale. Caveat emptor: the reserves in such sales will usually be pitched at ambitious levels. The dealers are, in effect, trying it on, taking a free bet, and hoping that a gullible buyer will take the bait.

A dealer working as an auctioneer is adopting a cunning disguise. Conveniently for him, there is no after-sales relationship with the buyer. If someone pays too much, there is no come-back afterwards with an auctioneer as there is with a dealer. "A good dealer will advise his client to pay up to a certain price," said a trade source. "The auctioneer wants to push the price to the highest point possible. No auctioneer is ever going to advise a winning bidder that

he paid too much. What a great position to be in if you are selling your own painting in your own auction. And all the time you can pose as a 'gentleman auctioneer'."

Something else our auction first-timer may note: every single lot appears to sell. Can the auctioneer be this successful? On checking the firm's website next day, however, he finds that in fact only 70% of the lots are listed as sold. So what happened to the other 30% overnight? On closer inspection he may discover that they were all sold to paddles number 746 and 733 – fictitious buyers. Alternatively, he may remember that the bidding appeared to stop just below the lower estimate (which must have been the reserve) on some lots and the auctioneer in the rostrum didn't appear to note down the number of a paddle after he crashed down the hammer. Those paintings, too, were unsold. So why don't some auctioneers publicly announce that lots are being passed instead of engaging in all this theatre and subterfuge?

Before the start of his end-of-year sale in November 2007, John de Vere White made a point of telling his audience that he would make it quite clear when a painting hadn't been sold. The move was a reaction against, and a public challenge to, his competitors. "This business that others are at [knocking down lots to fictitious bidders] is an outrage," he said. "Let's be honest: if I'm in the rostrum and suddenly I get a run of five pictures that don't sell, I might gargle over the sixth or seventh one but I wouldn't say 'sold to paddle 22'. I would do a bit of gargling because you don't want people to say 'f*ck it, they're selling nothing'. But this idea of knocking every picture in the room down to a paddle, and then it turns out they're not sold, is mind-boggling.

"I'm definitely the most transparent auctioneer from the rostrum in Ireland. It's important that people in the room know exactly what's going on. There shouldn't be any element of doubt about whether a picture sold or not. I would also much prefer if all pictures were opened at the reserve price, instead of this nonsense [of taking bids off the chandeliers]."

The different ways auctioneers bid up to the reserve price are intriguing to watch. One points to a book in front of him – as if these fictitious bids are commissions. Another swings his head from one side of the room to the other, usually picking a well-populated corner, so no-one can work out who is supposed to be bidding. "Two-four, two-five, two-six, two-seven," he goes, head swivelling from side to side almost as fast as he can say the words. Buzzer says his method is not to look at anyone in particular as he goes through this particular charade. Indeed, at his sale in June 2008, for example, he made no effort to pretend that he was taking real bids, instead calling out the numbers like a nursery rhyme until he reached the reserve, and only then seeking an actual bidder.

"It would be more transparent if the opening bid that the auctioneer sought was the reserve," he admitted. "Where there's a reserve of 100, some houses open the bidding at 50 and go up in fives. We should cut this rubbish out." But they won't. Audiences at auctions expect a bit of theatre, and want the auctioneer to be a showman. Dealers and experienced collectors know exactly what is going on. They know, for instance, that the first few lots in

every auction have low estimates, and that if the auctioneer hits a bad patch during the sale, he may run up a picture to far in excess of its top estimate and knock it down to a fictional bidder. That'll perk up everyone in the room.

Finally if our auction virgin plucks up the courage to buy something himself, he may get an unpleasant surprise afterwards – the add-on charges. If he buys a work for €14,000, our first-timer may be nonplussed to find himself paying about €16,750 after the inclusion of the auctioneer's 15% fee plus VAT (so 18.15% gross) and perhaps a 4% resale royalty, depending on where he's bought. If he has been to Sotheby's or Christie's, the extras are even higher, due to their 25% premium. There he will pay well over €18,000 for the same picture. If he has been selling, 10% plus VAT will be deducted from the hammer price. Unless he has been clever enough to exempt himself, the auctioneer may levy a further 1.5% of the hammer price, plus VAT, for insurance.[13] There's a charge of about €50 for photography. One collector who sold a number of works at a recent auction in Dublin for €54,000 was crestfallen to receive a cheque for just €46,000 after all the deductions were made.

While the buyer (and seller) should beware, there is money to be made for those who are alert. "Auction houses do foolish things too," said Robert Ballagh, no fan of the secondary market. "A couple of years ago, a work of mine was up for auction and it was an original painting but it involved silk screening in the hand, like Andy Warhol; screen printing. Because of this the auction house thought it was a print, and estimated it accordingly. Somebody I know bought it for a couple of grand when it should have sold for 10 to 15. It's that sort of thing I worry about – the lack of curatorial care that seems to be part of the auction business." While Ballagh as an artist is naturally displeased, most dealers and collectors would regard such sloppiness with glee.

Mark Nulty of the Oriel Gallery, a habitué of auction houses, is motivated by a simple motto. "There's always a bargain at every auction," he says. "At least one. And I am always trying to find it."

That's the incentive; that's what keeps them coming: the notion that you as a buyer can outwit the auctioneers, despite all their intrigue and theatre, all their machinations and manoeuvres. You can sift all the sand and find the granule of gold. Of course in order to do this you must be prepared to ignore the aesthetic worth of sculptures and paintings; you have to treat them as chips in a poker game. You most certainly do not "buy what you like."

The art market attracts all sorts: oddballs, frauds, get-rich-quick merchants, cynical tricksters, nouveau riche, social climbers, unwitting grannies buying wedding presents, and savvy experts watching eagle-eyed for the slip that hands them a bargain. "What great people to test your wits against," one dealer marvels. "That's why it's such a great game."

13 A way around this is for vendors to ring their own insurance companies and inform them that a painting is being moved from their homes into auction. Then they can inform the auctioneer that insurance is not required.

7

THANKS A MILLION, BIG FELLA

"But, oh! this business of selling paintings, and all the ridiculous false values that are placed on works of art. I would like all paintings to be free. I would like the artist to be given an annual salary so that his paintings could be given away to anybody who wanted them…I would like to take the money element out of art so that perhaps painting would be viewed in rather different terms."

Jack Smith, British artist, quoted in Conversations with Painters, by Noel Barber

ONE EVENING AT THE END OF JUNE 2006, A RECORD 300 PEOPLE REGISTERED to bid at a sale in Adam's. The Irish art market was at fever pitch that summer – *The Little Harvest, Mayo* had sold for €210,000 just a month earlier – but this level of interest in one auction was unusual given that all 67 lots were by just one contemporary artist. And it wasn't Louis le Brocquy or Sean Scully or Basil Blackshaw that had over 300 people cramming into the upstairs auction room on St Stephen's Green, it was Mark O'Neill.

Adam's was doing something quite radical and controversial here. It was trespassing on the territory of the galleries, usurping their role, by having a selling exhibition of a contemporary artist. And although the auction was being organised by David Britton, formerly of the Frederick Gallery and O'Neill's dealer, Adam's didn't seem entirely sure of itself. All the lots were being sold without a reserve price. So

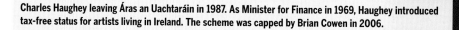

Charles Haughey leaving Áras an Uachtaráin in 1987. As Minister for Finance in 1969, Haughey introduced tax-free status for artists living in Ireland. The scheme was capped by Brian Cowen in 2006.

buyer interest alone would decide how much money was raised. O'Neill, who did soft, unchallenging paintings of dogs, cattle, sheep, marts, flowers, fruit, interiors, exteriors and still-lives, was popular and his exhibitions sold out and individual works did well at auction. But this was different; this was 67 paintings in one night. This could flop.

The artist himself was nervous. "Three weeks beforehand, with all the work framed, had I been given the option of pulling out, I would have done so," he said. "My bottle went altogether. It was a very anxiety-ridden run-in to that auction. For courtesy, I felt I should be there on the night, so I met people just beforehand and then vanished. I couldn't hack it."

He passed the next few hours pottering around St Stephen's Green. He bought some cookery books and sat in the park flicking through them, keeping an eye on Adam's entrance, checking to see if many of the 300 bidders were leaving early. At 9pm they surged out – it was over. O'Neill went back inside. "There was the excitement of walking through the auction house, and someone gave me a thumbs-up so I knew it had done quite well," he said. "Then I met David Britton and he took a bit of paper out of his pocket, tore off a bit, and wrote on it what the exhibition had grossed. And I couldn't believe it." The figure that Britton wrote on the piece of paper was €500,000. All 67 lots had sold – one for €21,000, another for €20,000, a few for €12,500, a couple for €11,000 and several for €10,000.

If O'Neill had grossed €475,000 from an exhibition in a gallery, his dealer would have taken about half. When he was represented by Britton in the Frederick Gallery, the split was 70/30 – an unusually generous division of the spoils. But with Adam's, the cut was even more in the artist's favour; all O'Neill had to pay was the auction seller's rate of 13.5%. So 86.5% of the proceeds were his, minus VAT. In short, he had earned about €0.4m in one night, one of the biggest pay-days ever enjoyed by an Irish artist.

And the beauty of it was that, thanks to the artists' exemption scheme introduced by Charles Haughey in 1969, it was tax-free. For a PAYE worker to take home €0.4m, he would first have to earn almost €1m. O'Neill, an affable and unassuming man, readily acknowledges that he hit the jackpot. "It was boom-boom time for me," he said. "The tax scheme has changed since that summer of 2006. In the budget later that year, it was decided that artists would have to pay income tax over a certain amount.[1] So in 2007, a significant amount of what I earned went on tax. But I'm a lucky guy and I'm happy with that. I think it's right that as I'm doing very well, I should contribute. So I've no qualms about that.

"Being an artist now is great. It's the best of times. How lucky are my generation of artists. A lot of other people have done well too – builders and so on – but I have the luxury of being able to sit at home and paint pretty pictures with music of my choice blasting and my two dogs at my feet. We've just got it so good."

The boom has indeed been good for artists' incomes but, as with art prices, they came from a low base. "I think it's a good indicator of the changing nature of Ireland that we all stay here now," said Robert Ballagh, who had to sign on the dole in the 1970s, and to work as a postman

in order to support himself. "Up to the 1960s, artists of every flavour emigrated. Those that stayed lived miserable existences. There were only about 50 of us when I started. It was literally impossible to make a living from painting alone. I had to do other things – poster designs and so on – just to put bread on the table. There was a handful making a living – le Brocquy always made a modest income, even back in those days. Pat Scott, possibly. But lots of artists that I knew then – Arthur Armstrong, George Campbell – lived very modestly. Now their work sells at auctions for 30, 40 or 50 grand. Boy, could they have done with that money then."

According to le Brocquy, no painter could survive in Ireland during the war years without private means. "I had no money and had to turn from painting canvases to painting murals in pubs, illustrating text books and even designing theatre sets for Jimmy O'Dea's revues at the Gaiety Theatre in order to get by," he once said.[2] In the 1950s he supplemented his income, as so many artists do, by teaching.

Prior to the current boom, one of the very few Irish artists who made decent money in his own lifetime was Sir William Orpen. He was later condemned by his brother-in-law, Sir William Rothenstein, for settling on the "golden treadmill" of portrait commissions. Bruce Arnold, his biographer, reckons that Orpen could charge £2,000 for a portrait in the mid-1920s, and his annual income was about £35,000.[3]

Orpen was the exception. Sean Collins, a Dublin dealer, represented Harry Kernoff in the early 1970s. When you look at Kernoff's paintings now and wonder why the artist used paint so sparingly, Collins says, it's because he couldn't afford it. "If he had a tube of white paint, he would make it last a long time. He had never really sold anything very much, except for around pubs – he might do a portrait of the owner. He never had any money. He'd put an awful frame on his picture – part of a fish box or something – and they'd look terrible."

Collins realised that if Kernoff's work was framed properly, it would soar in value. So he went to the artist's studio and bought a couple of hundred watercolours. "I paid him as best I could – it was good money, he'd certainly never had anything like that before. And I took them away and framed them like they were important pictures, and he hardly recognised them when he came into my gallery. He was shocked by how well they looked. After I had an exhibition of his work, I commissioned him to do three portraits of himself, phonebook size. And in the first one there's paint splashed all over the place – because he now had no problems money-wise.[4] For the last three years of his life, Kernoff was quite wealthy. After the exhibition he was in vogue and much sought after. People were buying his stuff. So he had at least three years of pretty good life – which was something."[5]

1 €250,000 a year.
2 Irish Arts Review, Summer 2006.
3 Orpen: Mirror to an Age (London,1981).
4 The work is now in Dublin City Gallery the Hugh Lane.
5 Kernoff died in 1974, at the age of 74. His auction record up until 2008 was the £119,000 sterling fetched by Sotheby's in the Irish Sale of 2001 for In Davy's Parlour Snug: Self portrait with Davy Byrne and Martin Murphy. But in June 2008, Adam's sold A Bird Never Flew on One Wing for €180,000 after some clever promotion. One of the bidders saw the painting on the RTE Six-One News about half an hour before it was auctioned.

Detail from Mark O'Neill's Outside the fuel shed which sold for €28,000 in his second single artist auction at Adam's, June 2007.

Mark O'Neill 2007

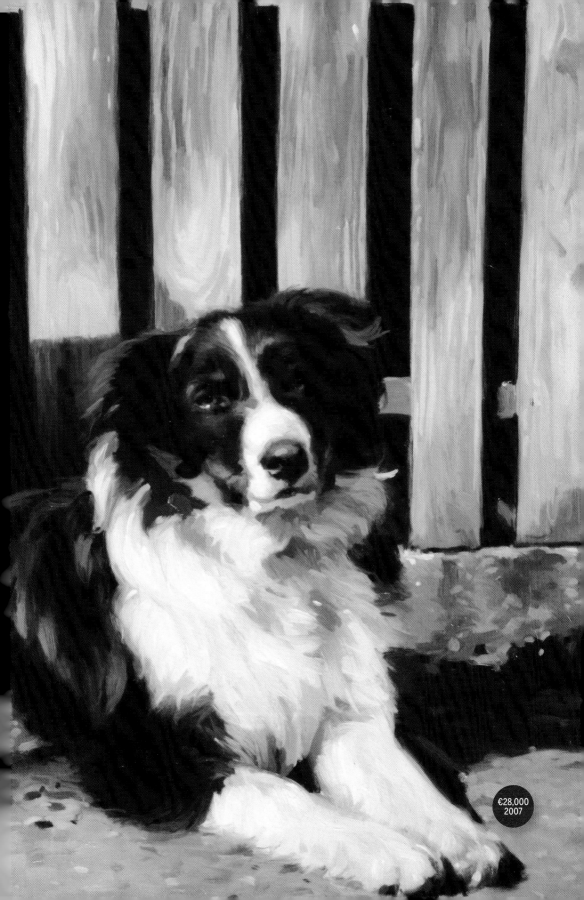

€28,000
2007

That was more good years than many had. Antoinette Murphy recalls that when she and her husband started collecting in the 1960s, artists were literally starving. "They didn't have enough to eat. They were lucky if they sold a couple of pictures in a show. We knew these artists, they were friends of ours. There were few galleries and few buyers," she said. "Now these artists have as much money as they want, and in some cases are buying the work of younger artists. I think that's such a terrific turnaround."

Mark O'Neill has seen both sides. He was born in 1963 of an English father and an Irish mother. Growing up in Southport, he was inspired in secondary school by a brilliant art teacher who taught a realistic style of painting. O'Neill got into art college at a young age, able to skip the foundation years because he had such a good portfolio, and for three years studied graphic design. Afterwards he got a job as an illustrator, working for clients such as Harrods, Guinness and Southern Comfort, designing posters for Warner Brothers, including the 1987 film *The Big Easy*, the one featuring a sultry Ellen Barkin and Dennis Quaid.

O'Neill's main job was designing book jacket covers. For two years he worked on Catherine Cookson novels. His bosses would constantly ask for more frocks and mist; he worried about being typecast in romantic fiction. A split was inevitable, and it happened on the sixth Cookson book. He had hired models and costumes and spent two weeks doing the illustration, and at the last minute they asked him to point the carriage a different way, or something. "I said I'd change it but there'd be a fee, and they wouldn't pay any more. And that was it. A few months later my book jacket appeared but another artist had finished it. This went to court, and I won, and I got my 2p for every book in WH Smiths. So I had £12,000 and it meant I could come to Ireland and buy a little place, which I did in the late 1980s."

Childhood summers had been spent in Laois, his mother's home place, so it was to the midlands that O'Neill gravitated, ending up in Tullamore. His plan was to carry on doing illustration work for London clients, but it didn't work out. He ended up missing deadlines, and the business dried up.

"So I started teaching secondary school students, getting them ready for art college," he recalls. "I was teaching them privately – £2.50 per night – in an old barn. It was quite convivial, paint flying, plaster of Paris – everything was let rip. I was doing demos for the students. I once set up a still life of bricks and masonry, and rather than let them paint – because we were using acrylics – they watched me painting, and I ended up with a nice one. I put a cheap frame on it – because money was tight – and it ended up in a coffee shop in Tullamore and sold immediately for £100. And then the coffee shop asked for more, and their customers began to ask 'are you getting any Mark O'Neills in?' and that was the start of it."

The realisation that he could sell his work to ordinary people was an eye-opener for O'Neill. In England, buying original artwork is a hobby of the titled and the rich. On the wall of a typical middle-class British household are prints – a Jean-François Millet painting of children crying, or maybe Renoir's *Umbrellas*. "It was a revelation to me that people wanted

original art work on their walls," the artist said. "I could bring you to houses here – such as the butcher's wife in Bunclody who I think has 38 of my paintings now – where there are obsessive collectors. You'd never know – your neighbour could have a huge collection. In Lancashire, where I grew up, the homes I visited had prints."

But selling a few works in the local coffee shop was not going to earn him a living in the Ireland of 1988, especially as O'Neill worked in a painstaking fashion and his output was low. He still struggled financially. Paying the electricity bill was an achievement. "I was really thin, under-weight, it was tough," he said. "Other than the few paintings selling in Tullamore I was thinking 'look, this is the end of it, I'll have to get back to London' and go back to doing what I didn't want to be doing.

"I went for a few interviews for teaching jobs in Ireland, but I didn't have the Irish language qualifications. I have never drawn social welfare, but that was just around the corner."

He rang around some more venues to see where else he could put paintings, and then a few galleries started ringing – the Forge in Co Louth, among them – and word of mouth spread about O'Neill. "Over the space of two years it really started clicking and eventually I eased out of teaching," he said. The Frederick Gallery offered him an exhibition in 1996 – his first show in Dublin – and it sold out, so they offered him another one. "In the last 14 years of painting, everything has sold. From the Tullamore days of scraping the barrel, it's been gratifyingly quick. I'm not cocky about the success. I'm still thinking – 2008, will it change? I'm the type of person who will always be looking over the shoulder."

O'Neill was battle-hardened from his early career in London. He had seen publishers creaming it and illustrators take the left-overs, and was determined this wouldn't happen to him as a painter. So when Britton offered to become his dealer, O'Neill asked for a higher commission than any other artist in Ireland was getting, and he got it. "Maybe David Britton had a hunch that the paintings would sell, and felt his gallery could afford to drop the rate a little," he said. "But some galleries go in the opposite direction and think 'let's charge him more so he can carry other shows that mightn't sell so well'. Other galleries take 50% and out of the artist's share comes the postage, catalogue and framing, so he could end up with 30% of the sale price, which just isn't fair. Some of these galleries are in expensive premises and I'm sure high overheads are a factor. Maybe the Frederick's rent was a little lower but I think, basically, David is a decent guy, he's not a robber."

Now O'Neill's output was unashamedly moulded to the demands of the market place. One of the first instructions Britton gave him was to reduce the size of his signature. For his third exhibition O'Neill did a theme of boxes and truck drivers. 'Whoa," Britton told him. "Hang on a minute. You've got to be really thinking about the market place." O'Neill stresses that he wasn't told not to paint certain things, just to be realistic about what buyers would like. So boxes, truck drivers and masonry disappeared from his repertoire, to be replaced by sheep

HARRY KERNOFF

BORN: 1900 IN LONDON

DIED: 1974

PAINTING STYLE: REALIST

HIGHEST PRICE AT AUCTION: €180,000 (ADAM'S, 2008)

FANS SAY: THE MOST AUTHENTIC PAINTER OF DUBLIN AND ITS PEOPLE IN THE 20TH CENTURY

CRITICS SAY: ESSENTIALLY A GRAPHIC ARTIST, HE TENDED TO OVER-EMPHASIZE BANAL DETAILS.

IF YOU COULD OWN ONE: BANK HOLIDAY, KILLINEY, CO DUBLIN

BEST EXAMPLE ON PUBLIC DISPLAY: SUNNY DAY, DUBLIN, 1943 (AIB COLLECTION)

Aaron "Harry" Kernoff was born in London to a Russian/Jewish cabinet maker and a Spanish mother. The family moved to Dublin when he was 14 and his father, Isaac, became a bespoke furniture maker. His son, while apprenticed to the family business, attended evening classes at the Metropolitan School of Art. In 1923 he became the first evening student to win the Taylor scholarship in both oils and watercolours. Jack B Yeats was among the judges; Sean Keating was among his teachers.

From the early 1930s he began to do portraits of the famous Irish people of his day, in pastels, watercolours and woodcuts. Subjects included literary figures – Behan, Kavanagh and Joyce among them – but Kernoff was just as interested in the "characters" of the Dublin pub scene. He rarely moved outside Ireland – apart from a trip to the Soviet Union in the 1930s and a summer in Nova Scotia – but travelled extensively around the country, painting extensively in Kerry and Mayo.

A small man with thick glasses and a big black hat, he cut a highly recognisable character around the Grafton Street area for decades. An excellent illustrator, he produced drawings for theatre sets, periodicals and publications. His painting style shows a variety of influences, including modernist ideas in the early part of his career and cubist influences later. But in the end he rejected these styles in favour of a realistic

€180,000
2008

approach to his subject matter, and his oeuvre has left sociologists and historians with a wealth of historical detail about the capital and its people. Kernoff's work is now a consistent performer at auction, its sentimental and jocular tone having won a large following during the boom. A striking self portrait with Davy Byrne, owner of the pub of the same name, and Martin Murphy, a set designer at the Gate Theatre, was bought by Andrew Lloyd Webber at Sotheby's in 2001 for £119,000. A Bird Never Flew on One Wing, which had hung in the back bar of O'Brien's pub on Leeson Street for over 30 years and which lists Dublin bars (the names of which Kernoff sourced from the telephone book) broke that record at Adam's sale in the summer of 2008.

dogs, horse fairs and pretty interiors.

He agrees that it was a formula, one he could use to produce 80-90 paintings a year. Weren't they a bit chocolate boxy? "Guilty as charged," he replies happily. "It's what I'm into – the still-lives with pretty jugs and windows. I like pretty things. I like having a house with interesting collectables – that's me. The painters that I like – such as John Singer Sargent [6] – paint beautifully and sweetly. I'm lucky that the type of painting I do is what people want to buy. I don't know if I could paint more masculine, aggressive things if the market was different."

When Britton was head-hunted by Adam's in 2005, O'Neill initially wasn't sure whether to follow him. But he was persuaded that nothing would change for the worse – he would be looked after as he always had been, his shows would still sell out. Suspicious and wary of galleries, O'Neill was easy to convince. So the Frederick Gallery closed in 2005 with his show, and it was agreed that his next exhibition would be with Adam's the following year.

"I knew this was a new model, that artists hadn't exhibited with auction houses before, so I was a bit worried," he said. "But my paintings had done well at auctions and in 2006 there wasn't a whisper of the Celtic Tiger slowing down. It just looked like boom time. The real thing that swung it is that towards the end of my time at the Frederick, a lot of people were saying to me 'how do we buy Mark O'Neills?'. Because on the opening night of the exhibitions, they were all sold. So I felt that in auctions, nothing is sold in advance. The bravest wins."

There were 66 paintings in O'Neill's second auction with Adam's in 2007. That was one fewer than in his debut year, and on the night[7] three of the 66 didn't sell, though they did afterwards. The sale grossed €404,000, with a top price of €28,000 for a portrait of the artist's two dogs sitting outside a shed. A painting that featured on the cover of the catalogue – one of the artist's dogs sitting beside a chair – made €22,000. Britton professed himself "delighted" afterwards, and insisted that he never expected the success of 2006 to be repeated. But with other dealers and auctioneers publicly stating that they believed O'Neill works were now "fully priced", there were warning signs that Adam's shouldn't pursue this auction model much further.

"Effectively it was a sell-out again. A little bit less was grossed, there wasn't quite the same number of paintings and I wasn't as happy with the exhibition either," said O'Neill who, nevertheless, took home about €250,000. "It had been a rough year to get an exhibition together – which happens. Some years are better than others. The top images – sheepdogs – flew through the roof and the top prices exceeded the top prices of 2006. But a few still-lives struggled, just got to their estimates. It's the unpredictable nature of auctions that have me worried. I like the idea of being in control of the price."

What exposed O'Neill further was that other artists hadn't follow along the trail that he pioneered. Martin Mooney, a Belfast-born painter who is also represented by Adam's, was expected to have an auction/exhibition in 2007 but instead chose a fixed-price sale. O'Neill

admits that Mooney's change of heart was a factor in his decision not to have an auction in 2008. Britton said he was comfortable with that choice: "It was a good idea to have auctions originally. It set a level for the pricing. Now the prices have levelled out."

O'Neill is now likely to slow down his output, conscious that the market cannot indefinitely handle up to 100 fresh paintings every year. He feels confident enough to do that now, is calmer about his success, would like to put more excitement into his work. He thinks he'll take his time over some large-scale, adventurous paintings, using big brush strokes.

As with many artists, he ploughs some of his earnings back into art. He bought half a dozen Martin Mooney paintings at Adam's exhibition in 2007 – he'd been struggling to get this artist's work through dealers. "I'll go into a gallery [and buy] if they have a show I want, but I'll go the auction route too," he said. "I scour the catalogues when they come in. I'd love a George Campbell, and I bid over the phone for *Showery Night* at the Adam's sale in December 2007.[8] It's exciting. I'm delighted when I get something, but you worry that you spent too much. I buy on the internet too, with mixed results. There have been some disasters, where I took the painting out and just used the frame."

This is not about supporting his fellow artists – he buys paintings that he considers a good investment. With Shinnors and Teskey, he thinks he's missed the boat. Their prices will keep going up. "People have said to me over the last five years 'can it keep going?' And it has kept going. I think the market is better than ever."

THE TAX-FREE COMMERCIAL SUCCESS OF ARTISTS SUCH AS O'NEILL HAS LED TO GRUMBLING IN other parts of the market. Wasn't the whole point of the tax exemption scheme set up by Charles Haughey in 1969 to support struggling artists, not to be the icing on the cake, the jam on the bread of wealthy, best-selling painters? The introduction of droit de suite, the resale royalty, in 2006 – giving artists a percentage every time their work sells at auction[9] – caused even more resentment in the trade. Stories circulated about artists making excessive demands on their galleries. Some of these painters, it was felt, had become far too big for their boots.

"They're too well looked after," snorted Garrett O'Connor, the art auctioneer. "The rest of us have to go out there and earn a living, and whatever we do we have to pay tax. There's artists living here earning up to a quarter of a million and not paying any tax on it. That's absolutely wrong. Everyone should be taxed. Struggling artists are the ones that should be looked after and given grants. The likes of Mark O'Neill should be seeding back, developing the younger ones who can only earn €30,000 from a show."

"Some artists are very greedy," O'Connor continues. "It's hard to work with a lot of them. If I get a good price for an artist, say €5,000, he'll then start going to the market and looking

6 Born in 1856 in Florence to American parents, Sargent was a successful portrait painter who progressed to landscapes and completed over 2,000 watercolours.
7 27 June 2007.
8 See Chapter 11 for a fuller account of this auction.
9 On which subject, much more in Chapter 11.

JOHN DOHERTY

BORN: 1949, KILKENNY

PAINTING STYLE: PHOTOREALIST

HIGHEST PRICE ACHIEVED AT AUCTION: €84,000 (ADAM'S, 2007)

FANS SAY: HIS PICTURES CONVEY AN IMMEDIATE, SOMETIMES RAW PRESENCE AND HIS TOUCH WITH PAINT IS SKILLED, THOUGH UNSHOWY

CRITICS SAY: WHY NOT JUST TAKE A PHOTOGRAPH?

IF YOU COULD OWN ONE: OLD DOCKYARD BUILDING, CASTLETOWNBERE

BEST EXAMPLE ON PUBLIC DISPLAY: THE OLD FOX, MOUNT CHARLES, CO DONEGAL (MERRION HOTEL)

After training as an architect at Bolton Street college, John Doherty moved to Australia where he studied art, then travelled the world and eventually settled in Melbourne, but returned regularly to Ireland for his artistic inspiration.

Doherty adopted a photorealist style, using buildings in small, rural Irish towns as his main subject matter. Photorealism developed in the 1970s as a reaction against abstract expressionism. The artist works from photographs, using a variety of technical processes to transfer static images onto the canvas.

One process (which attracts scorn from conservatives) is to use a slide projector, with the artist drawing over the projected image. There is, however, a great deal of skill then required by the artist to make the image appear photographic.

As with Doherty, the photorealist artist usually chooses man-made structures, the better to show off his technical ability. The result is paintings more real than photos, which are flat, shallow and lack detail. One of Doherty's main themes has been street scenes, especially doors and windows. There is a nostalgic aura about many of his paintings, which have captured an Ireland that is passing, especially traditional shop-fronts and rural petrol stations that are being replaced by

€84,000
2007

IMAGE COURTESY OF ADAM'S © JOHN DOHERTY

homogenised chain stores. Another subject is marine objects – buoys, lighthouses, old boats. "Doherty haunts harbours and scrap yards, collecting favourite craft, which speak to him visually," said critic Hilary Pyle in advance of a 2008 exhibition. "[He paints] layer upon layer in oil or acrylic, investigating beneath superficial surfaces the hidden nuances that underline each image." He has exhibited several times at the Taylor Galleries in Dublin, and had solo shows in Australia. His work hangs in the National Gallery of Victoria and the Institute of Modern Art in Chicago, but he has only come to the attention of Irish collectors in the latter half of this decade.

171

for five grand off everyone. Or if I put his picture in at a reserve, he'll say 'I want more'. They always want more. The contemporary artist can be greedy, no doubt about that."

His sentiments are echoed by Suzanne Macdougald of the Solomon Gallery, who believes the money has gone to some artists' heads. "A lot of young artists flounce around and some have become very greedy," she said. "Loyalty has totally gone. The scene has changed enormously. I don't like a lot of it. When things are going well, it's all the artists' doing. When things are going badly, it's all your fault. Artists are difficult to deal with, generally speaking. They've difficult personalities, and it's a very solo life, working by themselves a lot of the time. Some have problems with alcohol and depression. It goes with the psyche. They're not the easiest people to work with. They need constant reassurance."

These are still minority views, however. The consensus is that a few artists are doing extremely well, but nothing like as well as leading earners in other occupations and professions. "I know one of the top 10 artists in Ireland," said Ian Whyte. "He does about 30 works for an exhibition every two years and a couple of commissions in between. The show might pull in €100-150,000. He pays no tax on that, so it's the equivalent of being paid €100,000 a year. But the top ten of any other occupation wouldn't look at €100,000."

Due to the Freedom of Information Act, the Revenue Commissioners now publish the names of everyone who successfully applies for the artists' exemption scheme. In the period from 1 April 2002 to 31 March 2008, some 1,146 "painters" got this exemption. Under the Revenue's liberal definition this included 81 "artistic photographers" and six cartoonists. There were 259 sculptors availing of the tax scheme, of which at least 30 were doing installation art pieces. So in total, 1,400 or so[10] visual artists joined the tax-free scheme in that six-year period. The names of the many hundreds of artists who applied before 2002 have not been published by Revenue, so apart from Mark O'Neill and John Doherty there are few big earners on the current list – no le Brocquy, Kenneth Webb, Basil Blackshaw, Kingerlee, William Crozier, Shinnors, Teskey or Peter Collis.

Revenue has said that over half of those in the scheme had artistic income of less than €10,000. This statistic has sometimes been used by art lobbyists to argue that most artists are living in penury. On the other hand, 59 artists who avail of the scheme declared income of over €200,000, and grossed a total of €56m. Publication of *that* statistic caused considerable envy, and undoubtedly influenced Brian Cowen's decision, as minister for finance, to make artists pay tax on income over €250,000 a year.

The problem with all these statistics from a visual artists' point of view, however, is that they include musicians and writers. The tax-exemption scheme is also used by songwriters, journalists, novelists, playwrights and celebrity authors. In the same period as the 1,146 painters and 259 sculptors joined the scheme, so did 205 playwrights, 575 authors and 281 musicians. The writers' section is a particularly eclectic selection – with everyone from Cecilia Ahern to Charlie Bird, with memoirs by the likes of rugby pundit George Hook and former

Labour party leader Ruairi Quinn, chick-lit by Claudia Carroll, comedy scripts by Mario Rosenstock, and a novel by Irvine Welsh, author of *Trainspotting*. The reason why so much non-artistic fare qualifies is because the legislation setting out the terms of the exemption scheme says that work must be of either artistic *or* cultural merit. The term "cultural merit" is being interpreted quite generously.

The inclusion of authors and musicians in the Revenue's figures means we cannot deduce much about visual artists' incomes. In the top 5%, the 59 "artists" who had annual income of €200,000 or more, there may be 10 painters, but there's hardly more. Many of these top earning "artists" are musicians – undoubtedly U2, Westlife and Van Morrison are in this elite group, and you could surmise that the likes of Ronan Keating, Daniel O'Donnell and Andrea Corr are thereabouts too. Several bestselling authors are in that top 5% also – any or all of Maeve Binchy, John Connolly, Cathy Kelly and Irvine Welsh.

Similarly, there are many writers and musicians in the bottom-income group – those earning less than €10,000 – so we can't presume that most of those are painters either. The author of any modestly successful memoir or novel published in Ireland earns €10,000 or less. Remember that the tax exemption only applies to income from artistic projects. In the same way as most authors have day-jobs as journalists, politicians and rugby pundits and pay tax on income from those sources, the vast majority of artists have jobs as teachers, childcare workers or art officials and pay tax in the normal way in those occupations.

While the tax exemption benefits every Irish artist, there is another support scheme which helps just a select few. It derives from another idea of Charles Haughey's – Aosdána. Members of this self-selecting group of elite artists are eligible to receive a grant from the Arts Council, known as a cnuas. The value has been small. It was €12,180 a year until 2008, when it was decided to increase it to €20,000 over the next three years. To qualify, an artist has to make an assertion that his income is not more than one and half times the value of the cnuas – so €18,270 has been the threshold.

This is a nonsensical requirement – sustaining oneself on such an annual income would be almost impossible – and is probably being ignored. Among the visual artists in receipt of the cnuas in 2007 were Felim Egan, a successful contemporary artist represented by the Kerlin Gallery, and Dorothy Cross, a sculptor also represented by the Kerlin and whose work also commands good prices.

There, too, were Martin Gale, Edward Delaney and Maud Cotter who, as *Phoenix* magazine pointed out in an article on this subject,[11] "have achieved significant reputations and exhibited widely". *Phoenix* argued, plausibly, that "the evidence suggests that more visual artists should be relinquishing the cnuas during this boom period, which would not prevent them from re-entering the system during the lean years that inevitably lie ahead."

10 Some people applied in two categories, e.g. sculpture and paintings, or applied twice in one category so there is an element of double counting. See http://www.revenue.ie/index.htm?/publications/lists/art_list3.htm for the full list. It's updated a few times a year.
11 'High Society' 4 May 2007.

Several artists have handed back the cnuas – most famously John Banville, the author, who said he wanted to make way for a young writer or an artist in greater need of financial aid.[12] Banville said the cnuas had at one point kept him off the breadline: "I was very grateful for it. It's a wonderful, marvellous thing." But he suggested that other artists didn't need the cnuas any more either and should be making way for needier people. Perhaps if Aosdána set a more realistic income requirement, and then enforced it, the cnuas might become a "wonderful, marvellous thing" again for young, deserving artists.

Another boon for contemporary artists is the growth in corporate collections. In the 1970s, fewer than half a dozen companies bought art as a means of supporting painters as well as decorating their walls; now there are up to 100 such collections. Flick to the back of the Taylor Galleries' catalogue for John Shinnors' Twenty Two Paintings exhibition in 2004, to take a random example, and you find that the Limerick artist's work is the collections of AIB, Analog Devices, Bank Trust (a company in the International Financial Services Centre in Dublin), Coopers & Lybrand, Dunlow Ewart, GPA, Insurance Corporation of Ireland, IONA Technologies, Irish Aerospace Ltd (in Shannon), Irish Cement, Irish Life, Irish Management Institute, Jurys Hotel, Shannon Development, United Drug, University of Limerick and Wexford County Council.

Undoubtedly some companies have an eye to the investment potential of the works they buy – and Aer Lingus raising about €0.6m by selling 20 paintings out of its storeroom in 2001

Left: Dorothy Cross with her work Amazon at the Irish Museum of Modern Art. Above: Felim Egan in his studio. Both artists are represented by the Kerlin where they have a strong following. Both artists were in receipt of a cnuas in 2007.

was proof that there is money to be made if companies pursue a savvy purchasing policy. But many firms make a virtue of buying with their eyes rather than their ears. Microsoft, for example, which employs over 1,200 people in Ireland, says it buys to please its workforce. The company's collection was started in 1996 and is managed by a voluntary committee of employees.[13] Workers choose pieces from exhibitions held in Microsoft three times a year, with each show lasting about three months. Just over one-third of the exhibited works are bought each time, by artists such as Mary Rose O'Neill and Eamon O'Kane.

Axa, an insurance company, takes a similar approach. It started a collection in 1995, hiring an artist, Bernadette Madden, as adviser and purchaser. She sources work mostly from graduate shows and from galleries, but never from auctions, so that artists are supported directly.[14]

Another support for contemporary artists is the annual Royal Hibernian Academy exhibition, held in Dublin each summer. It features over 500 paintings, sculptures and photographs, some by members of the RHA but mostly by artists who submit up to three pieces at a cost of €15 each to an open competition, which is judged by a committee of 10-12 Academy

12 The Irish Times, 13 December 2001.
13 Circa art magazine, Spring 2000.
14 Ibid.

members over three days. The RHA exhibition has flourished in the boom. Artists tend to price their works ambitiously, and are often rewarded. In both 2006 and 2007, the exhibition grossed over €1m, with the RHA taking a 25% commission. Top prices in 2007 included €85,000 for a Peter Curling and €65,000 for a Blackshaw. About 15,000 people attended the exhibition, and some artists sold several pieces. John Coyle and Brett McEntaggart both sold six out of seven works for a total of €27,300 and €29,000 respectively.[15]

The boom also made it easier for artists to go it alone, selling directly at art fairs or off the railings on Merrion Square. Being a "personality" from another sphere helps, as Kevin Sharkey and Thelma Mansfield, both former RTE presenters, have proved. You also need to offer "affordable art", selling for no more than €1,500 a painting, and the subject matter should be safe and jolly. Louise Mansfield, Thelma's sister, is perhaps the most successful of this group, with images of children playing, ballet dancers, and sailing boats. For those who crack the market, as Thelma and Louise appear to have done, the returns can be phenomenal.

"There's one particular artist who sells on the railings and at art shows and they go like hot cakes," said Ian Whyte. "They're €1,200 -1,500 a piece, and the same ones over and over. It's just a formula, almost a manufacturing process. At a show in the RDS, that artist sold 100 pictures in one weekend, earning about €120,000. That's 100 grand for the weekend. Imagine what they're doing over a year? And of course up to €250,000 it's tax-free. The critics and most galleries regard the work as utter crap. It's the buyer who decides, however. Isn't the customer always right?"

While the honey pot is bigger, there are a lot more artists buzzing around it. "I'm not sure for the younger artist starting out now that it's any easier than when I was," said Robert Ballagh. "I knew every artist in the country. There were about 50 of us. Every year now a couple of hundred graduate from art colleges. I think young artists struggle – unless they can make that leap from being unknown to barely known, which is hard."

In fact, only a fraction of art college graduates become painters and sculptors. The courses, such as those provided by the National College of Art and Design, prepare them to be curators; arts officers working for local councils or firms; product and web creators; gallery owners; clothes, jewellery or hat designers.[16] There is a strong take-up of these graduates in the workforce.

So, yes, the art boom has been good for its practitioners. Frances Ruane says: "It has allowed a lot more artists to live decent lives without having to get a million other part-time jobs to support themselves, to build decent studios, to not be up to their necks in hock. It has allowed smaller galleries, popping up all over the place, to make a living, as well as less well-known artists who wouldn't have a chance of getting near the upper tier. It's been good for everybody."

15 The Irish Times, 30 June 2007.
16 NCAD awarded 275 degrees in 2006, half of them to design graduates. "About 30% would be artists," said then college head Colm O'Briain. "So each year we would be graduating 40-50 students who have specialised in fine art. They become self-employed, setting up small to medium-sized enterprises. They either collaborate to set up a framework by which they can exhibit or create studios."

NO, IT'S NOT A LACK OF MONEY THAT'S THE PROBLEM NOW, IT'S THE AUCTION MARKET. ARTISTS are mesmerised by it, enthralled, thrilled when they get big prices, and simultaneously resentful, suspicious and condescending about auctions and their flashy buyers. One part of them loves their work being hammered down for a record price – it means they can use Tippex and a black marker on the prices of the works in their garages and storerooms. Another part of them hates it – they get only a tiny fraction of the price in droit de suite, and eye-catching auction results attract speculators.

An artist may have been carefully nursing a customer base, edging prices up a thousand or two at each exhibition every couple of years, then bang! A price treble or quadruple what he normally asks is achieved at auction, maybe because of one over-enthusiastic bidder who couldn't get on the gallery's waiting list. The gallery can't jack every price up to the auction level – all those customers, so carefully nurtured, would disappear. But nor can the auction price be ignored; because too great a disparity between what the artist's works fetch at auction and his gallery price is an invitation to speculators to buy and flip.

Worse yet, some of the flippers will be the artist's friends. He sold them paintings cheaply in the 1980s and 1990s, and now that he's "hot" they're cashing in, making thousands from his work, his inspiration.

No-one more embodies all these contradictory feelings, no artist carries within him such a wide spectrum of emotions about the auction market, as John Shinnors. He bursts with pride as he tells you about his first big auction price. He remembers where he was, what he said when he heard about it. "It was a strong piece, large enough, I liked it a lot," he recalls. "This was back in the early 1990s. I gave it to the RHA for nothing, for a benefit. It was auctioned on a Friday night. I was in the pub and got a call on the pub telephone from a pal of mine.

'Do you know what your picture is after making? Ten thousand pounds.'

'Jesus, did it?' says I. 'Really?'

It was worth £10,000 though, you know? It easily was. It was a very strong picture – *Scarecrow with a vision of Mars* – and I really liked it. But I was also surprised, in a way, that £10,000 was paid for it. You wouldn't have many contemporary works fetching that unless they were huge, or if Bobby Ballagh had done something special. People at that auction then wanted to see other pieces of mine."

Shinnors can't pinpoint exactly when the tide turned for him, when he went from being an obscure but respected artist known only to a tiny clique of collectors to being the hot property of the Irish auction rooms, a painter whose works were fought over on the floor of the Taylor Galleries. But that £10,000 sale was a catalyst. "Everything changes after something like that."

In 1998, John de Vere White bought a large, 4ft by 4ft Shinnors from the Taylor Galleries for one of his clients; he paid £3,000 for it. "This very wealthy fellow who lives on my road,

the picture was in the hall of his house," Buzzer said, "and I went in after a year and said 'why aren't you hanging up the John Shinnors?' And he said 'it's too big, I can't fit it anywhere'. So I said 'sure we better sell it then'.

"We brought it into our summer sale in 2000 and two people started to bid for it – one wealthy fellow who was getting married and the fiancée wanted it as a wedding present; and the fellow he was bidding against, his wife wanted it. Heaven for the auctioneer. We sold *Badger and Young Underland* for IR£36,000. Now the Shinnors pictures that had been selling for £4,000 in John Taylor's, they weren't £24,000 in the next sale, but they were £6,000. So he was able to increase his gallery price by 50% because of this one-off auction price. That sale was responsible for shifting Shinnors onto a new level."

PADDY BENSON

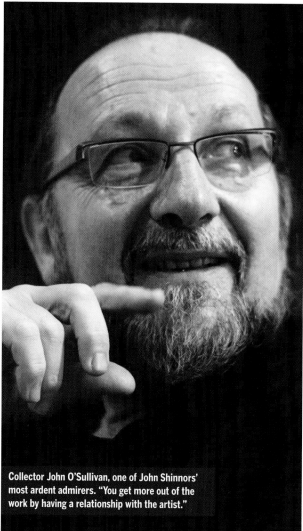

Collector John O'Sullivan, one of John Shinnors' most ardent admirers. "You get more out of the work by having a relationship with the artist."

Record prices at auction had the same effect on Donald Teskey, John Doherty and several other contemporary artists. It made them desirable; overnight every serious collector wanted one. Doherty, another artist represented by the Taylor Galleries, made his auction debut at Adam's in December 2005 when five of his photo-realist works from the collection of Ernie's Restaurant in Donnybrook were offered for sale.

The highlight was *Old Dockyard Building in Castletownbere* which Adam's displayed in its front window. The work was estimated at €10,000-15,000.

"I was sent up to that auction by a very rich man in Dublin and told to go to 50 on it," Buzzer said. "And we weren't successful. It went for 56." Adam's had several offers of over €20,000 on its books before the auction, with five bidders in

the room and another nine on the telephone. Doherty had come into his kingdom. "Ever since that sale you can't for love or money get near a John Doherty," Buzzer said.

But just because high auction prices made John Shinnors' reputation doesn't mean John Shinnors has to like auctioneers. In fact, he's deeply suspicious of the business. "The only place you can be sure that it's straight is a cattle mart, because you know all the farmers and so you can spot if someone is a stooge," he says. "Art is a commodity to the auctioneer. Some of them were at marts a few years ago; next thing they're into art."

He recalls the time an auctioneer planted his son outside the Hunt Museum in Limerick at 7.30am one Friday in order to be first into their Christmas exhibition – so he could grab the only Shinnors painting. Some of these auctioneers, the artist says, "are about as transparent as a piece of Perspex."

He feels let down, too, by people who twist his arm to sell them a painting, only to flip it. He once gave a present to somebody – "it was a personal picture, from a scene I remembered in London, a bed on a Sunday afternoon" – and it was sold within nine months. "I told him: 'remind me never to give you anything again'." But then there was a woman to whom he gave a small work on paper. She sold it, but Shinnors knew her circumstances were poor. She came up to him in the pub to explain. "I said to her 'look, you can't eat the wallpaper. I understand'."

It's profiteering he hates. He once asked a wealthy man he knows, who has 20 of Shinnors' paintings, 'what keeps you going?' The man told him making money was the heartbeat of his life. "I've been making money all my life and I'm very good at it," he said. Shinnors doesn't understand that motivation. He's reasonably well off now, but money isn't his muse. He lives in the same house, still drinks in the Spotted Dog pub. He's considered getting a friend to put one of his paintings into an auction. It would make far more than in an exhibition, and he wouldn't have to pay the gallery commission, but he won't do it. "I think for artists who are serious about their work, who want as many people to see it as possible, and want to get recognition in the press, galleries are the avenue to achieve that," he said. "I'm comfortably off. I'm not exactly mad about money. I live in a working-class area. I wake up every morning and wonder if my car was vandalised last night."

He has a little contacts book with the name of everyone who's bought his pictures. Between the pages of it are letters from fans who want to buy more. He's not prolific – maybe 20 works a year – and he refuses to turn his easel into a production line. "I could churn them out – black and white, more Shinnors, black and white – simple. And all the people in that contacts book, I could ring them up and say 'your picture is ready'. But I've become selective."

His favourite quote is from Mao Tse Tung – "when you open a door, some flies get in". When you offer your paintings for sale in an exhibition – open the door – some undesirable types with improper motives – flies – get their hands on your work. It happened in May 2007 when Shinnors took part in an exhibition at the John Martin Gallery in London. A speculator

flipped one of the six paintings into Morgan O'Driscoll's sale in Cork within months. John Martin contacted Shinnors to apologise. "He wrote to me – he was very irate – and said 'I've shielded myself against the profiteers'. But I said 'John, there's nothing you can do. As Mao Tse Tung said, when you open a door some flies get in. Galleries can't screen customers when they come in and want to buy a picture'."

But Shinnors screens them. That's how much it matters to him who buys his work. He doesn't deal with dealers, but he did a commission for one. "And we were here in the studio and I said 'listen to me now; you promise me you'll not resell those paintings. You have to say that to me'. He said 'I promise'. I kind of trusted him. And I know he didn't sell them. He wanted them for his apartment in Dublin."

All of this fastidiousness leaves Shinnors' collectors in an awkward position. At least one bought his work in the 1980s in order to support the artist. Now that he's doing well, where's the harm in turning a little profit for themselves?

John O'Sullivan is one of Shinnors' most ardent admirers. He remembers where he was when he first fell under the spell of the Limerick artist's work. Walking down Baggot Street one afternoon, there was an exhibition in the Bank of Ireland centre – a group show of le Brocquy, Crozier, Tony O'Malley, Charlie Brady, artists he knew. "There were two small Shinnors. At first glance they looked abstract, and then you started to see the shapes. They were dark and mysterious. I liked the darker end of the palette so I was drawn to them, even though I'd never heard of Shinnors before."

There was an exhibition at the RHA some time afterwards, and O'Sullivan bought a big Shinnors there, *Bank Holiday Weekend*, for IR£1,200. A few months later he got a padded envelope from Limerick and inside was a card from John Shinnors and a watercolour that was a study for the painting. From there, a relationship started. O'Sullivan likes to get to know his favourite artists, to find out what makes them paint as they do, to talk to them about their art. "You get more out of the work by having a relationship with the artist," he said.

Shinnors, he would like to think, got a lot out of their relationship too. O'Sullivan, an executive with IONA Technologies, introduced his work to the IT millionaire market. Two of the founders of IONA – Annrai O'Toole and Sean Baker – bought Shinnors' paintings. When John de Vere White wanted a Shinnors, the auctioneer came to O'Sullivan. And that's where the problem arose.

O'Sullivan is a PAYE worker. He has to subsidise his buying by selling. So he tries to buy wisely and sell well. A couple of le Brocquy prints worked out nicely – he bought them for €600, sold them for €6,000. But of course it's not always that neat; he bought a Richard Kingston for €8,000 and it sold for €7,500. He has a dozen or more Shinnors, but he knows how problematic selling them would be. So when Buzzer came looking for a painting, O'Sullivan initially said no.

"I can't put a Shinnors into auction because he'll be after me. I'll get into trouble," he said.

"No, no," Buzzer reassured him. "No need for an auction. This is going into a private collection." It was for Johnny Ronan's house on Burlington Road. So that was fine; Shinnors would never know. O'Sullivan got €20,000 for *Bank Holiday Weekend*, the work he'd originally bought for £1,200. "I said nothing to anybody," he said. "I needed the money. This wasn't done frivolously." Anyway, he reasoned, getting into a collection like this would be good for Shinnors – hanging alongside le Brocquy, Sean Scully, Hughie O'Donoghue in the house of a multi-millionaire who likes to show off his paintings.[17]

But O'Sullivan didn't get away with his little ruse. Soon afterwards the *Irish Arts Review* had a feature on architecture, and it included a half-page full colour photograph of a room in Johnny Ronan's house. And there, hanging over the fireplace, was the Shinnors that O'Sullivan had sold. "Imagine getting caught like that," the collector groans. "I wondered if Shinnors would see it. I thought he would, that someone would point it out. I met him a few months later at an opening in Boyle. We went for a few pints afterwards, and after about the third pint Shinnors said to me: 'Didn't you buy that painting of mine that I saw in the *Irish Arts Review* the other day?' I had to put my hands up.

"He was miffed about it for two reasons. One of his early collectors was getting rid of his paintings, an early supporter selling his work. And the fact that I had made a few bob. He wasn't angry or anything like that, but he was definitely giving me a bit of a nudge. My access mightn't be as good if he thought I was going to be moving them on."

HE IS SIX YEARS YOUNGER THAN JOHN SHINNORS, BUT ALSO FROM LIMERICK, AND JUST AS "HOT". Donald Teskey is another artist of the boom, about four to five years behind Shinnors on the rising parabola of art prices. Some dealers shake their heads and insist his prices are too high. "Teskey and Shinnors are over-priced compared to what else is out there," said Mark Nulty of the Oriel Gallery. "For €50,000, you could get into Yeats's watercolours, you could get a Tony O'Malley or a Louis le Brocquy. Fine art should not be fashionable. I think Shinnors' and Teskey's prices will suffer if there's a slowdown."

Perhaps he'll eventually be proved right, but the market cooled considerably in 2008 and Teskey's prices didn't suffer. At Whyte's sale in February, *Footbridge at Seapoint* sold for €32,000 and *Street in Safed* went for €20,000, both well above their top estimates, and two months later, again at Whyte's, *Plateau I, 2005,* from his series based on the Mayo coastline made €44,000.

After he graduated from the Limerick School of Art in 1978, Teskey concentrated on drawings, selling to public collections and eventually having a nationwide exhibition in 1991. It was then he started painting, and two years later had his first show at the Rubicon Gallery in Dublin, featuring studies of the capital city and its suburbs. All this time he was teaching,

17 One source who visited Ronan's house says he was asked: "Would you like to see my art collection? It's better than John Magnier's." Ronan declined to be interviewed for this book.

Left: Donald Teskey's Plateau I, 2005, which fetched €44,000 at Whyte's April 2008 sale. Above: Teskey, Limerick born, has seen both prices and interest in his work soar over the last number of years.

in the Dublin Institute of Technology and in the National College of Art and Design, paid by the hour, returning to his studio in the evenings exhausted but focused. As his artistic career took off, he wound down his teaching hours to give himself more time to paint. In 1998, he was able to stop teaching altogether.

Teskey and the Rubicon slowly built up a customer base, selling out each exhibition but just nudging up the prices each time. There was no thought of the secondary market. "I knew the auction houses existed," he said. "But I assumed they were selling manuscripts and the odd historical painting. I knew nothing of how it would affect my work. I knew Shinnors had had success around that time – 1998 – which kind of launched his career, which has been remarkable. But I still wasn't paying much attention to the secondary market – I was working, painting, exhibiting, just going about my business."

That all changed on 16 April 2002. Included at the fag end of a de Vere's sale –

€44,000 2008

IMAGE COURTESY OF WHYTE'S

lot 223 – was *Cottages by a Harbour*, estimated at €4,000-6,000. It had sold two years earlier at the Rubicon for about €1,000 less than the lower estimate. Now its buyer was flipping. Other Teskey collectors watched intently to see how this first big auction sale would go. The *Cottages* sold for €7,000. "It was a very good price, not an outrageous one, but really encouraging," said Teskey. "I was delighted. Because I knew I had good, loyal collectors who had been buying my work for years through the Rubicon or RHA because they really liked what I was doing and had formed a relationship with me through my work. Success at the auction made me feel that the faith and respect these people had, in me and for my work from the early days, was vindicated."

Teskey's prices took off immediately. In November 2002, de Vere's sold another of his works – *Great Ship Street* – for €15,000. That price was replicated by Whyte's the following spring for *Women on Synge Street*. "It was a good feeling, almost a sense of relief, a bit scary too," Teskey said. "It's the kind of position any artist would love to be in. I had wanted to make bigger and more visceral paintings and I took this good fortune as a signal to start challenging myself, to move the work on creatively and stretch myself technically."

But the door was open, and soon the flies came in. Teskey's prices brought the artist to the attention of collectors and dealers whose only interest in art was its monetary value. Guessing that the Limerick man would be the next big thing in Irish art, they tried to get basement-price works at his Dublin and London galleries with the idea of doubling or trebling their money at auction within a year.

"I hadn't anticipated the level of speculative buying – that threw me at first," Teskey said. "The Rubicon had to field more and more inquiries. It didn't have much experience of this type of client before that auction result, and from then on my exhibitions and the selling of my work required more careful handling and management, to prevent it being exploited in a way that might be harmful or problematic. With such high prices being achieved at auction, ultimately the gallery prices have to rise but we didn't want to see them shooting out of control. I tend to be quite careful and restrained. I am particularly conscious of what might happen when the economic boom winds down and prices normalise."

The danger for Teskey, and other contemporary artists who become fashionable overnight, is that speculators will push their prices through the ceiling and, once they've made their money, disappear in search of a new host. Prices suddenly fall, the artist is no longer "hot", buyers presume the painter has been "found out", having been "over hyped". In fact, the artist had almost no control over this process and the prices were little reflection of the quality of his output.

Teskey is well aware of how the secondary market can distract painters, and as a relatively young man with a lot of painting still to do and creative choices to make, he cannot allow auctions and their prices beguile him. "I must remain focused," he said. "I don't want to feel that I might be making decisions based on how well my work is doing in auction houses,

which are a bit like a hall of mirrors, their results oddly out of proportion with the real scheme of things. Some works become big and overblown, more than they deserve; others that should do better are diminished. Some artists with considerable reputations don't automatically achieve fair results at auction houses.[18] I don't know who buys my work in auction houses, and I'm probably better off not knowing."

Teskey has been exhibiting in London for 15 years, but it's Irish people who are buying there now. His London gallery also tries to keep the work out of the hands of speculators, but it's impossible. Sotheby's, which launched a contemporary Irish art sale in 2006, is always keen to get its hands on a Teskey. Because the artist refuses on principle to consign a work himself, there is a huge incentive for Teskey collectors to offer up a painting and make a profit.

Auction houses distort the primary market. Like a giant planet with enormous gravity, they suck up everything that comes close to their orbit. "Auction houses may well be more of a hindrance than a help, in that it's more difficult now to get work off artists," said John P Quinlan of the Vanguard Gallery in Cork. "I wouldn't deal with a speculator if I thought that's what he was. But if you come into me tomorrow to buy a painting, I have no right to ask you what you're doing, where you're putting it. So it's an awkward one to police. We are always looking for new clients. It's better for business to sell a painting to a new client than an existing one, because you are expanding your business.

"I get phone calls now on a regular basis – 'have you any Teskeys?, have you any Shinnors?' They'd be pure speculators. I say I have nothing, even if I have. Some New York galleries inter-view clients – 'where's the painting going to go? What are you going to do with it?' All I can do is be extra vigilant with names that are hot at the moment."

But these are good problems, these problems of the boom. Robert Ballagh once painted an ironic self-portrait with his face masked by a book titled *How to Make Your Art Commercial*. Signing on the dole in the 1970s as a "sometimes unemployed self-employed artist", it must have been impossible for him to imagine how commercial his art would become, that within thirty years his works would be flipped in and out of auction houses, the same pieces being sold twice, even three times, in the space of a few years.

"Somebody went into the Gorry Gallery where I had a show in 2006 and said they had to have a Robert Ballagh," the artist said. "He was asked 'which one?' and replied 'It doesn't matter'. He pulled out a photo of an interior from a posh magazine. Some wealthy socialite had a Robert Ballagh on their wall so he had to have one.

"Another part of the conundrum we're in now is that there are people buying who haven't a clue. I'll say this against myself – the time to buy a Ballagh or a le Brocquy is not now. It was a few years ago. Never buy at the top of the market."

18 Michael Cullen, Felim Egan and Barrie Cooke are three examples of artists who sell strongly in their galleries but never achieve headline prices at auction.

8

AND THE BRAND PLAYS ON

A lady, sitting next to Raymond Loewy at dinner,
struck up a conversation.
'Why', she asked 'did you put two Xs in Exxon?'
'Why ask?' he asked.
'Because I couldn't help noticing?'
'Well', he responded, 'that's the answer.'
From The Art Of Looking Sideways
by Alan Fletcher

BRANDING IS MOST OFTEN ASSOCIATED WITH
consumer goods – McDonald's, Google,
Toyota, Coca Cola. A strong brand is
distinctive, has a personality, and adds value to
a product by making it seem reliable,
consistent and of good quality.

Most top brands have distinguishing logos
– the golden arches, the Nike tick, the three-
pointed Mercedes star. And branding in art
works the same way. Artists are essentially
brand names – marketed, promoted and sold
just like products.

As with brands, the work of some artists
is instantly recognisable. Say the word

What moves me
most is Pierre's
belief in my
work, a belief
which he is clearly
determined
to make
perceptible to a
wider world."
Louis le Brocquy.

Louis le Brocquy photographed in 2006 in his Dublin studio at the time of his 90th birthday. In the
background is a portrait of his son, Pierre, which he was working on at the time.

Knuttel and you conjure up images of long-jawed, square-faced shifty-eyed gangsters against garish backgrounds. Yeats? Thick swirls of paint forming a wild horse or a west of Ireland tramp. But not all branded artists are instantly recognisable: think le Brocquy, and no distinctive style comes to mind. Yet Brand le Brocquy is one of the strongest in Irish art, a triumph of astute dealership and skilful marketing.

There is evidence that Irish consumers are particularly conscious of labels and brands, a loyalty that leaves them vulnerable to being ripped off and helps explain why they pay higher grocery bills than their European counterparts.[1] Just as many middle-class people refuse to shop in Lidl or Aldi, many art buyers eschew certain art brands. Graham Knuttel is an example: as an artist who became too obvious, his initially successful brand lost prestige. Some art buyers would no more hang a Knuttel over their fireplace than they would serve Piat D'Or at their dinner party or park a Lada in their driveway.

"There is a certain amount of labellism in some quarters," said Ian Whyte. "People buy a particular picture because it has a cachet. They have to have a le Brocquy or a Yeats – it has to be something well known. Someone asked me one time about two similar William Leechs – one was €20,000 and the other €40,000. The reason one was 20 was because it wasn't signed. It'd be like buying a Prada handbag without the Prada label on it, or a Mercedes without the badge on the front. Buyers like the fact that when someone walks into their room they see Leech written on the painting."

During the boom, a certain snobbishness even developed about representational art. Buyers increasingly want semi-abstract work that challenges them. Their ability to decipher meaning in the abstraction is proof of their knowledge and sophistication. A representational painting which everyone can instantly understand affords no opportunity to show off erudition.

So what are the elements that create strong artist-brands in Ireland? Galleries play a role. A few – such as the Taylor, the Kerlin and the Rubicon – are strong brands themselves and give added-value to the work of artists who hang there. That said, Dublin, Belfast and Cork galleries do not have the clout of London's or New York's.

Critics have a lesser role. What they write in newspapers and magazines (as distinct from what they're paid to write in auction catalogues and official monographs) has minimal impact on the market. Bruce Arnold can say as often as he likes that Louis le Brocquy is a "middle-grade painter", and buyers will still pay upper-grade prices for his works. Jerry Saltz, a senior art critic with *Village Voice* in New York, has said: "At no time in the last 50 years has what an art critic writes had less of an effect on the market than now. I can write that work is bad and it has little-to-no effect, and I can write it is good and the same thing will happen. Ditto if I don't write about it at all."[2]

There are three factors which have helped create strong artist-brands. First, provenance. When well-known collectors sell, their ownership adds value to the work; when they buy,

they move the market with their money. Second, recognisability. Many of the strongest brands are linked to instantly recognisable images – from Paul Henry's west of Ireland landscapes to Sean Scully's solid blocks of bright paint. Finally, marketing. If an artist or his dealer in combination with auctioneering firms vigorously promote a body of work, and the media either actively or lazily collude with their efforts, the public tends to buy that work, even if it is of indifferent standard.

THE CATALOGUE PRODUCED BY THE NATIONAL GALLERY OF IRELAND FOR THE CENTENARY EXHIBITION OF Jack B Yeats's work in 1971 lists the owners of almost all the 144 drawings and paintings that were loaned to the museum for the show. The Yeats owners include doctors, Protestant businessmen, ex-patriate Irish, British lords and ladies, a scattering of dealers. A portrait of John Millington Synge was owned by "Her Majesty the Queen." *Conversation in a Tent* was listed as the property of Earl Mountbatten of Burma. Several oils belonged to Lord Moyne, an heir to the Guinness brewing fortune. Several more were the property of Sir Basil and Lady Goulding from Enniskerry. Lady Dunsany in Co Meath owned *In Memory*[3] and *The Expected*; The Marchioness of Normanby in Whitby loaned two others, and John D Rockefeller was on the list of owners too.

The biggest consignment came from John Huston, the director of such films as *The Maltese Falcon* and *The African Quee*n. An accomplished painter himself, Huston had bought a house in Craughwell, Co Galway in the early 1950s. From then on he added Irish art to his already impressive collection, especially works by George Campbell and Yeats. It is said that Huston took two Yeats paintings instead of money as his fee for appearing in the 1963 film *The Cardinal*.

This 1971 snapshot of ownership shows what a distinguished bunch of international collectors first bought Yeats's work. Their eminence underpinned his market. Many of these purchases were made either in the artist's lifetime or shortly after his death, and the buyers paid good money at the time.

Typical of them were William and Joan Roth, an American couple whose collection was consigned to Christie's in 2004. The Roths visited the Dawson Gallery in the 1960s to find "paintings by Jack Yeats stacked against the wall."[4] For a few thousand pounds apiece they bought works such as *Here She Comes*, which made £565,250 when it was sold by Christie's 40 years later. Another early Yeats buyer was Ivan Allen of Ballymaloe House in Cork, who began an art collection in 1944. He once sent a lorry load of tomatoes to the Dublin market and instructed the driver to call around afterwards to the National Gallery to collect a parcel.[5]

1 A European study by Future Foundation found that 70% of Irish 55-year-olds, 50% of 40 to 45-year-olds and half of those aged 25 to 39 consistently buy the same product. Reported in the Daily Mail, 16 August 2007.
2 Quoted in The $12 million Stuffed Shark, by Don Thompson.
3 Also known as Bachelor's Walk, In Memory. See Chapter 10.
4 Quoted in Christie's catalogue for the Irish Sale 2004.
5 http://ballymaloe.ie/history/ivan-allen.html.

What came back to Cork on the lorry was *A Blackbird Bathing in Tir na nOg*, one of Yeats's best works, which sold at de Vere's for €820,000 in 2005 after Allen died.

Yeats has always been the gold standard of Irish art. His prices cannot be said to be a barometer of the market, since they tend to remain constant even during recession, but that is part of the attraction for wealthy investors who want to tie up money safely. Yeats's reputation was carefully nursed by Victor Waddington, his dealer, who developed a price structure based on medium and size that collectors grew to trust.

"He was seen as a safe figure to collect," said Bruce Arnold, the artist's biographer. "By the 1970s, Waddington was an anchor for the value. People knew that if they bought a Yeats in Cork or London they could, at the end of the trail, go to Victor and he would pay well."

Partly because of the glittering provenance of celebrities, millionaires and aristocracy, and partly because his prices are so dependable, Yeats is a must-have for most collectors of Irish art. Hanging a good Yeats oil over your fireplace is the equivalent of saying "I spent €250,000."

As Robert O'Byrne has observed, "he has become the artistic equivalent of a trophy wife." Auctioneers lust after him almost as much as collectors; they rarely hold an "important Irish art sale" without a least one decent Yeats oil.

One difficulty, however, is that while there are dozens of great Yeatses, there are hundreds of indifferent ones. "An awful lot of them are potboilers," said Lochlann Quinn. "The great Yeatses are probably only 10-15% of his output. That's still a lot of paintings, but if you want a Yeats, you can get one. You don't have to spend an awful lot of money. To get a great one is a different matter."

The Yeats market climbed steadily throughout the 1970s and 80s but got a jolt when Hilary Pyle produced the official catalogue of his work in 1992. Until then, nobody knew exactly how big Yeats's oeuvre was. When the artist died in 1957, most of his major works were still in the studio.[6]

Victor Waddington then carefully controlled the flow onto the market, ensuring there was never an over-supply. So Pyle's work caused quite a shock: it listed some 1,200 oil paintings and 700 drawings, and ran to three volumes of 1,856 pages with over 1,800 illustrations.[7] "People didn't quite realise how many there were," said Mark Adams, the London dealer. "I think it shook the market a little. But then the economic situation picked up and everyone started to look at it differently. Yeatses started to make mad money."

Dealers and auctioneers were quite picky about which Yeatses they bought, however. By the mid-1940s, Yeats was producing dozens of pictures a year, with obvious implications for quality, and about half his oils were painted after the age of 70, by which time most artists are past their best. Bruce Arnold has calculated that Yeats's output went from 5 paintings in 1941 and 20 in 1942 up to 77 in 1946.

"There are an awful lot of bad Yeatses out there, especially the ones he painted in the

1940s," said Bernard Williams of Christie's. "Waddington wanted a big supply because he had a big demand for them. A very good Yeats is worth £1m, but a bad one isn't worth £200,000. We are all more sensitive now in how we market Yeats. In the past, auctioneers would take in an indifferent Yeats, albeit a 24 by 36 inch, hoping to get a half a million pounds. Well, you can't. We tend to put them in now with reasonable estimates."

Yeats has a small international audience – mainly Irish Americans. A reflection of British opinion is the comment made by the *Daily Telegraph* critic who said: "Yeats is a provincial on the rim of European achievements, one who is not deserving of mainstream, million-dollar prices." Such British indifference has put a ceiling on the artist's prices.

"I think the Irish connection is pretty important, and you either see Yeats or you don't," said David Ker, the British dealer who has bought eight major works this decade for a "European" collector.

One of these was *The Whistle of a Jacket*, an image of a galloping horse and jockey. Trade sources believe Ker's mystery buyer is JP McManus, who is tax resident in Geneva but has completed a large new residence in Limerick and would surely be partial to a picture of a steed. McManus was also linked to Yeats's *The Wild Ones*, bought by another London dealer, Simon Dickinson, for £1.2m sterling at Sotheby's in 1999.

That purchase was the high-water mark for Yeats. Like many records set during the boom, it is unlikely to be broken for some time. Mid-ranking Yeats paintings come to the market a-plenty, and there are prices in the €400,000-700,000 bracket most years, but there hasn't been a £1m Yeats for almost a decade, despite strenuous efforts by some auctioneers to persuade owners to consign.

"A lot of Yeatses are changing hands privately," explains one dealer. "It suits everyone, because the cost of selling at auction can be high and the risk of it failing is high too. The air at the top is thin. When the bidding goes over £700,000 for a Yeats, how many people are left? At this stage not many, and even if a great Yeats came to the market now it might make a million but not much more."

The attraction of Yeats for Irish collectors isn't all about provenance, of course. Prior to the growth in prices and education, he was the only Irish artist many of his fellow countrymen could name, and that was in part due to his more famous older brother.

"Irish art had such a limited impact that Jack was seen by many people for much of the 20th century as the only serious Irish painter," Bruce Arnold has noted. That gave Yeats a sort of first-mover advantage when the market took off, and his themes of nationalism and horses were natural crowd pleasers.

Above all, though, Yeats is popular because he is indisputably a great painter. This is a quality brand.

6 From Sligo with Love… Jack's gems come to town; Bruce Arnold on the Arts, Irish Independent 29 March 2008.
7 Review: [untitled], by Merlin Ingli James in The Burlington Magazine.

IN 1996, AT THE START OF THE IRISH ART BOOM, LOUIS LE BROCQUY WAS NOWHERE TO BE SEEN.
His auction price averaged about IR£12,000.[8] Even allowing for Irish buyers' diffidence towards contemporary art, this was a third-division bracket. Yeats, Orpen and Lavery were well into six figures by then. A second division of Paul Henry, Gerard Dillion, William Leech and Frank McKelvey were getting from IR£20,000 to IR£100,000. Keeping le Brocquy company in the third division were the likes of Evie Hone, Camille Souter, Mary Swanzy and Patrick Leonard.

Le Brocquy wasn't even living in Ireland; he hadn't resided in Dublin since his marriage in 1958. He and his wife, Anne Madden, were based in a villa in the foothills of the Alps in southern France, making their own olive oil and wine, painting in separate studios, exhibiting their art locally, and making the occasional foray back to Dublin for the opening of an exhibition or the launch of a book, as often as not in the company of Charles Haughey or some other luminary. In his own words, le Brocquy had "dropped through a crack in the floorboards."

Within five years, all that had changed. Le Brocquy was at the top of the first division, having become the third Irish artist to break the million-pound mark. He was being referred to as "Ireland's greatest living painter." And the 84-year-old was back in Dublin, where his market was, where his market always had been.

So how was the le Brocquy brand developed so successfully in such a short time? By a combination of factors. The market was moved by a couple of rich admirers, aided by aggressive auctioneers who were keen to create a contemporary star, and cleverly promoted by the le Brocquys themselves – subtly by Pierre, the artist's second son who worked as a dealer in Paris, and more blatantly by Madden, herself an artist.

The turning point was the retrospective exhibition of his work staged by the Irish Museum of Modern Art in late 1996 and early 1997. Opened by President Mary Robinson, it was the first le Brocquy retrospective in Ireland since 1966 and featured almost 100 works. Shortly after the exhibition ended, one of the paintings – *Man Writing* – was auctioned in Christie's Irish Sale. The relatively small canvas was purchased for £133,500 by Lochlann Quinn, who hung it in the front hall of the just-opened Merrion Hotel. It was a vivid demonstration of the power that even a small museum such as IMMA has to enhance the provenance and thereby the value of a body of work. Those collectors who loaned their le Brocquys to that retro-spective exhibition were to be richly rewarded.[9]

Three years later a key work from that retrospective – *Travelling Woman With Newspaper, 1947* – came into Sotheby's. Sensing an opportunity, its Irish director Mark Adams mounted a huge promotional effort to get a big price for it in the Irish Sale of 2000. This was a "major painting", which had "established le Brocquy as Ireland's first figurative Modernist painter," Sotheby's said. Travelling Woman was inspired by Picasso, and "marked a watershed in Irish art." It was "the most important Irish Modernist painting ever to appear at auction" and "a masterpiece by the man acknowledged as the greatest painter working in Ireland today." Of

course le Brocquy was actually the greatest painter working in the foothills of the Alps, but the market for his work in France was limited and the buyer was certain to come from Ireland.

In its catalogue note Sotheby's also amplified a speculative claim made by Dorothy Walker[10] that the painting had "reputedly been seen by Willem de Kooning at the Stedelijk Museum in Amsterdam in 1949, influencing his own painterly vision of women." De Kooning, a Dutch-born American painter, was one of the fathers of abstract expressionism, also known as the New York School, and painted the important *Woman* series in the 1950s. Le Brocquy's *Travelling Woman* was not just a great painting in itself, Sotheby's was saying, it was also a significant work in the evolution of modern art. It represented "a startling link in the development of post-war international Modernist painting."

"Sotheby's pulled a masterly trick for *Travelling Woman*," said one art historian who preferred not to be named. "They illustrated it in their catalogue with a not dissimilar de Kooning of the same period and made the leap, put out the suggestion that de Kooning could have been looking at le Brocquy.[11] So they tied le Brocquy into the full school of New York. Now if you look at any book on De Kooning, and there are 30 of them, you'll never come across le Brocquy in there. Same as with any monograph on Bacon, you'll never find le Brocquy in the index. But it was a clever piece of marketing to say 'here's a great 1940s picture which pre-figures Abstract Expressionism. So give us an abstract expressionist-type price for it'."

And they did – Michael Smurfit purchased *Travelling Woman* for £1,158,500 sterling, an auction record that stands to this day.

In its press release after the sale, Sotheby's said the "staggering" million-pound price placed le Brocquy "within a very select group of artists whose works have commanded prices in excess of £1m during their lifetimes", citing Bacon, Lucien Freud and David Hockney as the others. Mark Adams said that the £1m barrier was "increasingly seen as the surest test of an artist's international importance."

In a market-led environment, one in which collectors and not critics decide what's important, Adams' observation was absolutely correct. Crass, perhaps, but correct.

It must have been hugely satisfying for Sotheby's to see their pre- and post-sale patter reproduced faithfully in the next day's press. *The Irish Times* reported[12] that the £1m sale underlined the painter's growing international reputation and was "perhaps the greatest honour he could receive." Referring to le Brocquy's *Head* series, *The Irish Times* reckoned it had

8 Irish Arts Review 1996.
9 While I can find no example of it, the potential for abuse is obvious. Museum boards are populated by collectors, who should excuse themselves from meetings where decisions are taken that might affect the value of their works. Museum boards must also bear in mind that collectors may donate or loan works by a particular artist in order to improve the value of other works in their possession.
10 In Louis le Brocquy (Dublin: Ward River Press 1981).
11 Or was le Brocquy looking at de Kooning? In May 2003, the Irish Times' art critic Aidan Dunne profiled the top works in Smurfit's collection, including Travelling Woman. He reckoned the 1947 work "echoes contemporaneous aspects of the work of Willem de Kooning in the US." Echoes or pre-figures? Surely either Dunne or Sotheby's is wrong. Maybe both are.
12 20 May 2000.

JACK BUTLER YEATS

BORN: 1871, LONDON

DIED: 1957

PAINTING STYLE: AT FIRST, GRAPHIC; THEN EXPRESSIONIST.

HIGHEST PRICE ACHIEVED AT AUCTION: £1.23M (SOTHEBY'S, 1999)

FANS SAY: IRELAND'S GREATEST PAINTER

CRITICS SAY: HIS FATHER WAS EVEN BETTER

IF YOU COULD OWN ONE: O'CONNELL BRIDGE

BEST EXAMPLE ON PUBLIC DISPLAY: THE LIFFEY SWIM (NATIONAL GALLERY OF IRELAND)

€820,000
2005

Born in London, he was the youngest of four surviving children of the portrait painter John Butler Yeats, and brother of poet William. He lived with his maternal grandparents in Sligo from the age of 8 to 16; and many of his later works draw on memories of that childhood, including fairs, circuses, horse races and local characters such as tinkers, seamen and travelling players. "Sligo was my school and the sky above it," he once wrote.

Rejoining his parents in London, he attended art school there in 1887. From the age of 17 he was able to support himself, first as an illustrator, then as a poster artist in Manchester. He produced pen and ink drawings for journals, and cartoons for Punch magazine under the pseudonym W. Bird. In 1894 he married Mary Cottenham White and the following year staged an exhibition of water-colours in the RHA in Dublin. He and his wife first settled in Devon but in 1910 he moved permanently to Ireland, living first in Greystones. Political strife erupted soon afterwards and Yeats, a republican, found inspiration for such works as The Funeral of Harry Boland and Bachelor's Walk, In Memory.

Hilary Pyle, his biographer, has noted that Yeats concentrated not on the conflict itself but on the tragedy it produced for ordinary people. An example is Communicating with Prisoners, depicting a group of women calling up to prisoners in the tower of Kilmainham jail.

Having made the transition from drawings to oils, Yeats then effected a huge change in his style in the 1920s. His work had been descriptive, with

horses, race meetings, boxers and markets among his favourite subjects. His early landscapes were characterised by low horizons, which allow figures to tower up against the sky. Now he removed the sub-structure of drawing, moved towards abstraction, engaged with more dramatic events, painted less well defined figures and adopted a much brighter palette. Some conservatives don't make the leap with him, and insist that Yeats's best work was done in the 1910s and early 1920s. It is a minority view; several works painted in his seventies are regarded as masterpieces. My Beautiful, My Beautiful – often cited as his single best painting – was painted in 1953 when he was over 80.

Yeats moved to Dublin city in 1917 and held almost yearly one-man shows there, also exhibiting in London, Boston, Paris and New York. A prolific **CONTINUED ON NEXT PAGE**

"an unquestionably iconic authority. So, too, does he, as is proved by the price achieved this week for *Travelling Woman*."

The following week le Brocquy and Madden moved permanently to Ireland. Within a few months Taylor Galleries in Dublin had staged a sell-out show of his tapestries.

Sotheby's had another "important" work by the artist – *Sick Tinker Child* – in its Irish Sale one year later. Two le Brocquy exhibitions were staged to coincide with the May 2001 auction – new paintings at Gimpel Fils, le Brocquy's gallery in London, and tapestries at Agnew's in Bond Street, a show organised by Mark Adams, who had just left Sotheby's. Prices reflecting le Brocquy's new-found "iconic authority" were demanded by both institutions.

The 28 tapestries were priced from £35,000 to £75,000 sterling,[13] and 10 of them were said to have been sold on the opening night. "All woven in the last three years at the Rene Duche factory at Aubusson, they mainly recreate much earlier designs," *The Art Newspaper* noted.[14] "*The Garden of Eden* series was made in 1952, but in these versions the colours have been inverted from the originals." Such inversion has been a constant feature of le Brocquy's career. Many ideas have been recycled, or simply redone in different colours. Some disgruntled early collectors complain that the repetition seems to be inspired more by commercial than artistic reasons.

The Gimpel Fils show re-explored another le Brocquy theme – torsos and their implied human presence. These 12 works were priced from £90,000 to £200,000 sterling. This was an enormous upward leap from the £25,000 price tag on le Brocquy oils a few years earlier, but six were sold within a week.

These shows were payback time for le Brocquy, who had derived no direct benefit from the huge prices obtained for his work at auction or indeed from Lochlann Quinn's subsequent purchase of *A Family*.[15] His son Pierre argued that galleries had to set high prices in order to deter flipping. "They are structured in response to demand," he said.[16] "They are also a deterrent to speculators who have recently moved into this market, buying simply to resell quickly, without regard for the work."

CONTINUED FROM PREVIOUS PAGE

writer, he produced plays and novels, largely neglecting painting in the 1930s. He returned to the easel with a vengeance in the 1940s, painting about 500 works, about half his total oeuvre. He first exhibited with Victor Waddington in 1943 and remained with this gallery until his death.

Although his reputation is at its strongest in Ireland, his work is in leading museums all over the world and, unlike many of his Irish contemporaries, Yeats's reputation never suffered after he died.

The Tate held a retrospective in 1948 and the National Gallery of Ireland has held three. He remains the gold standard of the Irish art market, with several paintings having changed hands for more than €1m.

Few, of course, would begrudge le Brocquy earning decent money in the twilight of his career. A self-effacing, courteous and charming man, he was modest and genuinely over-awed by his belated success and the resulting honours heaped upon him by the civic and artistic establishment. Nevertheless, there was a vague unease in some circles about how overtly commercial the le Brocquy operation quickly became – and a glance at the artist's official website or that of Anne Madden, both compiled by their son Pierre, is proof of how much thought, organisation and effort goes into their promotion.[17] There is a page entitled Top Results at Auction – should an artist's agent publicly boast about such things? – which swells the price that le Brocquy paintings fetched in Dublin auction houses by including the buyer's premium, something Irish auctioneers themselves never do.

Pierre has been given a public imprimatur by his father. "For 15 years he has been a mainstay of my work," Louis said in 2006.[18] "What moves me most is Pierre's belief in my work, a belief which he is clearly determined to make perceptible to a wider world. He [has become] the guardian of my work – a guardian who has brought to many a genuine insight to my painting." He also talked of his son's "sustained advocacy of my work" and of the "imaginative projects" that Pierre had thought up for his father.

"They were always great publicists – Anne and Louis," said Brian Coyle of Adam's. "They were always well in with people like Charlie Haughey, who did a lot for art. And perhaps they were an influence on him in that regard." Le Brocquy forged other very public friendships with celebrities, such as poet Seamus Heaney, playwright Samuel Beckett, and of course Bono. Not that artistic self-promotion is a new phenomenon – Picasso and Salvador Dali were leading exponents.

"Louis was his own best marketeer. He never missed a trick as far as promoting pictures and prints to augment his fame and his sales," said Bruce Arnold, the artist's sternest critic. "And why not? Picasso did the same. He had prodigious energy, dealers everywhere selling his work, and he made enormous amounts of money which he couldn't take with him and left his family tearing themselves to bits. I don't think that will happen with Louis. Every member of his family would endorse and stand over what has been done with his reputation."

Le Brocquy is now a boon to art auctioneers. His output over a 60-year career was prodigious, and his print work sometimes stretched to editions of several hundred. There are endless watercolours, portraits, drawings, illustrations, tapestries and Heads. He spent years doing "studies" in chalk, charcoal, watercolour and oil in preparation for doing the Head series, and did lots more studies of the same subjects afterwards. Dozens of his works are sold each year by auctioneers at every price point from €2,500 to €800,000.

13 Arts column, Daily Telegraph, 7 May 2001.
14 1 May 2001.
15 See Chapter 5.
16 Daily Telegraph, op. cit.
17 http://www.louislebrocquy.com/ and www.anne-madden.com.
18 Quoted in Irish Arts Review, Winter 2006.

Left: Markey Robinson's The Harbour at Ardglass, Co Down.

The market is supported by favourable (even fawning) media coverage and establishment acclaim, which reached apotheosis around his 90th birthday in 2006 and the conferring of the Freedom of Dublin the following year. RTE Television showed separate documentaries on le Brocquy and Madden which, as Emmanuel Kehoe in the *Sunday Business Post* pointed out, were deferential to a fault. "Respect is one thing, relentlessly exhausting deference is another," the television critic complained. "The awed approach to Madden and le Brocquy is becoming more than slightly cloying."[19]

The executive producer of *Anne Madden: Painter and Muse* was U2's Larry Mullen, and one of the contributors was Bono. Another was Enrique Juncosa of the Irish Museum of Modern Art who, in a moment of delicious irony, reckoned one of Madden's influences must have been de Kooning.[20]

Soon afterwards IMMA staged a retrospective of Madden's work, a decision which attracted howls of derision from some dealers and collectors – in part, perhaps, a reaction to her too-forceful personality.

€54,000
2007

"The idea of Anne Madden having a major retrospective in IMMA was a nonsense," said John O'Sullivan, who had limited success with her work when he ran a gallery in Enniskerry. "The great unspoken, of course, is that nobody would be the slightest bit interested in her work if she were not married to Louis le Brocquy. Her art is slight and decorative, and I can think of 50 Irish artists more deserving of a show at IMMA."

19 One line in the script, written by Bill Hughes, was: "Anne Madden and Louis le Brocquy decided to enrich their lives with children." As Keogh observed: "Presumably they went about this in the same way most of us do."
20 The auction market for Madden's work is tiny. Only two works sold in 2007, for example, and her record price is the €15,000 achieved for a diptych in 2004.

What will become of the le Brocquy market after he passes on? Usually a great painter's prices increase after his death, because the supply is now cut off. Such is the size of le Brocquy's oeuvre, this may not be a factor. Another difficulty is that his market is overwhelmingly Irish. It is notable that Sotheby's and Christie's invariably put le Brocquys into their Irish Sales, and have not attempted to create a British clientele for his work or much develop the small French one.

A more rounded critical view may emerge posthumously. Given his venerable nonagenarian status, critics currently prefer to keep negative comments about le Brocquy on an off-the-record basis. There is plenty of good old-fashioned begrudgery about the artist's success of course, but there is also genuine criticism. It centres on the Head series, which started with Joyce, Beckett, Francis Bacon and William Butler Yeats, and ended up with Charles Haughey and Gay Byrne.

"He was essentially a middle-grade painter who passed through phases that were good, bad and indifferent," said Bruce Arnold. "At his best he painted some startling pictures around 1960-62, but then, in my judgment, made a terrible mistake. He went into the quasi-portraiture of famous people, numerous Heads of Beckett, Joyce etc. To me that was a truly meaningless pursuit. You cannot paint portraiture out of your head. So what is it you are doing? Are you imaging a James Joyce face and saying 'this is he, this is his face'? Truly it's confusing. And he moved on from that to the painting of Bono. I really despaired of Louis. It was an extraordinary thing to do."

Le Brocquy's painting career was effectively over when he finally achieved success at auction, which meant he couldn't produce high-quality new work to take direct commercial advantage. The shows staged in the 00s – both in the Taylor Galleries and Gimpel Fils – have been lambasted. "The last show in London – Homage to his Masters in 2006 – was a desperate embarrassment which Pierre shouldn't have allowed put out," said one British-based art critic. "It featured re-workings of artists like Manet and Goya and was just cringeing."

Eamon Delaney, editor of *Magill* and son of renowned sculptor Edward, agrees. "Le Brocquy's great achievement was the Tain series, which were amazing and showed a European and Irish sensibility," he said. "But the Homage show was an embarrassment, and not fit to hang on the railings of Merrion Square."

Some criticisms may be a reaction against the aggressive promotion of le Brocquy. Too much hype can lead consumers to question the value of any product.

Pierre le Brocquy insists that his efforts over the last 20 years have been all about broadening understanding of his father's work, not about cashing in. "It is based in a belief in the work. I'm an old fashioned dealer in that way," he said. "One has to be aware of the realities of the market, but I am more artistic."

To the charge that his father's work has become too commercial he replies: "People have had [various] opinions – it's too modernist, it's too repetitive'. Some now find that it's too

commercial. But the work hasn't changed. He's always produced only for his own creative necessity. There is speculation around his work which I try to control, if anything. If I was to put a gallery price of €40,000 on a major oil Head of Beckett, I would see it in London a short time later selling for 600."

Pierre says he is regularly asked for commissions from private individuals: "huge sums" are offered by wealthy businessmen if only Louis would paint their children. He turns them down.

"The auction prices are consistent. Each one confirms another. The pricing is a reflection of the quality of the work," Pierre said. "But prices mean nothing to Louis. He couldn't sell a painting in the early 1940s or 50s, and these same paintings are now making large sums of money. The motive has never been financial for him because the work is the same. *A Family* is the same painting now as then, whether he couldn't sell it for £50 then or it goes for £1m now. It doesn't change the painting for him.

"Jack B Yeats said to Louis early on: 'critics have opinions, true artists have vision'. It takes time for the artist's vision to be shared. His work wasn't as readily accepted as it is today. Time is on my father's side, and the quality is there."

WHILE YEATS AND LE BROCQUY ARE THE TOP BRANDS IN THE IRISH MARKETPLACE, A HOST OF OTHERS are vying for our attention, metaphorically jumping up and down and shouting "me too", even though the artist himself may be long dead. These "brands" are being promoted by dealers who usually have 50-100 paintings they want to shift. Some of their promotional work is done beneath the radar, performed so skilfully as to be barely perceptible. Much of it, however, is brash, brazen and unapologetic.

One of the most enigmatic brands in the art market is that of David Marcus Robinson, known as Markey Robinson. He is either one of the artistic geniuses of the 20th century, an unfair victim of snobbery who will one day make €1m, or he is a desperately mediocre painter who is being hyped up by a small cabal of dealers who have hundreds of his works in their warehouses. Both views are sincerely held. Meanwhile Markey's prices climb inexorably, and if he hasn't made €100,000 by the end of 2008, he will soon afterwards.

Legend has it that Belfast-born Markey called into the Oriel Gallery on Dublin's Clare Street in the 1970s looking for directions to the American Embassy. "Disillusioned by the apathy which his paintings seemed to generate he had decided to emigrate," according to Oliver Nulty, the gallery owner.[21] "Luckily he was carrying one of those works under his arm, unframed and unvarnished. I bought it instantly and dissuaded him from emigrating, promising to promote, sell and export his paintings instead." Thereafter Markey became a fixture around Dublin's art quarter.

Using the Oriel's upper floor as a base, he sallied forth dressed in parka-like clothing,

21 Quoted on the gallery's website.

Portrait of the artist

CAMILLE SOUTER

BORN: 1929, NORTHAMPTON

PAINTING STYLE: SEMI-ABSTRACT LYRICAL

HIGHEST PRICE AT AUCTION: €57,000

(DE VERE'S, 2005)

FANS SAY: "ONE OF THE BEST, MOST DISTINCTIVE BODIES OF WORK EVER PRODUCED BY AN IRISH ARTIST." AIDAN DUNNE

CRITICS SAY: SHE NEVER MASTERED OIL ON BOARD

IF YOU COULD OWN ONE: HANGING MEAT WITH COW'S HEART

BEST EXAMPLE ON PUBLIC DISPLAY: WE ALL WENT DOWN TO THE RIVER (OFFICE OF PUBLIC WORKS, CURRENTLY HANGING IN ARÁS AN UACHTARÁIN)

S he was born Betty Pamela Holmes, the daughter of the managing director of a shoe-manufacturing company who took over its Dublin office when she was three, and settled his family in Sandycove. In 1948 she returned to England to train as a nurse at Guy's Hospital, London. Diagnosed with tuberculosis two years later, she spent a year in hospital on the Isle of Wight and attended art classes as part of her occupational therapy.

In December 1953 she married Gordon Souter, an Old Vic actor, who is credited with giving her the nickname "Camille" after the tubercular heroine of La Dame Aux Camelias by Alexander Dumas which she was reading. The name stuck; the marriage broke up within two years. In 1955 she set off for Italy, making collage paintings from local newspapers, and selling her first paintings out of sheer necessity.

She returned to Dublin where her art was slow

€42,000 2007

to take off. Her first exhibition of small works at the El Habano restaurant performed modestly. Afterwards dealer David Hendriks bought several works for stock at £5 each. She first visited Achill in 1959, and began the Basking Shark series using local materials such as boat enamels and bicycle paint purchased from the local hardware store. It was around then that she took to wearing a fisherman's crocheted woollen beret which was to become her trademark. In 1960 she married sculptor Frank Morris and they settled in a run-down dwelling on Calary Bog in County Wicklow.

IMAGE COURTESY OF WHYTE'S © CAMILLE SUITER

Sir Basil Goulding, one of Ireland's leading collectors, became her patron, setting Souter up with a studio in Enniskerry and eventually buying up to 150 of her paintings. Goulding was such a determined collector that it was said to be difficult to buy Souter's works in the 1960s. Not hugely prolific and working on paper, she had a penchant for destroying anything she considered to be sub-standard and this also limited supply. She even retrieved works from buyers in order to destroy and replace them.

The shock of Morris's sudden death in 1970 has been credited with inspiring her bloody Slaughter-house and Meat series. She then settled permanently in Achill, at one point learning to fly in order to be able to paint the aircraft and runways around Shannon airport. She did a series of works themed around the Gulf War in 1990.

She now lives a semi-reclusive existence on Achill, having rebuilt her studio there in 2006. That same year she was the subject of a monograph, The Mirror in the Sea, by Garrett Cormican, published by Whyte's. The cover features a cod's head – the ironic self-portrait she painted in 1993.

wearing scarves and rings, and pulling a two-wheeled woman's shopping bag full of his paint-ings, which he sold to anyone who would give him £20. An eccentric figure often mistaken for a tramp, he also slept on the floor of the Apollo Gallery on nearby Dawson Street and in Salvation Army hostels around the city. Markey rummaged through skips and rubbish tips looking for cardboard and paper, shoeboxes, posters, plywood, even book covers on which to paint. His output was stupendous – some weeks he would paint hundreds of pictures – and even the most ardent Markey admirer concedes that only a tiny fraction of these were any good. He used the same themes over and over – clowns, women in shawls, departing fishing boats, white-washed gable ends – all geometrically shaped and easy on the eye.

Up to the time of his death in February 1999, Markey's work rarely made it into auctions. "We used to groan when we got one for sale," said Brian Coyle of Adam's. "Literally groan. You couldn't get £300 for him. But then the better pictures weren't on the market either. The mass-produced later ones, which are selling now for huge prices, that's what we were being offered. The earlier ones came out after he died."

Markey was found dead in a small terraced house in a Belfast side-street. Eleven bank accounts were found in his name,[22] containing £114,248 sterling and IR£63,684, proof that the 80-year-old was neither a pauper nor a fool. Immediately, his prices started to soar. In Adam's sale of May 1999, *Sifting Corn* made IR£15,500, about five times more than Markey's best work had been fetching just a few years earlier. "There is no doubt but that when Markey died there was a concerted effort to move his prices up very considerably," said John de Vere White. "By somebody. Suddenly his prices were rocketed up. And then they sort of fell back. Now they're up again and have found their own level."

Soon afterwards Markey's two daughters and only next-of-kin, who had emigrated to America with their mother when they were children, came forward to secure their inheritance. They challenged the Oriel Gallery to provide a full inventory of the works it held. When this wasn't forthcoming, Annie Robinson and Bernie Muldowney took Oliver Nulty to court and won a temporary injunction stopping the Oriel from selling any Markeys that it did not legally own.

The daughters' claim was that some of these paintings were the property of their father's estate, and that because of a domineering relationship between Oliver Nulty and Markey many of the sales of paintings between them "were capable of being challenged on the grounds of undue influence."[23] The Oriel countered that it was in legal ownership of those Markey paintings which it held, and there was no factual evidence to suggest otherwise. The injunction was soon lifted and this potentially fascinating case was settled out of court. The exact terms are unknown, but sources in the art world believe the settlement involved a number of Markey paintings.

22 Gallery blocked on sale of artist's work, The Irish Times, 2 April 1999.
23 ibid.

Both Annie Robinson and Bernie Muldowney are now artists in their own right, painting in a not dissimilar style to their father's. Their work is promoted by the Apollo Gallery, as is that of Patrick Robinson, Markey's grandson.

The Oriel and the Apollo promote the Markey brand in different ways. The Apollo has lobbied the National Gallery of Ireland to buy a Markey for its permanent collection, and wrote to the museum in 2007 wondering why he wasn't included in a Treasures of the North exhibition from the Ulster Museum. "There are no works by Markey in the show but there is also no work by other well-known artists such as Frank O'Meara and Bacon and [this] is in no way a reflection of the reputation or importance of those artists," the NGI replied. Turning a negative into a positive, Julian Charlton published the reply on the Apollo's website on the basis that "for the NGI to link Markey Robinson and Francis Bacon is a great boost for Markey's followers."

To such straws those followers must cling. Asked for his views on the Apollo's campaign, Lochlann Quinn, the NGI chairman, replied: "I wouldn't see the current board buying a Markey but that doesn't mean that 10 years from now a board might say 'well, that's a great Markey'. If there is such a thing."

Part of the reasoning behind the Apollo's campaign is that Markey's prices will increase further if the NGI hangs him. "The Tate in England goes out and buys contemporary artists. That can send an artist's prices sky-high," said Julian Charlton. "But in Ireland there isn't patronage of working artists by the big galleries, and there was a snobbery towards Markey in Ireland."

"You haven't really seen his price accelerate yet," Charlton predicts. "I think the day will come where €100,000 will seem very little to buy a Markey, or where he is picked up by Sotheby's of Paris, in which case Ireland is out of it. If any artist from Ireland is going to break through in a really massive way, in the sense that Picasso broke through, it has to be Markey. Because all the older generation, they're pretty much set. Yeats, Osborne – their markets are mature."

The Oriel, meanwhile, promotes the Markey brand in more conventional style: featuring his work in group exhibitions, holding retrospectives, and sponsoring publications about the artist, who is not mentioned in standard reference books. "Markeys have always sold, even during recessions," said Mark Nulty, Oliver's son, who now runs the Oriel. "People come in from European countries and America looking for his work. He did thousands, there's no way of keeping track, and there are several hundred great works. There are gems.

"My father gambled on him back then. Adam's wouldn't take him, de Vere's barely took him in, but that changed in the 1990s. The general public dictated, through their love of Markey. I know he is going to make 100 thousand soon. I sold *Flowers from Many Gardens* in January 2008 for €75,000, which is the record for a private sale. De Vere's sold one last summer for €54,000 – and that was unsigned. Critics still don't rate Markey. My father used

to get quite annoyed about it. He should be in IMMA and the National Gallery, but I've gone past caring."

While Markey's prices are likely to nudge ever upwards, many critics and disinterested dealers will never be convinced. "I knew Markey well and he was one of the few people I never bothered with," said dealer Sean Collins. "I liked him as a person but I wasn't interested in his paintings – they all looked the same. Oliver Nulty and Philip Solomon had thousands of them and they marketed carefully. I just can't get excited about Markey. I've been down the cellar in the Oriel and you to through racks upon racks of the same, over and over again. It gets very monotonous."

But auctioneer Garrett O'Connor believes that Markey is what the music business calls "a grower." "There's no hype in that market, no-one's bidding it up, it's genuine," O'Connor said. "Dealers buy at high prices but they re-sell them. I've got to like him, but only in the last 10 years. Any dealer will tell you that Markey has a magic. Children adore them, because they see something of themselves. For a while the London sales people would say 'oh, we're not going to catalogue that.' Now they'd take the hand off you. They're internationally collected, they're different, and there's no-one else quite like them."

A distinctive brand, then, but likely to remain a controversial one.

WHAT SORT OF ART IS CREATED UNDER CONDITIONS OF EXTREME COMMERCIALISM? IRELAND IN THE boom years will be a good case study for academics who address this question. For now the feeling is that contemporary Irish artists are cleaving close to the market, playing it safe, and not challenging themselves because they don't need to. "I think artists are becoming more market conscious," said Alan Hobart of Pyms Gallery in London. "They want to be in Ireland because of the tax system, and yet they want to expand. I think Ireland becomes quite insular for them. To make great art you have to push yourself all the time and I think a lot of Irish artists have become polarised because they are not getting out into bigger arenas."

This generation of artists doesn't exhibit much abroad because it sells so much at home.

24 A few galleries in Dublin do bring their artists to international art fairs. See Chapter 9.
25 Born in Northumbria in 1935, Bewick is based in Kerry. A prolific artist who works in a number of different media, she has a solid auction market up to €5,000. Salmon on a Plate sold for €48,000 at Adam's in December 2004, a "spike" created by one of her wealthy admirers.

MATT KAVANAGH/THE IRISH TIMES

Sean Scully at the unveilling of his painting Titan's Robe, acquired by the Irish Museum of Modern Art.

"They don't have to go to London, New York or Paris, so they're not going," said Ian Whyte. "Which is not a good thing. But an artist can only produce so many paintings a year. It's not like U2: it does them good to sell another one million CDs in the United States so they go there and do concerts. If an artist is not going to sell any extra, why bother? If a dealer or gallery can sell all they want here, why should they bother going abroad either? To be fair there are artists who go anyway and promote their works."[24]

With a queue of buyers on their galleries' waiting lists, some artists stick with a style that sells and just keep churning out crowd pleasers. Gillian Bowler says: "Some artists are very calculating and know how to market their work and have reached a stage in their life – and I suppose you can't blame them – where they want financial security. And there are others who just push the boat out all the time regardless of money and I reserve my greatest admiration for them. Grace Weir is an example – someone who went out of her mould, and I have a lot of her metalwork paintings of screws, nuts and bolts."

Bruce Arnold admires Neil Shawcross for similar reasons: when the English-born artist completed a set of portraits in 2004, he decided not to do any more. "He told me: 'I don't know where I'm going. I've come to the end of it. I've done everything I wanted to do in this way. I've now got to pause.' I admired him hugely for that," Arnold said. "William Crozier would be the same, and Barrie Cooke, who is doing his own thing and doing it very well. These are people who I think don't paint in order to repeat themselves; they paint in order not to repeat themselves.

"Some years ago Pauline Bewick[25] rang me up and said she felt hemmed in, wanted to go big and market her work in a more energetic way, have more exhibitions, produce more work. It was a scheme and she wanted advice. I told her it was the wrong thing and would spoil her reputation by turning her work into something it isn't. Whether or not she has done that now I don't know. I think she has."

While some artists thrive by maintaining a distinctive style, others are accused of growing stale or getting stuck in a rut, and lose appeal. Consider the diverging fortunes of Sean Scully and Felim Egan. Both are known for geometric abstractions: Scully paints large, brightly coloured stripes; Egan moves a small square around the perimeter of his canvases. To the casual eye they appear works of equal standard, suited to a hotel lobby or an apartment with a minimalist interior. But there the similarity ends. Scully is the current darling of the auction market, whose best work fetches more than £200,000 sterling. Egan is now almost friendless in the secondary market, and still hasn't broken the €20,000 mark.

Sean Scully is currently the only "Irish" artist with an international reputation. But he is

"Irish" only in the sense that the Duke of Wellington or Lord Kitchener[26] are: born in Dublin in 1945, Scully left for England at the age of three and his subsequent artistic training and career owe nothing to Ireland at all. He settled in New York in 1975 and became an American citizen eight years later. He currently has studios in America, Spain and Germany, and his work is in the permanent collections of leading museums worldwide include the Tate in London, and both the Museum of Modern Art and the Guggenheim in New York.

The Scully market took off in 2005 as his Wall of Light series began a tour of America. That February, Christie's set a new record of £198,400 sterling in its Post-War and Contemporary Evening Sale for *Bridge*, a trademark Scully comprising two series of vertical stripes. But the record was short-lived – smashed by Sotheby's a few months later in its contemporary art sale. *Temozon*, from the Wall of Light series, sold for £377,600, almost three times its top estimate. The trade press described it as "the most remarkable result of the evening," no mean achievement given that the auction included a rare Lucien Freud self-portrait and a collaboration by Jean-Michel Basquiat and Andy Warhol. The purchaser of this record-price Scully? Alan Hobart of Pyms Gallery, who was buying for a client. It transpired that Hobart had been buying Scully's work for 10 years, and owned about a dozen of them, one of which was on loan to IMMA.

The purchase made a major statement to the market, since Scully's gallery prices were less than half of what Hobart had paid. Indeed *The Art Newspaper* wondered if the dealer knew what he was doing. Was the bidder "unfamiliar with the artist's market and its availability", it asked?

Clearly The Art Newspaper wasn't. Because buying a top Scully through a gallery was almost impossible due to the tight control the artist kept on his work. Scully insisted on his dealers interviewing buyers in order to weed out flippers, in the process strangling the supply to auction houses. "Scully knows his market and controls it, and his dealers, very much so," said Hobart. "He doesn't want his pictures coming up in auctions. He is very wary of them."

This suspicion can be traced back to a bad experience that Scully had with Charles Saatchi, the British collector, in the 1980s. Saatchi publicly bought 11 of Scully's works between 1983 and 1986 and then offloaded them to a dealer in Switzerland to make space in his warehouse for up-and-coming British artists. A furious Scully felt betrayed. Saatchi was insouciant. "I don't buy art to ingratiate myself with artists," he said. "Of course some artists get upset if you sell their work, but it doesn't help them whimpering about it and telling anyone who will listen." Scully reckoned that Saatchi spent $250,000 on the 11 works and sold them for $4m, but had

26 On being teased about his Irish birth, Wellington is said to have remarked that "being born in a stable does not make one a horse." Kitchener was a Kerryman.
27 Ironically, the Hugh Lane is also home to the reconstructed studio of another "Irish" artist, Francis Bacon who was born in Ireland but wiped the dust from his feet after he left.
28 Northern Ireland art collectors are notoriously hard-nosed, and are reluctant to give dealers their margin. The Christie's sale was easily researchable on the internet, but a quick re-sale would always be more difficult in Northern Ireland compared to the Republic.
29 They don't any longer.

to admit that the collector's interest did put him on the art map.

"He wasn't badly burned by Charles Saatchi, it's a travesty of what happened," said Oliver Sears, a Dublin art dealer familiar with the Scully market. "All collectors are entitled to do exactly what they want with works they buy. Saatchi got a good deal for his Scullys in about 1990. Then the art market collapsed and Scully did badly after that. It was an unfortunate confluence. Scully has, unbeknownst to him, benefited from this sort of carry-on since, and I know that from inside knowledge of the market. The difference is the climate; it's changed now. Because of the Irish mania, his prices have gone through the roof. Nobody else has been putting them up – it's the Irish. What's extraordinary about the Scully story is how he managed to retrieve the situation."

In 2006, Scully donated eight of his works to the newly re-opened Dublin City Gallery, the Hugh Lane on Parnell Square, which now has a Scully room[27]. It was a munificent gesture by the artist, but one which is bound to boost his market. "He was generous to his home city when he didn't need to be, because he has an international market," said an art curator. "It's not like le Brocquy, who has to cultivate Ireland because he has nowhere else to go. But if the Hugh Lane is falling over itself to devote a room to you, why not donate a few pictures to it? It's a whole room, and he's not Rothko yet."

Scully's prices are growing at a steady clip. Sotheby's sold a major work of his in both their Irish sales in 2007, making an extraordinary £192,000 for *Westray*, which had been sold by Christie's one year earlier in New York for $140,000 and subsequently went unsold at an exhibition by The Taylor Gallery in Belfast[28]. Irish auctioneers have also begun to have success with Scully, with Whyte's selling *Curacao* for €92,000 in late 2006.

Commenting on the success of the Scully brand, Sears said: "The work is instantly recognisable and now, because of his marketing skills, really hard to find." Even though British critic Michael Newman says he is "absurdly over-rated", a million-dollar Scully is only a matter of months away.

SOMETIMES THE MARKETING OF AN ART BRAND IS OVER-DONE OR OVER-WROUGHT, AND THE artist eventually suffers. An example is Graham Knuttel. At one point in the early 1990s, his art was a status symbol, a way of giving your home instant cultural credibility. No longer. Why? Maybe because everyone heard the Sylvester Stallone story once too often.

"When we first represented Graham[29], you couldn't get him arrested, you couldn't sell him," said Julian Charlton of the Apollo Gallery. "The first exhibition was in our basement in 1990 and only Christy Moore showed up. The incident where it took off was when Stallone bought him and that was reported. In 1993, Stallone was a big, big star. Studios were still bankrolling him for a slate of pictures. He was making *Demolition Man* at the time. His friend, a movie director, was walking down Dawson Street and saw Knuttel's pictures in our window, came in and asked about them. He took a video and a catalogue about Graham's work back

and next thing there's a call from New York saying 'Sly would like to buy some of Graham's work'. He bought about 14 pictures."

And how much did Stallone pay? "He got a very good deal, next to nothing. I don't think he had to pay any real cash for them. He was staying in London and Graham flew over with the pictures and there was a photographer there and a photo was taken of Sly giving a punch to Graham's chin. When that ran in the Irish press, the market took off. Rambo/Rocky, this billionaire who can buy anything in the world, is buying this Irish painter."

Knuttel and the Apollo milked the Stallone connection for all it was worth. "Hollywood stars are such a nuisance," Graham once said to a reporter. "The last time I did a portrait for Stallone he rang me eight or nine times to change the picture – friends to be put in and taken out, depending on whether he had just fallen out with them. Eventually I told my secretary: 'If Stallone rings again, tell him I'm not doing it'." On another occasion the pair fell out when Knuttel portrayed him with thinning hair. "He wanted me to paint more hair and I refused," the artist said. "There was all sorts of trouble."

The monosyllabic star of *Tango & Cash* and *Stop! Or My Mom Will Shoot* was soon joined in his appreciation of Knuttel by other Hollywood actors. Tabloid newspapers reported that Robert De Niro had one, as did Whoopi Goldberg, Arnold Schwarzenegger, Frank Sinatra and Teri Hatcher. "Hollywood is a funny place," Knuttel confided to *The Mirror*[30]. "Once one person has something, they all want it." Soon Irish celebrities wanted them too. "I am very proud of a Graham Knuttel painting I bought almost 10 years ago," Lorraine Keane, the TV3 presenter, told a newspaper in 2001. Knuttel's website listed actor Colin Farrell, motor-racing owner Eddie Jordan, singer Christy Moore, The Thrills pop group, Principal Management and then-taoiseach Bertie Ahern as other owners. Westlife found Cristal champagne in their dressing rooms one night before they went on stage in the Point…along with a painting of themselves by Graham Knuttel.

The artist's exhibitions were opened by the likes of Grainne Seoige, another TV presenter, and Gerry Ryan, the 2FM DJ. Knuttel paintings were hung by several Dublin restaurants. By 2000, they were so popular that thieves were apparently stealing them to order. *The Sun* reported[31] that a Knuttel was cut from its frame during an exhibition at a hotel in Killiney, and quoted "art expert Hugh Charlton" (of the Apollo) as saying lieutenants of Martin "The General" Cahill were the likely culprits. "They got a taste for that kind of crime and would be the ideal choice for someone wanting a work of art stolen," Charlton reckoned.

The Sun's story concluded: "Collectors of Knuttel's work include Robert De Niro, Arnold Schwarzenegger and pop star Jim Corr." Presumably it wasn't implying that any of these were responsible for commissioning the General's gang.

30 Artist makes a Sly move, March 29, 2001.
31 General's villains behind art swoop; Exclusive; 30 March 2000.
32 This author once received flowers after writing a piece about Sharkey, who mistakenly thought the tone was positive. On realising his mistake, he followed it up with a letter of complaint.
33 Described in "Painting into the Light", Sunday Tribune, 6 May 2007.

Eventually, however, all the tabloid newspaper coverage of celebrity owners damaged the Knuttel brand. Snobbishness is a key factor in art sales. Collectors use art to enhance their social status, and for many of them having the same paintings as "billionaire Rambo/Rocky" would be crass not class. Nor do many art buyers take their cultural cues from politicians or television presenters. Meanwhile. serious art critics were lambasting Knuttel, every Sly reference in the tabloids seemingly adding venom to their epithets. "His paintings are to art and art practice as 38DD silicone-enhanced breasts are to the female body, or verses in Hallmark cards to the cultural insight of Anthony Cronin," wrote Medb Ruane in *The Sunday Times* in 2005.

"What distinguishes them from wallpaper are the frames he puts around them...This wallpaper, for people too scared to have an eye of their own, works on the basis of patterning and repetition: know your audience, tell them what they want, and do it again and again."

While Knuttel's work didn't advance artistically, it also became something of a social cliché, the equivalent of hanging a framed cheque on your wall. "In the end I suppose Graham became very familiar," admits Julian Charlton. "Anyone who makes it big can become very familiar."

KEVIN SHARKEY WAS ALREADY FAMOUS WHEN HE BEGAN TO PAINT IN 1989. HE WAS THE FIRST BLACK presenter on Irish television, as the co-presenter of Megamix, a pop music programme in the 1980s. Later on he played a cameo role in Father Ted. Sharkey had an enthralling back-story: adopted by a couple in Killybegs who treated him appallingly, sometimes tying Kevin to the bed for a day without food and water; shipped off to an industrial school in Galway where the Christian Brothers sexually abused him; leaving home at 16 and drifting into drink and drugs; working as a cook and a naked model, and once living in someone's wardrobe; coming to terms with homosexuality; and finding, at last, redemption and therapy in art. Sharkey could tell this story in an articulate, entertaining and charming way, and journalists never tired of hearing it. When a favourable piece was published, Kevin sometimes sent around flowers or one of his pictures[32]. He was a master of the art of self-promotion.

Sharkey didn't paint in a conventional style. He didn't use a brush, for example, instead mixing acrylics on a canvas and spreading them around with a paint scraper.[33] He worked fast, so fast that his problem was "the paint takes too long to dry."

He got around that by working on several pieces at the same time. His output was colossal; hundreds upon hundreds produced in 17-hour working days, and Sharkey boasted to a British newspaper that he'd made £2.5m in four years. The art establishment sneered, but what did he care?

When galleries wouldn't accept him, he opened his own: in Dublin's Francis Street, in London's Mayfair, in Ibiza, Donegal and Mayo. He says he sold 450 paintings in 2007 alone. Many of these were at art fairs where, jealous rivals noted, Sharkey would leave buyers weak-

kneed with his charm, cajoling them in his lilting Donegal accent.

As with Knuttel, Sharkey was able to drop the names of celebrity collectors to receptive reporters. Bob Geldof had one of his works, as did Kate Moss, Pete Doherty, Sinead O'Connor, Liam Neeson, Charles Saatchi[34]. "Incredible, don't you think, for someone who was abused and thrown into borstal?" he demanded of one journalist. "I think it's f*cking incredible."

Being a celebrity already is a huge advantage to someone who picks up a paint brush (or even a paint scraper) with a view to creating a career. Unlimited soft media coverage awaits, as Ron Wood of the Rolling Stones could testify. Or Guggi, for whom the word Bono is never more than a journalist's sub-clause away.

Sharkey was great copy; he could name-drop, slag off the art establishment with a turn of phrase as colourful as his artwork, and had amazing anecdotes about his miserable child-hood, such as the time his mother in Killybeggs bathed her other seven children, then the dog, and finally Kevin in the same water.

Journalists adorned their stories with bouquets. Sharkey, they said, was "an internation-ally distinguished artist and one of Ireland's top abstract painters" (RTE), who had "risen to the top of the Irish art scene with many sell-out exhibitions and unprecedented critical acclaim" (Galway Independent); who "has attracted admiration from high-profile art lovers, including celebrity chef Nigella Lawson and advertising guru Charles Saatchi" (Irish Independent). That sample, out of dozens of possible examples, is taken from the first Google search page.

Many of these laudatory remarks were harvested by Sharkey and highlighted on his website, where hung a gallery of favourable newspaper articles. Sharkey also recycled compli-ments when he was being interviewed, saying things like: "Well I don't know how good I am but the Sunday Tribune/Sunday Times/Independent just said I was brilliant, so who am I to argue?" As often as not the compliment would be published again.

The apogee was reached in a small diary item in the Irish Arts Review in Spring 2003. The Review's features are thoughtful and measured, but its diary column is a straightforward series of plugs. "Bank on this artist," was the headline over a small notice about an upcoming Sharkey exhibition. A few weeks later Sharkey appeared in the Fame & Fortune column in The Sunday Times' money section, a feature in which famous people are asked how much is in their wallets, what will they do after retirement, and what was their best investment. The introduction noted that "The Irish Arts Review recently called him the artist to bank on." Noticing this comment, the sub-editor picked up the theme for the headline, which went: "Bankable artist not the retiring type."

This was grist to the Sharkey publicity mill. Soon the endorsements "Bankable artist – The Sunday Times" and "Bank on this artist – Irish Arts Review" were being used on his website and promotional material. They were joined by "collectable", "critically acclaimed and sought after," and "Ireland's first art superstar"[35]; other sobriquets handed out as easily as Smarties

by non-arts journalists who preferred to recycle rather than research. In fact, no critic of standing had "acclaimed" Sharkey, and to describe as "bankable" an artist who produced hundreds of works a year, who had never been sold for more than €1,000 in a major auction house, and who was not represented by a gallery, was patently absurd.

In late 2007, Sharkey closed his showrooms in Francis Street, Mayfair, Ibiza and Mayo and moved to Dublin's docklands, saying he wanted "to move up into the Sean Scully area, of painting large works for large sums of money."

"I love the idea of working big," he went on. "It can be very restrictive at times on small canvases. I do get a lot of lawyers who buy my work, but more and more I get hotels, restaurants. Spas are another one – they've started coming looking for pieces. Architects come here and leap on the big paintings because there's so many colours in them. It brings lightness to their designs which can be sombre-looking, lots of stone and slate. So I'm focussing on corporate. It's London that did it for me – we get a lot of corporate business there. That really opened my eyes to the fact that there is a huge market out there for larger pieces. And like any artist out there, Jesus, I want to do less work for more money."

Coinciding with Sharkey's move was an announcement that he was getting married… to a woman, a Moldovan who had been his girlfriend for about a year. The inevitable media headlines ensued. His sister, Patricia, wrote a letter for publication in *The Sunday Times*[36] saying she read of the nuptials with little or no surprise since her brother's favourite maxim seemed to be that there is no such thing as bad publicity. Challenging some of the details that her brother had given in press interviews about his early life, she wondered why he had promoted himself in such a way. "We his family, and the people of Killybegs, are saddened and hurt by Kevin's need to bedevil us," she said. "We believe he could have succeeded on his merit, but this way was so much quicker and surer."

Before starting to concentrate on the bigger pictures, Sharkey had a half-price sale at his galleries. "Hurry now while stocks last," said the small ad in *The Irish Times*.[37] The notion of selling off stock at discount turned art economy on its head: artist's prices must always go up, never down. The view of collectors who had bought full-price works by Ireland's "most bankable" artist can only be imagined.

Asked to explain, Sharkey insisted that the "real story" was much more interesting[38]. "How does an untrained artist, who's sold 450 paintings this year alone, come from difficult beginnings to become one of Ireland's most successful artists?" he demanded. How indeed.

34 "And Saatchi doesn't buy just anybody," Sharkey told Podge and Rodge on RTE Television. The puppets agreed.
35 The "offenders" being Ireland's Homes, Interiors & Living Magazine; Irish Arts Review and Hot Press. The Sunday Tribune put Sharkey on the cover of its magazine in September 2007 with the strap line: "Sharkey: The emerging talents of Ireland's most bankable artists." Graham Knuttel, featured in the inside piece. "Surprisingly affordable," the Tribune said, adding that "Knuttel's career went stellar in the 1990s when people such as Arnold Schwarzenegger, Sylvester Stallone and Whoopi Goldberg started buying his art.".
36 Published on 11 November 2007.
37 12 January 2008.
38 Letter to the author, 21 October 2007.

Detail from Still Life with Flower, by Martin Mooney.
Achieved €9,650 at Adam's in October 2007.

€9,650
2007

9

THE ART OF THE DEAL

"If I hadn't been a footballer it's possible I could have become an artist. Perhaps I still will be. I really love drawing. Both me and Victoria really like art. We look for original works. In our house in England we have some pieces of great value."

Former England captain David Beckham

THE MIDDLE MAN HAS BEEN SQUEEZED BY THE art boom. Dealers have long been the intermediaries of the trade, the go-betweens. Traditionally they matched paintings to collectors, and acted as the broker between artists and the market. Collectors bought from dealers and sold to them. Artists let dealers look after their affairs, usually paying them 33%, 40% or 50% commission for the service. Now the model is breaking down, to the point where some experts predict the eventual demise of the dealer. "I don't think the gallery is going to last," says Bruce Arnold, who operated one for years.[1] "I think

COURTESY ADAM'S © MARTIN MOONEY

1 I have used the word "dealer" to include "gallery owner", although strictly speaking gallery owners are only a subset of dealers. The majority of dealers do either own a gallery or have access to one, however.

it's facing huge problems – of staffing and security, of finding materials, and of persuading artists to join the team, and then keeping them."

"Dealers have been squeezed out of the market," confirms auctioneer John de Vere White. "In our June 2007 sale of 115 lots, over 100 were from private individuals willing to take whatever the market was prepared to pay. With so many pictures coming to the auction market, why would anybody buy from a dealer instead? Nobody is going to sell a picture privately now either. Why would you? If you've got something good, who can put a value on it in this climate? And I would think of those who want to buy pictures, 80-90% of them are going to the auction houses rather than galleries."

Even as he gives this interview in his Kildare Street office, Buzzer's staff are phoning people in the auctioneer's contacts book. Do they like Donald Teskey, the clients are asked? They do? Because it so happens that the auctioneering firm is hosting an exhibition of a painter, Aidan Bradley, whose work is very like Teskey's. The clients have already received a catalogue in the post. Would they consider buying a Bradley?

"We've sold 40 of his paintings over a two-day period," Buzzer says. "They're priced between €2,000 and €2,500." So, even as he delivers a eulogy to dealers, his auctioneering firm is siphoning another €100,000 away from galleries.

Artists, who have always chafed about handing over 50% commission, no matter how good the gallery and how excellent the service, are delighted to have a new retail opportunity. Some have no loyalty to the gallery system, and don't care whether dealers live or die. A vice grip – auctioneers being one set of teeth; artists the other – is tightening on the middle man.

Of course this is an international trend, not just an Irish one. Decades ago Sotheby's and Christie's stopped being clearing houses which sold only to dealers, and allowed the dealers trade with collectors and museums. Since the mid-1980s the two firms have targeted private collectors directly, and their auctions became far more exciting affairs as private buyers spent more extravagant sums than dealers would ever dare to pay.

It was rather ungrateful of the Big Two, because dealers had been their bread and butter for years. "The first recession that I worked in – 1984 – it was the trade saved the auction houses because they were still buying for stock," said Bernard Williams of Christie's. "But between then and 1990 we were slightly pushing the trade aside. We were becoming the retailers, and now of course we are the main retailers. And that's why you have all these dealers closing down. They can't buy for stock and sell on at a profit anymore because of the internet and catalogue distribution. You can't hide the price of something you've paid for. Yes of course they still buy things cheaply and have them re-framed and cleaned and hang them in a nice gallery in Molesworth Street and sell on. But there isn't a huge amount of trade like there used to be, and dealers nowadays rarely buy for stock. They're advising people and charging 5% or 10% for their knowledge. They're buying on behalf of people."

In fact there are almost as many types of dealer as there are dealers themselves. Most of

them have galleries, but some operate from home. A minority represent living artists only, their job being to act as agents, to ensure that their artist's paintings get into museums and the best collections. But the majority deal in a mixture of living and dead artists, both Irish and foreign.

Almost all of them have a connection with the secondary market: some dealers buy at auction in order to source work for their exhibitions, others buy for clients, or maybe just to copper-fasten their artists' prices, to support the value of their stock.

Some dealers are brokers, doing the messy side of art transactions for time-poor collectors. Others are advisers or curators, helping private buyers to mould collections and ensuring that they don't buy the wrong paintings or pay too much. Still more are really collectors themselves, and do deals in order to finance their private purchases. Perhaps that very multiplicity of roles, that lack of focus, has caused the problem. They've taken on the opposition on too many fronts.

SUZANNE MACDOUGALD IS DUBLIN'S BEST-KNOWN DEALER. TALL, BLONDE AND ELEGANT, SHE CARRIES herself like the model she once was. Fiery and haughty, she's prone to making dismissive or cutting remarks in an imperious, west-Brit accent. Her favourite words include "silly" and "daft", and they've seen plenty of service during the boom. But this toughness may be a front, the protective shell that a woman needs in the macho world of art dealing. She sometimes stands in the knot of dealers at the back of auction rooms, the only female presence in this maelstrom of big money and bravado where intimidation of rivals is a key tactic. Behind the flinty front, Macdougald is surprisingly soft, vulnerable even. And she's been hurt in the warfare that has erupted between dealers and auction houses. She's a casualty.

Born in Bournemouth in May 1945, she is the daughter of an RAF bomber pilot and her mother was a dental hygienist – Britain's first.[2] Her family moved to Ireland when she was a baby, lived in a big house in Dundrum, and she was brought up in a determinedly Protestant way, topped off with an education at Alexandra College. Schooling ended abruptly when the 16-year-old was offered modelling work, and among her contemporaries was Hilary Frayne, who married businessman Galen Weston in 1966 and is Ireland's richest woman.[3]

At the age of 21, Suzanne met and married Kamran Fazel, a glamorous Iranian whose mother worked for the Shah and whose brother was a junior minister. In 1967 they opened Ireland's first nightclub, Croc's on Baggot Street, but it soon closed due to the constant attentions of the gardai who were zealous in enforcing Ireland's strict licensing laws.

Her marriage broke up after about two years, and Macdougald moved into a rented mews on Dublin's Lad Lane. For a while she hosted Jackpot, an RTE quiz show, alongside Terry Wogan. One of Macdougald's model friends was learning sculpture and happened to intro-

2 At the salon of Madame Suzanne, Sunday Independent, 11 February 2007.
3 As calculated by The Sunday Times' Rich List.

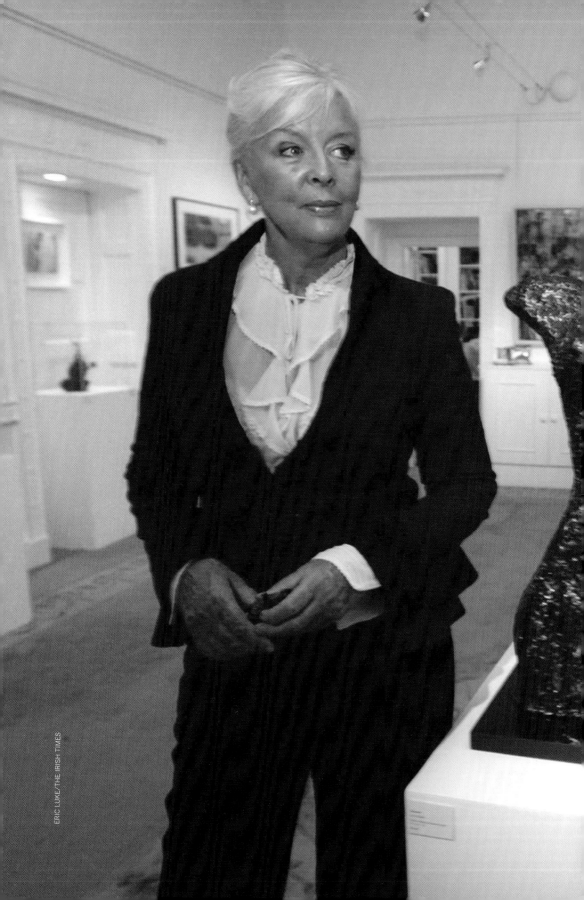

"We made money for other people, not for us," she sighed. "I just wish we had the money to do it for ourselves." Suzanne Macdougald.

duce her to Enzo Plazzotta,[4] her London tutor. "I thought his work was wonderful," Suzanne said.[5] "I asked if I could bring over some pieces. That's how I ended up with my first exhibition. It went really well, and I thought 'this is a great business'. Little did I know what was to come."

For about six years she operated a gallery out of her house in Lad Lane, and then in 1981 came one of those happy coincidences. Just as the lease on her mews was up, she was approached by Philip Solomon, a dealer, who asked if she'd run a gallery for him. "This was manna from heaven because I'd never been employed by anyone before in my life," she said. "Solomon owned the place for about a year and then decided to go back to England. And so, with a lot of help from the bank, I bought this gallery in Powerscourt Townhouse in 1982."

The reaction of the fusty Dublin art world can be imagined. "I was never taken seriously at the outset," she has said.[6] "I was 'the blonde model'. People said 'who does she think she is?'."

For well over a decade, the business was a struggle. "There was no art market, there was no money," she said. "We lived very much from hand to mouth. Sometimes I couldn't afford to put stamps on the envelopes. It was very amateurish. I imported a lot from the UK because I didn't represent any Irish artists – I didn't know any. You can't label the people who buy art any more, but in those days it was definitely the professional people, the lawyers, doctors. It's only quite recently that I've started to feel comfortable in the business – in the last 10 or 12 years. From about 1999."

Her eye and her judgment, her ability to spot a promising artist, helped some collectors make lucrative investments. "We made money for other people, not for us," she sighed. "I just wish we had the money to do it for ourselves." Her clients included Tony O'Reilly, who credits her with having an eye for the sort of work he likes. When Michael Smurfit moved his company headquarters to Clonskeagh, Macdougald was asked to organise much of the commissioned work including sculptures by the likes of Linda Brunker, Conor Fallon and Edward Delaney. Nowadays clients ring her up looking for works by a particular artist, maybe someone represented by the Taylor or the Kerlin. Can Macdougald help? Or they want to sell part of a collection – can the Solomon offload the works?

"I can't divulge my clients' names," Macdougald says, all dealer discretion. "But we have bought for some *im-por-tante* people. And we have been responsible for putting a lot of work into their collections." She has also done more than any other Irish dealer, and certainly any auctioneer, to improve public awareness and appreciation of art, specifically sculpture. The Solomon has organised a series of outdoor exhibitions, such as the temporary installations at the top of Grafton Street featuring work by the likes of Patrick O'Reilly and Orla de Bri. In May 2008, the Solomon Gallery organised an exhibition of sculptures in Dublin's Iveagh

4 About whom further information can be obtained at http://www.plazzotta.co.uk/public_displays.htm.
5 In Sunday Independent, see note 2.
6 The Art of Existence, Image magazine, July 2008.

Gardens featuring over 100 works in bronze, glass, timber and steel by 60 Irish, British and French artists.

As with any dealer, Macdougald was always on the look-out for new talent. Three or four wannabes come into her gallery every day – maybe one a month is any good. Letters, emails and DVDs with artists' work flood in. "I do get excited about new finds – sometimes they've walked in the door, sometimes we've gone after them," she said. "I used to do a lot of work with young people; I don't so much now. I can't afford to. I can't take as big a chance as I used to."

Because of the boom, there's now a glut of other galleries to contend with. Not even galleries, shops. "They buy and sell work, but they don't represent artists as we do," Macdougald said. "They don't have regular exhibitions, hold stock of their artists' work, constantly promote them, take them to fairs. There's a lot of dross out there. They call themselves galleries but they're not." Her voice drips with sarcasm as she says: "They are premises which sell framed work."

But her main rival these days is the auction trade, a far more formidable foe. Take marketing. Auction houses only have to promote about four sales a year, while galleries like the Solomon have a show a month. They can but look enviously at the enormous auction-house ads in *The Irish Times* every Saturday. Auctioneers send out 5,000 catalogues to clients; the best galleries have mailing lists of no more than 1,500. A catalogue costs about €4 to produce, and postage comes to about €3,000 per run – a think-twice expense for a gallery, small beer to an auctioneer.

"They are all producing much better catalogues, better invitations, spending money on promotion," says Macdougald of her new rivals. "Before they used to sit back and wait for it to come in the door. When Whyte's came in the old boys had to sit up and take stock and reinvent themselves.

"Auctioneers have taken a lot of income out of the market – I mean to the tune of millions. The galleries bring artists up to a particular level, and the auction houses are benefiting. They cash in at the end. We're the people who took them when nobody had heard of them. The auction houses have never invested in an artist."

These days she can barely bring herself to say his name, but one of the artists she culti-vated is Martin Mooney. Born in Belfast in 1960, he was taken on by the Solomon Gallery in 1988 soon after he left college, and it hosted his exhibitions every two years thereafter. A tradi-tional painter, whose perfectly executed works are in the formal style of the Old Masters, Mooney soon found a market for his luscious still-lives and cityscapes. Macdougald steered his paintings into the collections of her friends and top clients – Tony O'Reilly, Michael Smurfit, Norma Smurfit, Miranda Countess Iveagh, Dermot Desmond. Twice he was invited by Prince Charles as an official royal painter on foreign trips. Lochlann Quinn commissioned Mooney to paint the Merrion Hotel's Georgian interior. "We definitely did an enormous amount to

PAUL HENRY

BORN: 1876, BELFAST

DIED: 1958

PAINTING STYLE: POST-IMPRESSIONIST

HIGHEST PRICE PAID AT AUCTION: £298,000 (CHRISTIE'S, 2005)

FANS SAY: IRELAND'S MOST IMPORTANT LANDSCAPE PAINTER

CRITICS SAY: HIS LATER WORK IS REPETITIVE AND TRITE. SOME FIND HIS OVERALL OEUVRE UNCHAL-LENGING – HENCE THE NICKNAME THE BANKERS' PAINTER.

IF YOU COULD OWN ONE: THE TURF GATHERER, 1911 (RIGHT)

BEST EXAMPLE ON PUBLIC DISPLAY: LAUNCHING THE CURRAGH (NATIONAL GALLERY OF IRELAND)

€300,000 2007

Henry grew up in an evangelical household, his father a Baptist minister. Apprenticed to a linen firm, he soon left to enrol as a student in Belfast School of Art and five years later went to Paris and studied at the Academie Julian. It was there that he met Scottish-born painter Grace Mitchell, whom he later married. In 1900 he moved to London, and worked as an illustrator on a number of newspapers and journals, later moving to Surrey. In 1910 came the seminal experience of his life – a trip to Achill Island. Travelling there for a short holiday, he was supposedly so bewitched that he tore up his return rail ticket and threw it into the sea. "I felt that here I must stay somehow or other," he said. "I would go no further." The Henrys settled in the village of Keel, taking lodgings with the postman, and eventually stayed for nine years. Inspired by the resilience of the local people, Henry

CONTINUED ON NEXT PAGE

promote his career," Macdougald said.

No-one knows exactly why they fell out, but Mooney left the Solomon in 2004. Dealer-artist relationships are usually for life, more stable than the average marriage. True, Macdougald has had other fallings-out, but not as many as people might expect. Rowan Gillespie,[7] the sculptor, has been with her since she started as a dealer in 1974.

Maybe the real problem was where Mooney went next – to David Britton in the Frederick Gallery. When Britton moved to Adam's, Mooney went with him. Another of the country's top-selling living artists lost to Irish galleries. When Britton wrote the introduction to the catalogue for Mooney's first exhibition with the auctioneering firm, he seemed to rub it in.

"Martin is very excited about working with us at Adam's, his exclusive agents in the Republic of Ireland, and we all look forward to a long and fruitful relationship," Britton said. The words "exclusive agents" were added at Mooney's request – so that there would be no ambiguity in the public mind, so that art buyers would know that the split with the Solomon was permanent.[8]

CONTINUED FROM PREVIOUS PAGE

painted many compositions of potato diggers, and (showing the influence of Millet) women in home-spun red flannel. He later wrote that he had "yet to see people who worked so hard for so little gain."

He then switched to landscapes. His horizons were low, and he stacked the sky with clouds, a flourish that was to become the Henry hallmark. The unsettled weather that is characteristic of the west of Ireland supplied a never-ending variety of backdrops.

The Henrys also travelled widely through Connemara, although their extended stay took a heavy toll on their marriage. They returned to Dublin in 1919, and both began other relation-ships.

When they finally separated in 1929, he moved in with painter Mabel Young, marrying her after Grace's death.

In 1925, Henry was commissioned to design a Connemara poster for the London, Midland and Scottish Railway. This proved to be so popular, not just in Ireland but throughout Europe and America, that it seduced Henry into repeating himself.

"He ultimately became trapped in his own imagery," S. B. Kennedy has observed. Henry exhibited widely in North America and Europe. He suffered a nervous breakdown in 1945 and later went blind. Although he wasn't able to paint again he did produce an autobiography. He died in Enniskerry.

Heavily influenced by Whistler, his former teacher, Henry was a master at using few colours to create effects. Whole paintings are composed with just a few shades of white. He believed tone was more important than colour, and because he liked to capture the dawn and early morning, subdued hues often dominate.

His best paintings were all done before 1930; after that Henry was painting from memory.

Macdougald was furious, feeling betrayed and hurt. Not referring to Mooney by name, she now says: "I don't think it's fair that auction houses are exhibiting artists. I think any artist worth his salt is associated with a really good gallery. Look at someone like le Brocquy who has been with the same two galleries for 50 years. Artists sort of hop around today. The scene has changed drastically. And it's money..."

But Brian Coyle, Adam's chairman, did get a blast of her anger. "Yes, she was very upset about Martin Mooney," Coyle confirmed. "She went ballistic [with me] one time out at a party given by well-known people in Dublin. The claws were out." He does an impression of a tiger.

But Coyle insists the two are old friends; sure wasn't he was at her 60th birthday party? "I like Suzanne, she's a very business-like type lady." Nothing personal, then; inheriting one of her top artists was just business. "Suzanne has done well in recent exhibitions," Coyle points out, almost in mitigation. "Colin Davidson[9] had a very good sale for her."

Britton defends taking Mooney out of the gallery system, arguing that Adam's gives him a better service. "The catalogue that we produced [for Mooney's exhibition in 2007] is probably superior to any gallery catalogue that I have got recently," he said. "We would spend about €20,000 on production and posting the catalogue to 5,000 people. We can showcase the pictures – our front window on Stephen's Green is seen by an awful lot of people. We are charging [the artist] only two-thirds of what he would be paying in another gallery. I am quite surprised at galleries that do charge 50% and how little they do for their 50%.

"So I think [exhibitions of living artists] complements what we are doing, and we do support the arts. I know there are certain quarters giving out, and one person in particular, but [Mooney] had already left them. It wasn't as if we poached him. I was approached by [Mooney] originally about the possibility of having a show."

Adam's says it promotes its artists all year round, just as a gallery would. It organises commissions and puts works by Mooney and Mark O'Neill into its major auctions twice a year. Auctioneering firms are not ploughing the profits they make from such highly successful artists into new talent, as galleries would. But apart from investing in young artists, what justification is there for galleries taking such high commissions? In the 1980s, the industry standard was 33%, and then it crept up to 40%. At the turn of the decade galleries like the Solomon increased their commission to 50%. And out of his half the artist must pay VAT and, in some cases, share in the cost of the catalogue.

Antoinette Murphy, an influential collector who opened the Peppercanister Gallery in

7 Worked in bronze, Gillespie's best known sculptures are the Famine series on Dublin's Custom House Quay. Internationally successful, he has completed commissions in Toronto and Colorado.

8 Britton said: "That's something the artist requested. There were people representing themselves as if they were representing Martin, and they weren't, and he specifically asked me to point that out in the catalogue. It's to tidy up affairs. There were galleries saying 'further pictures available on request', which implied that they were still representing Martin Mooney, which they don't....I am only following instruction."

9 A young Belfast painter discussed in Chapter 12.

Dublin in 1999, outlines the sort of service that old-style dealers give their stable of artists in return for taking between 33% and 50% of the price of a painting. "Our artists come in and talk to us," she said. "Sometimes we advance them money if that's needed. It's a good support system for artists and that's why most of the young ones want to get into galleries. It gives them a sense of support and security and that we bother about them. Artists think they are getting a good service – otherwise why would so many want to be with a gallery?"

Macdougald adds: "A gallery only makes something when it sells. In the meantime I have staff, rates, heat, light, electricity, security, insurance… the expenses of running a gallery are enormous. It costs me to put work on the wall. We nurture an artist's career, we promote them, we do all the work for them. I think artists are more influenced now by money – I'd be naïve to say that they are not. I suppose [the Mark O'Neill route] is tempting for a lot of people, yes. But the bottom line is that it is not actually benefiting his career. He can paint, but he is not challenging himself."

CYRIL BYRNE/THE IRISH TIMES

COURTESY JOHN DALY

Single-artist exhibitions and auctions of Mooney and O'Neill by Adam's are not the only way in which auction houses have entered the primary market. Most now hold "modern and contemporary" sales, and artists are approached directly and asked to submit paintings. Many are happy to do so. For artists with no gallery representation, sales at auction are a way to reach a wider audience. Many established artists also like to see a few of their works going through auction houses each year in order to keep their paintings in the public eye. Their dealers will consign if necessary, making sure that the auction's reserve is the gallery price.

For auction houses who find it tough to get top-quality material on the secondary market, fresh works from "hot" contemporary artists are a way of filling the gap. Sotheby's launched a contemporary Irish sale in late 2006, and grossed £1m.

"Nearly every auction house in the country has approached me to give them work directly," said Robert Ballagh. "I haven't done so, so far. I'm not comfortable with that. Far be

it from me to be singing the praises of the galleries, because when I started off I used to rail about them charging 33.3%, and now it's 50% pretty much everywhere. But I do have some sympathy for them trying to survive now. They have to pay rent on a city-centre premises, put on 10 or more shows a year, do invitations, catalogues, drinks. Even the smartest gallery owner in the world is going to put on shows that don't sell, because you can't predict the public taste. Auction houses are in a win-win situation. They don't have anything like those overheads. If a painting doesn't sell, it's no skin off their nose.

COURTESY OISIN GALLERY

Opposite top: **Patrick Taylor of the Taylor Galleries in conversation with Grainne O'Malley, a relative of artist Tony O'Malley.**
Opposite bottom: **John Daly of Hillsboro Fine Art.**
This page: **Donal McNeela of the Oisin Gallery.**

"A lot of galleries are closing. If someone told me 'I'm going to put my SSIA into opening a gallery', I'd say 'are you mad?'" It doesn't strike me as a place to make a lot of money unless you have an established artist on your books. There have been heroic examples in this town over the years of gallery owners doing it for the love of it and putting on artists they admired. None of them are left. Over the years I've watched them come and go."

Donald Teskey is another artist who will not, on principle, give his work to auctioneers and who dislikes their undermining of the gallery system and the consequent distortion of the art market. "A good commercial gallery operates by balancing the work of new, up-and-coming but not yet sellable artists with their older and probably more commercially successful artists, ensuring a flow of contemporary ideas to be nurtured for the future," he said. "This balance is what keeps a gallery alive and relevant to both the general viewer and the collector." Teskey points out that by selling artists directly, auction houses are also drawing away buyers from galleries, which are better places to learn and to get advice.

Mark O'Neill puts the case for the opposition: he sees "no excuse" for galleries charging 50% commission, plus extras. "Anyway it's an open market – let the best model, the best shop-seller win," he said. "The best gallery, the one that deals with artists kindly, is going to keep hold of its stable and survive. Even if one gallery does struggle, that's the law of the jungle.

"Yes, galleries may be having it tougher than they ever did, but there's only four artists showing with Adam's, so that's not a big deal anyway. And the other galleries were never going to get a penny off Mark O'Neill because he was with the Frederick. That was a closed account, so they are not losing out on my money."

Dealers like to think that artists such as O'Neill and Mooney forfeit professional cachet by not being with galleries. The price of keeping more commission is a diminution of artistic respectability, perhaps. "I think that it's not, in the long term, very advantageous for the artist to be associated with an auction house," said gallery owner Ib Jorgensen. "This trend hasn't happened anywhere else – not in Britain, for example. In the long term the artist finds that they're not going to get critiques from art critics in newspapers.

"Yes, the auction houses are taking a lot of private clients away from galleries. But I don't mind that, I see it as competition. One has to be open to competition and just be ahead of it."

IF YOU CAN'T BEAT THEM, JOIN THEM, RUNS THE OLD ADAGE. JUST AS AUCTION HOUSES HAVE STARTED to compete in the primary market, some gallery owners decided to vie for a share of the secondary market spoils. "We now do consultancy work, and we buy and sell," said Macdougald. "We are art dealers as well as gallerists, and the dealing actually pays for us to be able to have that.

"It's not all about money but the bottom line is that I have to pay my bills, which have become higher and higher. So Tara Murphy[10] and I go to all the auctions every year. We source work both for ourselves and clients. The money we make from that helps a lot, basically pays to keep the place going. And I love working in the second-hand market. It's very exciting, you get a kick out of it. It's the fun part. The gallery is boring, really."[11]

The irony is that David Britton discovered this half-and-half model when he was at the Frederick. The money he made on the secondary market is what allowed him to take only 30% commission from Mark O'Neill. "When I was doing shows in the Frederick, it was the secondary market that paid for me to charge less commission to the living artist," Britton confirms. "That was how I could get people who were only starting out. Secondary pictures helped finance the more contemporary ones."

There is still a reservoir of goodwill among collectors towards galleries, and a determination to support them. Gillian Bowler, for example, prefers to buy from dealers rather than auction houses. "I would feel sorry for gallery owners because they did such a huge amount to build up contemporary art collections and it is really hard for them to make money now," she said. "I met someone casually a few years ago and he said he was thinking of setting up an art gallery and I said 'why? You are not particularly interested in art'. And he said 'Yes,

10 Tara Murphy, the Solomon's director.
11 And in August 2008, she announced that she was closing it. Solomon Fine Art, the rebranded company, no longer operates from Powerscourt House off Grafton Street. Instead it will do up to four exhibitions a year at the Merrion Hotel and represent only a small number of artists. See http://www.solomonfineart.ie/
12 Taking care not to put watercolours over radiators, for example!

but it's a great tax loss'. I told him it would work as a tax loss alright.

"Suzanne Macdougald is still going strong – she still has Basil Blackshaw on her books – but she's mixing it with popular stuff. She has clients asking her to source paintings and I can imagine that I might do that, because there are some old Blackshaws I would like. Suzanne has her head well screwed on in terms of making money and staying alive in business."

But becoming quasi-auctioneers is not the answer for all dealers. As Donal McNeela of the Oisin Gallery points out, it brings problems of its own. Droit de suite, the resale royalty, is one of them. Dealers who want to buy and sell paintings at auction will have to pay it like everyone else. They may try to pass it on to clients, but will that work? "It's another unfortunate tax on us," he said.

Established in October 1978, the Oisin on Westland Row is a family-run operation. In the face of the auction house enemy, director Donal McNeela had to examine his own business model and he wonders why there isn't a way for him to sell work as auction houses do. "I doubt that I could say to a single client of mine: 'look, the price of this painting is €2,000 and, by the way, my selling fees are 20% on top'. None of them would give it to me." But that is precisely what auction houses do.

Gallery owners work longer hours, have relatively higher overheads, and it doesn't pay them to sell a painting for less than €1,000 when you factor in VAT, credit card charges, staff commissions. "People think that you sit on your behind and wait for someone to come in and then sell them an expensive painting," said McNeela. "It's just not quite as easy as that. But you can't stop the march of business. Galleries complaining about auction houses is like newspapers complaining about the growth of the internet. It's pointless, change will happen. There's no wrong in what they're doing. All we can do in response to the auction houses is look after our clients as best we can."

Galleries must play to their strengths, he believes. One of these is allowing purchasers to buy at leisure. "The auctioneer's business model is that he can only sell 300 pictures in a night – probably 250 is slightly better," McNeela said. "You start at 6pm. By half seven, a lot of people are tired. Each picture is only getting 25 to 45 seconds. The auction depends on people being available on the night.

"In galleries, people come in, look at a painting, look at it again, maybe buy it but maybe try it first. It's a different selling process and we should have the upper hand in a down time." Flexible payment methods – allowing purchasers to pay over six months, for example – are standard in the business. Discounts of 10% or more are obtained by a minimum of haggling. Would-be purchasers are allowed to take a work on loan for a week or two to help them decide. Some galleries such as the Oriel guarantee to buy back work at the sale price. Galleries will usually send out staff to hang paintings in your home.[12] As McNeela says, it's a better model when there's no boom. Does that mean they have to sit it out?

Naturally the boom has not been all gloom and doom for dealers – how could it have

Portrait of the artist

EDWARD DELANEY

BORN: 1930

STYLE: SCULPTOR

RECORD AT AUCTION: €21,000 (ADAM'S, 2007)

FANS SAY: IN THE 1960S HE REDEFINED IRISH ART, BY REJECTING THE ACADEMIC STYLE WHICH PREVAILED DURING THE FIRST HALF OF THE CENTURY.

CRITICS SAY: SOMEONE OF HIS TALENT SHOULD HAVE MADE A BIGGER IMPACT AND LEFT A LARGER LEGACY

IF YOU COULD OWN ONE: MARCH OF THE PEACE WOMEN

BEST EXAMPLE ON PUBLIC DISPLAY: WOLFE TONE STATUE, ST STEPHEN'S GREEN (RIGHT).

Edward Delaney (seated) and Patrick Murphy Director of the RHA (left) pictured at the opening of the exhibition of Edward Delaney sculpture at the RHA.

Born in Claremorris, Co Mayo, he left school at the age of 14 with little education. After moving to Dublin he worked in a hardware store in Rathmines by day, and insinuated himself into the National College of Art and Design by night. By just turning up for classes, and ignoring the usual entrance requirements, he infiltrated fully into the college and eventually graduated. His teachers included painters Sean Keating and Maurice MacGonigal, who helped him get an Arts Council scholarship to Germany. Delaney was keen to learn the art of lost-wax bronze casting, or as he later described it, "the secrets of the foundries". Lost-wax is a highly skilled method of casting, with which few were familiar at the time.

When his money ran out, Delaney worked as a welder, fitting together tram tracks in Munich. He got a master's degree in bronze casting in 1958. He moved to Salzburg to work alongside an Italian sculptor who had been commissioned to design new bronze doors for St Peter's in Rome. In all he spent seven years in Germany and Italy, studying art and mastering the techniques of bronze casting. He represented Ireland at the Paris Biennale in 1959 and again two years later.

On his return to Ireland in 1961, Delaney got

two major public-sculpture commissions in Dublin – Thomas Davis on College Green, which was unveiled by Eamon De Valera on the 50th anniversary of the 1916 Rising; and the statue of Wolfe Tone and the Famine memorial at the corner of St Stephen's Green opposite the Shelbourne Hotel, which was unveiled in 1967.

Tone is 10ft tall and was cast in Delaney's back yard in Dun Laoghaire. Eamon, his son, says that one of his first memories is of the statue "being lifted by crane from our back garden and over the little houses." It was damaged by a loyalist bomb in 1971 and repaired by its creator.

Delaney moved to Carraroe, Co. Galway in 1980, where he installed a foundry. But instead of working with bronze, he turned to stainless steel. He developed an open-air sculpture park around his house which he called Beyond the Pale.

He also designed record sleeves for the Chieftains; and a series of prints that tell stories based on the Old Testament, which was published in 1970. His work is in the collection of the Hugh Lane Gallery and the Ulster Museum, and the RHA staged a retrospective in 2004.

been? A lucrative new phenomenon is the art fair. The most prestigious is part of the Interior Design Show held in the RDS each May. Here, some 22 galleries display their wares, having been selected from a much wider group of applicants by a steering committee. Individual artists are not welcome. The average stall costs about €6,000 for the weekend, and if it doesn't pay in sales – though several do – it does in terms of extending the customer base. "I don't do it for the sales; I do it for the contacts," said John Daly of Hillsboro Fine Art. "The people I sell to I already know, but I also give out hundreds of brochures."

Art Ireland, held each November in the RDS, is a popular but more downmarket affair – the indoor equivalent of hanging paintings on the railings of Merrion Square. No established galleries attend. "It's dreadful," one dealer sighs. "No collectors go there. It's for artists that don't have dealers, some celebrity artists, and some galleries from the north." In 2006, organisers say the fair attracted 10,000 visitors who spent more than €2m at the 80 stands. In 2007, organisers boasted that over 13,000 people attended and spent €3m.[13] Such suspiciously round figures must be treated cautiously, of course, particularly since people in the art business are generally reluctant to give accurate figures.

With a stand costing €2,000 plus VAT, Art Ireland represents something of a gamble for an artist. Undoubtedly the likes of Kevin Sharkey and the Mansfield sisters can do well. Art Ireland boasts that since its inaugural year in 2000 the event "has attracted high-profile art collectors including Norma Smurfit, Brian Dobson, Mike Murphy, Dermot Desmond, Pauline McLynn and Michael Flatley."

A few Irish galleries take part in international fairs. Mother's Tankstation and the Kerlin both sent artists to Art Basel in June 2008. This event has been called "the Olympics of the art world", with 55,000 people travelling to the Swiss city to look at the work of 2,000 artists, living and dead. Some 900 galleries apply for the 290 available spaces – and the privilege to pay at least €20,000 for a stand. But no wonder – sales gross about $300m. Six art dealers sit on a selection committee deciding who gets in. Collectors are so keen that some have been known to disguise themselves as workmen in order to get a sneak preview before the official opening – the idea being that if they spot something they like, they can race to that stand when Art Basel formally opens its doors.

The Kerlin Gallery attends London's Frieze, a contemporary fair held each October. It is a relatively new event which has won instant prestige. Here, too, about 500 galleries apply for 150 or so spaces. "Frieze best illustrates the divide between art-industry insiders and outsiders," one British commentator has noted.[14] "Favoured collectors and agents get in early, eat and drink free in sponsored VIP lounges…VOPs [very ordinary people] wearing sneakers queue for the opening and drink £7 wine from plastic glasses."

13 www.artireland.ie
14 Don Thompson in The $12 million stuffed shark.
15 Ibid, and Art Attack, Sunday Times magazine, 30 March 2008.
16 http://www.kingstreetfineart.com/

John Daly of Hillsboro Fine Art attends Art Miami, the biggest satellite of Art Basel Miami Beach, an offshoot of the European fair. It's an opportunity to bring the international artists in his stable to the attention of a wider audience. "It costs a fortune, and you only tend to pick up a few clients," Daly said. "But you gradually raise the profile of your artists and when you appear every year, people start coming back to you."

Irish art fairs are more democratic and relaxed affairs than the international ones, a chance for dealers to spend uninterrupted quality time with clients, and to sell to them in a shopping-mall or retail-style setting. The presence of so many buyers and the number of red dots on pictures (be they authentic or not) has the same reassuring effect as rival bidders at an art auction – everyone else is buying something, so it's fine for me to spend too.

International trends suggest, however, that Irish auction houses may eventually attempt to muscle in on this lucrative new arena. In 2006, Sotheby's took over Noortman Master Paintings, a Dutch dealership, which continued to exhibit at Maastricht and other art fairs. In response, Christie's demanded that it be allowed a stall at Maastricht, and reportedly threatened a European Court challenge, or to set up shop in the town square, if it was refused.[15] The organisers caved in, stipulating only that Christie's show art that was being sold by private treaty and not by auction. Christie's set up a wholly owned subsidiary, King Street Fine Art, "to concentrate on private sales and high-calibre works of art, specifically with a view at this stage to exhibiting at TEFAF" [16] i.e. Maastricht.

This sets a useful precedent for Irish auctioneers. Indeed, given that Adam's and de Vere's are selling contemporary artists direct, it would be plausible for them to turn up at an art fair displaying Mark O'Neill and Aidan Bradley side by side with the Taylor Galleries showing Mary Lohan and Martin Gale. Furthermore, some Irish auctioneers maintain a stock of paintings which they sell to clients privately. These could also be displayed at art fairs. This, however, would be regarded as a major incursion onto dealers' turf, an outright declaration of war.

Some galleries did go to the wall during the boom, but far more opened than closed, and there were about 130 in the Republic at last count. A peek at their accounts in Companies House reveals a sheaf of healthy balance sheets. On The Wall Gallery Ltd, which owns the Kerlin, had €683,207 cash in the bank when it filed annual returns in October 2007, with debtors owing €132,335 and net assets of just under €0.5m. The Taylor Galleries' directors – John and Patrick Taylor – paid themselves €203,333 in 2004, €248,012 in 2005 and €666,666 in 2006. Dublin's most prestigious gallery had €1,811,681 cash at hand in August 2006, up from €1.37m the previous year, although its debtors owed €986,152.

The Taylors are known as something of a soft touch in the art trade, and several collectors say they have had to badger the gallery for bills. Who knows how much it has written off to unscrupulous buyers who took advantage of the Taylor brothers' gentlemanly approach to business and never bothered to settle up?

With other galleries, however, a legitimate grumble is that they don't pay up in a timely

manner themselves. Not surprisingly, no artist attached to a gallery will make a complaint in public, but this author knows of a painter who waited almost several months to be paid after one of his works sold in the Christmas exhibition of a leading gallery. Little wonder that artists are increasingly trying to go it alone – setting up co-operative ventures such as Four, Monster Truck and Mother's Tankstation.

"I had to create the space to sell my own work because, to be honest, the feckers didn't want to pay you," said Kevin Sharkey. His Francis Street premises was allocated to New Irish Artists Market House (NIAMH), a co-operative which complains that, despite the boom in art buying, there has been no comparable growth in exhibiting opportunities. It promised that there would be "no commissions involved, no unfairly curated joint exhibitions, no 'not-paying-the-artist-when-work-sells' situations, no clashing styles of artists' work hanging side by side, no unauthorised-by-the-artist sending of work out on 'approval', no disagreements when it comes to taking work out and swapping pieces". A typical painter's gripe list these days.

"A lot of artists are now taking my lead and just doing it themselves," said Sharkey. "If galleries paid up when they're supposed to, it wouldn't be so bad, but you'd end up with a nervous breakdown trying to get the money out of them. Slow-to-pay wouldn't be so bad – but some of them wouldn't even pick up the phone [when he went chasing money owed]. The business end is something that a lot of artists are not good at. That's

Ben Dunne at Westpoint gym, Blanchardstown, Co. Dublin.

Artists without galleries
will queue up to have
their works hung by
Dunne, but this will
be no picnic.
"If their product isn't
shifting, they'll be
taken off the walls,"
he threatens.

why they're artists in the first place. They're not vocal, so they put their expression into their work.

"Galleries like to keep artists insecure, because it stops them from getting teeth and biting them. But artists are starting to fight back now, and that's good because Irish art is huge."

The odd artists' co-operative is not going to upset dealers too much but another development could. Ben Dunne, the former head of Dunnes Stores whose philosophy is to 'pile em high and sell em cheap', has converted a 7,000 sq ft cricket pavilion in Kimmage into an art warehouse. The Norah Dunne Gallery is named after his late mother and, depending on how it fares, could be followed by two more. These would be named after his late sisters, Therese Dunne and Liz McMahon, and the locations being mentioned are Cork, Galway or Belfast.

Dunne, who has taken painting lessons and has an extensive collection of art himself, is no fool and has done well with factory-sized gyms at three Dublin locations. Art supermarkets are not a new idea – the capital city has seen several come and go – but one run by Dunne could make a dent. Predictably, he is promising that the Norah Dunne Gallery will "change the mould". It will attract art buyers by offering low-cost works – "nothing for more than €1,000". By trumpeting that he will take less commission from artists – 25% compared to 50% – the businessman is attempting to tap into a reservoir of public resentment towards galleries. He also promises such consumer-friendly notions as a six-month return policy if buyers aren't happy.

Artists without galleries will queue up to have their works hung, but this will be no picnic. "If their product isn't shifting, they'll be taken off the walls," Dunne threatens.

His populist comments will turn the heads of starter couples of modest means who just want to put a still life over the mantelpiece and not have to deal with the condescension of galleries, the over-hyping of auctioneers or the impenetrability of critics' prose.

"I have been thinking about this for a while, as someone who frequently attends art exhibitions," Dunne said.[17] "It has struck me these galleries are always cramped and stuffy, with people bumping into each other and nobody with room to walk around. All these galleries are in town where it is impossible to get parking, and you end up walking for ages in the rain to get into an exhibition where 60% of paintings are already sold before opening night."

The Norah Dunne Gallery will have "ample parking", he promised. Some art buyers need hear no more. Despite what Dunne says, however, Dublin's art galleries are far more amenable to the public than New York's or London's. "Try and walk through the door of an art gallery in London – you'll find it's almost impossible," said Julian Charlton of the Apollo. "The doors are sealed. You have to ring on the door bell and say who you are. In this country, ordinary people can walk into galleries and buy paintings. That's not possible in America, London or Paris. We have a more democratic market."

In time, the rise in buyer's premium at auction houses – especially London's – may push

people back towards galleries. The service and knowledge offered by a good traditional art dealer may also come to be appreciated by this new generation of art buyers. Few of them will have heard of Jimmy Gorry, or visited his modest gallery on Dublin's Molesworth Street. Gorry doesn't deal in the "hot" artists of the auction houses – he specialises in 18th and 19th century Irish art. The business was started by his grandfather, James Joseph Gorry, about 100 years ago. The accumulated knowledge, experience and craft of identifying paintings, restoring them, valuing and selling them has been passed down through three generations to Jimmy.

His gallery has a selling exhibition once a year, or less often – it depends on how long it takes to accumulate 60 top-class works. Public institutions such as the Office of Public Works and the National Gallery of Ireland get first pick. After that it's first come first served. Collectors have to queue outside waiting for the 6pm opening. No telephone calls go out in advance to favoured clients. Even Larry Goodman's pilot has been known to sleep outside the museum in his car in order to be first in line and secure two choice paintings for the beef baron.[18]

"We don't encourage people to buy as an investment," said Gorry. "We're an old-fashioned gallery. We try to get people who collect pictures as an interest for their whole life. So we don't have many people coming in saying 'what's a good buy? What's a good investment?' I don't encourage that. There's too much of that going on, in our view. People are going into auctions and buying names, and they don't think 'is this an early, middle or late work? Is it a good or a bad one?' They just buy. They say 'a 16 by 20 Paul Henry went for so much, therefore this one must be worth X'.

"Auction houses are dominating the market worldwide and a lot of the trade has been crushed by them. The fees they charge both buyer and seller are such that auctioneers can pay for pictures to be reframed and restored, and to have wine receptions. It's like they're having exhibitions. And they're more fussy about how they hang the pictures. They have good-quality catalogues with articles researched and written by academics." All of this was the traditional turf of the dealer. All these roles have been usurped.

But Gorry reckons there will still be a place for the dealer. Why? One reason is because paintings get old, and then they need restoration and repair. "All these Paul Henrys will start to crack; they will become old pictures," he said. "Paintings done in the late 19th century buckle and crack. It's a natural ageing process." And where will the buyers of the boom go when their investments wither? To whom will they turn for help? Perhaps to him.

17 Sunday Independent, March 2007.
18 Another art collector who favours 18th and 19th century works is Ken Rohan, who in the early 1990s was the controversial beneficiary of a tax break introduced by a Fianna Fail government giving tax relief on art collections in historic houses that are open to the public.

10

"It's not art if you don't get paid for it"
Andy Warhol

ONE OF THE HIGHLIGHTS OF IAN WHYTE'S SALE on 22 February 2005 in the RDS was a full-length portrait of singer Sinead O'Connor in the nude. It had been commissioned two years earlier by a Dublin nightclub from artist Jim Fitzpatrick, but once the painting was finished O'Connor wanted it for herself. Now *Strange Days* was back on the market with an estimate of €15,000-20,000.

The audience had to wait for the nude portrait until lot 226. In the meantime there were several good prices to admire. *Wounded*

John Kingerlee's On The Beara Peninsula which sold for €36,000 in February 2005. That record price was smashed seven months later when a 12 inches by 17 work, Grid, by the Beara-based artist achieved a record €60,000 at Whyte's.

Pigeon by Louis le Brocquy went for €50,000, and a Paul Henry slightly exceeded its upper estimate at €87,000.

But lot 75 would have made them sit up. *On The Beara Peninsula* by John Kingerlee had been estimated at €10,000-12,000 but sold for €36,000. Who was this hot young artist, the viewers must have wondered, leafing through their catalogues for his biographical

€36,000
2005

information. Not so young at all, as it turned out: just five days earlier Kingerlee had turned 69. So he'd achieved prices like this many times before in his lengthy career? In fact, no, the buyers at Whyte's would have discovered.

The price they had just witnessed was a new record for his work. Indeed, apart from one sale at Christie's the previous year, Kingerlee never got five-figure prices. True, one of his works had sold for €10,500 at a charity auction in June 2003, but that wasn't a reliable guide – buyers regularly go over the top when they're bidding for charity. Up to 2001, Kingerlee's record at auction was £650, or about €1,000. By April 2003, despite the boom in Irish art prices, it was still a modest €4,800.

If those who attended Whyte's sale in February 2005 were surprised at the price

Kingerlee's *On The Beara Peninsula* achieved, they were in for quite a shock at Whyte's September auction later that year.

RTE cameras were there filming for a documentary, and *The Irish Times* reported that the atmosphere was further heightened by the number of bids being taken by the row of telephonists. Lot 112 was a smallish Kingerlee abstract, 12 inches by 17, featuring six rows of five tiny plaques set on a green background. The catalogue entry was effusive – someone called Jonathan Benington from Bath reckoned that "in these remarkable *Grids* of Kingerlee's both the means and the end seem to be without parallel in contemporary painting." The estimate was €20,000-30,000. "Bidding started at €14,000 and mounted inexorably to its peak," *The Irish Times* said. It didn't stop until it reached €60,000.

The word afterwards was that a collector from New Jersey in the United States was the purchaser. The Dublin art market was agog. Only a handful of contemporary artists, the likes of le Brocquy, William Crozier and Basil Blackshaw, whose pedigree has been proven over decades, make prices like that. So what was going on?

A few months later the same *Grid* appeared on the front cover of a lavish 280-page biography of Kingerlee written by Benington. Presumably we'd find some answers here. "John Kingerlee has covered his tracks well," Benington began. "His geographical remoteness goes a long way towards explaining why it has taken 40 years for his highly original and contemplative paintings to be unveiled to the world." Living on the Beara peninsula in west Cork, Kingerlee had operated "at several removes from the commercial art scene, safeguarded his artistic integrity" and painted "for personal satisfaction rather than any financial reward."

Some 200 pages of the book were given over to reproductions of Kingerlee's paintings, including *Grids*, heads, abstract landscapes and collages. These were, at the very least, "difficult" works, not revealing themselves to a casual viewing. But Benington was positively bowled over, insisting that "one has to revert to Rothko to find a precedent for drawing a line so emphatically in the artistic sand."

As the book progressed, it became clear that no praise was too extravagant for its author to bestow. Because Kingerlee worked with a limited range of colours it "inevitably prompts comparison with other practitioners of white-on-white discipline such as Whistler or le Brocquy." But because the subject of the artist's scrutiny seems to be not so much the landscape as the atmosphere that envelops it, "hence a more appropriate comparison would be with some of the late works of Turner and Monet, for example the latter's *Haystacks* series."

We were told that Kingerlee "esteems *Finnegans Wake* as one of the greatest of novels." But then James Joyce and the Cork-based artist "tap into the same wellspring of innovative creativity, accessible only to those who are willing to tear up the rule book… Just as Joyce turned the novel on its head, questioning the very meaning of language and returning it to its pre-cognitive origins, so too has Kingerlee gone out of his way to reconfigure the grammar and meaning of painting."

Kingerlee explained to his biographer how one of his paintings once saved a woman's life. Having discovered that her husband was having an affair she'd resolved to kill herself, but first popped into a gallery, saw one of Kingerlee's paintings, bought it, and thought better of doing away with herself. "I'd like the work to have that quality," the artist said. "So that it gives life to people."

In his work journal for 2003, reproduced in the book, Kingerlee speculated that his *Grids* would one day be recognised as a distinct art movement. "At the beginning of the 20th century: Cubism. The beginning of THIS century: the *Grids*. Well, I wonder. Do you really think so? Perhaps."

The book cost €50 (£35 sterling), but there was also a deluxe leatherbound edition which came with a mixed-media drawing and cost £2,000, with the proceeds going to the Ireland Fund. It was launched in the Leinster Gallery in Dublin in February 2006. Soon afterwards Kingerlee's prices were on an upward trajectory again.

At Sotheby's Irish Sale that May, a *Grid* sold for £60,000 sterling (about €80,000) and in October another went for exactly half that. But on 15 November came a real jaw-dropping moment. Lot number 462 in Sotheby's contemporary art sale in New York was a *Grid Composition* with an estimate of $50-70,000. Sandwiched between a pair of Sean Scullys, it sold for $156,000, or about €120,000 based on exchange rates at that time.

Gallery Gora in Montreal, which had just hosted an exhibition of Kingerlee's works, immediately circulated news of this extraordinary price on the internet. "This newly established world record clearly demonstrates the growing demand for this leading world artist," it trumpeted.

Not everyone was impressed, though. Zeke's Gallery, a Canadian art blogger, noted that the *Grid* sold by Sotheby's of London just a few weeks earlier for one-third of the price was larger than the new world-record holder.

Meanwhile other Kingerlee paintings were selling in Sotheby's for as little as €2,000. Zeke also wondered why Gallery Gora was saying Kingerlee's work "fizzles with energy" while Sotheby's was quoting Benington as saying it had a "meditative calm" and "evoked a serenity." Contradictory, no?

But by now Kingerlee was supposedly paying tribute "to the prismatic disintegration and reassembly of the everyday by the cubist masters Picasso and Braque," while "comparisons can also be drawn with the *Harmonies* of Paul Klee."

All this time Irish auctioneers were knocking down Kingerlees at strong but not stratospheric prices. A couple of weeks after the New York world record, Adam's sold a *Head and Figures* for €25,000. So what did Dublin's dealers and auctioneers make of the artistic James Joyce in their midst. What was their explanation for the extraordinary take-off in Kingerlee's prices in the twilight of his career?

In fact, some felt Kingerlee's prices were artificially high. The staggering sums achieved

The €60,000 Grid as sold by Whyte's in September 2005.

€60,000
2005

achieved in Dublin, London and then New York did not represent anything like the true value of his work, and wouldn't be sustained, they believed. "It's an unreliable market; you can't trust it," one auctioneer ventured. "I couldn't say to friends or clients: 'you ought to buy a work by this artist'. I wouldn't be confident that people who paid €30-40,000 for his pictures would get their money back under normal market circumstances."

One of his rivals agreed. "The thing has been over the top completely. A huge operation was put in place to market Kingerlee. And it shows the power of the auction house – one big price for an artist is a fluke, a second is a trend, and a third is a market. In a small country like this, if you want to manufacture a market it's not too difficult." The implication was that someone had done precisely that: manufactured a market for the Beara-based artist.

Ian Whyte says of this phenomenon; "Kingerlee's prices have rocketed in a very short period of time, which people would worry about. You used to be able to pick up Kingerlees for 50 or 100 quid five or six years ago, small ones. His [recent] work is good [but] I find it difficult to see where the prices are coming from. But then I would say the same about some other artists as well."

So who exactly was marketing Kingerlee? Perhaps a clue could be found inside the flap of Benington's book, because it had been produced not by a conventional publisher but by "Larry Powell Management."

And in the acknowledgements Powell is thanked for introducing Benington "to the artist

and his work and for uncovering so much information on the artist's early life". And in the list of collectors who allowed their Kingerlee paintings to be reproduced for the book, sandwiched between the likes of Hillary Clinton and Tony O'Reilly are Mr and Mrs L Powell.

So perhaps here was the key to Kingerlee's prices – a phenomenal saga even by the standards of Irish art prices over the last decade.

WHEN PEOPLE TELEPHONED LARRY POWELL IN NEWRY DURING THE 1970S AND 80S, THEY NOTICED how eager he was to talk about art. He loved being distracted from his day job, running a meat-packing factory, and would natter on for hours about paintings and his favourite artists. "He once told me art saved his life," says one of those who called him regularly during those years.

Tall and grey-haired, Powell looks a bit like actor Leslie Nielsen, star of the *Naked Gun* series. He was part of the great Down football team of the late 1960s; a sub when they won the All-Ireland of 1968 and wing back when they won the league earlier that year. Running a business in Newry during the Troubles took courage. "We supplied all the northern supermarkets with meat," he says. "The likes of Sainsbury's and Tesco were afraid to come into Northern Ireland. Naturally so – they thought they were going to get blown up. So we had it all to ourselves. In a way it made up for being brave enough to stay in Northern Ireland."

He soon found a pleasurable way of investing profits from Mourne Country Meats. His wife had an interest in antiques and silver and, from about 1970, Powell started going to auctions with her. He went from thinking that "art was for cissies" to taking a huge interest. Building an art collection provided a respite from the grim business of meat packing and the unrelenting gloom of the Troubles. "One of our first paintings was by Constance Markievicz and gradually we purchased Wilks, McKelvey, Craig and Armstrong. I started a collection for our factory which through time became a major collection, and included Yeats, O'Conor, O'Malley, Warhol and Scully."

Powell was known as a shrewd buyer – someone who would take a picture off the wall of an auction room to check the back of it, who would have a quiet word with the auctioneer beforehand to get a better idea about the reserve. All the guile he'd needed to run a business in South Armagh was applied to the art market. Soon enough Powell realised that paintings weren't just a diverting hobby, they were a way of making money.

Roderic O'Conor was his first attempt at turning a profit. The Roscommon-born artist, who died in 1940, was an obvious target for speculators. Even in the late 1980s he still had a minor reputation in Ireland compared to his contemporaries. And you had to sift for the gems amid all the dross that he painted.

As Lochlann Quinn says: "There are a lot of crap O'Conors but the best are great." Or as Mark Adams, a London dealer, puts it: "He's a difficult artist. One in ten pictures is an absolute cracker. But the other nine? Crikey. On a bad day you wouldn't touch him with a barge pole." It was even a challenge to work out the genuine O'Conors, since his wife, Renee Honta, added her husband's signature on works (including her own) after his death, and touched up others. Everything was sold together at an auction in the Hotel Drouot in Paris in February 1956 – the entire contents of the O'Conors' studio was offered in bundles of 10 and 15. All the paintings – his and hers – were stamped Atelier O'Conor on the reverse. The auctioneer could not tell them apart, so everything was sold as his.

Her style was so similar (perhaps unconsciously so) that experts have taken decades to sort out what's what. In 1981, Sotheby's sold *Farm Outhouses* as the work of O'Conor. In 2004, Whyte's sold the painting as the work of Renee Honta, hugely reducing its value. When an experienced dealer or auctioneer sees a bad O'Conor, or a "heavy" one, they detect Renee's hand. To the uninitiated, the Atelier O'Conor stamp is all the provenance needed. One prominent Dublin businessman bought a cart-load of O'Conors with the stamp on the back, and couldn't believe how cheap they were. Turned out half of them were by his wife.

Some art books attribute certain works to O'Conor, and knowledgeable dealers point to them, shake their heads and smile.

In short, O'Conor's work was ideal hunting ground for an art enthusiast with a sharp eye who knew his onions and had done his homework.

Once he had acquired a great deal of O'Conors, Powell set about promoting the artist in ways that would become familiar. He commissioned a British production company to make a film, in which international art critics waxed lyrical about the Irish painter, and circulated it to collectors such as John Magnier as well as television stations in 16 countries.

The idea, he says, was to raise consciousness. "I persuaded the Hugh Lane Gallery to put in a Roderic O'Conor room for three or four years so the whole of Ireland could see his work. I was the most instrumental person in doing that. Because I thought O'Conor was so important for Ireland, the legacy he left. He exhibited alongside the likes of van Gogh and we in Ireland knew nothing about him. I put a lot of money into the O'Conor project and I didn't get anything out of it. Dead money. But they're like hobbies. That was my passion. It kept me sane throughout the Troubles in Northern Ireland."

In 1992, Powell did something else to promote O'Conor: he commissioned a book. And the writer he hired was Benington, who had done a masters project on the artist. It was Lochlann Quinn, however, who put up most of the money – £15,000 – which helped pay for the book's colour illustrations.

Quinn had also fallen in love with O'Conor's work, although he had no intention of making money from it. "Larry Powell tried to develop a business, to become commercial with O'Conor," Quinn says. "He was pushing the artist but he had a commercial reason. He probably did make a bit of money buying and selling the O'Conors – but no more or less than others. Anyone who put aside work for about four years during the boom would have sold at a profit."

After a flirtation with Gladys McCabe, a minor Irish painter ("she started out at £50-£100 and ended up at £1,000 by the time he was finished," says one auctioneer) Powell's next serious liaison was with Andy Warhol. It was only in the years immediately after his death in 1987 that the American pop-artist became a cult figure. Powell's idea was simplicity itself: there were lots of Warhols in America, very few in Britain. So buy up a collection in the USA, ship them to London, do a bit of promotional work, then sell them at a profit.

RODERIC O'CONOR

BORN: 1860, ROSCOMMON

DIED: 1940

PAINTING STYLE: POST-IMPRESSIONIST

RECORD PRICE AT AUCTION: £792,000 (SOTHEBY'S, 2005)

FANS SAY: "IRELAND'S MOST INTERNATIONAL ARTIST. HIS LEGACY OF PORTRAITS, NUDE STUDIES, STILL LIFE AND, ESPECIALLY, LANDSCAPE PAINTING, REVEALS HIM AS THE IRISH ARTIST WHO WAS MOST IN TUNE WITH AVANT GARDE DEVELOPMENTS IN EUROPE." BRIAN KENNEDY

CRITICS SAY: "HIS PAINTING, ALL TOO OFTEN, IS DENSE AND HEAVY, HIS COLOURS HOT, HIS COMPOSITION QUITE OFTEN BAD WITH UGLY, ILL-COMPOSED NUDE STUDIES AND LANDSCAPES THAT ARE SCENES FROM HELL." BRUCE ARNOLD

IF YOU COULD OWN ONE: LA JEUNE FILLE, (CIRCA 1920)

BEST EXAMPLE ON PUBLIC DISPLAY: VIEW OF PONT-AVEN (ULSTER MUSEUM)

Born into a wealthy family of lawyers, who were descended from the ancient high kings of Connacht, O'Conor was educated by the Benedictines at Ampleforth near York and later at the Metropolitan School of Art in Dublin and the RHA. In 1883 he followed in the footsteps of Walter Osborne by going to Antwerp, and studying under Michel Marie Charles Verlat, who taught his pupils to work quickly and spontaneously. O'Conor moved on to Paris, and while he made occasional visits to Ireland afterwards, he never lived here again.

The heir to a large estate, he never needed to worry about earning money and was able to paint full-time. In Paris he was greatly inspired by the Impressionist landscape artists such as Pissarro and Sisley. In order to pursue his own interest in landscapes, O'Conor moved in 1889 to the artists' colony at Grez-sur-Loing, 70 miles south of the French capital. He began to paint in a bold, Impressionist manner, clearly influenced by the likes of

Monet. He has been described as "the most innovative English-speaking artist who worked in France at the time", although precisely how big a compliment that represents is difficult to gauge.

Two years later he visited that other great artists' colony of the time, Pont Aven in Brittany, and became fast friends with Paul Gauguin, the famous post-Impressionist painter, who along with van Gogh now heavily influenced O'Conor and pushed his painting in a different direction. It was in Pont Aven that he

CONTINUED ON NEXT PAGE

In this venture he was joined by an enigmatic and controversial partner: bestselling author, one-time Conservative Party MP, and soon-to-be convicted perjurer Jeffrey Archer. The two had tripped over each other as they searched out obscure Warhol paintings around the world, and decided to co-operate rather than compete. "I suggested we should work together, rather than bidding against each other," Archer told *The Times* in 1998. "And off we go, him ringing me from Australia, Tokyo, Amsterdam to say he's got a Mao or a Donald Duck, and we each pay half."

By October 1998, Archer reckoned he had 42 Warhol paintings and 285 prints. "I went mad and started buying all over the world," he told the *New York Times*. But the wheeze wasn't working. A gallery was set up in London's Bruton Street to sell the Warhols, but the art-buying public didn't bite.

"They were too early," a prominent British art dealer explains. "The prices were too far ahead of the market. People knew they had been bought just a year earlier in New York for X. They couldn't justify the mark-up. Archer and Powell had so much money tied up in them that they had to dump the Warhols in the end. They lost a lot of money."

Typically, the silver-tongued Archer made a virtue out of a necessity, insisting that he was only selling off the collection because Warhol's auction prices had gone through the roof in America.

After an *Orange Marilyn* sold in New York for a whopping $17.2m in May 1998, Archer suggested he and Powell were "bloody geniuses. We've spent a lot of money, but not that amount."

CONTINUED FROM PREVIOUS PAGE

developed a method of colouring in parallel stripes, using bold colours to capture seascapes and landscapes. Most of his best work was completed in this period. Gauguin wanted O'Conor to travel with him to Tahiti to paint, but the invitation was declined.

In 1904, O'Conor moved back to Paris where he concentrated on painting still life and nudes in his studio in Montparnasse. He stopped innovating and concentrated on developing a painting style of his own. Later he lived for a time in the south of France and travelled throughout Europe, living also in Torremolinos. In 1933 he married Renee Honta, his model, and they settled at Neuil-sur-Layon in the Loire valley where he died seven years later.

O'Conor is thought to have disliked dealers, and not to have been keen on selling his work. As a result there was a huge backlog in his studio when he died, and it was only cleared in a sale held in 1956 after the death of his wife. O'Conor's reputation was revived in the 1980s, with retrospectives at the Musée de Pont Aven and the Barbican in London. A few leading Irish collectors, such as Lochlann Quinn and Larry Powell, then strenuously awakened interest in O'Conor in Ireland, commissioning an illustrated biography, and sponsoring an O'Conor room at the Hugh Lane Gallery.

After their personal Warhol debacle, the "bloody geniuses" fell out and never did business again.

"It's not often Larry meets his match but, that guy [Archer]!" muses art dealer Mark Adams. "I was still at Sotheby's and we helped Larry out a bit on that one. Seeing Larry quite shook is unusual. The Warhol estate is such a nightmare about what's right [authentic] and what's wrong,[1] and I think the two of them just got slightly taken for a ride. They were sold some wrong ones. To what extent Archer knew about that I don't know. A lot of prints were produced by Warhol's printers and whether they were authorised by him or not is a moot point. The estate says no, but it's such a snake's nest about authenticity, and I think they were probably on the line. But they didn't have the backing of the Warhol estate and that automatically makes them wrong."

There was a setback for Powell on another front too: the end of the Troubles meant that the big supermarket chains were now brave enough to do business in Northern Ireland again. "Tesco and them all came in, and overnight we lost about 50% of our business," he said. "We went from making a lot of money every year to losing maybe half a million one year. That couldn't last. Lucky enough I had the art collection to sell – it saved 65 jobs. We sold that and paid off the debt. It was terrible to have to sell it – the Howard Hodgkins, Warhols, five O'Conors. Everything in it had to go. But then we had our own private collection, luckily enough, and that's still intact."

After handing over the business to the next generation, Powell was now free to give more time to his art sideline. One person he decided to champion was John Minihan, a photographer from Athy, whose work included iconic photos of the reclusive Samuel Beckett taken in Paris and London in the 1980s.

Minihan had an impressive archive – snaps of Francis Bacon, Al Pacino, The Who from 1965, Jimi Hendrix just before he died, and 22 sets of Beckett. Powell knew just how to market this treasure trove. "I said to [Minihan], 'we'll run this nearly as a business. This is the way it has to be. You can't just give out your pictures willy nilly'. John would just give them to anybody for a hundred euros or whatever. 'I'll approach Sotheby's,' I told him. 'I'll approach Ian Whyte first of all, and then Sotheby's. I told them what John had, that there is a market for photographs, and he is going to score.

"I wasn't there for the sale of John's Beckett picture [the famous one taken in Le Petit Café] in Whyte's [September 2005], which Ian really did as a favour to me. I said: 'Please do it.' He put it in as the last item in the sale. He says 'what estimate will we do?' I said put it in at a low estimate, 500 to 600. If it makes €1,000 wouldn't that be brilliant? So I was having a meal in Roly's [Ballsbridge]. Next thing my mobile went. 'It's Ian here. It went for €6,400. Nineteen bids. Nineteen different bidders'."

1 The Andy Warhol Authentication Board has refused to authenticate paintings received directly from Warhol, has declared as "wrong" paintings that had been authenticated by the Warhol Foundation, and has even reversed its own opinions. The difficulty is that Warhol didn't paint much himself. In many instances, he just oversaw the process.

Naturally Minihan was delighted by this upturn in his fortunes, and with Powell's management. "It just took a weight off my shoulders. It took a lot of baggage away that I didn't have to deal with. Larry showcased my work in the best galleries and museums in the world," the photographer said. "Like any agent, Larry takes a percentage. But he places the work where it should be. You have to have good representation. Look at Damien Hirst – he's got marvellous representation. So I'm delighted. It's a hard world out there. It's nice to have someone who really appreciates your work, who has a terrific understanding of photography, who knows the art world and how important photography is in the art world today."

One of the subjects that John Minihan had photographed was a reclusive artist in west Cork – John Kingerlee. And Minihan had come to like his work. Early in 2003, Powell was organising an art auction to raise money for the Special Olympics which was going to be held later that year in Ireland. Powell was travelling the countryside persuading some of the country's best-known artists to donate work to the sale.

"I took six months off, went around to every artist in Ireland, told them the story, all the proceeds would go to the Special Olympics," he said. "When I was in west Cork, I was talking to John Minihan and I said: 'who have I missed down here?'. He said 'have you been to John Kingerlee?' Says I, 'there's a name from the past'. I had seen his work in the mid-1980s, and bought some but hadn't seen it since. 'Well,' Minihan said, 'as far as I'm concerned he's the only real artist down here. He's the real deal'. So I went to see him. And when I saw his work the hair literally stood on the back of my head. I just couldn't believe it."

ECCENTRIC IS THE WORD MOST OFTEN USED TO DESCRIBE JOHN KINGERLEE. PEOPLE WHO HAVE MET HIM say he is "strange" or "odd", while Benington's otherwise adulatory book admits that he is "reclusive" and not naturally possessed of social skills, choosing for almost all of his adult life to live in remote places, possessing "a natural tendency to gravitate towards the margins of civilisation." An example of the effect he can have on people is a story Benington recounts from about 1960 when Kingerlee hitched a lift in north Yorkshire. After a while the driver "stopped the car at a telephone kiosk in order to enquire whether his passenger was 'safe to be out', so taken aback was he by [Kingerlee's] fanatical behaviour."

Born in Birmingham in 1936, Kingerlee moved to London when he was six weeks old, and his father got a job managing a gentleman's poker club. He was looked after in part by his aunt Anna, who trained horses for the circus. Indeed Kingerlee's first memory is playing under the belly of a circus horse. Anna's boyfriend at the time is said to have been the actor Douglas Fairbanks Jnr, and the couple supposedly took such a shine to the young Kingerlee that they thought of adopting him. The Blitz disrupted their plans.

Perhaps the circus put some of the wildness into Kingerlee. He didn't take to formal education – being still illiterate at the age of 11 – and his parents eventually packed their "problem child" off to boarding school despite their modest circumstances. After finishing his educa-

tion in 1955 he worked in a variety of jobs, including as a gardener and in a bicycle factory, and thought first that his vocation might be as a writer. Instead in the early 1960s he began painting and, although married with three children, he decided this would be his way of life. It was, as Benington says, "an enormous leap of faith" for a 26-year-old with no formal artistic training. The family moved to Cornwall, where they lived a hand-to-mouth existence as Kingerlee taught himself to paint.

But it never became the career he'd wanted, and in 1974 he and his wife Mo turned instead to pottery, subsidising their income by selling hand-moulded pots and bowls. His was a bohemian, fractured existence. Kingerlee dabbled extensively in drink and drugs, and two years of surrealist paintings were created under the influence of hash. By 1977 he had five children, but domestic pressures sometimes overwhelmed him and Kingerlee spent extended periods living in squats or with friends.

Foreigners find it easy to fall in love with west Cork, and such is what happened to Kingerlee and his wife when they visited for a walking trip in 1981. Abandoning their house in Cornwall, and even the furniture in it, they moved into a place in Cleanagh, near Allihies in the Beara peninsula. The rent was just £5 a week, but they weren't getting much for their money: no electricity, running water, toilet, television or telephone. Without a car they were cut off from the outside world. Because their house was set down in the bottom of a hollow, they were even isolated from their immediate surroundings.

To have survived one dark winter there would have been an ordeal; the Kingerlees did five, before moving to more modern accommodation in Kilcatherine where John was able to establish a studio.

From this new base, Kingerlee was finally able to attract a wider audience for his work. True, he had displayed paintings in Britain in the late 1960s and again in the late 70s, but his contribution to group shows in the Tom Caldwell Gallery in Dublin in late 1987 and again in 1990 and 1992 were the first time that his paintings achieved any serious recognition. Participation in such exhibitions moved Kingerlee into the minor league of Irish painters, on a par with dozens of others. A short review of the 1990 exhibition by *The Irish Times* art critic Brian Fallon described it as "uneven." But Ian Baird's art price guide from 1991 reveals that Kingerlee's paintings sold well enough at that exhibition, two of them fetching about £1,000.

Kingerlee helped make ends meet by selling paintings to his neighbours and to the occasional passing art dealer. When his work finally made its way into Irish auction houses, it was not greeted by any particular acclaim. *At Ramadan*, a 1989 work,[2] was withdrawn at de Vere's in 1997 after being estimated at £400-600. Two years later *Kilcatherine* 1990 fetched £280 sterling in Belfast – the only recorded sale of a Kingerlee at auction in the late 1990s. Two years later, in 2001, *Winter* sold at Whyte's for £660.

Not that Kingerlee didn't have admirers. In 2002, when he had a show at the Leinster

2 Probably inspired by his conversion to Islam the previous year.

Gallery, collector John O'Sullivan got a call from one of them, recommending strongly that he buy something from the exhibition. "'You have to go in and buy them, he's a coming artist,' I was told," O'Sullivan recalls. "So I go in and, yeah, it's curious work. It jumps off the wall at you. It's very distinctive. The way he layers on the paint – he clearly uses his palette knife extensively. There's a kind of a mysterious quality to a lot of it. And I was quite taken by it. So, although not sure if this guy was going anywhere, I bought a little piece for myself. I was hanging work from various galleries in IONA and making it available for staff to buy. So I got about a dozen Kingerlees, all for under £1,000, and encouraged people to buy them. I wanted to promote the Leinster Gallery, and also I thought they were interesting works. But not one sold, so we gave them back. Overall my assessment would be that he's a good minor painter, a footnote in contemporary Irish art."

One auctioneer agrees with that estimation. "Kingerlee is a good artist, very quirky. His early stuff, some of it, is lovely, different. And you'd get a lovely market from say €1,000-5,000."

Another leading auctioneer is quite harsh in his assessment, however. "I never hear of any other artist saying that they think Kingerlee is fantastic. And the hardest thing to get is the appreciation of your peers. He's never had an exhibition in a major gallery. All these comparisons to Matisse and Turner, I think it's just nonsense."

You could also say Irish art critics are divided – both only two of them have given a verdict. In a review of Benginton's book,[3] Brian Fallon noted that Kingerlee "has been a (slightly fringe) presence in the Dublin art world for some time…[and] appears to be the kind of artist who gives rise to a semi-private cult. The art itself is quirky, ultra personal and verging on fantasy." The *Grid* series, supposedly the apex of Kingerlee's achievement, he found "very mixed in quality and some are frankly dull. Abstract art is not Kingerlee's natural area."

Actually it is figurative art that is his weakness, according to Fallon's successor as art critic in *The Irish Times*, Aidan Dunne. "While his work is uneven – he seems abidingly uneasy with figurative subjects, for example, can be very heavy-handed with line and colour, and has a tendency to sentimentalise things – at his best he comes across as a capable, if minor, lyrical painter." For him, Benington's book "doesn't substantiate a claim that Kingerlee should be regarded as a major artistic figure or as being in any sense 'revolutionary'."

Down the years one or two people had tried being Kingerlee's agent, but it never quite worked – partly because the artist appears genuinely not to be motivated by money. John de Vere White says: "I remember a very shrewd dealer, who's out of the market about 15 years, and he befriended Kingerlee, who used to come up [to Dublin] and stay with him, and he thought Kingerlee was a great painter. But he couldn't make progress with Kingerlee, who was quite a strange fellow. So Kingerlee has been around a long time and loads of people

3 Irish Arts Review, Summer 2006.
4 'I really wouldn't be here now without Frank,' Hirst told the Guardian in July 2007. "I'd still be drinking and I probably would have found some way to f*ck it all up if Frank hadn't come along."
5 Such is the boom in Irish art prices, however, that nowadays the contents of a studio such as this would all be auctioned, no matter what the damage to the artist's reputation.

cottoned onto him and tried to promote his art but for one reason or another, maybe his character, it never went anywhere."

Once Larry Powell stepped into his studio in west Cork early in 2003, it started to go somewhere pretty fast.

IT IS DIFFICULT TO THINK OF A SUCCESSFUL IRISH ARTIST WHO DIDN'T HAVE A FIRST-CLASS AGENT. Yeats had Victor Waddington, le Brocquy had Leo Smith, Robert Ballagh had David Hendriks, and after he died tried to get by without an agent and paid a high price for going it alone. Invitations dried up, public galleries didn't buy his work. "I was the most well known unknown artist in Irish art," said Ballagh. "I got left out of the whole machine in terms of who got bought from museums and collections, who was chosen to represent Ireland at Biennales."

Damien Hirst, probably the best known contemporary artist in the world, has been brilliantly managed by Frank Dunphy, a Christian Brothers' boy from Portrane.[4]

These agents fulfil a myriad of tasks, leaving "the talent" to get on with their painting. They set up exhibitions, handle requests from corporate clients, make sure there's a nice steady drip of paintings and the market isn't flooded, get the artists' best work into leading collections and keep it out of the hands of speculators, plant stories in the press, and dress up their client's back story to portray them as being as flamboyant as Dali, as unpredictable as van Gogh, and as talented as Rembrandt. Sometimes even more drastic action is needed to protect their client's work and reputation.

When Letitia Hamilton died in 1964, Brian Coyle of Adam's was asked by the executor of her will to do a valuation of what was left in her studio in Lucan. "They were mostly unfinished pictures," he recalled. "Neil Smith was her agent, and I decided we'd ask him to make us an offer for the whole lot because you couldn't sell them at auction – you'd ruin Hamilton's value. But Neil said: 'Oh I don't want any more Lotties.' I said: 'Neil, if you don't do it, we'll put them into an auction and the value will go down.' So he paid £1,000 for them. What he did with the pictures, I don't know. I think he may have destroyed them, and rightly so. They were rubbish. I think that's what he did – but that was his job, to protect the artist. That's why you need an agent if you're an artist."[5]

A good agent watches the auction houses like a hawk. You don't want your man to sell for too little, and sometimes you don't want him to sell for too much. Too high a price and he'll be into your gallery next day insisting that you sell all his work for what he just made at auction. A worse fate is if there are no bids at all for your artist's work, and you may need to put your own paddle in the air and buy it for stock rather than leave it sitting there, unwanted, when you have a dozen more just like it in your warehouse. Leo Smith, it is said, went along to all the auctions when a le Brocquy was coming up, and wasn't shy about doing his job as an agent when duty called.

TONY O'MALLEY

BORN: 1913, KILKENNY

DIED: 2003

PAINTING STYLE: AT FIRST FIGURATIVE, LATER MOVED TOWARDS ABSTRACTION

RECORD PRICE AT AUCTION: €77,000 (ADAM'S, 2006)

FANS SAY: A MATISSE WITH A CELTIC EYE, A GENIUS OF COLOUR AND FORM

CRITICS SAY: AT HIS PEAK IN THE 1960s, HIS PALETTE WAS TOO SOMBRE, AND HIS PAINTINGS COULD BE GLOOMY AND BROODING

IF YOU COULD OWN ONE: GARDEN IMPRESSION, PARADISE ISLAND, BAHAMAS

BEST EXAMPLE ON PUBLIC DISPLAY: HAWKS SEARCHING CORN, 1968 (IRISH MUSEUM OF MODERN ART)

His father was a salesman for Singer sewing machines and a Sinn Fein activist; his mother ran a small shop in Callan, Co Kilkenny. While O'Malley was drawing from an early age, he only started oil painting as he recovered from a bout of tuberculosis in his forties, an illness that cost him a lung.

Working as a bank clerk with the Munster & Leinster, O'Malley was moved around the small towns of Ireland, leading a bachelor, boarding-house existence, painting surreptitiously and storing his artwork in suitcases and boxes under his bed. Cut off from outside influences, he developed a style of his own. In 1955, O'Malley saw an ad in the New Statesman for a painting holiday in St Ives, and was electrified by the experience of learning and painting in a community of artists. He revisited in 1957 and two years later retired from the bank. Frustrated at the lack of opportunities for artists in Ireland, he resignedly emigrated by cattle boat to St Ives in 1960. "I liked the psychological freedom of Cornwall, where painters were accepted – many different kinds, of course, but painting itself was accepted as a human activity, with many different facets," he said. It was an inspiring change from stultifying rural Ireland of the 1950s. Under the influence of what has been called "the centre of abstract painting in Britain", his work moved away from being figurative. But he never regarded his work as abstract: "I

COURTESY OF JANE O'MALLEY

would rather use the word non-objective."

O'Malley was to live in Cornwall, off and on, for the next 30 years. He did return to Ireland some summers, including spending a month drawing on Clare Island, his father's birthplace, in 1970. "The resultant drawings were remarkable," critic Brian Fallon, his great champion, has said. In 1973 he traded in his bachelorhood to marry Jane Harris, a Canadian artist, and with her help his career entered a golden age. The couple travelled to the Bahamas each winter to stay with Jane's family, and there Tony painted several brilliantly coloured works, his style taking on a more sensuous and brighter quality. Recognition finally came in Ireland, with two major exhibitions, in 1975 and 1979, and representation with the Taylor Galleries in Dublin. The O'Malleys returned to Ireland in 1990, and settled in Callan. Three years later Tony was elected a saoi of Aosdána. Despite suffering bouts of severe ill-health throughout his life, he lived to the age of 90.

Ian Whyte said: "If you had an artist and one of his works came up in auction and you're selling him for, say, €10,000 each in your gallery and the auction estimate is four to five, well it's in your interest to either buy it or make sure if goes for eight to ten. You don't want to upset your current exhibition and have people saying 'well I can buy it in the auction for four to five grand'. One or two galleries would do it – attend to make sure that their artist is not going to be unsold or let go too cheap. And they'd be prepared to buy it in themselves even."

Not that auctioneers are crazy about the practice. There was a definite note of disapproval in the voice of James O'Halloran of Adam's when he said recently: "People are putting paintings into auctions and buying them back themselves to inflate the price... I think it's highly unfair. It's manipulating the market by creating a false sense of an artist's worth. The price is nothing whatsoever to do with the artist and it's being done by people who see art as a commodity. It's a part of the art market and it's difficult for anyone to regulate it."[6]

Supporting an artist's price at auction costs his agent next to nothing when he owns what's being sold. All he has to pay the auctioneer is the buyer's premium. If he's a good client of the auctioneer's, maybe not even that.

The practice of dealers buying their own artists' works persists because so many art buyers in Ireland need the reassurance of a strong auction price before they'll dip their toes in the water.

They need someone else to flash their money before they'll take their wallet out. As one auctioneer says: "There's a lot of people in the market place who rely on seeing prices for work at auction even though that is only one factor in determining the value of work by a particular artist. They're not factoring in the artist's appreciation by his peers, the exhibitions they have, that their work has been analysed by academics, shown overseas. If you just push someone through the auction houses you'll get a very one-dimensional level of promotion."

POWELL WENT ABOUT THE BUSINESS OF PROMOTING KINGERLEE MUCH AS HE HAD WITH MINIHAN. The first step was to control supply – so he bought up the entire contents of Kingerlee's studio. The exact sum involved is not known, but a rough estimate is €300,000-400,000. The deal also gave Powell, as Kingerlee's agent, ownership of everything painted from then on.[7]

The next step was to promote the work, and that had to be done largely without Kingerlee, since he had neither a personality that could be sold to the media, nor the artspeak that might impress the critics. Asked where his images come from, Kingerlee is wont to reply that it's a "mystery" or a miracle. "People can take what they like from them. I don't want to pin anyone down."[8] Editors of *Circa* and *Apollo* tend to require something a little more profound.

The abstractness of much of Kingerlee's oeuvre was a help to its promoters, however. If you didn't get them, it was because you hadn't looked at the paintings for long enough, or with an open enough mind, or maybe because your taste was too conservative or figurative.

One art dealer remarked: "Kingerlee was perfect for the sort of treatment he received because his stuff was so abstract. You can read what you like into it."

And they did. One idea that was pushed in the mid 00s, when the world was on edge about terrorism and war in Iraq, was that Kingerlee's paintings were a chill pill. As Benington told his local newspaper,[9] "I think his time has come and the sort of art that he produces is right for the times we live in, which are so full of hatred and violence. His paintings are a tonic. It is very meditative, almost a Zen-type of work. The paintings have a feel-good factor."

Powell is remarkably open about how he promoted Kingerlee. "For me, John was a major discovery. I was so impressed that I felt I had to show his work to a bigger audience. From my point of view, here was an artist who had progressed over a period of 15 years to international status. So I rang a few galleries – I thought he would be quite big in America. I took him to Barcelona first of all, and he had a very good show there, then Montreal, Bath, Cork, Dallas, Houston, Dublin, Galway and Beverley Hills. But I knew that no-one would listen to me. What's the point of Larry Powell talking about this artist? It doesn't work like that in the States. It has to be academics, professors, writers, art critics, only the best. So I went to the best."

Among those he hired was Benington, who took on the book project at the end of 2003, at a cost of €60,000-70,000. It was Powell who prised a lot of the biographical detail out of the reluctant Kingerlee which he then passed on to the art scholar for inclusion. But was Benington, as an academic, comfortable with being a cog in a commercial operation? "I am, so long as my involvement remains strictly an academic one which it always was," he said. "I just don't get involved in the promotion side of things. The book may be used as a tool to assist with promotion, but I'm not on a commission or anything like that."

Given the nature of the assignment, though, and who was paying, could he possibly have been critical of Kingerlee?

"Well I don't see my job as an art historian to knock people down. I didn't do that with O'Conor and I've done books on other artists, such as the British sculptor Sophie Ryder and, sure, a critical appraisal should arguably look at the good, the bad and the ugly, but it's not really the way I work, I'm afraid."

Once the book was ready in early 2006, Powell had a wonderful marketing tool. Copies were thrust into the hands of art critics and scholars who were contacted later and asked if they would offer their imprimatur.

Senator David Norris was one who did. "This beautiful book," he offered, "shows the artist in the heroic mould – like James Joyce he is undeterred by material consideration. His painting

6 The Irish Times, December 2006.
7 An exception was made for work linked to the Leinster Gallery.
8 This is his reply in a promotional video commissioned by Powell which is on the official website kingerlee.com. Asked what effect Morocco is having on his work, Kingerlee is stumped. Prompted by the interviewee that "time will tell", he agrees enthusiastically: "Time will tell."
9 Bath Chronicle, 10 March 2006.

enriches our experiences of Ireland and humanity."[10] Kingerlee's backers were so pleased with this endorsement that they included it in ads.

"The Benington book made quite a big difference; it launched Kingerlee's history to everyone," says Frances Christie of Sotheby's. "I think books always make a difference, because collectors get more of an idea of an artist, his styles, and how they got to the particular way they paint now."

Powell concentrated his promotional efforts on the *Grids*, which, as far as he was concerned, were "the zenith of John's career and without comparison in the world of painting." Small and formulaic (rows of small rectangles in varying colours), some were said to have take years to complete as the artist heaped layer upon layer of paint, and had to allow time for each to dry. In April 2003, shortly after Powell took over as his agent, Kingerlee had "14 or more" *Grids* on the go.[11]

By the following month he had "24 or more." In July he was talking about finishing them all together. By 9 November, he said he was "getting the hang of it by now." In the end the Benington book features 4 *Grids* completed in 2003, 13 in 2004 and a further 5 in the early part of 2005. Kingerlee's sudden burst of activity is hardly surprising: by then the *Grids* were attracting six-figure sums at auction.

Benington is surprised by how much emphasis was put on these works. "The ones that fetch the money tend to be the *Grids* and I think that's, arguably, unbalanced. I don't quite understand why such a premium is placed on the *Grids*, and then the landscapes and heads go for considerably less money. There are those who argue that the *Grids* are the pinnacle of his achievement,[12] which may or may not be true, but if John's general commercial viability is on the rise, I would like to see the other work treated fairly, or treated in the same way. If a *Grid* can make so much money, well why not a landscape or a head?[13] They're all from the same hand, after all."

This same question perplexes some Irish auctioneers: how is it that most Kingerlee works sell for less than €25,000 but *Grids* make €50,000 plus? "Certainly we are surprised at the prices we receive for some of the works," Whyte said. "The highest prices have been on new works consigned by the artist [i.e. by Powell], and the bidders are usually new to us, but in some cases well known in business or professional circles. His agent is an excellent marketing man and has good connections through the Ireland Fund and similar bodies of which he is a prominent member and this seems to have helped Kingerlee achieve prices that outpace many leading Irish artists.

10 Quoted in a Kingerlee advertisement in the Irish Arts Review.
11 Kingerlee, by Benington.
12 Benington is one of them. In Sotheby's Modern and Contemporary Art catalogue in October 2007 he provides the entry for a Kingerlee Grid (lot 46), which begins: "The series of grid paintings John Kingerlee has been working on over the last 10 years represent the apex of his achievement, both as a superlative technician and as a visionary artist."
13 And Benington is quoted on Whyte's website, in conjunction with the September 05 sale of Grid Composition, as saying : "In these remarkable Grids of Kingerlee's both the means and the end seem to be without parallel in contemporary painting."
14 http://www.ktcassoc.com/index.html
15 A former critic who died in September 2007.

"Larry Powell is to Kingerlee what Paul McGuinness is to U2 – without Paul, U2 were just another band. Without Larry, Kingerlee is just another Beara Peninsula artist. If he succeeds in getting him launched in the USA, these recent prices will seem very reasonable."

Kingerlee's prices took off as soon as Powell became involved with his work – early in 2003. The *Irish Arts Review's* look-back at 2003 noted that "the surprise of Adams' contemporary sale in April were two Kingerlee abstracts estimated at €500-700 each but sold for €4,800 and €3,800." Two months later, *Mabinoion* by Kingerlee sold for €10,500 at the auction Powell organised to raise funds for the Special Olympics. Powell was on hand afterwards to point out that the €10,500 was a new record for Kingerlee. It was a record that would be broken no less than five times in the next three years.

But who was paying the amazing prices? Powell says that the two Whytes' sales (€36,000 in February 05 and €60,000 the following September) were made by Alan Barnes, an English art dealer who operates a gallery in Dallas, who met Powell through the American Ireland Fund, and who staged a "sell-out" show of Kingerlee's work in May/June 2005.

IT IS LIKELY THAT WE HAVE SEEN THE LAST OF THE REALLY BIG KINGERLEE PRICES, HOWEVER. Only four of his works sold for €10,000 or more in Irish auction rooms in 2007, and there was only one *Grid*, which fetched €16,000 at Morgan O'Driscoll's in Cork. A *Grid* was also sold at Sotheby's, in its Modern and Contemporary Irish Art sale in October 2007, and this tiny work (7.5 in by 11.5 in) made £24,500. Kingerlee is likely to continue making steady prices at Sotheby's in London, but large-scale works have disappeared out of Dublin's auction rooms.

Not that Powell minds; his target is America. "People ask me about Kingerlee prices all the time, but in relation to the world market it's nothing," he says. "If you go to the contemporary sales in New York, it would be one of the poor prices. It's just incredible what goes on over there."

To help Kingerlee break America, Powell has organised a four-year tour of galleries – at amazing cost. For approximately $150,000, he has hired Katherine T. Carter, a marketing and public relations firm which specialises in "securing one-person museum exhibitions nationally for our artist-clients".[14]

Its website tells artists not to be embarrassed about using the services of a PR company: you are not compromising your integrity by getting assistance in "career development and promotion." They add: "In truth, these services can catapult a mid-career artist into the kind of success that enables them to focus solely on the production and quality of the work."

Part of the service provided by Katherine T. Carter is an essay about the artist written by a New York critic. In the case of Kingerlee, this material was provided by William Zimmer, one of Carter's founding associates.[15] When he died, another associate of Katherine T. Carter – curator Dominique Nahas – was assigned to the Kingerlee project. The 15-gallery tour,

running from September 2007 to 2011, is supported by a bombardment of advertisements in Irish and international art journals, quoting laudatory comments from Zimmer and Nahas. And while the galleries are second-division, an intensive promotional campaign may work better in America.

Benington reckons the "main reason why the States puts such a premium on John's work is that they can see all the influences. You have a very well informed audience. They can see his inheritance going back to Picasso and [Georges] Braque, Paul Clay…they pick up on all of the vibes very quickly."

Alan Barnes, an English dealer who operates a gallery in Dallas and who is effectively Kingerlee's agent in America, gives a more prosaic reason. "In America, a lot of people are willing to be guided into buying something. Young early collectors are buying Kingerlee, some hedge funds; some heavyweights have seen the potential. [Bill] Clinton has one.[16] I'm lucky to have got on board now, because he is getting so expensive. If you crack it in America, you've done it."

While Americans see the glass half-full, Irish art dealers insist that it's less than half empty. Oliver Sears, who dealt in Kingerlee's work in Cork in the early 1990s, says: "It's my opinion that anyone who has spent big money buying a John Kingerlee will never again see the colour of that money. It's for the future to determine, but that's my view: it's a nonsense in correlation to price."

Damien Matthews, another dealer, believes that "sudden high-bid syndrome" only works in a country with a recently-acquired culture of collecting and a new-found knowledge of art. "Extreme promotion sidesteps the normal sequence of events which usually create a price structure within the market. A leap straight from studio to auction occurs," Matthews said. "Kingerlee's manager taking out full-page advertisements to publicise high-auction prices directly to the public is a most unusual and heavy-handed development. It's a little bit like being force-fed. But for those lacking confidence and experience, sometimes the confidence of the under-bidder is the next best thing."

Benington flashes two fingers at the begrudgers – he reckons there is a lot of sour grapes over Kingerlee's success. "They'd probably like to be in on the act but they're not. Lots of people would like to get a slice, but John's work can only be carved up so many different ways. So I just see it as professional jealousy, I'm afraid, being a bit of a cynic. People had a long time to get in on the act, and some really discerning people did get in early."

Whoever is right, and whatever the future holds for Kingerlee and his prices, collectors are big boys and have to take responsibility for their auction-room actions. If they have been persuaded by the Kingerlee marketing machine to pay too much for his work, they really only have themselves to blame.

16 An advertisement in Phoenix magazine (2 May 2008) described the Clintons as "big Kingerlee fans", on the basis that they own a collage. How they came to possess it – by donation or purchase – is unclear.

So had Larry Powell ever felt the need, as many agents before him, to bid up a Kingerlee work at auction? "Oh God no," he said. Even to protect the price? "Not at all, no. I would never do anything like that." Would he buy a Kingerlee painting at auction? "If I really loved a work, and I thought it was cheap enough. It depends on what they value it at." So if he saw a Kingerlee going at €2,000 and he reckoned it was worth 10 or 20, then he'd buy it? "Oh yes, by all means I would do that."

For Kingerlee it's all been good news – the artist himself is living happily ever after. With the money that Powell gave him, Kingerlee has bought a studio in Grenada, Spain, and another in Tangiers, Morocco. He is able to buy the best of art materials. Now in his mid-seventies, his money worries are over. Only a churl would begrudge him this belated success. In a way it is reassuring that the art world still rewards painters who stick loyally and aesthetically to their craft for a life time, when it was mostly neither profitable nor rewarding to do so.

"People used to come to my door and buy from me, but it was always a struggle," Kingerlee told the *Irish Arts Review* in late 2004. "It's great since Larry came along...I'm not poor anymore. We're not scrimping and saving. I just do the work, get some money, and go on working."

While Powell can perhaps be classified as a speculator, those who have met him know that he is also passionate, maybe even obsessive, about art, and that he really believes in Kingerlee. He pooh-poohs the large six-figure sum he has invested on the basis that it's worth it to see the artist relax and enjoy himself at the end of a tough life. "For John, it's brilliant. He's made more money in the last two years than he had made in the previous 40. It's changed his life. But it's not as if he's a young man and going to buy a villa in the south of France. He got the studios in Grenada and Tangiers, and that's brilliant for him. And that's the thrill that I get out of it."

11

SPLASH THE CASH

"Without covetousness, you are not going to have an appreciation of art. And I think that if covetousness by some magic was destroyed, art would come to an end. It's very rare to be able to appreciate art without wanting to own it."

Peter Wilson, former chairman of Sotheby's

THROUGHOUT 2006, THE STORM CLOUDS gathered along the horizons of the Irish economy. The boom was coming to an end. Specifically the property market, the main creator of wealth and jobs, was slowing and the only remaining doubt was whether it would end with a crash, a correction or a soft landing. Still the Celtic cubs partied on. With one eye on the menacing skies, they indulged in one last Bacchanalian orgy of consumer spending.

Irish art auctioneers, who had been filling bags with sand in preparation for the storm,

€70,000
2008

COURTESY OF ADAM'S © ESTATE OF COLIN MIDDLETON

Colin Middleton's The Sanctuary Montserrat III (Westerness Cycle) which achieved a record price for the artist of €70,000 at Adam's October sale, 2008.

put down their shovels and stared in amazement. Sales of Irish art had jumped by €9m to reach almost €24m in 2005, and most auctioneers figured that would be the end of it. Instead, the period from January 2006 to June 2007 was the most successful since the heady days of the late 1980s.

We have already seen some of the highlights: a Norah McGuinness selling for €210,000 at Adam's in June 2006; Paul Henry's view of Dooega on Achill getting €220,000 in December; the sell-out auction of Mark O'Neill at Adam's in the summer, with buyers prepared to splash out an entire SSIA for one work by a prolific painter at the start of his career; and not one but two auctions of Patrick Leonard works, with the market absorbing 300 of his paintings in less than two months and buyers still paying up to five times the reserves at the end.

This wasn't just happening in Dublin. Niall Dolan, a doctor, opened an auction house in Galway with the intention of holding two annual sales there and two in Limerick. Success was instant. In its November 2006 sale, Dolan's broke the record for John Shinnors, selling *The Baby* for €60,000. That record was just three months old – in September, Garrett O'Connor had sold *The Piano* for €57,000. The works had been painted by Shinnors in 1979 and 1980. Lean years for him. An art auctioneer could not have chosen a more auspicious year than 2006 in which to make his debut.

With so much money sloshing around, all the trade had to do was provide soakage. Adam's, who had held four art auctions in 2003 and in 2004, held nineteen in 2006. Their Christmas sale[1] grossed €5.9m, €2m more than the firm had ever taken on one night. The most remarkable lot was perhaps *Sick Tinker Child* by le Brocquy. In May 2001, at the height of the le Brocquy market, Sotheby's had sold this work for €360,000, the lower end of the estimate, and that after extensive promotion. Returned so quickly to the auction room, it could easily have been burned. Instead it sold for €820,000 to a Dublin buyer. A €500,000 appreciation in five years. Le Brocquy's *Fantail Pigeon* repeated the trick on a smaller scale – selling for €280,000, nine times what it had made five years earlier.

The Big Three – Adam's, Whyte's and de Vere's – between them grossed just shy of €30m in 2006. Privately, some of them were bewildered by this success. "There is no logic to the prices," one confessed at the time. "These are new buyers, with new money. It's not credit cards or loans, it's cash. There's a lot of women, including the wives of property developers. In some cases they're uninformed and paying far too much. It's like buying cars that can break the speed limit in reverse. There will be a correction eventually, because this can't keep going forever. And then some people will be caught out. Because if you pay too much for a house, at least you can live in it. Second-rate art will never improve."

Like Brian Coyle's "they'd hang them on the electric gates if they could", the comment is indicative of attitudes in the trade towards this new generation of buyers. A few dealers were even looking forward to a slowdown – a return to the normality they enjoyed, where you

1 As always, held in conjunction with Bonham's, a British firm.

could put an estimate on a picture and not have show-off arrivistes make a nonsense of it. Dealers enjoy doing business with genuine collectors who know about art and love it. Speculators taking a punt on a painting "as an investment" tend to be crass and highly demanding.

Only a handful of top-quality pictures came to the market in 2006, with the result that this vast reservoir of money was spent on mostly second-division artists. Whyte's, for example, got €180,000 for a Mary Swanzy – putting her price into the same league as Yeats and Paul Henry. No more than Dan O'Neill and Gerard Dillon, few art critics would put her work there.

Of course the problem of supply was not just an Irish one. Unable to source enough top-quality works by dead artists, Christie's and Sotheby's switched their focus to contemporary ones. The proliferation of museums around the world, each desperate to get a signature work by Renoir, Monet, Cezanne or van Gogh, means that good examples of certain art schools have virtually disappeared from auction houses. When a museum buys a painting, or is given one by a wealthy benefactor, that painting is dead. It will never return to the market. Furthermore, the price range of most dead artists is pretty much fixed. Not so with contemporary artists, whose values can double from one year to the next. This encourages collectors to flip and speculate, ensuring a plentiful supply of pictures.

In the 00s, the contemporary market became the most lucrative for auctioneers. Celebrity artists (Damien Hirst, Tracey Emin, Jeff Koons) produced outrageous work (stuffed sharks, unmade beds, diamond skulls) which was bought by celebrity collectors (Charles Saatchi, Joseph Lewis, Francois Pinault) encouraged by branded dealers (Larry Gagosian, Haunch of Venison, White Cube).

By contrast, the Irish contemporary art scene was unglamorous and low profile. Nevertheless, Sotheby's decided it was worth developing. Its creation of the Irish Sale in 1995 had been a success in the traditional market, and now it decided to repeat the trick – holding a Modern and Contemporary Irish Art sale in London in October, to coincide with the Frieze fair in Regent's Park.

The results in 2006, the first year, were reasonably encouraging. It raised almost £900,000 (€1.3m) with two-thirds of the lots sold. The best prices were €229,048 for a le Brocquy watercolour study of Francis Bacon and €143,155 for his *Study of Head from Memory*. Basil Blackshaw, Sean Scully and William Crozier were others who made good prices, but as these artists regularly turned up in the main Irish Sale, there was no surprise or novelty about that. One new artist who did get a huge boost, however, was John Noel Smith; his *Ogham V* sold for twice its top estimate at €53,683. That price prompted some dealers to scamper around the country buying up what work they could find by the 55-year-old Dublin-born abstract painter.

An especially pleasing aspect from Sotheby's point of view must have been the amount of publicity that this €1.3m sale generated: the Irish media gave it more coverage than any other art auction that year. As in the 1980s, Irish people took it as a compliment that Sotheby's

would deem our art important enough to sell. One newspaper,[2] for example, praised the auction house for the quality of its catalogue – "with texts that are much more in-depth than is the norm." Contradictorily, it noted that "some pieces need no explanation." Another newspaper[3] said the sale had been created "due to a growing demand for modern and contemporary art." How thoughtful of Sotheby's to meet it! The sale was supposedly "creating a buzz among big-money collectors worldwide".[4] Not quite – 80% of lots went to Irish buyers.

When Sotheby's brought the highlights of its second Modern and Contemporary Art sale to Dublin for a preview in October 2007, the social diarists swooned. "Our host, Sotheby's Arabella Bishop, looked fantastic in a turquoise and cream Diane von Furstenberg dress with Chinese neck as she greeted the British ambassador David Reddaway," purred Angela Phelan in the *Irish Independent*.[5] "Matty Ryan drove up from Thurles with the always chic Kate Ronan. They couldn't take their eyes off the Sean Scully picture entitled *Westray*. Shrewbury Road's most affable tycoon Niall O'Farrell cast a handsome eye around the room. Louis le Brocquy's *Tinker Couple* caught his eye..."

Irish auction houses can only dream about their lots being linked to celebrities and aristoc-racy. But it happens every April when Sotheby's tour the Irish Sale to Dublin, Belfast and Lismore Castle. In 2008, for example, "the beautiful Arabella Bishop was on terrific form, learned and loquacious about all the pictures," according to a *Daily Mail* gossip columnist at the preview night.[6] "Former polo player Oliver Caffrey travelled in from Kildare and caught up with Bono's best friend, the songwriter Simon Carmody..."

Christie's gets less of this soft-soap coverage. This may be because the firm has never opened an office in Ireland, while its representatives – Christine Ryall and Desmond FitzGerald – are based outside Dublin. "We looked a couple of times at the possibility but a high-street office attracts the plastic-bag brigade," explained Bernard Williams, who doubles as the Irish and Scottish director but spends far more time in Scotland. "For 20 years we had a sales room in Glasgow and we were the auctioneers of the people – but we didn't make any money out of it. A huge number of people came in, and we had to have a lot of staff. We're bigger and better than that. The Glasgow one shut in 1998.

"It's a people business. In Scotland, there's about 3,000 people that really count and I probably know 1,000 of them. That's what's important. Coming over here [to Dublin] and walking down Kildare Street and Molesworth Street, bumping into people, you get a flavour of what's happening. You don't need high-street premises to do that."

Sotheby's second Modern and Contemporary sale, held in October 2007, was no improvement on the first – grossing £1,000,550 (€1,434,344), with less than 60% of the lots sold. There were records for William Crozier, Basil Blackshaw, Patrick Swift and Hughie O'Donoghue, and Sotheby's expressed itself "delighted", saying bids had come from the Conti-nent and America. The struggle it had to fill the sale with top-quality contemporary work was obvious, however. Less than 20 of the 85 lots were of a high standard. Other handicaps were

20 HIGHEST PRICED IRISH PAINTINGS SOLD BY AUCTIONEERS*

ARTIST	TITLE	AUCTIONEER	PRICE	YEAR
Orpen	Portrait of Gardenia St George with Riding Crop	Sotheby's	£1.98m	2001
Le Brocquy	A Family	Agnew's	£1.7m	2002
Lavery	The bridge at Grez	Christie's	£1.3m	1998
Yeats	The Wild Ones	Sotheby's	£1.23m	1999
Le Brocquy	Travelling Woman With Newspaper	Sotheby's	£1.16m	2000
Yeats	The Whistle of a Jacket	Christie's	£1.1m	2001
W Scott	Bowl, eggs & lemon	Christie's	£1.07m	2008
Barry	King Lear weeping Over the body Of Cordelia	Sotheby's	£982,400	2006
Yeats	The Women of The West	Sotheby's	£938,500	2000
Orpen	Mrs St George	Sotheby's	£924,000	2003
Lavery	The Honeymoon	Christie's	£915,500	2006
Orpen	Interior at Clonsilla With Mrs St George	Sotheby's	£886,650	2002
Yeats	Singing 'Oh had I The wings of a Swallow'	Sotheby's	£881,500	1998
Yeats	The proud galloper	Christie's	£870,500	1998
Yeats	A Farewell to Mayo	Sotheby's	£804,500	1996
O'Conor	La lisiere du bois	Sotheby's	£792,000	2005
Lavery	Evelyn, Lady Farquhar	Sotheby's	£748,000	2007
Orpen	Gardenia St George On a Donkey	Christie's	£733,250	**2003
Orpen	A Mere Fracture	Christie's	£716,500	1998
Yeats	Leaving the raft	Sotheby's	£661,500	1996

* Excluding Francis Bacon, who simply isn't considered "Irish" in the art market, but including William Scott, who sometimes is. All prices given in sterling, as all of the records were set in this currency, and include the buyer's premium
** Sold privately immediately after it failed to make its reserve of £800,000 at the Irish Sale in 2003

that Sotheby's had just hiked the buyer's premium again, and that sterling was strong. The economics of shipping all these so-so paintings to Ireland and back, in order to make £1m, was questionable.

"I had a bit of an issue with the quality control in the last Modern and Contemporary Irish," said Mark Adams, a former Sotheby's employee. "I think they went to artists who hadn't shown anywhere and said 'would you give us a picture?' Buyers worked that out. Sotheby's need to tighten that sale up. It's a great idea but I'd question whether there are enough contemporary Irish artists of quality to sustain it. I can't believe there is enough money in it to make it worth their while doing it."

This time Christie's didn't bother trying to emulate Sotheby's. Bernard Williams ruled out

2 Sunday Business Post, 15 October 2006.
3 The Irish Times, 17 October 2007.
4 The Mirror, 8 October 2007.
5 A perfect week for art-loving socialites; 20 October 2007.
6 Art lovers spend the night eyeing rare paintings and each other; Talk of the Town; Daily Mail, 22 April 2008.

holding a contemporary Irish art auction, partly in deference to the gallery system which he claimed his firm does not want to usurp. "Sotheby's put a huge amount of time and effort into something that made £1m," Williams said. "All that exhibiting and everything. At that level, it doesn't make sense. They're not making money."

Sotheby's promised to be patient. "The seriousness with which we take the Irish market is that our chairman, Henry Wyndham, took the auction yesterday," said Frances Christie, a spokeswoman, on the day after the 2007 sale. "He is widely regarded as the best in the business. I think that shows commitment at a very high level."

Up to a point, Lord Copper: Sotheby's quietly dropped the contemporary Irish auction from its schedule in autumn 2008.[7]

THE MARKET IN IRELAND REMAINED BUOYANT THROUGHOUT THE FIRST HALF OF 2007. THE IRISH Sales in London were up on the previous year, with Sotheby's taking £6.1m sterling (up from £4.7m), their second highest total ever, and Christie's grossing £5.4m in a two-day sale, up about £600,000. The strongest auction in Dublin was de Vere's in June, who took in €4m, double its tally of a year earlier, with 85% of lots sold. That auction helped de Vere's to its best ever year in business. It ended up grossing €7.5m from four auctions, including premiums, and achieved a higher-than-average selling price of €14,500.

But as they packed up in June for their summer holidays, all the Big Three had headline prices to savour. Whyte's had sold *A Family (2)* by Louis le Brocquy, a later version of the work donated to the National Gallery by Lochlann Quinn, for €680,000. Adam's had sold another le Brocquy – *Study, Man Creating Bird* – for half a million. By the time the auctioneers came back from their holidays in the autumn, however, the Irish economy had fallen off a cliff. The value of Ireland's blue-chip stock collapsed, with banks taking an absolute pasting. Allied Irish Bank's share price fell from €22.50 to €12; Bank of Ireland's collapsed from €16.35 to under €10. Anglo-Irish Bank, Ryanair and even CRH, whose stock was supposed to be as safe as putting money in the bank, also suffered.

Further sapping investor confidence was the ripple effect caused after America's housing bubble burst. Over-night the term "sub-prime mortgages" had become part of everyday speech. These were mortgages given to high-risk borrowers, either people with low incomes or bad credit histories, sometimes both. Banks with high exposure to "sub-prime" mortgages closed throughout 2007, causing chaos throughout the credit market. In early September there was a run on Northern Rock, with queues of customers forming outside its branches in Britain and Ireland.

Meanwhile, the roof had finally caved in on the Irish property market. By November, house prices were down 5%. Unsold apartments and houses lingered on the market for months. Long gone were the queues of eager young couples outside show-houses looking to buy off the plans. Property developers were being forced to drop the prices of apartments

in order to achieve sales. When even that didn't work, some rented properties they had been planning to sell. Compounding the problem was the European Central Bank's hiking of interest rates, and banks' more cautious approach to extending credit. The 100% mortgages of only a year earlier disappeared.

Once people stopped buying, developers stopped building. Housing starts, which had peaked at an annualised rate of 100,000, fell to below 30,000.[8] By the summer of 2008, about a year's supply of houses and apartments sat unsold on the market.

The end of the construction boom was bad news for the Irish economy, which relied on building to create 14% of all jobs.[9] There were predictable knock-ons into the consumer market: when people stop buying new houses, they also stop buying electrical goods, furniture, lighting products. Even home-owners with no intention of selling feel less economically secure when the value of their property declines.

It was against this gloomy backdrop that Irish art auctioneers held their autumn sales. They didn't help themselves by mounting auctions of unmitigated mediocrity, with scarcely a top-quality painting among them. Whyte's made €1.24m in its September sale, down about 20% on a year earlier.[10] De Vere's had a right stinker: selling only about 50% of its lots and taking in €350,000. Adam's sold about 70% of its lots and grossed €450,000 with the only painting of any note being a Paul Henry west-of-Ireland landscape at €90,000.

The auctioneers approached their end-of-year sales with trepidation, but the results were better than expected. Ian Whyte had an average sale, grossing €1.76m, although this was buttressed by a collection of historical documents. The result meant that Whyte's 2007 figures were down year on year in terms of hammer prices (€8.4m versus €9.8m), lots sold (1,218 versus 1,617) and percentage of lots sold (73% versus 83%).

But Adam's showed its rivals that it still knew a trick or two about how to sell paintings. In the summer of 2007, the family of Dr Joseph Bartholomew Kearney, a Cork paediatrician and gynaecologist who had died the previous year at the age of 90, hired the firm to dispose of his art collection.

JB, as he was known, was a collector of the old school, in the manner of Gordon Lambert. He and his wife, Rhoda, had bought extensively in the 1960s and 70s particularly from Leo Smith in the Dawson Gallery, from David Hendriks, and the Taylor Galleries. Genuine art lovers, they bought without any thought to future value.

When David Britton visited Chiplee, the Kearneys' residence on Blackrock Road in Cork, he immediately realised what an opportunity this labour-of-love collection represented for Adam's. As he entered the hall he saw a le Brocquy tapestry, *Eden*, on his right and a wall of Barrie Cookes on the left. "Alongside, the hall table features exquisite sculptures by Edward

7 A Sotheby's spokeswoman said it was being held alongside the Irish Sale in May 2009, a diplomatic way of scrapping it.
8 Davy Research report on the Irish economy, 28 May 2008.
9 Central Statistics Office.
10 Fine Art and Antiques column, The Irish Times, 22 September 2007.

ROBERT BALLAGH

BORN: 1943

PAINTING STYLE: MODERN REALIST

HIGHEST PRICE AT AUCTION: £72,000
(SOTHEBY'S, 2007)

FANS SAY: THE FIRST IRISH ARTIST TO
DEVELOP THE POP ART STYLE

CRITICS SAY: A GLORIFIED GRAPHIC ARTIST

IF YOU COULD OWN ONE: UPSTAIRS NO. 3

BEST EXAMPLE IN A PUBLIC COLLECTION:
PORTRAIT OF NOEL BROWNE
(NATIONAL GALLERY OF IRELAND)

The only child of middle-class parents, Ballagh grew up in a flat at 14 Elgin Road in Balls-bridge and was educated at St Michael's, a preparatory school for Blackrock College, and then in Blackrock itself. He then became a socialist, his political philosophy reflected in his work as an artist. He first studied architecture at Bolton Street College, and played bass guitar with The Chessmen, a seven-piece group managed by Noel Pearson. Michael Farrell hired him as an assistant to paint two murals for a bank, and then Pearson got him to design brochures and catalogues for a model agency, launching him into a career as a freelance designer. He was invited to exhibit at the first show in the Brown Thomas gallery in 1968, where his painting of a blade was purchased by the Arts Council for £130.

The outbreak of the Troubles had a deep effect on Ballagh, prompting him to fuse art and politics, most famously with pop-art interpretations of Goya's Third of May and Delacroix's Liberty at the Barri-cades, classic images of repression and revolution. He dedicated them "to those who struggle to create a 32-county socialist republic in Ireland." After Bloody Sunday in January 1972, he chalked out the outline of 13 bodies on the concrete floor of the Project Theatre in Dublin and smeared them with animal blood. "I think, of all the political images I've made, it was the most effective," he said.

His breakthrough was a series of people looking at famous paintings, in which he replicated works by the likes of Jackson Pollock, Pierre Soulages, Jasper Johns and Andy Warhol, using bold figures and thick black outlines in true Pop Art style. He included visual puns in his work, a regular prop being the inclusion of books whose titles indicate themes. Ballagh also developed an Alfred Hitchcock-style propensity to include himself in his paintings, most successfully in The Conversation. Inspired by Vermeer's The Artist in His Studio, it depicts Ballagh talking to the Dutch painter about the future of art.

Portraying himself as a flasher for a kite to fly over Kilkenny for the city's arts week in 1978 was inevitably controversial, and duly banned by the festival committee. The theme of nudity, art and society's attitude to both was brilliantly dealt with in Inside No. 3 and Upstairs No 3, arguably his best work. His most iconic image, however, is a portrait of Noel Browne in the shape of a crucifix with pebbles spilling out of the canvas and onto the floor.

He has secured dozens of commissions to do portraits, although by his own admission he struggles with faces and, unusually, leaves this task until last. A slow worker with a small output, he painstakingly plans each piece before he starts.

Throughout his career Ballagh has supplemented his sporadic earnings from painting by designing stamps, book covers, posters and the set of Riverdance. He helped formed the Association of Artists in Ireland in 1981, and campaigned for the introduction of droit de suite, a resale royalty. The record price paid for My Studio 1969 prompted a revival, culminating in a retrospective at the RHA in 2006.

€26,000
2006

Delaney," he said.[11] "This was my first taste of the Kearney collection and it did not disappoint thereafter." In truth, while there were good examples of Yeats, Henry, le Brocquy and Middleton, the real gems were by lesser-known artists such as *Dublin, Showery Night* by George Campbell.

These would all be fresh to the market – never seen in public since the Kearneys bought them off the gallery walls. Adam's valued the collection at about €1.5m, but decided to set low estimates given the general economic gloom. An executor's sale always gives the auctioneer more flexibility. Executors don't want paintings returned unsold and so, unlike private collectors, never insist on ambitious reserves.

Adam's marketed the sale imaginatively. The Kearneys were well-known and liked in Cork, and hundreds of JB's patients would have admired his art collection down the years. Adam's exhibited the paintings Leeside prior to the sale, stirring up both local pride and nostalgia. The idea of acquiring something belonged to Dr J B Kearney motivated several bidders going into the auction. A contingent from Cork sat together on the night, and got up to leave as soon as the Kearney paintings were sold – even though there were another 100 lots in the sale.

The atmosphere on the night of 4 December was electric. The crowd spilled out of the auction room and down the stairs, bidders elbowing each other to ensure their paddles were visible to James O'Halloran in the rostrum. You could almost hear the swish of money, and taste it in the air. As early as lot 9, it was clear this was going to be a huge success: the Campbell, estimated at €25-30,000, went for €65,000. There was a Middleton for €110,000; a Patrick Collins for €58,000; and then a sale that had the audience gasping in disbelief – €185,000 for *Inishlacken* by Gerard Dillon. This was an aerial map of an island off the coast of Galway on which the Belfast artist had stayed in 1951.

While Dillon has many fans – several of them Northern Ireland collectors – critics are not among them. Bruce Arnold has described him as "essentially a minor painter, his figures often crude, his colours ill-conceived, his paint applied, as one would expect from a naïve and primitive technician, crudely." Even those who disagree with this harsh assessment would still puzzle over a price like €185,000 for such an unsophisticated work. A museum-quality Dillon made only €20,000 more in the less febrile atmosphere of a de Vere's auction six months later.

The Kearney collection eventually raised €2.5m, and the total sale made €5.4m, including premiums. This was the second-highest total ever achieved by Adam's, falling just short of its record in December 2006. Some 25% of the Kearney collection was bought by Alan Hobart, a dealer who has always been sure enough of his judgment to pay far higher prices than his competitors. So far he hasn't been proved wrong.

ONE DAY IN THE MID-1990S, MIKE HOGAN DROPPED INTO ROBERT BALLAGH'S STUDIO IN DUBLIN'S north inner city. The publisher of *In Dublin* magazine was an ardent admirer of Ballagh's work,

at one time commissioning the artist to do a painting for his house. "He was a great supporter," Ballagh confirmed. "He was always calling into the studio."

On this particular day Hogan bought one of several works the artist had in storage – it was a 6ft by 8ft work entitled *My Studio, 1969* (see painting pages 90,91). "It was painted in the mid-1970s but had never sold," Ballagh recalled. "Unfortunately, lots of my work that turned out to be 'valuable', 'iconic' or whatever wasn't when it was painted, and sat in my studio for years. I think he paid about seven grand for it or something like that."

Some years later, around about the turn of the century, everything went pear-shaped for Hogan – he ended up with a huge tax bill and a stable of loss-making publications. In October 2003 he announced the closure of *Magill* and *In Dublin*. The magazines' headquarters at Camden Place had to be sold, and that meant a lot less wall space for his art. *My Studio, 1969* became lot 93 in a Whyte's sale in February 2004 with an estimate of €20,000-30,000.[12]

"Mike Hogan was lucky in that in that I think there were two wealthy people who both wanted it, and bid against each other, and that's why it went up so high," said Ballagh. The winning bid came from Lochlann Quinn, who shipped the work to France to hang in his residence there. There was applause when Ian Whyte's hammer came down at €96,000.

Mike Hogan rang Ballagh afterwards. "He was in great excitement about the big price it fetched and said 'I'll have to do something'," Ballagh recalled. "He said 'I'll have to pay you some sort of royalty on this'. I reminded him that he wasn't obliged to do that. I told him he didn't have to."

In the fortnight after the sale, people stopped Ballagh in the street and congratulated him on the great price – the new record – that his work had achieved. "Everyone who spoke to me about this sale thought I had benefited financially and people were shocked to hear I didn't," Ballagh said at the time.[13] "I told them 'you should be congratulating the people who sold it. I am not entitled to anything'. It is a bizarre and illogical situation."

Hogan read these quotes in *The Sunday Times* and was furious. There was no acknowledgment of his offer to pay a royalty, no nod to his generosity. Ballagh was implying that he would get nothing out of the sale when Hogan had promised him 10%. People knew Hogan owned *My Studio, 1969* – it hung in a public place. Now they would think he was mean. More bad publicity, and he'd had enough of that. Seething, Hogan decided he wouldn't pay Ballagh a royalty after all. The two haven't spoken since.

Though he denies it was directly responsible, the sale of *My Studio, 1969* must have prompted Ballagh to revive a 20-year-old campaign for the introduction of droit de suite in Ireland. This artist's royalty means that each time a work of art is re-sold by a dealer or auction house, the artist gets a percentage. At the launch of Aosdána in the 1980s, Ballagh had publicly

11 Quoted in Adam's catalogue for the sale on 4 December 2007.
12 But only after being turned down by de Vere's. See Chapter 4.
13 Interview with the author in late February 2004. "Ballagh demands artists get a cut of resold works"; Sunday Times, 29 February 2004.

lobbied for its introduction and Garret FitzGerald, the then taoiseach, had promised to look into it. But nothing had happened. Irish auctioneers, a more influential and well-heeled lobby group than artists, successfully poisoned the minds of Irish governments against it.

It is ironic that the European Union succeeded where artists had failed, because Ballagh is no fan of the EU and has campaigned against its treaties. The European Commission was anxious to have a common policy on droit de suite in all member states and, over-ruling the foot-dragging by Ireland and Britain, ordered everyone to introduce it by 2006.

Faced with defeat, auctioneers lobbied the Irish government to at least introduce the royalty on terms most favourable to themselves. The EU, for example, allowed countries some discretion to decide the minimum price at which the royalty would be charged. It had to be levied on every painting worth €3,000 or more – but countries could be more generous and make the threshold €1,000, which is the British figure. This was what artists wanted. Auctioneers resisted, and got their way.

Top: **Then Minister for Enterprise, Micheal Martin introduced a statutory instrument in June 2006 relating to droit de suite for which Robert Ballagh (far right) had campaigned.**
Right: **Pauline Bewick who felt it was "greedy."**

Their campaign against droit de suite was at the very least ungenerous. Artists were to be granted 4% of the hammer price on re-sale of paintings worth from €3,000 to €50,000 and on a downward sliding scale afterwards, with a maximum possible payment of €12,500. Auctioneers, meanwhile, were taking 10% off the vendor and 15% from the buyer, and yet begrudged giving anything to the painter. On *My Studio*, for example, Ballagh's royalty would have been €3,804 had droit de suite existed. But the auctioneer's take from the transaction was €24,000 – €9,600 from Hogan and €14,400 from Quinn.

The Irish Auctioneers and Valuers' Institute commissioned a study from economist Dr Clare McAndrew the better to make a case against this "misguided effort".[14] McAndrew constructed various arguments, including the unlikely proposition that droit de suite would encourage art professionals "to ship [works worth more than €40,000] to destinations such as the US to sell without the added tax." This was supposedly because "the work of top Irish artists already attracts a huge following in the US…" Huge? Hardly. Sotheby's

and Christie's were unable to interest more than a handful of American buyers in their Irish Sales and don't bother bringing the highlights to New York and Boston any more.

McAndrew also pointed out that vendors who made a loss on the sale of a painting would still have to pay the levy. True, but sellers usually ensure they don't make a loss by insisting on a reserve. The economist's own (quite diligent) analysis of the market strengthened rather than weakened the case for droit de suite. In 2005, for example, McAndrew worked out that only 26% of all sales in the Big Three auction houses (who are responsible for 90% of art sales in the Republic) were works by living artists and worth more than €3,000. In other words, three-quarters of transactions in auction houses would not involve droit de suite.[15]

Ballagh's arguments in favour of the royalty were, for this writer, more persuasive. Auctioneers had spent well over a decade making enormous profits selling paintings as a commodity, without giving anything back. Works by artists who had never seen wealth in their own lifetimes – the likes of Arthur Armstrong, Gerard Dillon, Harry Kernoff – were changing hands for six-figure sums and their families were not entitled to a penny. Meanwhile speculators, dealers and auctioneers were creaming it. Artists like Ballagh himself, facing old age and reduced output, had no career pensions. They could not, like composers or writers, sit back in retirement and live off the royalties of their earlier success. They would instead sit back and watch in frustration as work from earlier years uselessly achieved ever-higher prices at auction.

Ballagh met John O'Donoghue, the arts minister, early in 2005 to encourage him to introduce droit de suite in as favourable a way as possible for artists. At the time he was "very pleased" with the response. But another year passed, and still no legislation, even though an EU deadline of which the Irish government had had five years' notice came and went. And so in April 2006 he decided to take the law into his own hands: he sued the government. Ballagh argued before the High Court that the state's failure to implement the EU directive on resale rights had cost him money.

With the gun to its head, the government finally acted. Micheal Martin, the enterprise minister, introduced a statutory instrument in June 2006, a temporary regulation.[16] Where the minister had a choice, he sided with auctioneers. The threshold chosen, €3,000, was the

14 The Property Valuer, Summer 2006.
15 Ibid.
16 As of autumn 2008, it still hasn't been made permanent.

highest permissible and the royalty rate on the first €50,000 of the sale price could have been 5% but was set at 4%.

The measures became effective from 13 June, by coincidence the day de Vere's had an auction. About one in four lots in its sale qualified for the royalty, including four works by Louis le Brocquy (who earned about €8,400), and paintings by John Shinnors, Sean Scully, Pauline Bewick and, by happy coincidence, Ballagh himself. On the day after the sale one artist – whose identity Buzzer was too gentlemanly to reveal – contacted the firm looking for his royalty payment.

It is a safe bet that the artist in question was not Bewick, who wrote to the newspapers[17] shortly afterwards saying she felt ashamed to be getting droit de suite. "I feel that it is greedy," she said. "Because once one has sold something – a house, a piece of furniture – it no longer is yours physically. In addition the new system creates gross paperwork, and helps only those artists who are already receiving high prices for their work." The arguments were similar to those made by a small number of British painters, including David Hockney and Howard Hodgkin.

A few weeks after the government introduced the resale royalty, Ballagh won his case. A judge awarded him €5,000 damages as compensation for the loss of royalties he had suffered from the beginning of 2006. More importantly to Ballagh, Justice Iarfhlaith O'Neill awarded him his legal costs, which amounted to €75,000.

In the first year of droit de suite, some 850 artists gave a representative body, the Irish Visual Rights Organisation (IVARO), authority to collect the royalty on their behalf. In July 2007, by far the biggest earner under the scheme – Louis le Brocquy – joined IVARO, giving a huge boost to its status. It now represents 1,150 "visual creators", as it quaintly calls them.[18] The auctioneers are still grumbling and groaning and privately refer to the artists' resale right scheme as "the arrs", but have no choice but to implement it. About €240,000 was collected by IVARO in the first 20 months.

Pierre le Brocquy argues that droit de suite reflects the fact that art is not just a commodity like pork bellies or gold. "Of course there has been a lot of resistance in the market; dealers want to be left alone," he said. "But I think droit de suite honours the profession. It distinguishes galleries from other forms of commerce. It makes the profession more noble. They should be happy that they are returning something to the artist."

An elite of artists is doing extremely well from droit de suite. Louis le Brocquy, who earned €32,900 from one auction in de Vere's alone, can expect an income of about €150,000 a year from the resale royalty from now on. He is followed in the earnings-league table by the likes of Sean Scully, John Shinnors and Basil Blackshaw. In the first year, about two-thirds of the pot went to the top ten artists. Opponents of droit de suite use this statistic as a criticism but,

17 The Irish Times, 25 August 2006.
18 IVARO artists' resale right report 2008.
19 Sharing the wealth, The Economist, 3 July 2008.

as Ballagh has pointed out, if the threshold had been €1,000 and not €3,000 many more artists would have benefited. It was auctioneers who wanted the higher limit. Nor is there evidence of any damage being done to the Irish trade by droit de suite. In the calendar year after its introduction – June 2006 to June 2007 – the market remained buoyant.

So far, only living artists benefit from the scheme. Everywhere else in Europe, the estates and heirs of artists who have died within the last 70 years also earn the royalty, but the Irish and British governments secured an exemption on dead artists until 1 January 2010 and can request a further two years if necessary.

Expect another campaign in 2009 from auctioneers and the trade to have that exemption extended. Their big argument will be that a small number of artists' descendants will benefit disproportionately. In France, seven families get 70% of the royalties; "most of them are very well off, including the Picassos and the Matisses."[19]

Ian Whyte argued after the sale of *My Studio, 1969* that the headline price would be good for Ballagh because he could now charge extra for paintings he sold himself. In fact, the artist benefited in a more direct way. His agent, Damien Matthews, organised a print run of 75 copies of *My Studio*, which Dermot Desmond launched at a reception in Dublin's Four Seasons Hotel. A framed copy cost €4,750 and some 52 of the 75 were sold. Some of these have already re-appeared in auction houses, as flippers try to turn a profit. In September 2007 one sold for €3,800 at Morgan O'Driscoll's in Cork.

All of the publicity surrounding droit de suite and *My Studio* undoubtedly helped Ballagh's retrospective at the RHA in late 2006. To coincide with it, Matthews staged a selling exhibition at the Gorry Gallery. Only four "difficult" pieces out of 104 didn't sell. So Ballagh has enjoyed the most commercially successful interlude of his career since the sale of *My Studio* in February 2004. Who says a rising tide doesn't lift all boats?

"I would like to think that the increase in prices is not due to the work Ian Whyte and his comrades did," Ballagh said. "It's due to the inherent creative value of the work. But of course they're not going to say that."

"Given that Ballagh was already a high-profile figure before this auction record, I don't think it has benefited him too much," Matthews argued. "As with most great works, *My Studio* was a very good buy – given that I have since sold privately several Ballaghs far in excess of this figure. Perhaps it has given the lesser collector confidence – as these high prices tend to do – but Ballagh was strongly collected long before this. Several of Ireland's richest and more knowledgeable collectors owned several examples of his work long before 2004."

Ballagh's legal challenge on droit de suite was not about money, it should be stressed. He gambled €75,000 in legal costs to win €5,000 damages. Presumably, having achieved this great victory for Irish artists, he has been weighed down by their garlands? They have been smothering him with kisses at the bottom of a goal-celebration scrum?

"I got one letter [of thanks] from one artist," he said. "Friends would have said 'well done'

NORAH MCGUINNESS

BORN: 1901, DERRY

DIED: 1980

PAINTING STYLE: FIGURATIVE

RECORD PRICE: €210,000 (ADAM'S, 2006)

FANS SAY: THE MOST UNDER-RATED IRISH PAINTER OF THE 20TH CENTURY

CRITICS SAY: HER STYLE DIDN'T CHANGE MUCH IN THE LAST 50 YEARS OF HER CAREER

IF YOU COULD OWN ONE: THE HARVESTERS (1959)

BEST EXAMPLE ON PUBLIC DISPLAY: GARDEN GREEN (1962, HUGH LANE GALLERY)

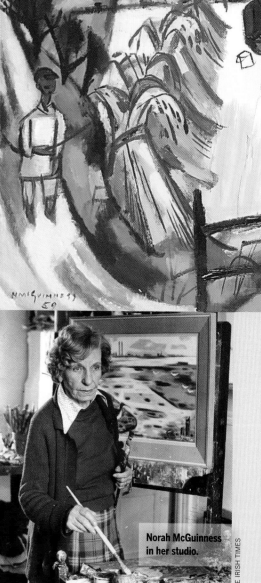

€210,000
2006

Norah McGuinness in her studio.

THE IRISH TIMES

The daughter of a Derry coal merchant, she was educated at Victoria High School and then attended the Metropolitan School of Art in Dublin, where her teachers included Harry Clarke, the stained-glass artist. In 1924 she enrolled at the Chelsea Polytechnic, and afterwards settled in Wicklow and began designing sets and costumes for the Abbey Theatre, including plays by William Butler Yeats.

She also illustrated his book Stories of Red Hanrahan and The Secret Rose, for which he lent her "a lot of Byzantine mosaic photographs" and as a thank-you dedicated the poem Sailing to Byzantium to the young illustrator.

In late 1929 she enlisted in Andre Lhote's atelier in Paris, where she remained for two years. Unlike other students there, however, she rejected cubism and even abstraction as "empty fields". She married poet Geoffrey Phibbs (later known as Taylor) in 1925, and had a daughter, but they separated four years later. In 1931 she spent five months in India, and then moved to London for six years. This was followed by a two-year stint in America – she had a one-woman show in New York

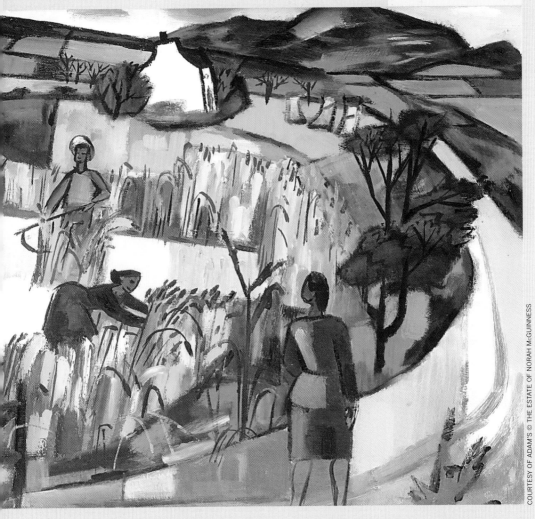

– and she returned to Ireland in 1939. McGuinness had been impressed by the highly designed shop windows in America, so she persuaded Edward McGuire of Brown Thomas to let her design the Grafton Street store.

She held the position of window designer for 30 years. She also returned to doing stage designs for the Abbey, including its first production of Waiting for Godot.

In 1944 she was elected chairman of the Irish Exhibition of Living Art in succession to Mainie Jellett, and later became its president, remaining in this influential role until 1971.

She regarded herself as a landscape artist, and although she remained figurative, the influence of cubism is seen in some of her work and she eventually moved to a slightly more abstract style. Her compositions were simple, but her great strength was the use of vibrant, joyful colours and her work in the 1950s particularly is still winning admirers. One series was based around Dublin Bay, including its sea gulls, sand dunes and mud flats.

The only retrospective of her work was held in Trinity College Dublin's Douglas Hyde Gallery in 1968, with over 100 works.

Another seems long overdue.

to me, but from the wider art community? One letter." Clearly the artists of Ireland have decided to astonish him with their ingratitude.

2008 WAS THE YEAR IRISH PEOPLE STARTED TO COUNT THEIR CHANGE AGAIN. UNEMPLOYMENT WENT over the 200,000 mark for the first time in a decade, jumping 30% in the year to May, and going up 19,000 in June alone, the highest monthly increase ever. The word "recession" re-entered our lexicon. Suddenly everybody was less secure about their job and their prospects, less inclined to spend. The value of their property and assets had been slashed. Their consumer confidence was shattered.

Zeros were knocked off the personal fortunes of some of Ireland's millionaires. Because it had already lost momentum, Ireland was especially buffeted by the storm lashing the global economy. Oil rising to $140 a barrel, the worsening credit crunch, and a 55% jump in food prices in one year all combined to create economic gloom on a scale not seen since the late 1980s.

The conventional wisdom is that a downturn in the art market follows six months to a year after a stock market collapse. So it proved. Irish art auctions in the first half of 2008 were more sober and noticeably less successful than those of the previous two years. Adam's first major sale of the year grossed €922,000 compared to the previous year's €1.6m.[20] Its "contemporary paintings and prints" sale a week later was hardly worth the effort. This auction grossed a mere €110,000, with only 55% of the 177 lots selling. Some prints went for as little as €40.

Ian Whyte's sales also experienced a slowdown, with his main spring auction grossing €2.06m, more than €1m down on the previous year.[21] Whyte admitted seeing signs of hesitation in the market, with lawyers and property agents noticeably absent from the sales room. Despite the economic slowdown, his problem with high-quality supply continued. "There is absolutely no way this country is short of cash," he said. "If it was in recession, we would be awash with art and antiques for sale." Fire sales, if they do happen, will almost certainly take place by private treaty and out of the public eye.

The main barometer of the Irish market remains the London sales each May, and these were 40% down in 2008 with almost half the lots unsold at Sotheby's (though they shifted another 10-20% privately afterwards), which grossed £4.15m. Christie's, which had been holding its Irish Sale over two days, had a one-day affair which grossed £2.6m with 55 out of 162 lots unsold. Bernard Williams, its Irish director, lamented the choosiness of existing buyers and the lack of new ones. "We are not seeing new blood with half a million pounds to spend like we did in the past," he said.[22] London's Big Two had made just over £11m

20 Fine Art & Antiques,The Irish Times, 5 April 2008.
21 Ibid, 11 May 2008.
22 Quoted in Fine Art & Antiques column,The Irish Times, 10 May 2008.
23 Artprice Global Index.

sterling from Irish art in 2007, but £6.7m in 2008.

The international art market, however, hardly broke stride. As with Ireland, it had a hugely successful 2006-2007, buoyed by an influx of wealthy buyers from China, Russia and India who concentrated on the contemporary market. Sotheby's had its best-ever sale in November 2007, raising $316m from a Contemporary Art Evening, which beat the old record of $286m from a Impressionist sale in 1990 at the height of the Japanese spending splurge.[23] One day earlier, Christie's had raised $325m from its contemporary sale.

There was a correction in early 2008, but fears of an art market crash similar to the one in the early 1990s proved unfounded. There may have been a sag in the middle of the market, but the top end was booming, thanks to the likes of Roman Abramovich, the owner of Chelsea FC, who bought a Francis Bacon triptych for $86.3m. Sotheby's broke its auction record again – making $362m at a sale in New York, with Christie's making $350m in its equivalent sale, the total including a Lucien Freud for $33.6m and a Mark Rothko for $50.4m. And it wasn't just contemporary artists that made staggering prices – one of Monet's large water lily paintings made £41m at Christie's in June. The firm's Impressionist and Modern Art Evening sale grossed £144m, yet another record.

The reason why the art market didn't follow the stock market downwards was not because the laws of economics had been re-written. Rather it was thanks to this surge of buyers from countries whose economies were flourishing, usually due to soaring oil revenues. Russian oligarchs, Middle Eastern sheiks, Chinese industrialists and Indian dotcommers took the seats in Sotheby's and Christie's that had been vacated by American and British stockbrokers and fund managers.

There was no such influx of new-buyer blood into the Irish art market, which remains of provincial size and of mainly local interest. While paintings were being sold for tens of millions in London, nothing made more than €200,000 in Ireland in the first six months of 2008. The spectacular price rises of the boom – the period from May 1995 to June 2007 – are clearly over for now. Art Market Research, a data firm, has calculated that Irish art prices grew more than 1,000% between 1976 and 2008. Growth on such a scale over the next 30 years is unimaginable. The buyers of the boom – many of them linked to property development – will not appear in such numbers at auction rooms in the near future, and auctioneers will struggle to replace them. The previous generation of multi-millionaire businessman collectors has also more or less finished collecting. Some of these are now poorer than they were in the late 1990s; the rest of them are wiser and make only sporadic purchases. It takes a quality picture to tempt them. And therein lies the problem: Irish auctioneers have huge difficulty sourcing Grade A works, and their sales are in danger of becoming giant carousels of dealers' stock.

Some art advisers now tell collectors never to sell. David Ker, a British dealer, says: "While I spend most of my life trying to persuade people to sell things, because most of our business

is selling things on commission, in reality if you have something good you should never sell it unless you have a very, very good reason to do something with the money. If you can make a huge profit now, you will make an even bigger profit down the line. I had to cash in some chips myself in the early 1990s because I was in Lloyd's,[24] but when I look at it today I want to slit my throat. My father, who was also hit by Lloyd's, had to sell good things, good Old Masters, before the substantial price rise in that sector. All people should do is weed out the secondary things in their collections."

Museums also buy with no intention of selling, and are a graveyard for paintings, as far as auctioneers are concerned. There is no reason why museums could not, discreetly if necessary, sell off paintings that they have no intention of showing again, and use the money for new purchases. Instead there seems to be a consensus that as much art as possible should be in public ownership – even if that means under sheets in a basement – and museums continue to lobby government for bigger acquisitions budgets, and to woo wealthy benefactors. The result is that the market for top "dead" art is slowly drying up.

The shortage of quality paintings could eventually threaten the future of the Irish Sales in London. If they can only source a couple of dozen decent pictures a year, Christie's and Sotheby's could easily revert to having British and Irish Sales. They are both stock market-listed companies, run by accountants whose eye is trained only on the bottom line and who are constantly seeking ways to cut costs. If the Irish Sales cease to be the nice little earner they have been, a business decision could be taken to drop them from the roster, thereby reducing marketing, cataloguing and transport costs. The fact that some of the most popular artists at Irish Sales – Lavery, Orpen, William Scott, Walter Osborne – have strong English followings, means their prices will not unduly suffer if they are sold in a British and Irish Sale instead.

When Sotheby's launched its Irish Sale in 1995, the idea of selling a country's art at a stand-alone auction in London was a new one. No longer. There are now sales based on art from China, South-East Asia, Vietnam, India, Scandinavia, Switzerland, Australia. A German sale and an Austrian sale have come and gone. There is a Greek Sale, a Scottish Sale, an American Indian Sale, an Important Canadian Art auction and, of course, several sales each year devoted to Russian art. The Irish Sale is but a small fish in this aquarium of international art. In May 2008, for example, just after it made £4m from Irish art, Sotheby's grossed £5.2m from a Scandinavian Sale including £3m for *The Dancing Shoes* by Helen Schjerfbeck, a Finnish artist.[25] This is £1m more than has ever been paid for an Irish painting at auction.

"The Irish thing is a very small part of what Christie's and Sotheby's do in a year," said Ian Whyte. "They raise £4m-£6m each, which is nothing. Next day they'll do £7m worth of Greek, then £30m-£40m of Russian, and £230m of modern contemporary stuff in New York. There's been talk that they might just adjunct Irish art into a modern British sale, or hitch it to a

24 Lloyd's names were an elite group of wealthy individuals who were the financial spine of the world's biggest insurance market. A series of natural disasters and calamitous errors in the late 1980s and early 90s left them seriously out of pocket.
25 Artdaily.org.

contemporary sale, and that would be a terrible pity. It's good for Irish art to have two Irish Sales in London, to have a week of it. It's an event for Irish art, gives it a profile. English buyers are seeing Irish art and being exposed to it."

While the cut-off point for Sotheby's Irish Sale may be £5m, for Christie's it is much lower. Art sources in London say any Christie's sale that grosses less than £2m is liable to be chopped.

Another reason why the Big Two started Irish Sales was in the hope of coaxing the top Irish collectors into buying international art, especially contemporary and Impressionist. In this they have not been successful – only Tony O'Reilly and John Magnier have bought significant non-Irish paintings. The lack of interest in French, British, Dutch and Italian work is all the more surprising when one considers that only a handful of Irish artists are of international importance. Irish collectors, confusing scarcity with quality, still pay big prices for comparatively ordinary Irish paintings when they could get better value in other markets. In 2008, Sotheby's brought some of the highlights of an Impressionist and Modern Sale to Dublin. While there were a number of Irish bidders at the subsequent sale, there appears to have been no Irish buyers.

"The Irish Sales were, in part, held as a way of attracting the newly minted to the more seriously priced sales," says a London-based dealer. "And it worked. However, there aren't too many newly minted Irish guys trawling the London sales rooms at the moment, and there are unlikely to be for the next few years. So, 'why bother?' is the private mantra of Sotheby's and Christie's staff."

Without these sales, Irish auctioneers will have to work much harder to promote and sell their product. The Big Two's marketing drive amounts to a giant annual promo for Irish art and a spend from which this country's auctioneers indirectly benefit. But they may soon have to budget without it. If a shortage of quality Irish paintings is matched by an exodus of wealthy Irish buyers from the market, and if the decline in the Irish economy continues while the Middle East and the Far East boom, the dedicated Sotheby's and Christie's sales are doomed.

It is also possible that we will see a casualty on the Irish scene. The surprisingly fast tumble of the Irish economy towards recession in 2008 was a wake-up call to companies with links to the property market. However, Irish auctioneering firms are small affairs with limited overheads and few staff. They should be able to survive a two- or three-year hiatus. "You don't have to be an accountant to work out what the auction houses are earning at the moment," John de Vere White said. "Whether I have a €1m sale or a €20m one, my overheads are the same apart from advertising. Therefore if the market went down by 50% in the morning, we'd all have tears in our eyes but we'd still be doing jolly well."

The economic slowdown may not result in a flood of paintings coming back onto the market, because the art boom was not financed by borrowings but with hard cash. There could, however, be a glut of paintings in the middle of the market, some from panicky

"investors" who need the money. Some of these may discover that they spent far too much and that, instead of getting a return on their "investment", their painting is worth less than they paid for it.

Faced with falling revenues, the temptation in the art business – never the most transparent – may be to cut corners, or take a chance. The provenance of certain paintings may not be as thoroughly researched. Dealers and auctioneers may be a bit more reluctant to declare something "wrong." The temptation to take an extra bid off the wall may be more difficult to resist.

"I think the whole market has turned a corner and it's now such a struggle for the auction houses to put together a good sale," said Bruce Arnold. "If they start into chicanery, then you'll end up with mud on your face because people are very shrewd. I have never thought that the auction houses have done anything other than their best here. The problem is that the greedy London auction houses smelt a golden egg in Irish art and muscled in, and then you had too many sales – London and Dublin – fighting for too few quality pictures."

Nevertheless, Arnold believes that the distorting factor created by know-nothing buyers paying too much is slight, because the Irish art market is underpinned by an ingrained culture of collecting. "People here have been collecting for over 100 years, which they haven't been doing in other countries that went through two world wars and various other problems," he said. "The new business classes and social elites thought of decorating their houses and buying pictures as a natural rite that they should follow. Consequently there is an underpinning that will survive. We may now see some good pictures going for small prices, or a few rocky sales, but then the market will stabilise again."

Buyers of the boom who do get burned will learn one important lesson – it pays to do your research. "Perhaps it's not too unjust to let them suffer for their lazy ignorance," said Damien Matthews, a dealer of the old school. "A lot of these 'new collectors' who didn't wish to be left out did not take the time to learn about what they were actually buying. If you were buying a sofa, you'd do more research than some of these clowns. The sad thing is, art is usually bought with earned money, thus the crap artwork they buy usually stays hanging on the wall. Those who have bought a lot of crap art usually buy until the walls are full, then their shallow interest stops, and they never get to realise how awful it is or what a terrible investment they've made. Some even believe the death of the artist will increase its value. No – crap is crap, dead or alive."

In fairness, art education did greatly improve during the boom years. People don't spend tens of millions without becoming knowledgeable about what it is they are buying. "The old thing was that if a painting had a pig or donkey in it, you could put it into the Irish Sale, but that's changed now," said Bernard Williams of Christie's. "The new band of collectors is very discerning. They do their research before they buy; they don't just see something in the catalogues. If they do their business like they do their research, you can see why they're the new rich. There are only a few silly buyers still. Occasionally someone comes in and spends

£1m, buys a few good things and a few things that have been around the block a few times."

Most people in the trade would agree that the "new collectors" have some catching up to do. "Not wishing to sound elitist but, not unlike wine appreciation and eating out, art collecting in Ireland is a reasonably new phenomenon," Matthews said. "The newly financially comfortable middle classes, buoyed up by the increasing value of their homes, budded forth with enthusiasm. Perhaps, as most had not yet developed a depth of knowledge required to be comfortable with their own taste, they bought more for status and investment than for true personal enjoyment. Because of this rush, people did not follow the useful principle of looking and learning before buying. This trend will become less evident as the market tightens and people use their eyes as their guide, rather than the art price index.

"Quite a lot of the art offered to the general public was, and is, of provincial quality. That is not to say Ireland does not have some important artists, we do, but their serious work is out of step with the gilt-framed, easy-going, colourful and impressionist style of base painting being pursued by the 'don't know much about art but know what I like' brigade."

Was it so awful, though, that nouveau riche south Dubliners bought a Markey or a le Brocquy to hang over their mantelpiece in order to show off? Julian Charlton of the Apollo says: "I think there's something rather sweet and nice about saying 'look at my Yeats' or whoever. It's better than 'look at my yacht' or 'what do you think of my car?'."

Nor does Lochlann Quinn see a problem with art becoming fashionable overnight. "Homes with paintings on the wall look much nicer than those without. And it's great for children growing up in that environment, because their eye is being trained without them even knowing it," he said. "So I think the fact that it's become fashionable or popular is a good thing. The future is good because we have awakened the eye and the interest of a whole generation."

There is a sense of being at the beginning of something, and not the end.. "Irish art has not been very successful in the period we are talking about," argues Bruce Arnold. "If you think that the greatest artist – Yeats – gets a bit over a million, what's a million these days compared with 80m for a van Gogh and 50m for a Monet? It's a small, limited market. The crème de la crème of Irish collectors are buying moderately interesting pictures for €1m and feeling very nervous about it, and that's how the market is sustained."

Julian Charlton perceives the same glass to be half-full, and continuing to fill. "I really think we're at the start of something in Irish art," he enthuses. "We're probably where Irish music was around the time of Thin Lizzy in the mid-1970s. At that stage there was the beginnings of an Irish music circuit – managers, promoters and publishers getting involved; bands were starting to get deals. When Irish artists sell for $40m, then we are on a par. But it's virgin fields; I think Irish artists will get to that.

"We're at the start of something. We're starting to see the beginnings of an art business."

12

"I'm a joker who has understood his epoch and has extracted all he possibly could from the stupidity, greed and vanity of his contemporaries."
Pablo Picasso

BEAUTIFUL INSIDE MY HEAD FOREVER WAS the title of the two-day auction of Damien Hirst's "art" held by Sotheby's of London in mid-September 2008. It featured a menagerie of stuffed animals including a calf, two sharks, a zebra, a black sheep, four cows' heads and a pony fitted with a plastic horn to make it look like a unicorn. There were "spin" and "spot" paintings, created not by Hirst but on machines operated by some of the 120 workers he employs.

Art critics were appalled. Robert Hughes described the works as "tacky" and "absurd"[1] and made by someone with "little facility". Fintan O'Toole wrote that Hirst's work was

Growing, by Una Sealy. "Doing a portrait is a two-way process. That's the reason why I love painting people. It's the only time as an artist that you're not completely alone."

1 In a television documentary made for Channel 4 and entitled The Mona Lisa Curse.

not that of a serious artist but of an exhibitor of curiosities.[2] "His are the aesthetics of the freak show and the funfair, of the prize at the parish fete for the most suggestive-looking carrot. He has talent and even genius…for marketing. But as an artist, he is frankly rubbish."

These critics were told they didn't "get" it. Germaine Greer pointed out that Hirst was a brand, and to develop such a strong brand "on so conspicuously threadbare a rationale is hugely creative – revolutionary even".[3] Hirst was supposedly subverting the art market, mocking it. But with the financial markets in global crisis that mid-September, was anyone in the mood for post-modernist irony?

The first of the 223 lots in the most audacious art sale in auction history went under the hammer on Black Monday, one of several Black Mondays that month. After a 15-minute delay to allow the press of buyers settle themselves, Ollie Barker of Sotheby's invited six-figure bids for a "spin" painting sprinkled with butterflies. It went for £850,000. *The Golden Calf*, a bullock preserved in formaldehyde with golden hooves, a head crowned by a solid-gold disc and horns made of 18-carat gold, was truly worshipped: it sold for £9.2m. As Lehman Brothers, America's fourth-largest bank, crashed; as the value of property and stocks plummeted worldwide; 223 objects with no intrinsic value and which would cost huge sums to maintain and insure, sold for £111m.

What had just happened? One commentator[4] reckoned this was "an astonishing phenomenon, one that had probably changed the art market forever", the auction itself being "perhaps one of the most brilliant and extraordinary works of conceptual art ever created". Perhaps, but it was far more likely that many of the bidders were buying out of fear. Hirst owners, and they included Hirst himself,[5] have a life-or-death interest in keeping his prices in seven figures. Anything less and the value of their "investments" – the dead animals – would tumble as fast as share prices. Like suckers lured into an elaborate pyramid scheme, they must keep the edifice standing or die in its debris.

"I love art and this proves I'm not alone," Hirst said afterwards. "And the future looks great for everyone." Hardly. Contemporary art of this type is the biggest confidence trick of the lot, hyped up by a cynical art industry to trick gullible millionaires who desperately want to buy class. It is a bubble aching to burst. Nevertheless, Hirst may well have made a contribution to art history – by redefining the role of artists, the nature of what they do and the method by which they succeed. Does everyone need to be able to paint, sculpt, draw or even install when some can simply lend their aura, or their brand name, to an object and make it art? Why go to art classes when it is marketing skills you require? Why learn to paint when you need to become a personality? Why waste time in a studio when you should be building a media profile, creating controversy and becoming financially aware?

2 The Irish Times, 20 September 2008.
3 The Guardian, 22 September 2008.
4 Andrew Graham-Dixon in the Sunday Telegraph, 21 September
5 He reportedly owns a share in a diamond-encrusted skull, entitled For The Love of God, which he created in 2007.

These are not just questions for artists working in markets where contemporary art is "hot"; they are global issues. And Irish students are already being taught how to be an artist in the Hirst era.

"In the current climate of post-modernity, there is no way of defining what is good and bad about contemporary art. The role of the critic has been superseded by the power of the buyer," said Mary Theresa Keown, 34, a contemporary painter from Enniskillen who works in Dublin. "Today's students are being made aware of how to tap into those opportunities, how to network, compose applications and target their audience, whether it be for profit or not. In some ways the motivation behind making art has changed. It has become more focused on business success than on self-expression or investigation.

"It is extremely hard as a young artist to create a career without being involved in the art system of marketing, and networking. Modernism allowed for a more structured appreciation of an artist. Now in an era of anything goes, it is increasingly more difficult to maintain an audience's attention."

Keown works with oils and collage, drawing inspiration from contemporary sources such as fashion photography, video images and interior magazines. She juxtaposes different styles, colours and textures, adapting her painting style to suit the imagery. She tries to avoid creating a brand image and yet worries about her work becoming so inaccessible that it is no longer recognisable, and then not sold. "I have this inability to churn out the same stuff," she said. "I take time to devise the next step in my own exploration and then try it out." She recently dropped her signature collage technique to concentrate on something different. "I'm always nervous about doing that, but I must. I hope that audiences will appreciate the steps I take. The trick is being able to convey a stability and progress in your career, and not too fast.

"There's so much art in the world, and if it's instantly recognisable then it's a winning formula as far as buyers and sellers are concerned. But if it doesn't have integrity, it won't last the pace."

Gillian Lawler, 31, from Kildare, is an emerging painter whose modern landscapes have achieved early commercial success, and representation from the Cross Gallery. A graduate of NCAD, she noticed how some of her contemporaries were hyper-conscious of the market and produced only work they thought would sell. "It's generally quite awful, has nothing to say, and in this respect is transparent," she said. "They produce work which reflects the monetary boom we've experienced over the past few years. But most of my contemporaries wouldn't do that; they produce work true to themselves. The expectation of selling an artwork doesn't tend to be the driving force of what they do."

That said, she would have preferred if NCAD in the late 1990s had taught her more about the practicalities of being an artist – such as how to put together a proposal for a curator. "You do have to get out there and push yourself and chase things," she said. "If you are shy and quiet, it is hard. I have known people who were really talented but just weren't willing to get

out there on the scene and talk to the right people – such as gallerists and curators, who can avail of project grants from the Arts Council, who may have access to interesting venues and other contacts which could further an artist's career. You meet them at openings and arty events. If you were shy and socially inept, you would miss out."

While creating a "personality" can be a good career move, unlike the Young British Artists (YBAs) of the late 1990s, Irish contemporary artists have had no need to draw attention to themselves by producing "shock" work or controversial concepts such as unmade beds. There was no need for any of that during the boom.

Among those buying art almost as fast as it was produced were dozens and dozens of

Left: City on Stilts 2, by Gillian Lawler. Above: Red Generator, by Elizabeth Magill. Right: FraAngelico, by Mary Theresa Keown. Far right: 'Café Window Piccadilly, London, by Colin Davidson.

corporate collectors – banks, insurers, stockbrokers, solicitors' firms…staid and sober companies trying to give themselves cultural cachet, a little coolness and sophistication by hanging modern art in their foyers and their boardrooms, by installing sculptures in their grounds and plazas. There was an added financial benefit if the works appreciated in value – the "investment upside", as they called it. Plus, if you display an artwork in an area used by staff or clients, the cost is tax deductible over eight years. And so, in April 2008, when IMMA staged an exhibition of contemporary art from members of the Business to Arts scheme it was called '10,000 to 50.' The 50 was the number of works chosen for the exhibition; the 10,000 was the number submitted for consideration. 10,000 artworks bought by a comparatively small group of businesses.

Typical of the collectors was KPMG who went into NCAD and asked students to "come up with work on their ideas of business, for one of our training rooms".[6] The firm ended up with paintings by two rising stars: Geraldine O'Neill and Diana Copperwhite. Generally, corporate

collectors want works that are safe, decorative and unlikely to shock or insult visitors. The curators of the IMMA exhibition noted the "relative conservatism"[7] of the corporate works, since paintings, and especially more traditional paintings, are favoured by business buyers.

About as risqué as corporate collectors get is work by Amanda Coogan, a 37-year-old Dublin artist best known for performance pieces such as *The Sacred Heart*, in which she stands open-jacketed, breasts partially revealed, "bleeding" with paint in a manner similar to the religious icon. Coogan has also paraphrased Michelangelo's *David*, and in *The Chocolate Performance* she ate her way through two metres of chocolate in just over five hours. For the conclusion of her MA degree in Germany, she scoffed a chocolate cake as quickly as possible.

Such safe performance art marks one outer boundary of the contemporary Irish art scene.

Naturally, portraiture thrived during the boom. For about €10,000, businessmen could be captured, honoured, maybe immortalised by one of the bright young things of contemporary Irish art. And although it's the stalest of formats, and those who can pay are often the least deserving of being painted (rich, grey, sixtysomethings), almost all of today's leading Irish artists paint portraits – Mick O'Dea, Conor Walton, Una Sealy, Carey Clarke, Maeve McCarthy... And the daddy of them all, the official portrait painter of Ireland, is James Hanley, secretary of the Royal Hibernian Academy. When Official Ireland wants to frame one of its icons, they send for Hanley, who at the end of 2007 had "at least two years" worth of commissions.[8] His

6 Quoted in Veni, Vidi, Medici, The Irish Times, 5 July 2008
7 Quoted in Art that Transcends the Greasy Till, The Irish Times, 3 May 2008

subjects have already included President Mary McAleese, Bertie Ahern, Ronnie Delaney, Maureen Potter. Fortuitously he's "interested in power portraits, like people in institutions for example."

Hanley, 43, is regarded with a degree of envy by his peers. He gives the impression of not having had to struggle for as much as one day of his career. In college in 1990 he won a £1,000 award from the RHA, and used it to rent a studio. His degree show after graduating from NCAD in 1991 was a sell-out. The following year he had his first solo show of 40 paintings in the River Run Gallery; another sell-out. He later married the gallery owner's daughter. "Got the show, got the girl," he would quip.[9] Portrait commissions rolled in from IMMA, the Abbey Theatre, the Irish army, from the RHA to paint the Taoiseach. The National Gallery of Ireland hired him in 2000 to paint Olympic gold medal winner Ronnie Delaney, and paid him so much that he could afford to build a studio in his back garden.[10]

Supporters insist that his painting is "slightly self-deprecating, mischievously subversive of itself" and that he has "his own distinct, humorous voice" with "nothing ingratiating or sycophantic about his style." Instead he is said to take "a distinctly cold, hard-edged view of things."

For the portrait artist to maintain independence can be difficult, however, given the demands of the client. "Most people who want to commission a portrait already have something fixed in the mind, and it's hard to meet that expectation," said Nick Miller, a 46-year-old Sligo-based artist represented by the Rubicon Gallery.[11] "They have to know my work and want it to be a painting more than a portrait. In those circumstances I will consider a commission."

The methodology used varies from artist to artist. Many work only from photographs and make no effort to disguise this, à la Francis Bacon, who loved to enrich with his own techniques the reduced information that photo images supply. For others, the traditional method of long sittings is essential. Conor Walton has said he needs a minimum of five. Much to the horror of his sitters, he does not stop when a good likeness is achieved. "Often you have to undo the likeness or play rough with the paint in order to push the painting forward," he has said.[12] "Sitters invariably think you're ruining their portrait at that point and want you to stop. It can take a real effort of will not to leave it there, and to keep pushing on."

"For me the person has to be there," agrees Una Sealy, an artist based in Howth. She paints portraits in three, three-hour sittings at the sitter's home, finding it easier to express people's personality once she's got to know them. "Doing a portrait is a two-way process. That's the reason why I love painting people. It's the only time as an artist that you're not completely alone."

8 You've Been Framed, The Irish Times, 1 December, 2007.
9 Artist paints himself out of a corner, Money section, Sunday Times, 16 May 2004
10 Ibid
11 The Irish Times, op cit
12 Ibid

The public perception of the portrait is that it is an honour bestowed on the great and good, and therefore artists should not dignify unworthy subjects. So there was a predictable furore when Mick O'Dea's portrait of Brian Meehan, a criminal serving a life sentence for the murder of journalist Veronica Guerin, appeared in the RHA's annual exhibition of 2003. O'Dea, who helped teach art in Portlaoise prison and who works from life, did a conventional portrait of Meehan, his brush strokes passing no judgment on the subject. Unfortunately, the Meehan portrait did not start a debate about whether the role of the artist is merely to observe and record. Instead, after an all-too-predictable controversy, the work was withdrawn from sale.

Gary Coyle, 43, from Dun Laoghaire ran into similar trouble when he devoted his first show in the Kevin Kavanagh Gallery to murder and drawings of crime scenes. A journalist noticed that a portrait of Peter Sutcliffe, the Yorkshire Ripper, was part of the exhibition and started a fuss. Coyle immediately took it down off the wall. "When I took my masters in London in the middle of all the YBA explosion, they would do exactly the reverse," he said. "They would talk up the sensation, drive up the popular media outrage, whip it up and get themselves depicted as a bad boy. That was the way to do it. But I think that's bullshit and short-term. I shrank away from all that."

The crime and porn scenes he featured in that exhibition didn't contain any bodies; they were just scenes. Exploring the theme of celebrity culture and voyeurism, he based the drawings on some rather sensational images but omitted what they actually were and just gave them a number to bypass all the controversy. "So there was never a big fuss, as opposed to, say, calling one of them Manson Murder 2 or something like that, which is what you would do in the UK. I just called them Scene of the Crime and gave them a number and no-one was any the wiser as to which murder it was."

Utterly eschewing the demands of the market place, Coyle's art mixes performance, photography and drawings. He is writing a one-man show about swimming, based on a diary he has kept about swimming every day at the Forty Foot and using some of the 7,500 still photos he has taken of the sea in south Dublin. "Is there an audience for all that? It's nebulous," he said. "Have I made any money from getting up on stage? – I probably have, but that has never been the motivation for anything I have done. I think Irish people are very open, actually. They will give things a bash. I know people who buy my stuff, some of my friends who are into contemporaries. I mean they wouldn't buy a video installation or a disc or something like that, but myself I think all that's mad anyway.

"The serious Irish art world is 300 or 400 people; I'd say no more than that. I don't know how a constituency is built up around an artist, in terms of putting out a name and saying 'he's the person to buy'. It would be great to have a Charles Saatchi type in Ireland to bring things on and to raise the profile – I'd really like to see it. I don't, though. The 0.5% of the population who buy art are by and large the professionals and they would be by their nature

conservative. But Irish people do have more open minds now, they travel a lot more, they see things in glossy magazines."

His themes include sex and death – "great subjects". And as the resurgence in interest in Francis Bacon proves, these are themes that have the longest resonance and ultimately attract the highest prices. "It's difficult to know with art what's going to last beyond its time. You just hope for the best," Coyle said. "I was at a Jackson Pollock[13] exhibition recently and I didn't think his art had transcended his time. You can but hope that you will, but no-one knows whether they will or won't."

IF PORTRAITS SEEM A JADED AND OUTDATED FORMAT, WHAT OF LANDSCAPES? COULD ANYTHING BE more clichéd and passé? Does any art scream "weekend watercolourist" more than trees, fields, fawns and soft horizons? No, any Irish artist who tackles rural landscapes in the 21st century would want to have something new to say, or be able to demonstrate a revolutionary approach. Two who do are Elizabeth Magill and William Crozier.

Magill, 49, is of Canadian birth and now lives in London, but she grew up in Northern Ireland and studied at the Belfast School of Art. Her landscapes are not done in the traditional sense; they are explorations of her own imagination and the memory of her childhood in Antrim. "I'm not so much painting what is there but what I imagine might be there," she has said. "These works are not landscapes as such, but more like suggested backdrops to how I feel, think and interpret the world."[14] A far cry from the formalism of old, Magill's free, almost wild style of painting is integral to the finished work – random streaks and blobs of paint deny the viewer an entirely representational vision, while even the way the paint dries or flakes off is incorporated into the image. The resulting artworks have been described as of "startling originality".

William Crozier was born and educated in Glasgow but settled in west Cork in 1983, and its landscapes have been a source of inspiration ever since. He paints in startling, almost lurid colours, such as orange and bright yellow, refusing to acknowledge the grey clouds, brown earth or uniform green that is Irish nature's palette. Crozier says that he can use the language of landscape painting to express his emotions about almost anything.[15] Showing influences from the east as much as the west, he sometimes raises the horizon line to almost the top of the canvas (in complete contrast to Paul Henry and early Yeats). Crozier has said that when painting the Irish landscape he must "tell the truth; say it simply." But at the same time he

13 An American painter, Pollock (1912-1956) was a moving force in the abstract expressionist movement. His work hugely divides critics and the public – "decorative wallpaper" and "one of the century's most influential artists" being the two ends of the spectrum.
14 Quoted on http://www.24hourmuseum.org.uk
15 Scenes from the heart, Sunday Tribune, 30 June 2002
16 Quoted on http://www.commentart.com/exhibition/William_Crozier
17 Born in Sligo in 1910, he died in 1994. Collins' greyish abstract landscapes were inspired by folklore and Irish mythology.
18 A British sculptor and environmentalist now living in Scotland who produces sculptures and "land art" in rural and urban settings using natural and found objects.
19. It was presented to the Tate in London in 1995

can only paint "that to which I have grown accustomed; objects or landscapes which excite or delight after long familiarity."[16]

Eddie Kennedy, who was born in Thurles in 1960, the son of a farmer, is now living and working in Dublin. He is engaging in the landscape tradition in a very modern way, but his inspiration comes from Irish history. "You get a strong sense of connection back to the art of the ancients," he said. "I have a great sense of affinity with places like Tara, Newgrange, Monsterboice, the stone circles. And then Patrick Collins[17] for me did something quite new in an Irish context – brought landscape into a contemporary painting language. I was very fond of his work."

He believes Irish art of the future will find more inspiration in the environment – especially the changed landscapes wrought by global warming, carbon emissions and extreme weather events. "I already see younger artists reacting to the environment, and the threat to it, in terms of the material they use," he said. "Installations and sculptures where people are interested in recycling; Andy Goldsworth[18] working with ice, water, snow, elements like that."

Two of Ireland's best known women artists make extensive use of natural materials – Alice Maher uses briars, trees, snails, bees and nettles, while Dorothy Cross, from Galway, has worked with snakeskin, cowhide, lobsters, jellyfish, and whale bone. One of Cross's best known works is *Virgin Shroud*, made from cow hide and her grandmother's wedding veil, which is in the form of a statue of the Virgin Mary, with four udders as its crown.[19]

But in tandem with Ireland's move from being a predominantly rural society to an urban one, the inspiration of many young artists is the built environment. Gillian Lawler's paintings are modelled on the high density buildings that shot up around Dublin during the property boom. "I grew up on a farm in Kildare and moved here about 11 years ago when Dublin was a very different place. I witnessed its dramatic transformation visually during the boom years, and it changed my work considerably," she said. "My studio had once been in a quiet neighbourhood, and suddenly it was surrounded by apartment blocks and modern building developments. It changed the character of the area and for me made it more claustrophobic." Lawler's art shows her unease with high-density development and reflects on how new buildings, while being an expression of human ambition, can also cause social problems, anxiety and alienation.

Francis Matthews, 27, from Inchicore who graduated as an architect from UCD in 2004, is another young artist who engages with Dublin's construction boom. "I always drew and painted when I was younger, so I decided to try painting at the start of 2005 and give it a year to see how it goes," he said. "It went well enough to continue." He got representation from Cherrylane Fine Arts in Wicklow, and was accepted twice at the RHA exhibition.

"It was through studying architecture in college that my interest in light and the built form was aroused, and this is the subject matter of most of my paintings," he said. "The city and its life are the main source of my inspiration. It is in a constant state of change, visually and physi-

cally, due to weather, time of day, time of year and human activity – from day-to-day activities such as putting out rubbish, to construction work. I like observing the changes the city undergoes."

Colin Davidson, 40, from Belfast, perhaps the most commercially successful of the emerging generation of Irish artists, admits that "since school, I've had a pre-occupation with the urban in my work." In 1999 he made a leap of faith by abandoning the thriving design business he had set up six years previously and becoming a full-time painter. The strength of the art market he found "liberating", allowing him to keep experimenting until he found his own style.

"Recently I've been exploring the interaction of multi-layered imagery as it appears in the reflections and refractions in the windows of shops or offices in city centres, and interacting with what's in there," he said. So his subject is neither the street, nor what's inside the shop, but the sheet of glass that separates them, and Davidson brilliantly captures the patterns, colours and light as they interact on that sheet of glass. Some of the paintings are so powerful that those who have seen them will never again be able to look out at, say, O'Connell Street in quite the same way. "It's really uncovering the abstract in our realities," the Belfast artist said. "I'm looking at the world and questioning what I see – what is real, what is not. There are many 'dualities' at work."

THERE IS AN IRONY IN THE FACT THAT, WHILE THE CONSTRUCTION BOOM PROVIDES AN INSPIRATION for artists and helped create a market for their work, it was a huge impediment when it came to that most basic of artist requirements: somewhere to work.

"I've found myself moving all around the country chasing good studio space," said Mary Theresa Keown. "I've just learned that the studio I'm renting is about to come down for re-development. This has happened to virtually all the spaces I have rented through the years. The buildings inhabited by artists are generally large, old and factory-type, with very basic facilities. It suits the owners to rent them out to artists until planning permission comes through. There is an established trend in certain areas in Dublin – artists move into old buildings, provide rent to the owner, who promptly finances planning for a redevelopment.

"With my unstable income I have never been able to establish a mortgage. Over the years I have gone on residencies that provide excellent facilities and are situated in beautiful surroundings, but like the Arts Council-subsidized spaces, they are heavily competed for."

With the middle of the art market suffering something of a collapse in 2008 – galleries were much more affected by the recession than auction houses – the problems are likely to get worse. "It's much more expensive to rent a space now and I think a lot of artists are really struggling," said Gillian Lawler. "It's hard to find warehouse-type spaces that are suitable for studios, particularly with adequate lighting and enough room. Many artists feel financially under strain. I have noticed a fall-off in sales over the past year, with people much more wary about purchasing artworks. But artists' materials are not cheap and studio rents have shot through

the roof in some places."

One option, of course, is to abandon Dublin and decentralise to a county like Leitrim. But it's not a panacea – young artists crave, even need, each other's company and being part of a vibrant artistic community can be an essential creative impetus. But they also need a space to call their own. "I don't think you can make art without stability," Robert Ballagh once said.[20] "You have to have a fixed place to make it. You can't be living from one bed-sit to another."

One of John Noel Smith's aims when he returned from Germany in 2002 was to build a proper studio in which to work. Originally from Malahide, Smith had emigrated in 1980, at the age of 27, and lived in Berlin for 22 years. "My concern was to have a space which would be equivalent in area to the atelier that I had in Berlin, but higher ceilings were required for the large works that I was planning," he said. "It was completed last year and compares well to other studios that I have visited throughout Europe. It was a great relief that it was completed. But I managed during its construction to conclude three one-man exhibitions. The worst time was trying to paint while the plasterers were working.

"I suppose artists need to be apart from others while simultaneously being a part of society. The studio provides this bilocated sanctuary."

Being an artist in the age of Damien Hirst requires, as never before, knowledge of the art industry, a commercial nous and the entrepreneurial ability to run what amounts to a small business. "I do think one of the biggest practical problems we face is the lack of information of the business aspects of becoming an artist," said Francis Matthews. "For example, the relationship between gallery and artist can be very loose and undefined, leaving the artist not really knowing where they stand. Also the commissioning of works, which can seem like a casual thing, can lead to difficult situations. How to price your work is another difficult aspect."

While it doesn't need to be taken to Hirstian extremes, art can never be divorced from commerce. Ultimately the market cannot be bucked. As John Noel Smith says: "It would be naïve to think that collectors and museums purchase art for its intrinsic value without reference to the pedigree of the artist or indeed how the art market views their saleability.

"The wise artist in the first instance will paint for himself. The market being notoriously fickle will not only punish those artists who hop on a bandwagon, but also those who have collected them."

20 Quoted in Robert Ballagh by Ciaran Carty (Magill, 1986)

EPILOGUE

Most of the art purchases that really mean something don't happen in galleries or auction houses at all. The art market puts a price on everything, but great paintings have a value that cannot be expressed in money alone. One Friday morning in late October 2006, collector John O'Sullivan set off on the road to Limerick. He had commissioned a painting from John Shinnors – "just one more piece to round off my collection; that'll be it, I swear." The Limerick artist had done a series of scarecrow heads five years earlier that were sold as a lot to Dunloe Ewart, but he'd agreed to paint O'Sullivan one in the same style.

Even though the two were old friends, the IONA executive approached Limerick with a degree of trepidation. What if he didn't like the commissioned work? And given that Shinnors was now making stratospheric prices at auction, would he be charging the market rate?

They met, as always, at the White House pub at the end of O'Connell Street close to Shinnors' studio. The artist was dressed in all-white, a Shinnors trademark – the most adventurous he gets is a variation of cream. They chatted over a Smithwicks and a coffee and then headed for the studio. The artist assured O'Sullivan that he'd like what he was going to see.

The painting was set up on an easel, covered. The wrappings came off, and light flew onto it from the large windows, the same ones at which Shinnors had stood 20 years earlier, keys in hand, ready to pack it in. "It was a masterpiece, way beyond what I had hoped for," O'Sullivan said. "In addition to the stark and ominous image of the scarecrow, there was a wealth of attendant detail – red stitching, flecks of colour and a shadowy mirror image. It is, to me, his best painting. I wouldn't swap it for any Shinnors I've ever seen and I've seen most of his paintings."

They had been tip-toeing around the commercial realities of this transaction – you tend to do that with John Shinnors. "I didn't know what he was going to charge me," O'Sullivan said. "If you'd asked me for an estimate, I would have said '20 grand if I'm lucky'. But he said only 16. If I flipped the painting tomorrow I could get twice this."

Deal done, they headed off to Willie Sexton's to celebrate. Thence to South's, another rugby pub. Only then did they return to the studio and Shinnors packed up the painting for its trip to Dublin. This scarecrow head will not be appearing in an auction room. It will remain

PADDY BENSON

John Shinnors: "As long as a picture holds, that's what I care about. If I see it after 20 years and go 'yeah, that's still okay."

in the place of honour – over the fireplace – in the collector's home.

There was a reassuring symmetry to this: Shinnors' best work placed with one of the artist's greatest admirers, and not an auctioneer in sight.

Since he became "hot", Shinnors has been getting taps on the shoulder as he sups his pints of Smithwicks in the hostelries of Limerick. Will he do a commission? He'd love to, really, but he doesn't do that sort of thing anymore.

A couple of years ago he was sitting up on his stool in The Spotted Dog when a man approached whose wife had just died of an aneurism. "She was only a girl, mid-thirties, a lovely woman, they had two children," the artist said. "He said 'John, can I see you?' And I knew exactly what he wanted. So I told him to come to the house, and he wanted me to do a portrait of his wife from photographs. I couldn't refuse. I just fecking couldn't, even though I was up to my eyes.

"Anyway I did it, got out the sable brushes, and painted her. It had to be realistic for him, and it was. I spent about five weeks on it. I didn't know what to charge him, so I only asked him for a few hundred quid. He said 'great'. He was delighted. It was an emotional experience as much as a business transaction. I see him now and again. He tells me that every night when he goes to bed, he says 'good night' to the painting, to his wife."

Does any painting bought in Ireland during the boom mean as much to its owner as this Shinnors portrait? And once again, not an auctioneer in sight, and no need for a dealer to act as matchmaker.

Of course artists need a market to survive, but if that art market does not find paintings their best home, and if it does not compel artists to do great and meaningful work, it's just making a small number of people rich.

"The art boom will last as long as the money does, but I'll still be painting anyway," Shinnors says. "If pictures of mine that were sold for €30,000 suddenly only get half that, I personally don't care. As long as a picture holds, that's what I care about. If I see it after 20 years and go 'yeah, that's still okay'."

He wants collectors of his work to be as passionate about these paintings as he is. "That's the way it should be," he says. It's not the way it's been.